DEGAS
The Complete Etchings, Lithographs and Monotypes

DEGAS

*The Complete Etchings, Lithographs
and Monotypes*

JEAN ADHÉMAR
and
FRANÇOISE CACHIN

Foreword by JOHN REWALD

A STUDIO BOOK

THE VIKING PRESS
NEW YORK

CONTENTS

FOREWORD

What is past is prologue.

To the memory of Professor Paul Moses who, before his death in 1966, had set in hand this work.

This book was prepared by Jean Adhémar and Françoise Cachin. It makes available to collectors as well as specialists an up-to-date tool for the study of the graphic works of Degas, something not previously at their disposal except for the catalogue by Mrs Janis. The section on Degas' etchings, by Jean Adhémar, draws heavily on the research carried out by Professor Paul Moses.

My friend Paul Moses taught at the University of Chicago. His interest in Degas was characterized both by passion and intellectual rigour, precisely the qualities of which good scholars are made. Attracted to art from a very early age, particularly the French nineteenth century, he developed the sort of enquiring mind that is not content to accept truths hallowed by tradition but always strives to extend the frontiers of knowledge. The curiosity of the researcher is an admirable attribute that, methodically exercised, will be rewarded by many discoveries. These discoveries may seem trivial in themselves; sometimes interminable hours of work may result in the shift of a comma in a historical text, no more than that, yet the man who can persevere and coordinate his finds will always end by increasing the store of human knowledge, whether by providing new facts or confirming old ones that had been forgotten, or by placing information in a new light.

Historical research concerning Edgar Degas is still in its infancy, and this in spite of the monumental work by P.-A. Lemoisne – or perhaps because of it. While Lemoisne was preparing his *catalogue raisonné*, the sensible course was obviously to wait for it rather than embark on projects that might become superfluous once Lemoisne's work appeared. And after his volumes had been published, between 1946 and 1949, it seemed pointless to explore a field where everything there was to say seemed to have already been stated. So it is that the fruits of tremendous labour and the power of a name can paralyse others who might have oriented their own energies in the same direction. But at a distance in time it becomes obvious that a great deal still remains to be done, not least in correcting the errors that have insinuated themselves into the body of scholarship.

It would be a relatively simple matter to list all the defects of the catalogue of Lemoisne. Yet before that is done one must first recognize him for what he was, a pioneer and a trailblazer, the man who assembled and classified thousands of photographs, trying to place them in some sort of sequence. It is only because we have this extensive documentation at our disposal that we find it so easy to criticize his methods.

There can be no doubt, for instance, that it would have been better to establish a chronology based on

stylistic rather than so-called historical criteria, taking into account the preparatory drawings, something that Lemoisne failed almost entirely to do.

It is known that Degas treated certain subjects throughout his life, apparently never tiring of a number of specific settings such as the racecourse or the world of dancers, washerwomen, milliners and musicians, women at their toilet and brothels. It is also known that he returned again and again to the same typical gestures and poses in his drawings, pastels, paintings, prints and even sculptures. Clearly it is not possible to group these repeated motifs together mechanically, according to subject matter. On the contrary, in terms of colour and especially in the handling, which changed radically over the years, they reflect the artist's development. In order to assign to all these different versions as nearly as possible their rightful place in the sequence, it is necessary to examine and compare the originals, many of which are now in the United States. (Such a procedure would doubtless have enabled Lemoisne to exclude, for example, a calamitous head of young girl with plaits which apparently was admitted at the last moment.) Similarly, as far as Degas' stay with his Louisiana family in New Orleans is concerned, Lemoisne was content to accept evidence available in France, without the sort of on-the-spot investigations that have helped us to obtain much useful information.

This is not said in any way to detract from Lemoisne's achievements but rather to indicate how much remains to be done. It was therefore up to those who came after Lemoisne to try to correct his errors and fill in the gaps he left. Paul Moses applied himself to the task with enthusiasm and patience. I remember a special trip he made to Pau – though it was only because of modest scholarships that he was able to go to Europe at all – in order to search the local press for reviews of exhibitions that had featured works by Degas, exhibitions organized by Paul Lafond, keeper of the museum at Pau and a friend of the painter. It was in one of these articles, not listed in any bibliography, that Moses found a description of a particular composition of dancers, and I remember to this day how persistently he endeavoured to identify this picture from the description in the review. The identification revealed that the date of execution suggested by Lemoisne was too late, for, although it is not axiomatic that a work is painted in the year when it is exhibited for the first time, it is clearly not possible for it to have been painted *after* appearing in an exhibition.

But the areas of Degas' work that particularly interested Paul Moses were his etchings and monotypes, the subject of this book. This major body of the artist's work had been deliberately passed over by Lemoisne and the cursory investigation of the etchings by Loys Delteil, published in 1919, demands radical revision. Within this mode of expression, restricted to black and white and the infinite range of intermediate tones, Paul Moses was able to appreciate and demonstrate the originality and inventiveness of a great master, who excelled in this just as he excelled in all he attempted.

In 1964 Paul Moses organized a small exhibition of Degas' etchings for the Renaissance Society of the University of Chicago, which was a model of its kind. Not only did it bring together many different states of the same plate, allowing comparisons to be made that threw light on the artist's working methods but, with detailed notes on each proof, the catalogue also showed to what extent Delteil's publication had been superseded. Here the reader was presented with a mass of references documentation, revisions and the discussion of dates of execution, which admirably reflected the young academic's tireless efforts.

In his introduction Paul Moses spelled out the problems facing anyone trying to introduce a little 'order' into Degas' graphic output, problems not all that different from those raised by the catalogue of paintings and pastels compiled by Lemoisne.

'Since Loys Deltail's invaluable *catalogue raisonné* of 1919,' Moses wrote, 'little has been published on Degas' etchings. The little that has appeared has depended heavily and often without question on the data that Delteil presented and on the conclusions that he reached. During the last twenty years, however, several critics have offered fresh observations about isolated aspects of the prints. . . . Much remains to be examined. Nonetheless, the tide of critical and scholarly opinion has turned to the extent that it can entertain the judgment by Miss Elizabeth Mongan that in time Degas would emerge as the major figure in the graphic art of France during the second half of the nineteenth century.'

Moses devoted himself initially to a study of Degas' monotypes, emphasizing from the outset that those retouched with pastel or gouache were not strictly within the domain of graphic art. He thus concentrated specifically on the 'pure' monotypes, intending to compile a catalogue and study them in depth. But first he wanted to trace Degas' development as an etcher, since the artist only turned to the monotypes – which were to prove such a marvellous vehicle for his genius – after he had mastered all the secrets of etching and lithography. Step by step, proof by proof, state by state, Moses explored each stage in Degas' evolution.

The French publishers, Editions des Arts et Métiers Graphiques, had guaranteed publication, and the author was hard at work on this his first book, when two young hooligans put an end to his life. This happened in Chicago on 26 March 1966. Paul Moses was thirty-six. The combined age of his assassins hardly amounted to as many years.

The publisher then entrusted the task of completing the book to Jean Adhémar, who had ample opportunity to appreciate the devoted scholarship of Paul Moses during the weeks he spent at the Bibliothèque Nationale, in particular in the Cabinet des Estampes, studying the famous notebooks that Adhémar has made available for research. Françoise Cachin was asked to concern herself with the monotypes, these being more the province of a museum curator. Thanks to this collaboration, all the knowledge and documents assembled by the young scholar will not be lost. I thank them for rescuing the name of my friend from the oblivion that threatened it.

I do not know, and no one knows, if the fatal bullet was aimed at Paul Moses because he was black. All I do know is that his death has been an immense loss, not only for his family but also for Degas scholarship, for the art world and for the rest of us historians, who had such good reasons to expect many significant contributions from him.

JOHN REWALD

The Etchings and Lithographs

INTRODUCTION

Degas is one of the greatest of the painter-printmakers. Yet it is only with extreme difficulty that a member of the public or an art expert can assure himself that this is the case. It is most unusual for any exhibition to include more than about twenty Degas prints. Very few proofs were pulled in the first place, they are rarely put on the market and are now owned by museums. Worse still, the complete body of the etchings and lithographs has never been available except in the indifferent reproductions of Delteil's *Le Peintre-Graveur illustré* (volume IX, 1919) which does not include the monotypes. It is therefore accurate to say that this book makes it possible for the first time to admire the complete range of Degas' work in this medium.

It was an area of his work that meant a great deal to Degas. He would pull trial proofs, carefully preserve them and sometimes add to them in crayon or pastel. But he himself is responsible for the oft-quoted aphorism, that black and white suffice to make a masterpiece, and certainly his own work proves the justice of this remark. Another remark he made, this time to Natanson, indicates his interest in questions of technique. Of Redon, he said: 'I don't often understand much of what he is trying to say, but as for his blacks – oh those blacks – impossible to print any as beautiful.'

The subjects chosen by Degas for his etchings and monotypes are the same as those in his pastels and paintings. They are all stages in an obsessive search for perfection. There are dancers in performance and back-stage, singers at *café-concerts*, a few portraits and the nudes. Scarcely any horses it is true, but on the other hand landscapes figure more prominently among the prints than among the paintings. Then there is Degas' interest in illustration, witness the monotypes for *La Famille Cardinal* by Halévy; presumably he took note of these typical figures of dancers and theatrical hangers-on at much the same time as Halévy was writing, or even earlier. Then there are the *Brothel Scenes* (1876–85). Françoise Cachin deals more fully with both these subjects in her introduction to the monotypes.

This interest in prostitutes is characteristic of the period 1876–90. But here it is not the triumphant prostitute of Emile Augier's play *Le Mariage d'Olympe*, nor really the prostitute as seen in many of the naturalist novels and stories. She is much more the sharp-tongued, good natured girl described by Maupassant (whose *La Maison Tellier* was published in 1881 and ran to twelve editions in two years). Degas would no doubt have agreed with Zola ('Comme elles poussent' in *Une campagne*, 1881) that 'in the tart who takes off her refinement together with her shift, it is the slum child who reappears, silly as a goose and common as a carthorse.'

Not enough, on the other hand, has been said about the boldness of the subject matter as well as the composition of the various series of *Women at their Toilet* which Degas produced between about 1876 and 1900 (starting not later than 1879 according to Theodore Reff's reading of the notebooks). Degas himself was well aware of it, remarking to Maurice Denis that if he had lived during the Renaissance he

would have painted David and Bathsheba, but living when he did, he painted women in the bathtub. Degas kept returning to this series of women bathing; as late as 1901, again to Maurice Denis, he said: 'I don't get out of *cabinets de toilette*, yet I too would wish . . . to be a Raphael. I just can't do it, why not?' The public was shocked; in 1894 (*Journal des Goncourt*, 2 December), Primoli heaped abuse on Degas, 'who, in his bathtub series, has tried to degrade the secret rituals of woman. He must hate women.' And at the second Degas sale, which included the large, beautiful pastels of nude women, Louis Dimier (in *Action française*, 31 December 1918) expressed his disgust at this 'indecency', these 'vulgarities', and also pointed out that 'the public is shocked'. Yet this was a common enough area to explore in his time. A fairly typical example is Zola's lengthy description of his heroine in *Nana* (1879), whose nudity 'obsesses and possesses' Moffat; 'her eyes half-shut and her yellow hair streaming freely down her back like a lioness's mane. . . . She displayed the compact loins, the firm breast of an amazon . . .'. This obsession with long streaming hair is certainly shared by Degas in both the series of women bathing and the *Maid combing Hair*; it makes sense of one model's comment (reported by Goncourt in 1894): 'An odd man, he spent the four hours of the session combing my hair.'

These women performing their toilet made a deep impression on the first artists to admire Degas – Forain, Suzanne Valadon and Lautrec, especially on Forain, of whom Degas said to Bergerat in 1879: 'Little Forain, he still clings to my skirts, but he'll go far if he'll let go.' Forain himself said to Halévy: 'Everything I am I owe to him. . . . He said four or five words to me and that was enough.' No one has previously commented on the links between Degas' *Cabinet de Toilette* and Forain's first drawings, accepted by the *Courier français* in 1888 (*At your age I had already left your father* uses the same models as the Degas but the servant becomes the mother). Forain returned to a similar theme in 1895 with the first of ten versions of *Drying after a Bath*. Suzanne Valadon did drawings and engravings of 'tub scenes' under Degas' influence; and Lautrec in his admiration showed himself in a better light than his master who, when told that little Lautrec was 'taking on his mantle', replied: 'Yes, but he's cutting it down to his size.'

Degas' engravings of dancers are, certainly, studies of poses and movement, but above all they are studies of artificial lighting. They belong to a specific period, *c.* 1877–80, and Degas never went back to them after that. Their originality and daring were not appreciated by Degas' contemporaries, apart from a few artists (Maurice Donnay, even though he was from Montmartre, criticized the *maître des danseuses* for his 'obstinate preference for the ugly and vulgar'), but the corresponding paintings attracted the attention of some of the writers of the time who frequented the *petits théâtres*. One was Félicien Champsaur, forgotten today but once a much-appreciated chronicler of the life of the *demi-monde*. In one of his earliest novels, *L'Amant des danseuses*, published in 1888, he took as his hero a man called Decroix, 'a painter of modern scenes', who painted 'Parisian theatrical life . . . capturing in rapid sketches the dancers, *divas* of the operetta, bareback riders, chorus girls and prostitutes. . . . Although it is true he does show ballerinas on stage, in apotheoses of electric light . . . it is also his pleasure, and the dark and gloomy philosophy that lies behind his work, to bring out their privation and indeed their near-ugliness.'

It was precisely such effects of lighting, the way it exaggerated and distorted the human face, that Degas sought to convey in his etchings of the *divas* of the *café-concert*, made at the same time. He was

familiar with this sort of study, certainly, Daumier's *Actors of Society* of about 1865 for example, but he saw the effects magnified by 'the crude gaslight' (Zola, 1879) in cafés where, instead of the plays that were once produced, popular *chanteuses* were to be heard, 'underscoring the risqué lines with a gesture and a look'.

The present method of dating Degas' engravings differs considerably from Delteil's. This is not to decry Delteil's achievements; he was after all writing in 1919. At one time or another all of Degas' etchings passed through his hands, notably when he was retained as the specialist adviser at the 1918 sale, and his account remains an interesting point of departure. He rarely attempted, however, to relate the etchings to the paintings (which of course were not accessible to him in the way they are to us) and he also tended to make such blunders as dating two similar pieces ten years apart.

While we have done our best to revise the system of dating, it is still impossible to be sure in every individual case that our suggested date is accurate.

It would appear, however, that from 1853 Degas had been a regular visitor to the Cabinet des Estampes, where he copied Italian Renaissance engravings, and that he himself started etching in 1856, before he went to Italy, under the guidance of Prince Soutzo, a collector of original engravings and of the work of Claude in particular. (Six etchings date from this period.) He took it up again in Rome in 1857 with Tourny, a professional engraver who won the Prix de Rome (seven etchings), and continued with it after his return to France. At about this time he noted down Meryon's address at the rue Saint-Étienne-du-Mont (and possibly visited him); and he copied in his sketch-books Dürer engravings and Van Dyck's *Iconography*.

He returned briefly to print-making with the etchers in Cadart's group (among them Manet, whom he admired greatly although he was reluctant to tell him so). This was in 1865 at the very latest and most probably in 1861–2, under the encouragement of Bracquemond (a further ten etchings). 'It is', wrote Baudelaire – not having tried it himself – 'so practical to guide a needle over this black plate which will reproduce with such fidelity all the arabesques of fantasy, all the hatchings of caprice.' It was not fortuitous that Degas' collection included almost the complete graphic works of Manet, together with engravings by Bracquemond, Legros, Millet and Pissarro. In one of his notebooks there are also copies and notes of pieces by Jacquemart and Seymour Haden.

Renoir went with Degas one evening after dinner to see Cadart, and later told Vollard how he 'brought out his splendid impressions. I dare not call them etchings or I shall get a roasting. There are always experts to keep on telling you how devilishly bad it is, and done by someone who doesn't even understand the basic principles of etching, yet what fine stuff it is.'

In 1875 Degas engraved a portrait of Hirsch as part of a competition between friends. But apart from this splendid and little-known piece, he engraved nothing from 1862 to 1877. In 1873, according to Pickvance, he sent *The Illustrated London News* a drawing for them to print, entitled *During the Break in the Ballet* (*Repos du ballet sur la scène*), but the magazine rejected it on the grounds that it was indecent. (Moses placed this story in 1891.)

Subsequently he again took up etching, this time for a period of one or two years. He asked Bracquemond for advice ('Don't desert me now,' wrote Lunois to Bracquemond at about this time,

'you know I want to learn how to bite'), for like all the other etchers he desperately wanted to learn the art of aquatint. In fact Bracquemond gave Degas very little help and he had some difficulty in mastering the technique. Degas wrote to him: 'the grains bite even without you, though you were supposed to teach us instead of letting us go all over the place.' The etchings of this period can be dated through Degas' obsession with *café-concerts* and the stage lighting of the singers. A notebook of 1878 mentions 'an infinite variety of subjects in the cafés, different tone values where the globes are reflected in the mirrors.' It was in 1877–9 that 'luminous globes' began to replace the old-fashioned lamps, providing, according to the newspapers, 'a softer, muted light'. Stylistic evidence suggests these etchings should be dated 1877–9, and this is supported by the documentary sources, in particular the journal *La Vie parisienne*. From its pages one learns that in 1879 the *café-concert* at Les Ambassadeurs was patronized by a large gathering of Parisians, all eager, after six months of summer, to rediscover 'the wings, the dressing rooms and the rest of that special world' (11 January 1879). Apparently the stars of operetta, Thérésa and Mlle Bécat, sang with not much voice but with their own special brand of charm. The actresses and women in the audience are described as wearing striped dresses just like those in Degas' prints. Another clue to dating not previously noted is a reference by Zola to the Degas dancers he saw at the fourth Impressionist exhibition: 'stupendous, captured in mid-movement; and *café-concerts* of astounding life, the *divas* craning forward over the smoky lamps, lips apart' – these of course being subjects we find in the prints.

Degas also executed a number of lithographs, and indeed maintained that this was the perfect technique for a painter. 'If Rembrandt had known about lithography,' he said, 'God knows what he would have achieved with it' (quoted by Valéry, who no doubt heard it *via* Rouart). Presumably it was at this time that he bought the eight hundred prints by Daumier in his collection. The two thousand Gavarnis he acquired in 1881 may not have meant as much to him and it is possible he bought them on the advice of Henri Rouart, a keen collector.

In the spring of 1880 Degas exhibited some trial etchings, among them the portrait of Mary Cassatt. He turned again to etching for the journal *Le Jour et la nuit* which he planned to edit in collaboration with Pissarro, Mary Cassatt and Bracquemond, with Caillebotte and May providing the finance. The journal must have come very close to appearing, for there is a letter in which Degas urges on his associates: 'Salmon [the printer] is in a temper and wants all the plates by Tuesday. A word to the wise should suffice? I am hard at work on my own plate. . . .' (see the notebook sketches). Always interested in technical experiments, he visited Geoffroy, the photographic printer, 'an inventor, a curious man. He's thinking of doing some wood blocks in colour in the Japanese style' (this was said to Pissarro).

Among the references to experimental techniques in Degas' notebooks are a mention of a 'voltaic pencil' (1878); of Lefman's 'relief engraving for typography' (*c.* 1875); we also find the name of Lucas, manufacturer of lithographic ink at 62 rue du Faubourg-Saint-Denis (Talc was another supplier, at 166 rue du Faubourg-Saint-Denis); the name of Lepage, originally known as a supplier of bristol-board, later as a supplier of 'paper of all colours'; Vigan, 41 rue de la Victoire, who sold Japanese vellum; Lenoir, 123 Boulevard Montparnasse, and 32 rue Montparnasse, who apparently also sold paper; Salmon, the printer, was at 87 rue Saint-Jacques (1879); Delâtre at No. 176 in the same street (1859–60).

In a notebook which Reff assigns to 1877–83, there are various notes on aquatint technique: 'Oil the

plate a little and sprinkle with powdered copal, which forms a distinctive grain. Heat as necessary. Once the grain is set, soap the plate thoroughly and then rinse well. You can paint with acid without it running too much. Apparently if you leave whiting in the holes you can remove the ground and even re-bite the grain.' There is also a reference to a book on print-making techniques written by Paul Bitterlin *fils*.

Or again: 'Transfer on to a zinc plate a design wetted with sodium sulphate. . . . Lay on a silvered daguerreotype plate a design wetted with gold chloride, and place under the stone. . . . Transfer ink and transfer paper, use for working with turpentine (1876). Apply flowers of sulphur mixed with oil on a copperplate, this gives a delicate tone.'

In a similar vein is the following letter from Degas to Pissarro in 1880 (*Lettres*, ed. M. Guérin, no. 16, pp. 33–6):

My dear Pissarro,

I congratulate you on your hard work; I hurried to show Mlle Cassatt your parcel. She compliments you on it as warmly as I do.

Here are the proofs. The prevailing blackish, or rather greyish tint is caused by the zinc, which is greasy and retains the printer's ink; the plate has not been ground down enough. I doubt whether you have the same facilities for this at Pontoise as in the rue de la Huchette [where Godard did the planing]. All the same you do need something smoother.

Even so you can see how adaptable the process is. Another thing you'll have to practise is graining a surface in order to obtain, say, a sky of a uniform pale grey. If Bracquemond the Master is to be believed this is no easy task. But perhaps it is not so bad if you intend to concentrate exclusively on original engravings.

Here is the method. Take a really smooth metal plate (this is essential, you understand). Remove every trace of grease with whiting. You have previously dissolved some resin in a strong concentration of alcohol. You pour this liquid, in the same way as photographers pour the collodion over their glass plates, taking care just as they do to tilt the plate and let it drain thoroughly; the liquid evaporates and leaves the plate covered with a layer of little grains of resin, of varying thickness. When the plate is bitten, you are left with a grained effect that is dark or pale according to the depth of the bite. This is necessary if you want to obtain even tints. Less regular effects can be obtained by using a stump or the fingertip or any other form of pressure on the paper that is placed over the soft ground.

Your soft ground seems a bit too greasy to me. You've used a little too much grease or tallow.

What was it you used to blacken the ground, to get that sepia tone for the background of the design? It's very attractive.

Now try something bigger with a better plate.

As for colour, the next one you send, I'll have a print done in coloured ink.

I have some other ideas too for colour plates.

Do try to produce something more finished. It would be such a treat to see some very careful outlines of cabbages. Remember, we've got to make a start with one or two really fine plates from you.

In the next few days I'll get down to it myself.

Caillebotte is turning his windows into refuges from the Boulevard Haussmann, so I'm told.

Could you find someone at Pontoise capable of cutting very thin copper sheeting into shapes traced by you? You could lay stencils like this on a line-engraving, perhaps with some soft or hard ground etching, and then print the sections that show through with porous wood loaded with watercolour ink. You could make some really attractive and unusual experimental colour prints in this way. Do work on that a little if you are able. Soon I'll send you my own efforts in that direction. It would be economical and something new besides. And those are good enough reasons for us to try it out, I should think.

No need to compliment you on the artistic quality of your vegetable gardens.

Wait until you feel more at home with it, then try some bigger things and carry them through. Good luck.

<div align="right">Degas</div>

After this Degas produced no more etchings until *c.* 1890, with the single exception of a piece commissioned by a ballerina of his acquaintance.

In 1889 he did announce a number of lithographs in the catalogue for the Peintres-Graveurs exhibition, but the entry is so unspecific that one is tempted to believe he in fact sent nothing at all, or else sent an old piece, a not unusual practice of Degas'.

It must have been at this time that he said: 'I think of nothing but etching, and yet I do none' (*Lettres*, p. 43). In 1891 he had a discussion with Jacques-Émile Blanche about lithographic techniques (Halévy tells us). He admired Mary Cassatt's 'delightful experiments with engraving', used his own press to pull proofs by Suzanne Valadon, and owned prints by Mary Cassatt and Berthe Morisot, Hiroshige and Utamaro, and various Japanese albums.

In a letter of 1891 he announced a series of nudes, lithographs of dancers, but in the event managed only one plate. He did however produce one or two lithographs of women bathing, and also one etching on the same theme. As was usual with him, he returned to the same motif on a number of different plates (using either transfers or fresh drawings), and pulled numerous states before he was satisfied. To his friends his experiments seemed excessive. One of them, Rivière, said: 'If Degas had only been content to draw his plate quite straightforwardly, he would have left us the finest prints of the nineteenth century.' But clearly Degas wanted to produce something on this theme for publication, as with the *Mary Cassatt* of 1879; possibly in Vollard's albums of *Peintres-Graveurs* or in the magazine *Pan*. It is quite impossible to be sure, for the chronology of Degas' late works is very difficult to establish with any degree of accuracy. He gave up etching in 1892, when his eyesight was deteriorating badly.

Degas produced, in all, sixty-four etchings or lithographs. For collectors, the principal source for acquisitions was the sale of Degas prints held on 22 November 1918 (catalogue by Loys Delteil), when 37 prints (304 proofs) and 17 lithographs (70 proofs) were auctioned. In addition, Degas had built up a completely separate and comprehensive collection, depositing the proofs one by one with Alexis Rouart. According to P.-A. Lemoisne, he told Rouart he was diffident about offering them directly to

the Cabinet des Estampes, but that his friend was to make a donation of them after his death if he thought them worthy of the honour. This is what Lemoisne is referring to when he writes (volume I, p. 134): 'Degas regularly brought Rouart's collection up to date, knowing that the complete set of his works was already destined for the Cabinet des Estampes.' This wish was granted in small part only, when on 7 July 1932, in memory of their father Alexis Rouart, M. and Mme Henri Rouart donated the proofs L D 22 and 32 and the eighth state of 26.

A few collectors and critics had been given prints by Degas. These include Roger Marx (whose prints were put up for sale in 1914 and acquired by the Library of the Fondation Doucet), Duran-Ruel, Manzi (the publisher known as 'the chevalier Manzi' who was Degas' inseparable companion), and Burty (five Degas etchings were included in the Burty sale of 1891: 'academies, portraits, sketches'). Mary Cassatt, René de Gas and Mlle Fèvre each owned a few proofs of his or her portrait. There was also an anonymous sale held at the Hôtel Drouot on 16 December 1908. On the cover of the catalogue was a reproduction of a Degas print – something quite unprecedented.

The big collections in America, Germany, Austria, etc. were acquired at the sales already mentioned, chiefly at the sale of 1918.

P.-A. Lemoisne adhered strictly to the ruling that forbids the Curator of the Cabinet des Estampes to build up a collection of engravings of his own; although he spent the greater part of his life cataloguing works by Degas, he owned no etchings by him; all he kept was a pastel bought as a wedding present for his wife.

There is still some confusion about engravings after works by Degas. In the body of the catalogue we mention Lauzet, who executed an engraving after Degas which Degas then tried to improve. Thornley is a different case altogether. He produced *Vingt Dessins de Degas* (1861–96), published by Boussod, Manzi and Joyant in 1898; *Quatre-vingt-dix Reproductions*, all signed by Degas, published by Vollard in 1914 (and by Bernheim *jeune* in 1918); and *Quinze Lithographies d'après Degas*, signed by the artist and the print-maker, published by Boussod in 1910 – the Degas sale of November 1918 featured a copy in excellent condition, in several tones and including trial proofs and duplicates, fifty-three proofs in all.

Thornley asked Clot to print a facsimile of a Degas pastel of pre-1909 called *The Ballet*, a head and shoulders view of a dancer tying her shoe. When Degas saw it he was angry. But, although his first reaction was to exclaim 'how dare anyone . . .', he ended by admitting, 'He's good, the swine who did that.' In fact Degas thought highly enough of this facsimile to own a proof before letters (included in the November 1918 sale); Clot pulled prints both in black and white and in colour. He also printed a lithograph by Thornley of a *Horse Race* after Degas, some proofs of which have recently come to light, as well as a head and shoulders of a dancer, seen from the right in profile, hand on her shoulder, which, although it is signed 'facsimile after Degas, Clot lith', was nevertheless included in *Germinal*, 'an album of twenty original prints'.

In the catalogue of the fourth sale of the contents of Degas' studio (2–4 July 1919) some items are listed as 'impressions in black by Degas'; they could be drawings, or tracings, or etchings, we have no evidence on which to form an opinion. Only three are catalogued, those originally numbered 359 and 385.

Thanks are due to my colleagues, who have been generous with their help: Joachim, Boon, E. Sayre, S. Damiron, Mary W. Baskett, Fr J. E. V. Borries, Mary Ann Elliot, Louise R. Richards, Emily S. Rauch, Gunther Troche, and also to M. Kornfeld (who revived the whole question of the states of the *Women Bathing*), and to M. Paul Prouté, Mlle Cailac, M. Romand and M. Petiet.

Acknowledgment and gratitude are due to Marcel Guérin, who gave me encouragement when I started my research in 1942, and to the late Professor Paul Moses, without whom this book could not have been written, as it is his studies that provide the basis for my own. Indeed it was originally to ensure the publication of his research that my own was undertaken.

Any work on Degas is bound to be indebted to the valuable studies of John Rewald which have thrown new light on so many questions.

I would also like to pay tribute to the memory of my childhood friend, Jean Nepveu-Degas, Degas' nephew, who early introduced me to his uncle's work, about which he was extremely knowledgeable, although he modestly decided not to pursue the line of studies that was expected of him.

JEAN ADHÉMAR

18

THE PLATES

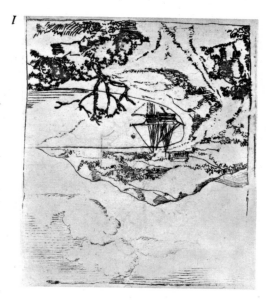

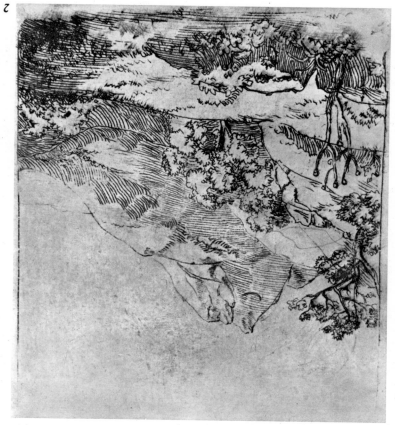

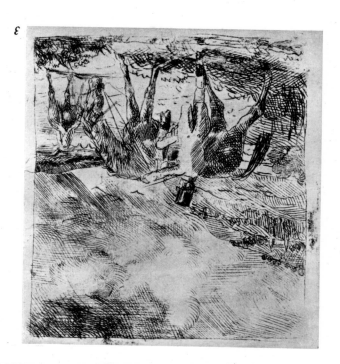

4

5

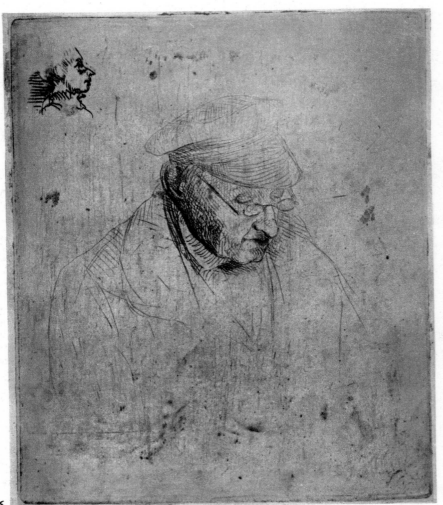

6

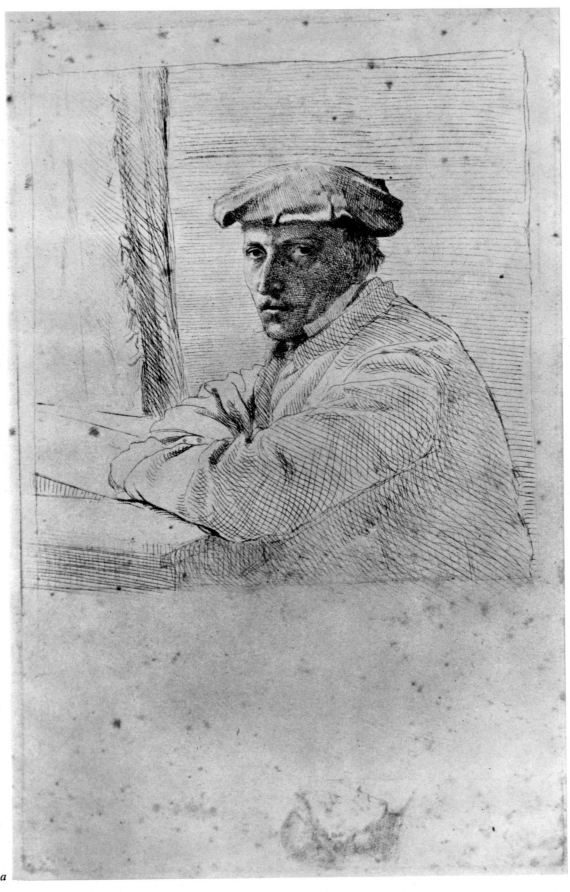

8 a

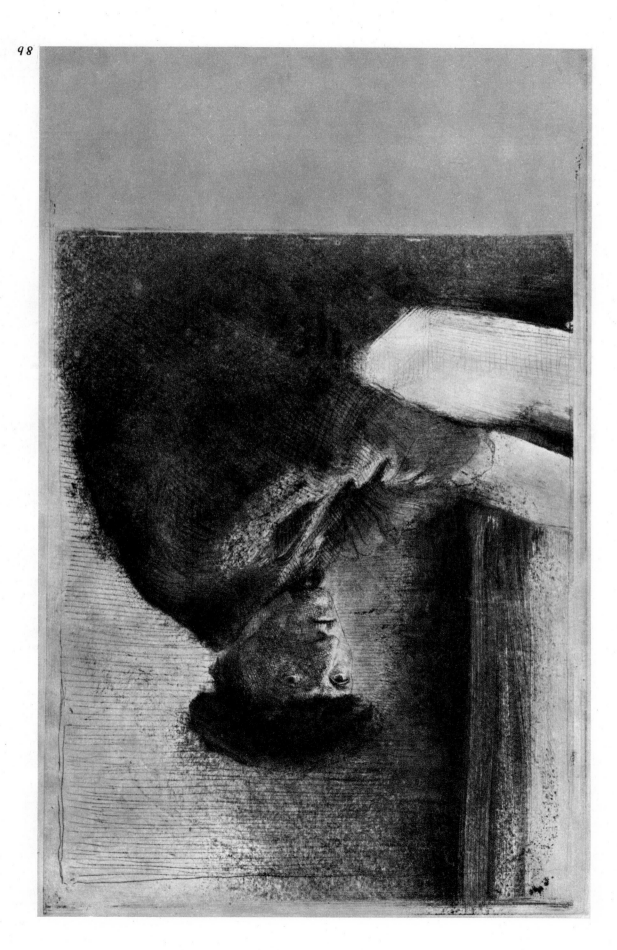

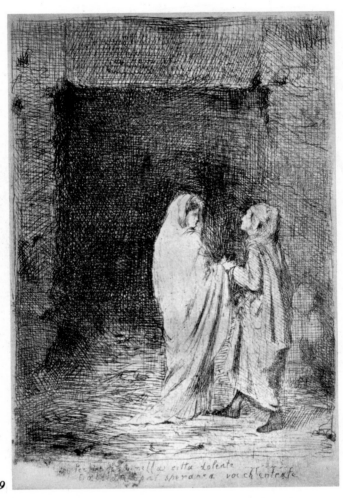

9

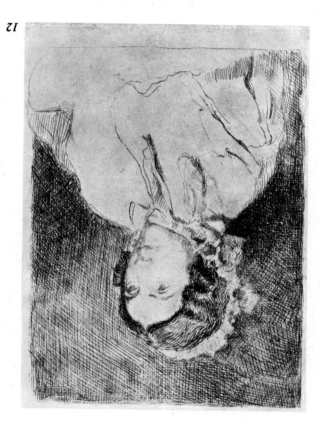

12

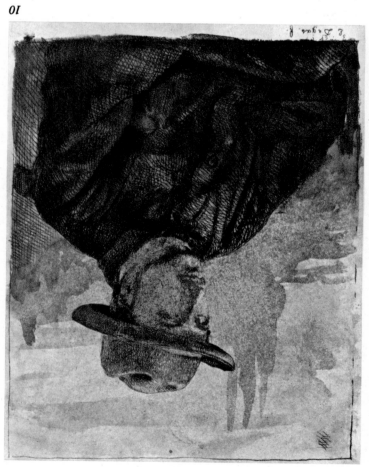

10

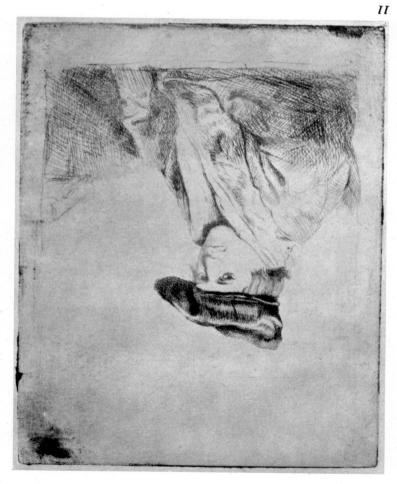

11

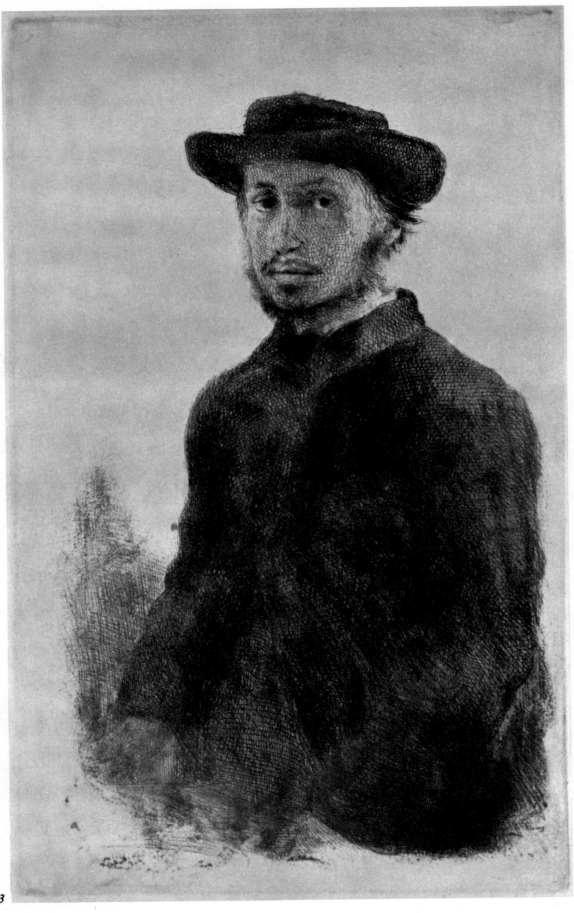

13

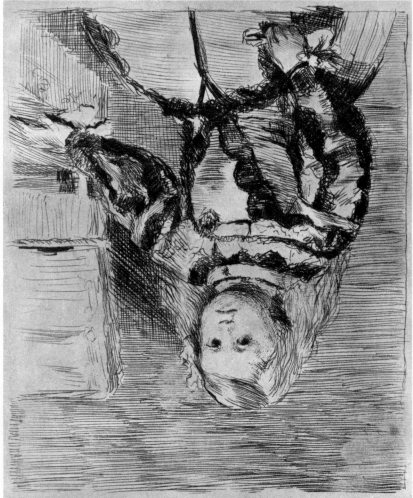

16

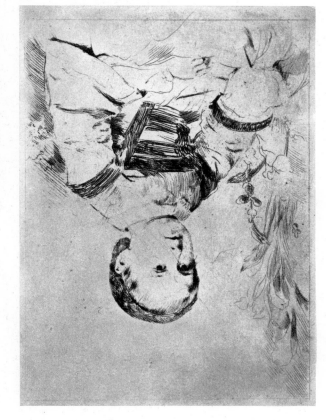

14

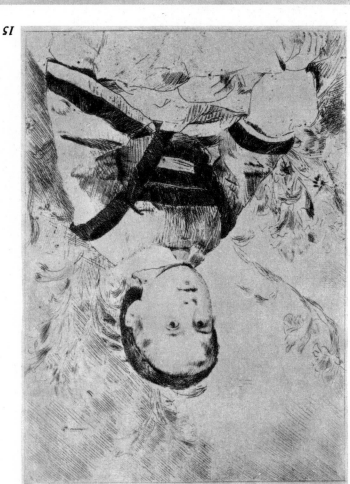

15

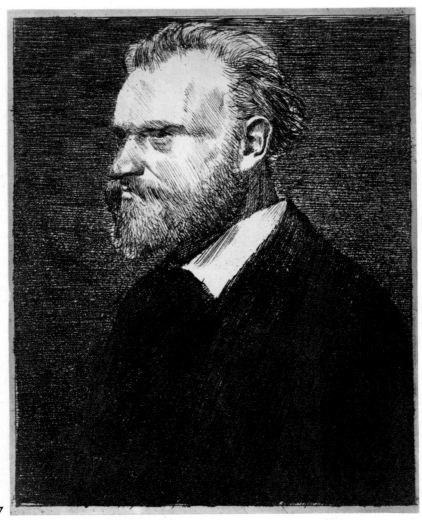

17

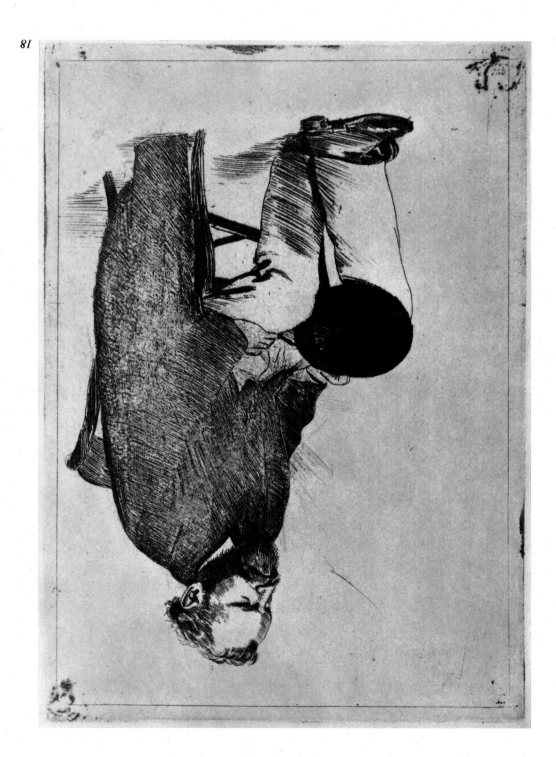

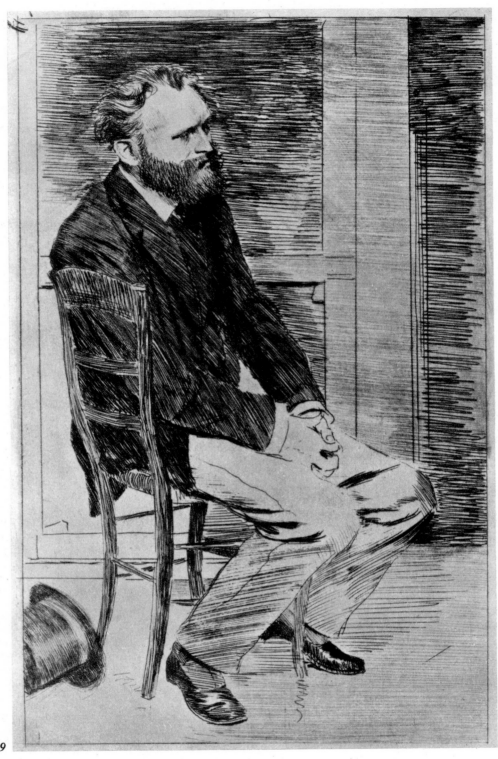

19

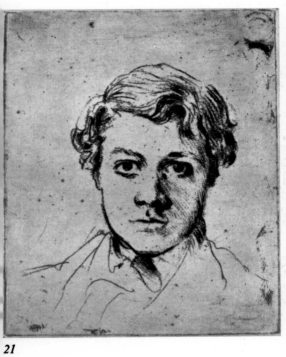

21

22

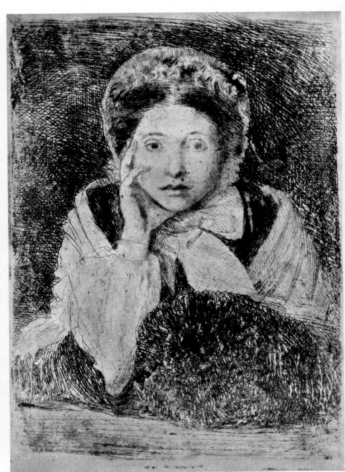

23

25

24

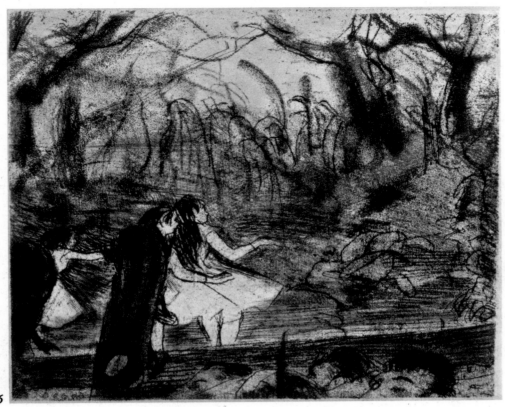

26

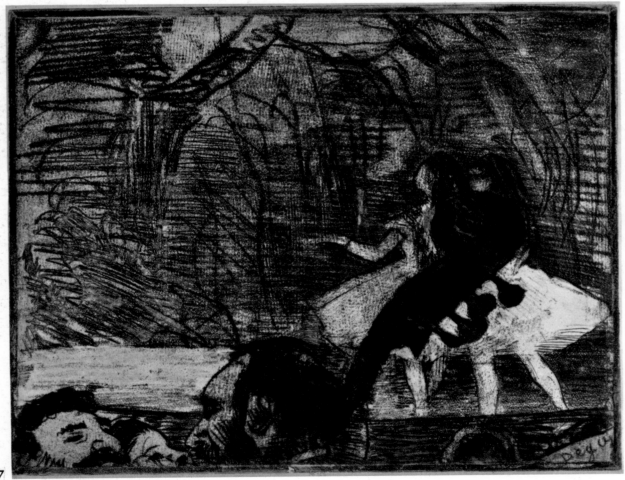

27

29

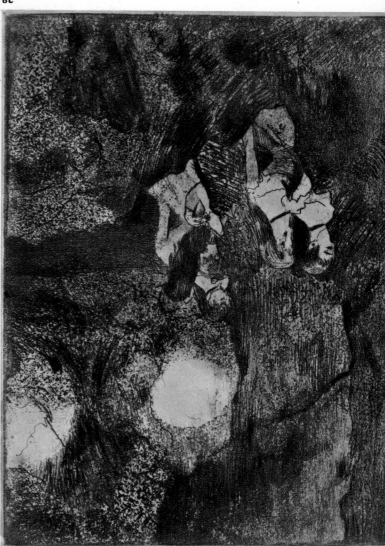

28

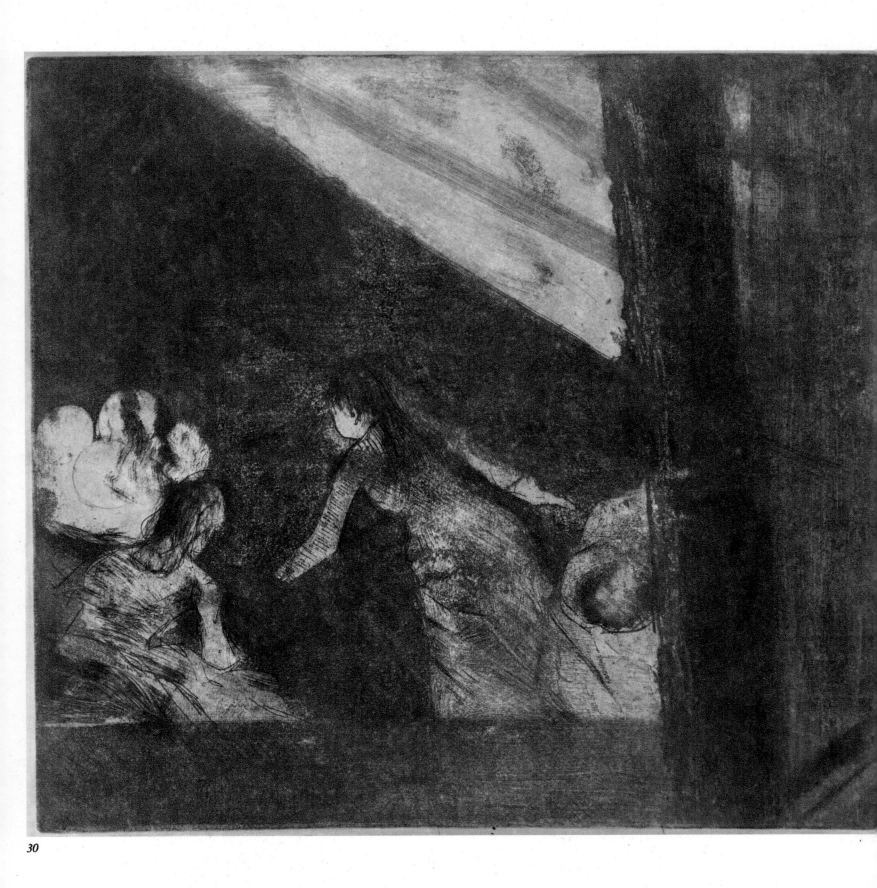

30

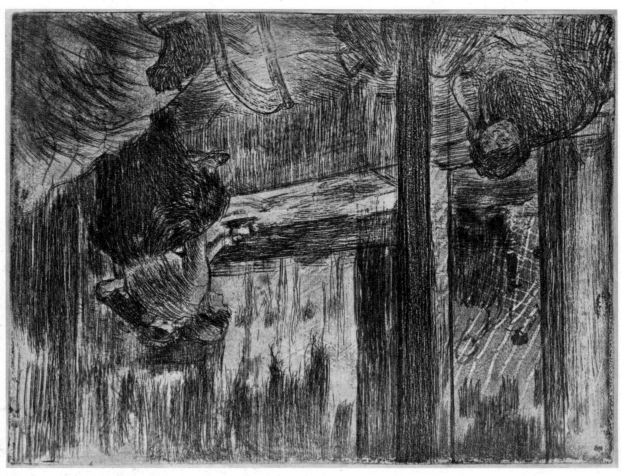

32

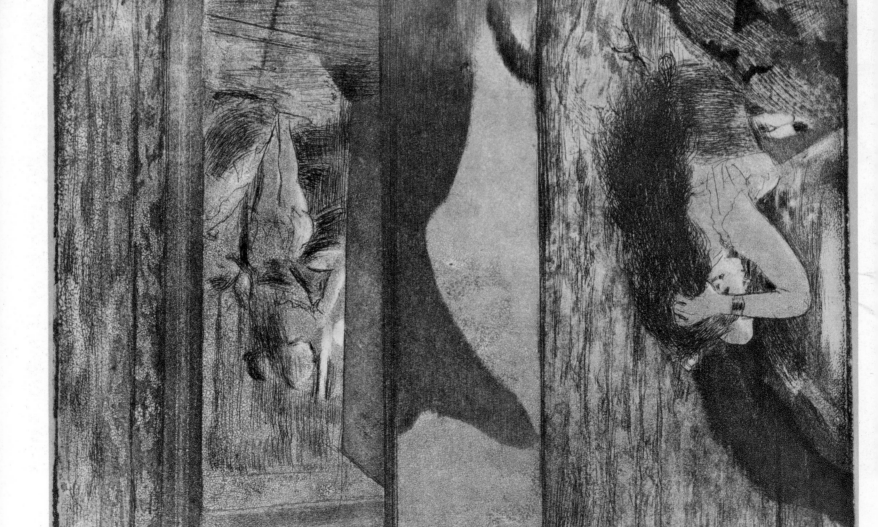

31

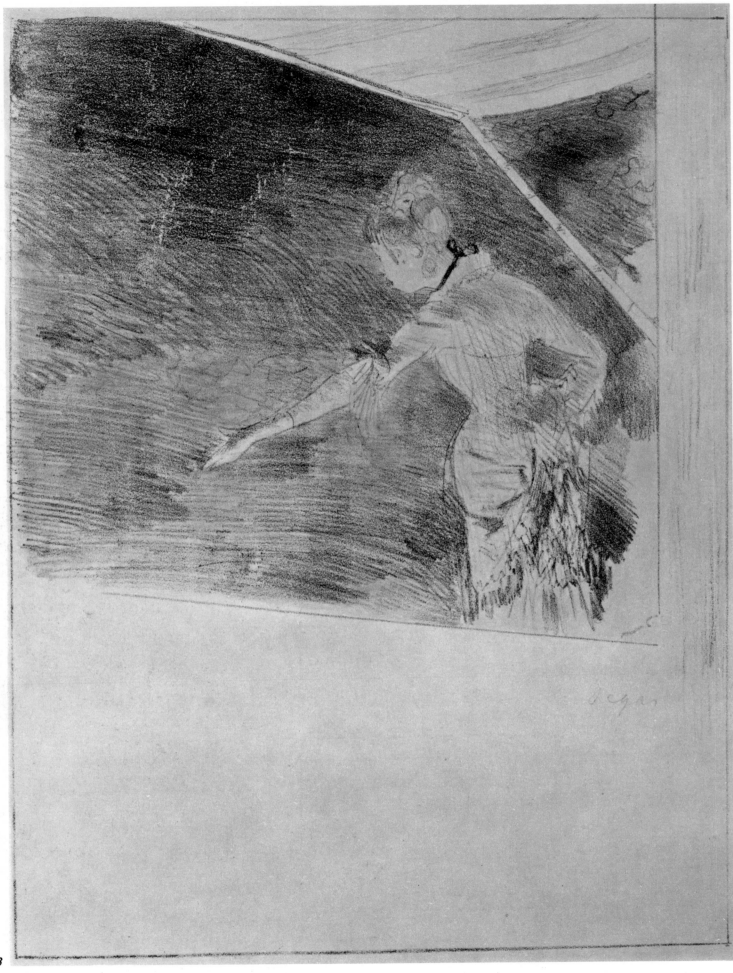

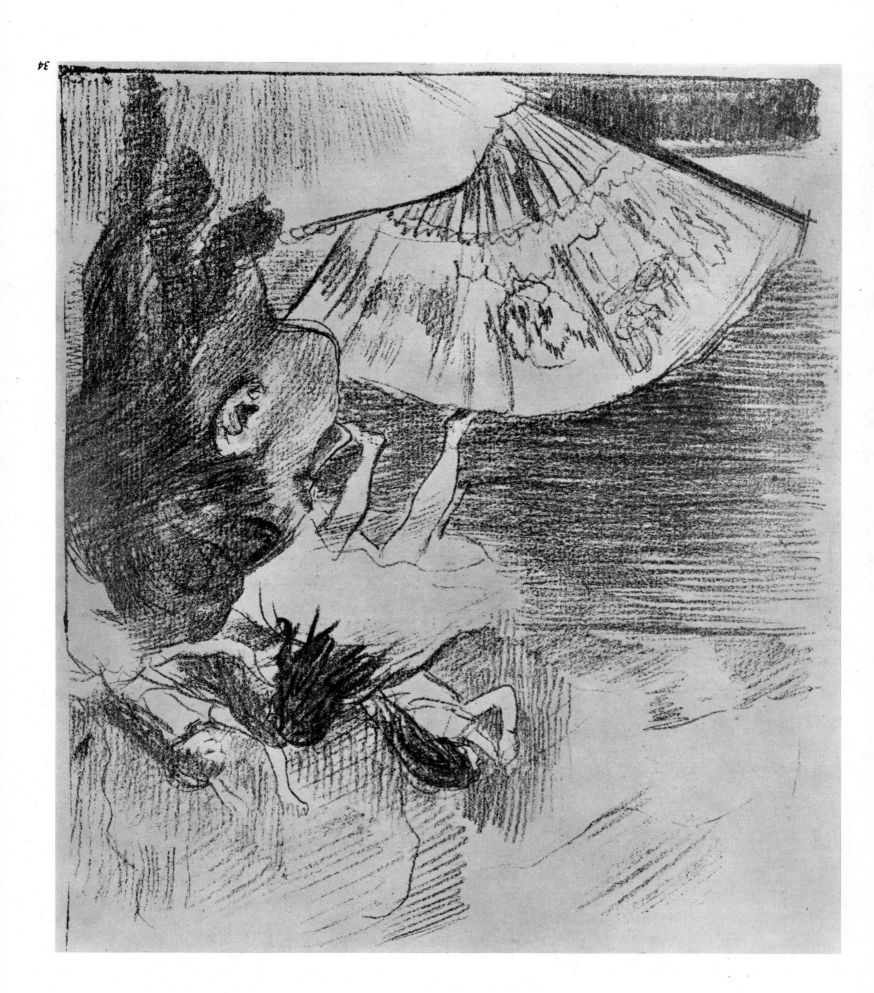

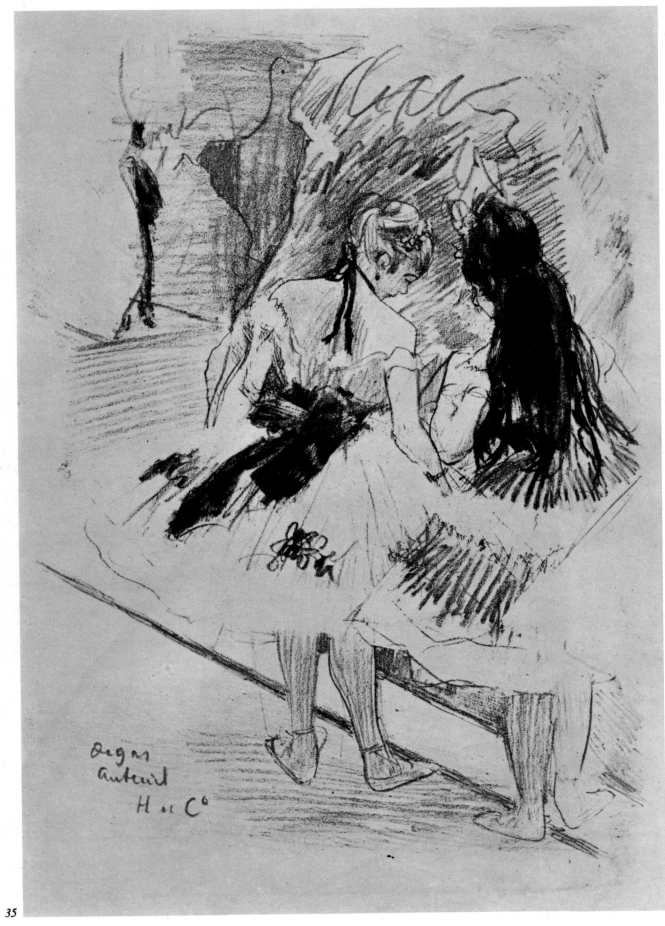

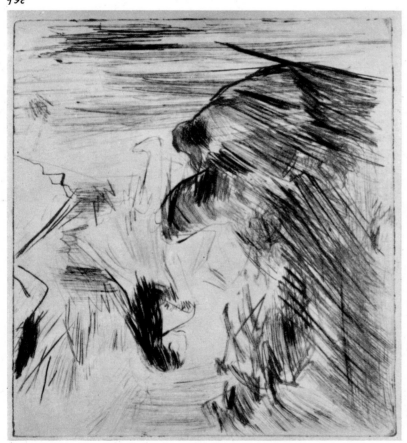

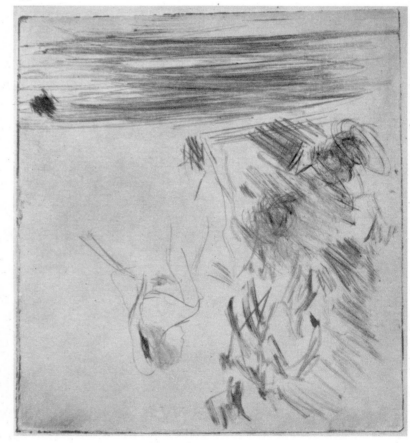

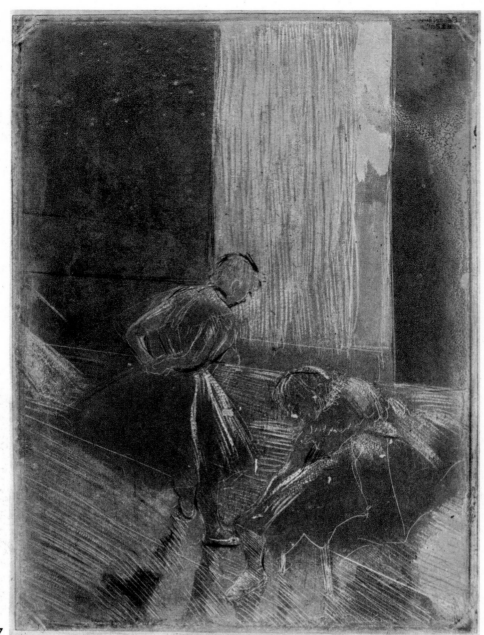

37

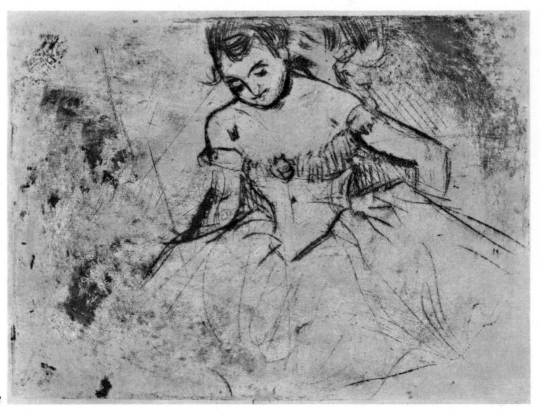

38

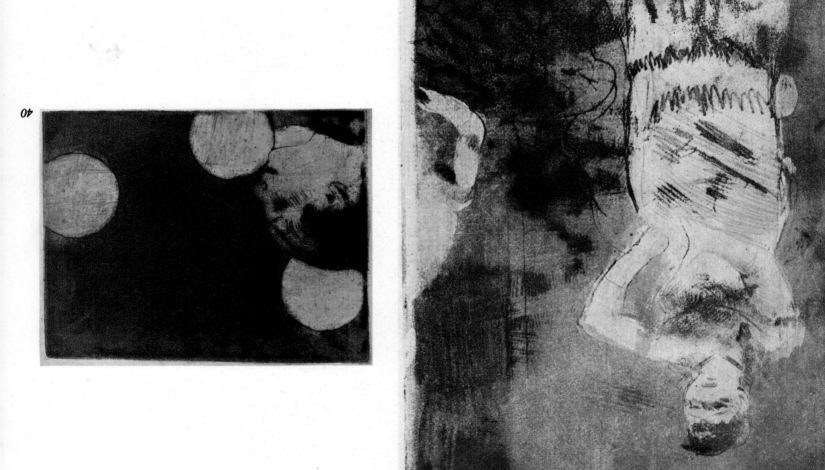

39

40

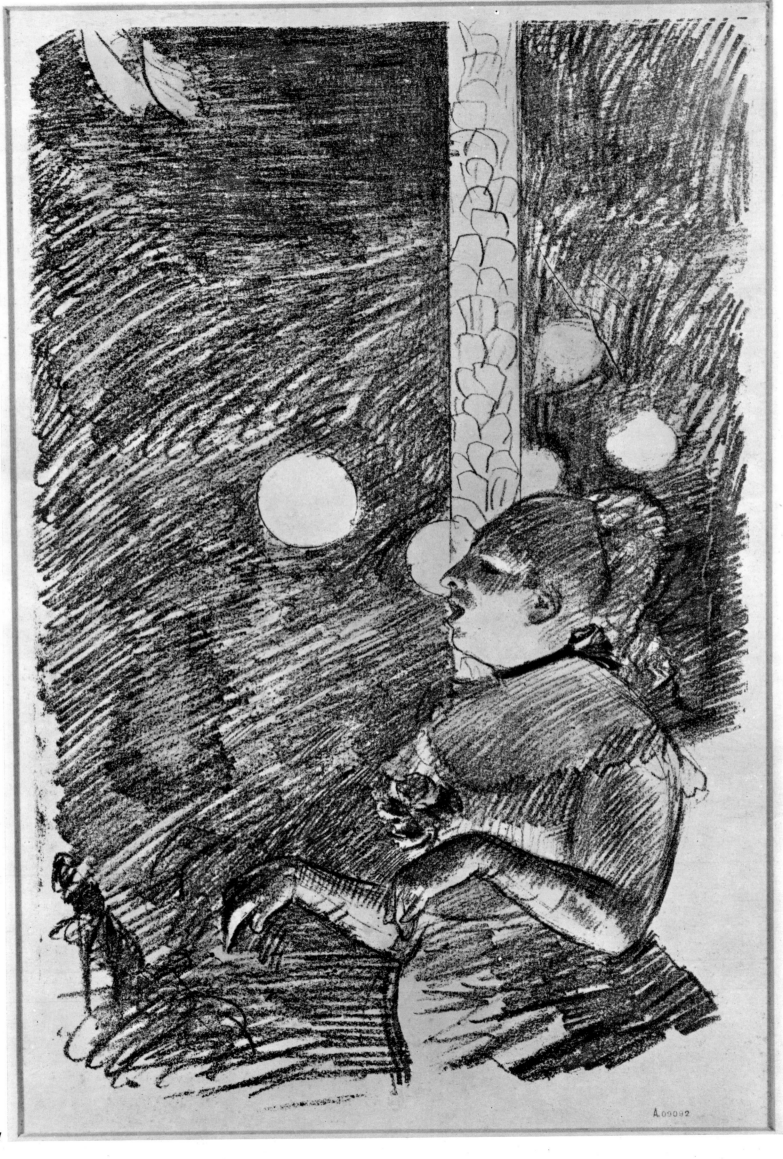

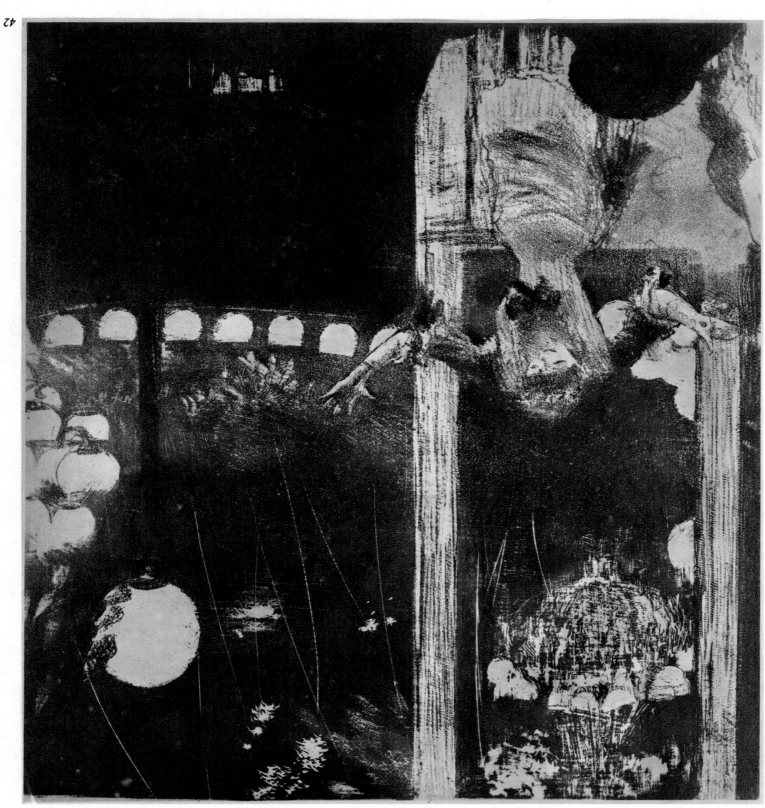

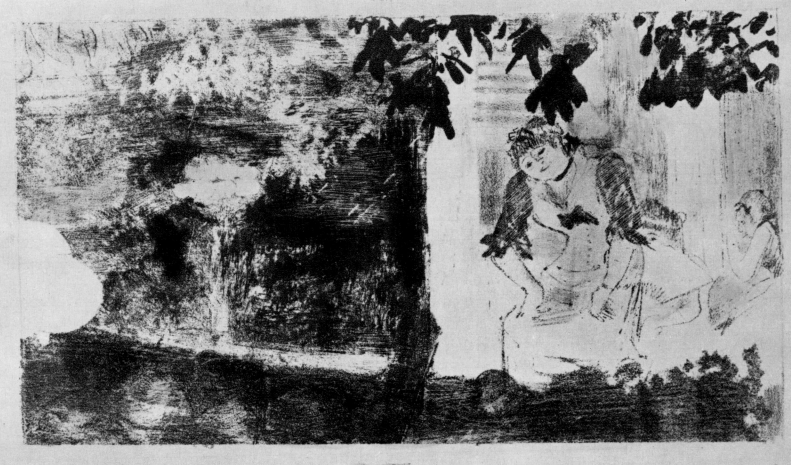

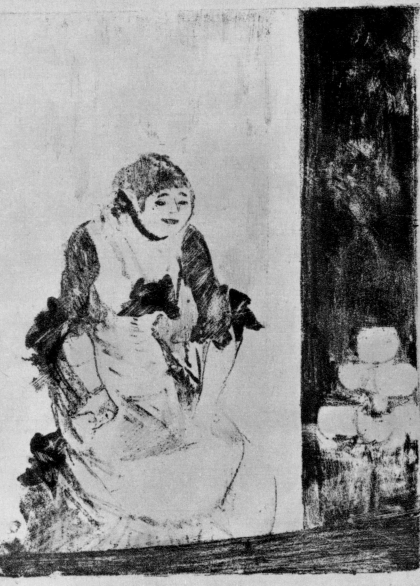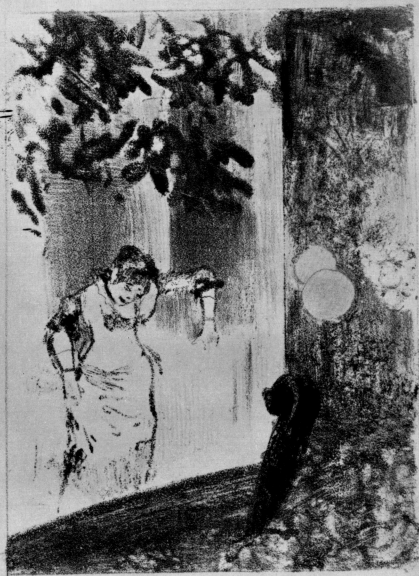

43

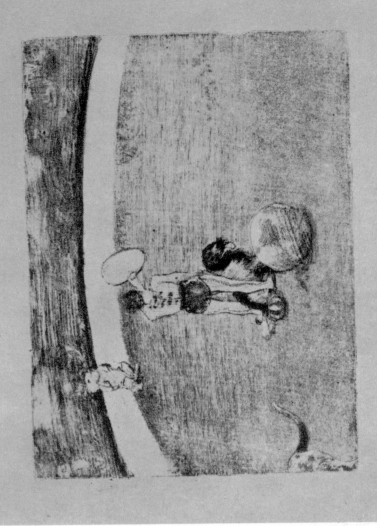 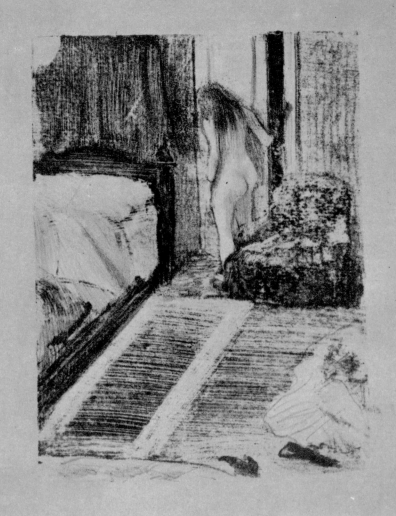

45

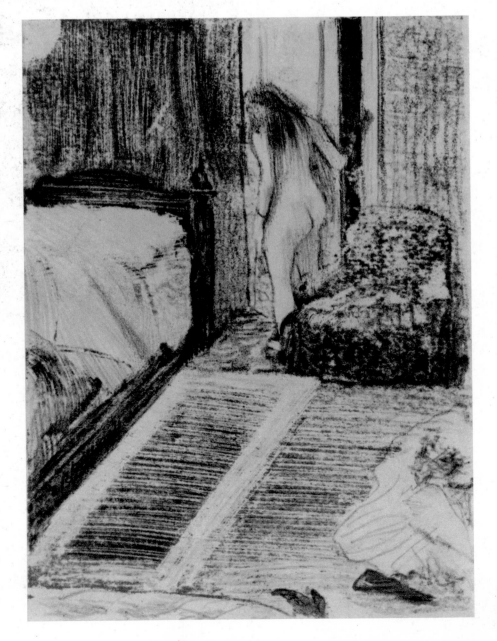

46

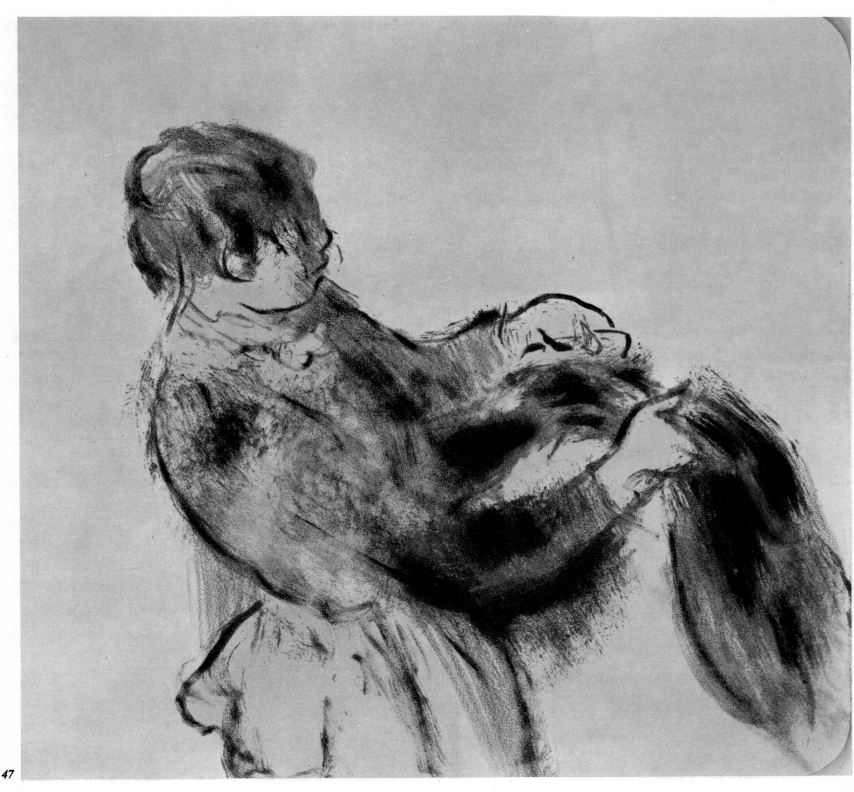

47

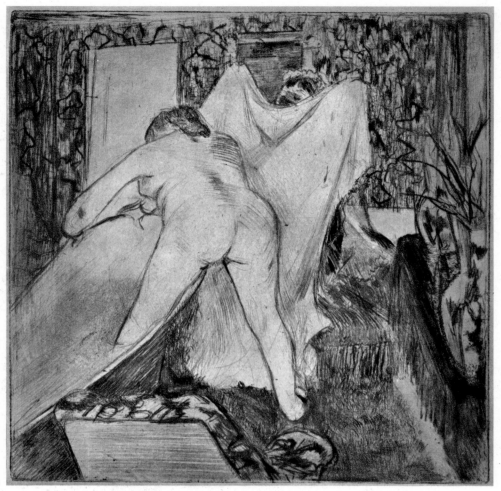

49 a

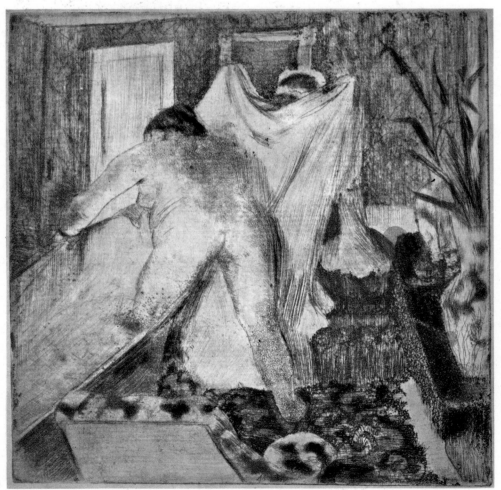

49 b

51

50

52

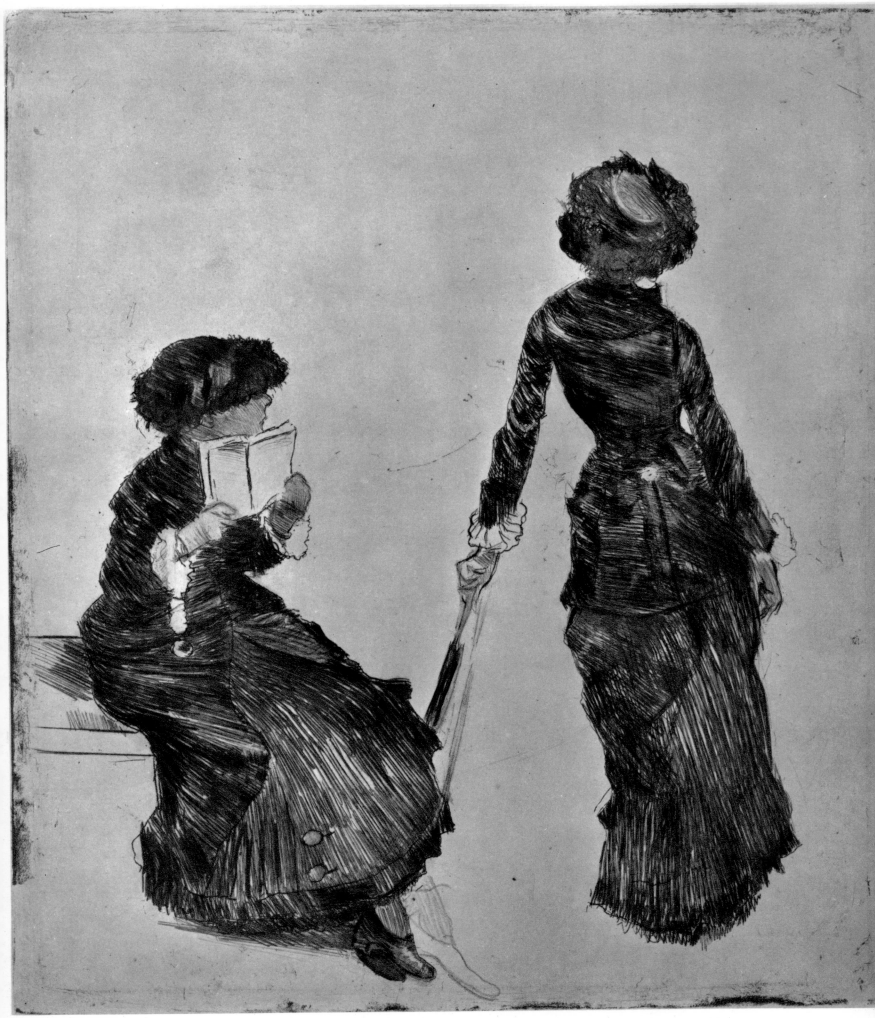

53a

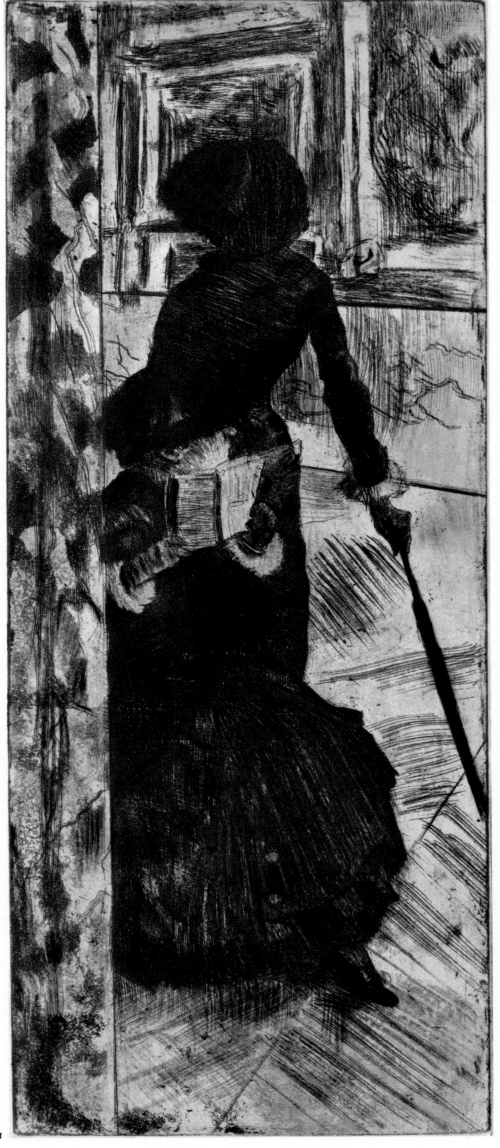

54a

55

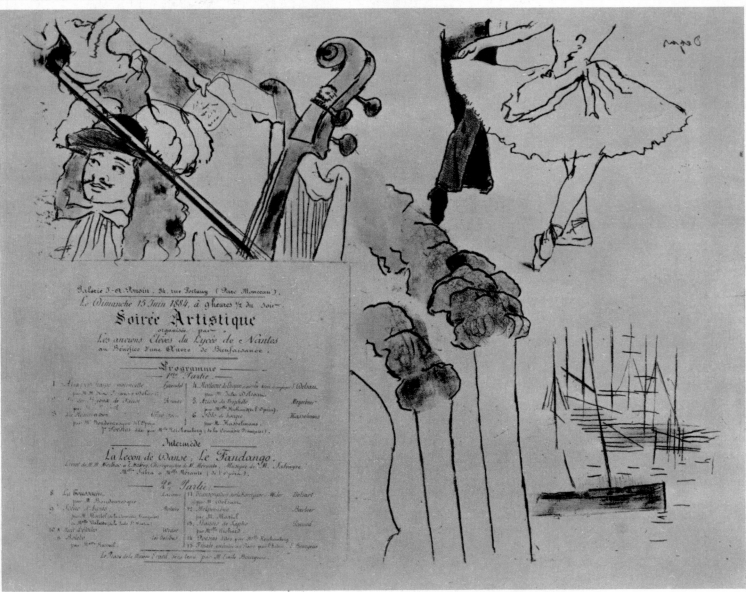

56

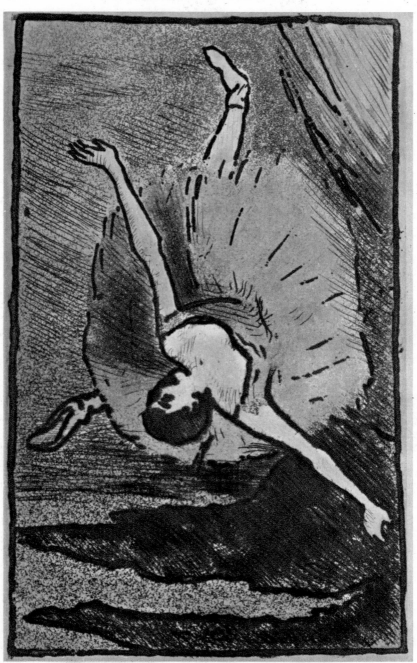

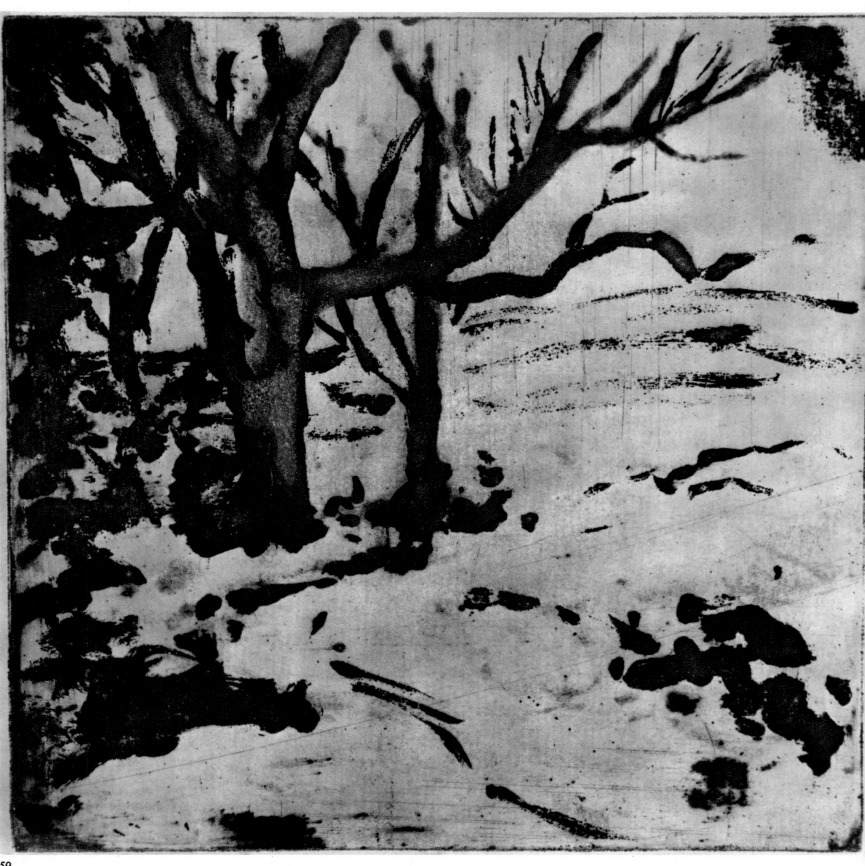

59

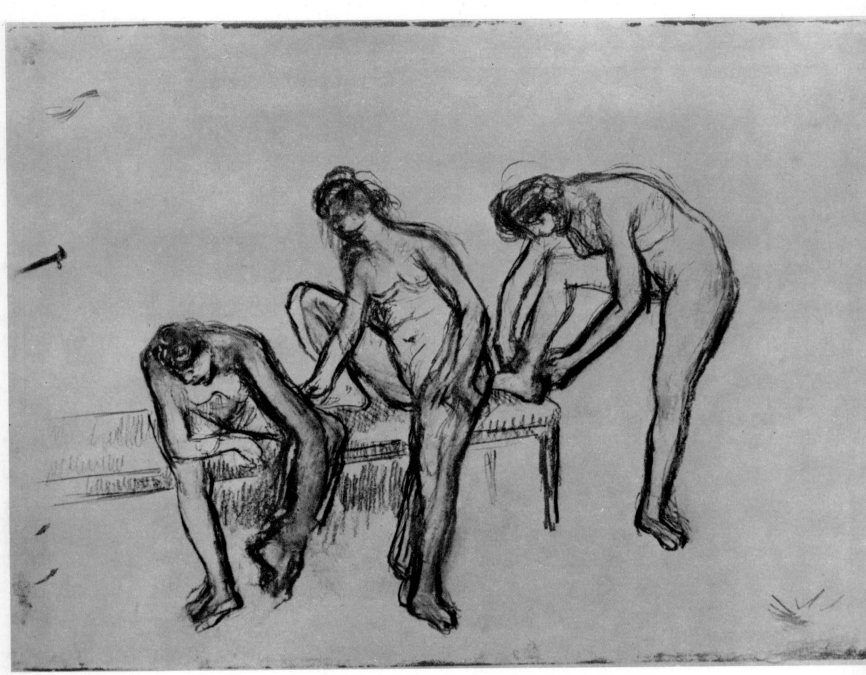

61

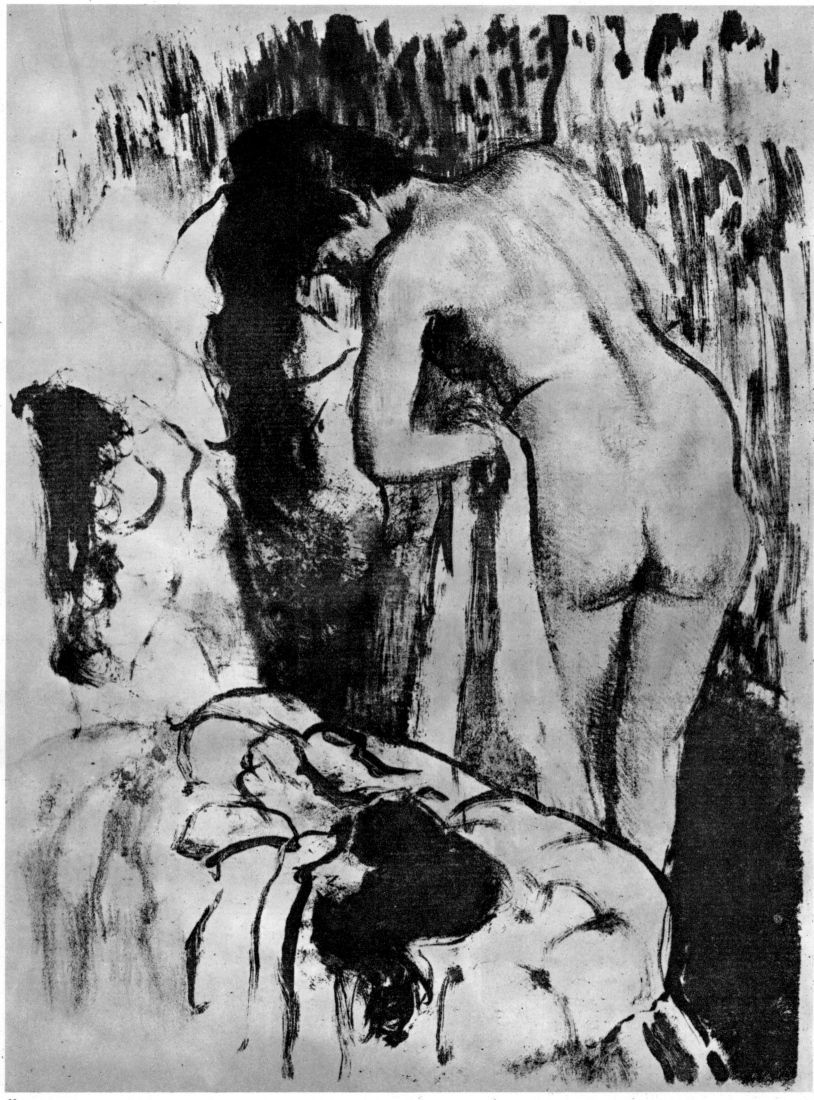

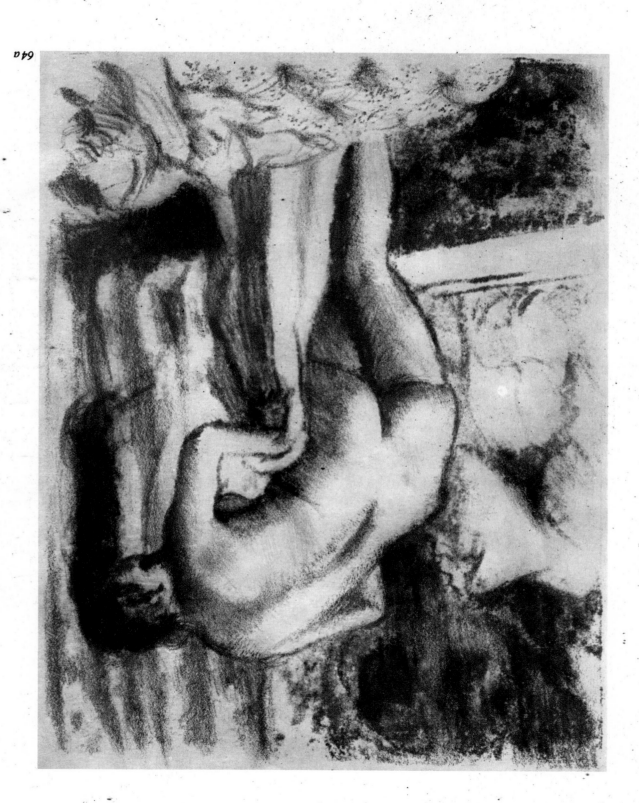

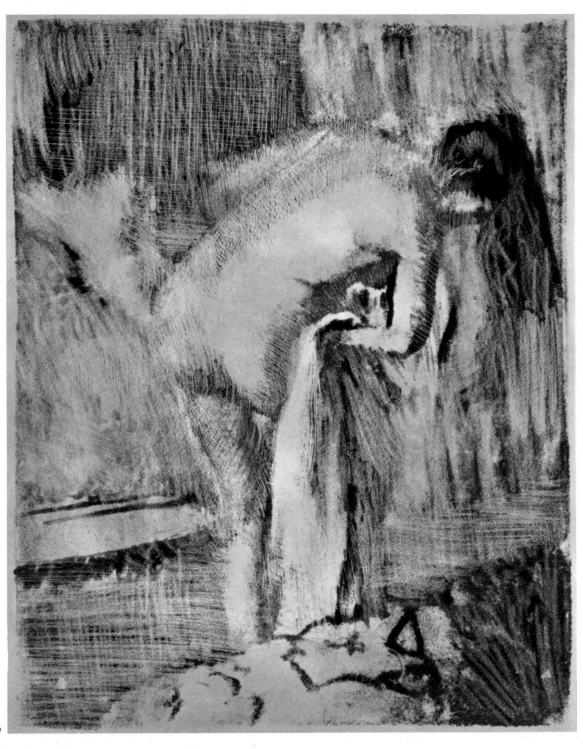

64b

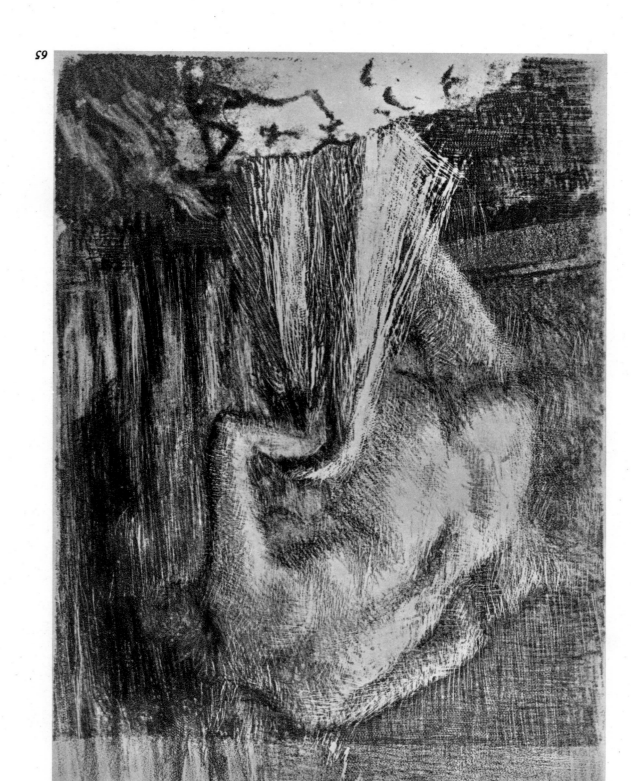

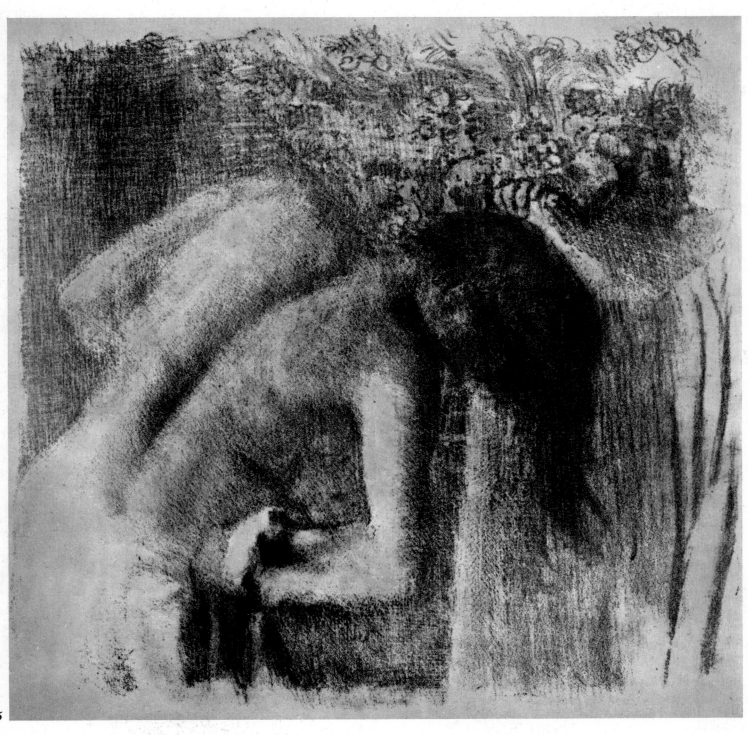

66

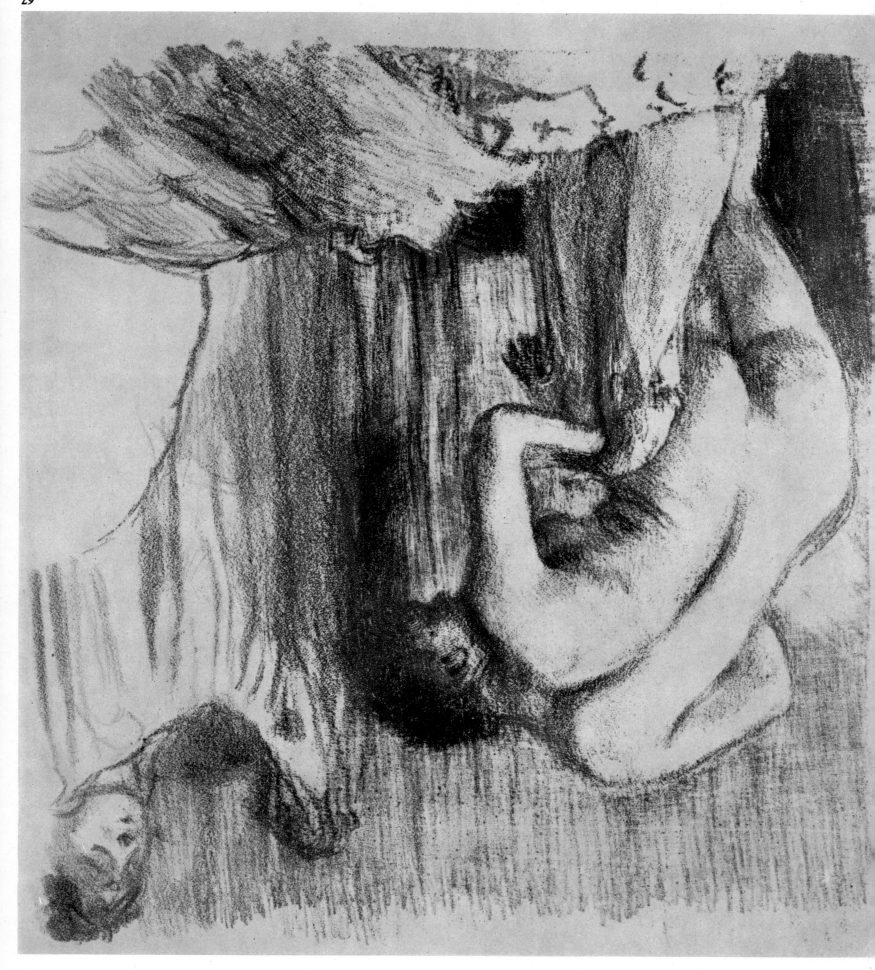

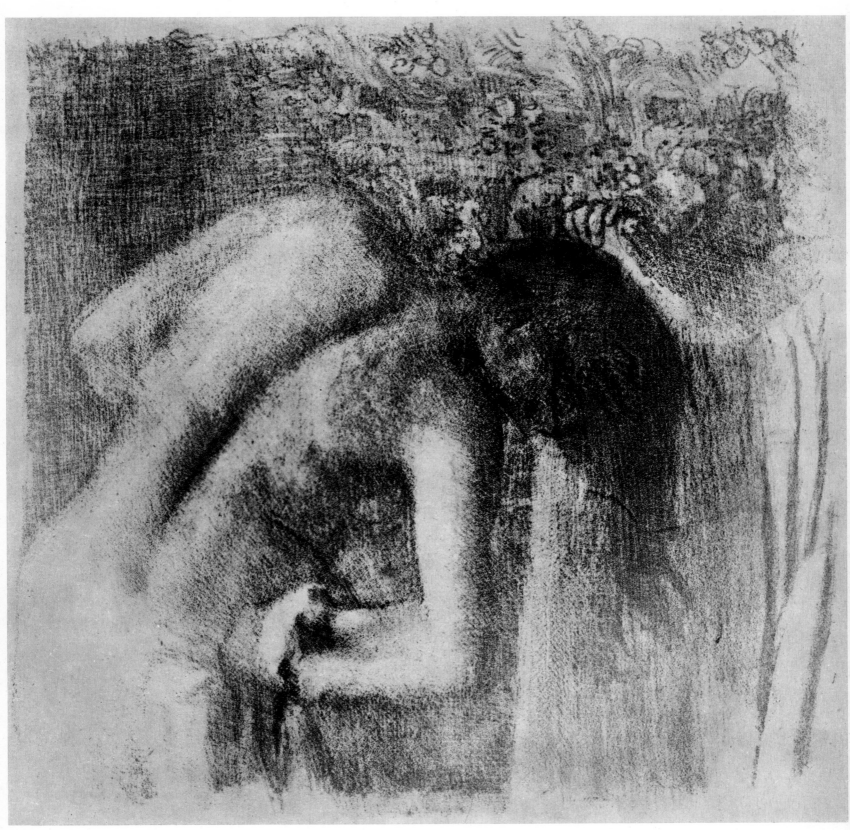

68

The Monotypes

INTRODUCTION

I TECHNIQUE

HOW DEGAS' MONOTYPES CAME TO LIGHT

Degas was full of contradictions: a reactionary and an avant-garde artist; a so-called Impressionist who hated *plein-air* painting; passionately fond of the work of Raphael and Ingres, yet a great Realist himself; a misogynist who painted nothing but women; an outspoken anti-semite whose best friend was Ludovic Halévy.

Another paradox is inherent in his use of monotypes. The print is traditionally regarded as an excellent means of making a painter's art more accessible, whether in the form of original engravings, destined for a quite small circle of collectors, or the reproduction of a painting in a large edition. Yet curiously enough, Degas, like Goya, chose a particular kind of print, the monotype, for the expression of the most intimate and personal scenes, literally the 'shadowy recesses' of his art. Still it is true that this attitude towards prints and monotypes was also Whistler's and Manet's, and was very much in tune with the general tendency of artists of the time to regard engraving as a subjective form, an area for experiment and expression quite as immediate and responsive as painting itself. The landmarks of this movement for the revival of a technique long left to the hired craftsman are the foundation of the Société des Aquafortistes in 1862 and of the Société des Peintres-Graveurs in 1889.

The monotype is of course, by definition, a unique object. It is therefore, paradoxically, an anti-print. Of all Degas' works it is the monotypes that have until recently been the least well known. Their existence was virtually concealed even after Degas' death because, by a series of coincidences, they remained in the possession of a very few persons. Even during his lifetime Degas allowed hardly anyone to see them. He showed three proofs in black and white at the Impressionist exhibition in 1877, then in 1893 at Durand-Ruel's gallery a complete series of monotypes in colour, all landscapes. The pastels exhibited at the other Impressionist exhibitions were occasionally retouched monotypes – in particular the series of *Women at their Toilet* shown at the last exhibition of the group in 1886. But the only people permitted to see the 'pure' monotypes were a few close friends like the Halévys and the Rouarts, or artists Degas liked and respected such as Bartholomé and Pissarro.

In view of their own later work it does seem extremely probable that some of the younger artists Degas admired, such as Toulouse-Lautrec or Gauguin who were allowed free access to his studio, saw them too. The former, of course, produced a whole series of brothel scenes, and Gauguin used the monotype technique quite often. But what is certain is that this area of Degas' work remained a closed book to the public for many years.

At the sale of prints held after the artist's death, on 22 and 23 November 1918, the monotypes were bundled together in lots, in portfolios, and not individually catalogued. On the basis of this sale Loys Delteil, the greatest expert of the time on nineteenth-century engraving, published an illustrated cata-

logue of the artist's prints, the principal and for a long time the sole source of information on Degas as a print-maker; the monotypes were not included, however. The first opportunity to see them came with Vollard's editions of Maupassant's *La Maison Tellier* in 1934 and Pierre Louÿs' *Mimes de Courtisanes* in 1935, both of which contained reproductions of a number of the monotypes of brothel scenes, and later on, in 1938, Blaizot's edition of Halévy's *La Famille Cardinal*, which included reproductions of most of the monotypes Degas had produced as illustrations half a century earlier.

There are a number of factors responsible for the rescue from oblivion of these single sheets – their very modern attitude, for example, their interest as curiosities, their astonishing three-dimensional quality, and also the sudden influx of large numbers on to the market, as for example at the sale of the Exteens Collection. In the last fifteen years there have been a few exhibitions in Europe – notably at the Lefèvre Gallery in London (1958) and the Galerie de l'Œil in Paris (1964). But easily the most important publication on the subject of the monotypes is the contribution by Mrs Eugenia Parry Janis, who followed up her catalogue of the 'Degas Monotypes' exhibition at the Fogg Art Museum, Harvard, in 1968, with a check-list reproducing every single one of 321 monotypes by Degas, whether in existence or lost, whether touched up with pastel or gouache or left in the original state. This provides a basic inventory, and is, with a few minor reservations, a superb piece of scholarship and research, which has been of enormous assistance in the preparation of this volume.

Would Degas himself have been pleased to know this aspect of his work excited so much interest? That is another question. His remark to Georges Villa in 1906, when he was an old man, is well known: 'If I could live my life again I should do nothing but black and white.' This is quite a surprise coming from an artist whose reputation was based largely on pastels and who was unequalled in his ability to exploit the glamour and delicacy of colour. Yet there was something in Degas (who was nicknamed 'the rigorous' by Mallarmé) which despised the over-sensual beauties of colour and responded to a reduced, stripped-down line that depended more on accuracy than charm, something in him that rejected dazzling display in favour of chiaroscuro effects in which the dark and the light each achieves its own intensity. But presumably he saw the monotype chiefly as a sort of experiment, something to dabble with in private (he called it 'cooking' or 'cuisine'), a studio piece destined to remain in the studio, that gave vent to his passion for exploring new techniques – a passion, incidentally, which led him to invent, or at least believe he had invented, new blends and new effects, so that in about 1880 he began to abandon altogether the traditional techniques of oil painting. Denis Rouart, who has made a particular study of these questions, relates the monotype to this general search for a technique and a mode of activity suited to studio work, something which the Impressionist generation had in effect repudiated when they rejected the practices of the academies and placed the values of observation and spontaneity above those of practice and application. Constantly moving between pastels and tempera, from using turpentine-thinned colour on oiled paper to pastel mixed with tempera on a monotype, Degas may have been able to recapture something of the spirit and alchemy of the craftsmen-artists of the Renaissance, as much technicians as they were creative artists.

In the monotypes, while re-establishing links with techniques apparently neglected since the seventeenth century, Degas managed to express quite as much about himself as in many of his pastels of dancers, and with a total lack of hypocrisy that appeals to us now as very modern. His peeps through the

keyhole of a brothel door teach us as much about him, his art and his age, as do his washerwomen and his ballet dancers, and his dream-world landscapes are as revealing as his more famous race-courses.

WHAT IS A MONOTYPE?

Degas hated the word 'monotype', preferring, so his historiographer Lemoisne tells us, to describe his works as 'drawings done with greasy ink and printed'. What exactly is a monotype? In principle it is a one-off impression. Should it then be classed under the general heading of prints? It is a technique that falls mid-way between an original drawing and a print, not really satisfactorily classed in either of these categories. It is a design drawn, not etched, in ink or paint thinned with turpentine on a copper or zinc plate, or sheet of glass or celluloid or some other smooth and non-absorbent surface. A proof is pulled on a sheet of paper; occasionally it is possible to pull a second, much paler, and very rarely a third that is paler still.

According to Lemoisne and Rouart, it was while watching proofs of his etchings being pulled by the printer that Degas had the idea of simply inking a copperplate, not using varnish or engraving, and then drawing on it a picture in reverse, in other words making the lines by removing the ink between them with a brush, needle, or pad, or even the fingertip, in order then to *pull* a proof on a sheet of paper just as though it were an engraving or an etching. The portrait of his engraver-friends Ludovic Lepic and Marcellin Desboutin, now in the Louvre, shows the former at work on a plate resting on his knee. On a nearby table is the piece of rag so indispensable to the monotypist. Eugenia P. Janis sees this as confirmation of the theory that it was from his friend Degas learned the technique, a view that is certainly consistent with the evidence of the first of the monotypes (*pl. 1*), which is signed by them both. From the start of the nineteenth century the historian of engraving, Adam Bartsch, had understood perfectly the monotype process used in the seventeenth century by Benedetto Castiglione. 'It is our opinion,' he wrote, 'that Castiglione placed a thick layer of oil paint on a plate of polished copper, then, in such a way as to approximate to the effect of a woodcut, the colour was removed as necessary to give the half-tints and pale colours required for the design. When the plate was laid out in this manner, he printed it on paper in the customary fashion. Proofs obtained by this process must of course have been unique, since the pattern of black on the plate was removed entirely by the paper of the first proof and was therefore unable to furnish a second proof. These pieces by Castiglione are, then, like those heavy black proofs you sometimes find among Rembrandt's prints, so that Castiglione's are in some degree imitations.'

In practice a monotype can be made in a number of ways. The first consists, as we have seen, in entirely covering the plate with black, then wiping away or removing the ink in such a way as to bring out the pale tones; this was the method Degas used for his earliest monotypes, the series of ballet dancers in which the tutus, legs and faces loom out from the shadow of the stage in just the way they did from the inky black plate (*pls. 1, 2*). Degas often used this technique for scenes of artificial stage lighting and for the singers performing in cafés (*pl. 20*). Some of the finest nudes were also printed in this way (*pls. 155, 161, 163, 167, 168 etc.*). With this negative image technique used by Degas for the early monotypes, light seems to emerge and pale tones loom out from the blackness. It is of some interest to note that it was this technique he used at the time his eyes were beginning to fail and when he was no doubt particularly sensitive to the effects and mysteries of light – as indeed his paintings already show, for example *Madame*

Camus in Red Dress (1870, Lemoisne 271) or *The Rape* (*c.* 1872, Lemoisne 340). The second method of executing a monotype is to draw on the plate precisely as though it were a sheet of paper, using Indian ink that may be diluted with spirit if desired, and then print it just as it stands. This was the technique used for most of the brothel scenes and the series of *The Cardinal Family*. The third method is a combination of the first two: drawing on a plate that is inked only in part, and then reworking with rag or a brush, or by hand. This third method was the one Degas used most often; it permits the maximum flexibility and variety. Degas, who loved 'dabbling' with technical matters, took delight in combining within one composition the vigorous black strokes of Hokusai set against a white background, and the inked and scraped sections which best represented the subject.

In *Siesta in the Salon* (*pl. 111*), for example, the women are simply delineated, with a witty and concise line that silhouettes their plump white bodies, but the curtain is smudged to show the direction of the folds, and the floor is mottled, by means of a stencil, in imitation of a thick carpet. Or there is the Lesbian scene (*pl. 122*) in which the passive woman is pale and white, and rather flaccid, and the other is active, the line of her body echoed by a strand of hair coiling down from her head to the small of her back; like a number of the nudes here, her body is 'moulded' by the print of Degas' thumb. You feel that the hand precisely echoes the vision, giving form to the scene glimpsed in the memory or the imagination.

Degas did also use a fourth method, but this was about ten years after the period we have been discussing and was applied exclusively to landscapes. The technique involved painting on a plate, but using several different colours of oil paint thinned with turpentine instead of black ink. We have a description of Degas using this process, taken from an account by Georges Jeanniot of a visit by Degas and Bartholomé to his house in Burgundy in the autumn of 1890:

> Degas was in raptures over the journey. With his astonishing powers of recollection he had noted different aspects of nature, and reconstructed them from memory in the few days he spent with us. Bartholomé was staggered to see him drawing the landscapes as though they were still before his eyes:
> 'You realize', he said, 'he didn't once stop me to take a closer look!'
> 'Have you any copper or zinc plates?'
> 'Here you are.'
> 'Perfect. And can you let me have a piece of material to make one of my special sort of pads? I've been wanting for so long to do a series of monotypes.'
> Once he was provided with all that he needed he started work without a moment's delay, not allowing himself to be distracted.
> With his strong but well-shaped fingers he grasped hold of each object, each tool of his genius, wielding it with surprising dexterity so that little by little there appeared on the metal surface a valley, a sky, white houses, fruit trees with black branches, birches and oaks, ruts full of water after the recent shower, orange-tinted clouds scudding across a turbulent sky above the red and green earth.
> All the pieces fell into place harmoniously, colours mingling, and the handle of the brush traced pale shapes in the fresh colour. These pretty things were born with apparent ease, as though he had the model before him.
> Bartholomé recognized the places their white horse had passed through at a brisk trot.

After half an hour, no more, came Degas' voice:

'And now, if you are all agreeable, let us pull this proof. Is the paper damp? Where's the sponge? You know soft-sized paper is the best!'

'Calm down, I've got some strong Chinese.'

'He's got Chinese? Let's see it then . . .'

I put a magnificent roll down on the end of the table. When everything was ready, the plate placed on the press and the paper laid on the plate, Degas said:

'What a terrifying moment! Go ahead! Start turning!'

It was an old press with a heavy wheel in the shape of a cross. Once the proof was obtained it was hung up to dry. We used to do three or four every morning.

Then he asked for pastels to finish his monotypes, and it was now, even more than in the proof-making, that I admired his taste, his imagination, and the vividness of his recollections. He recalled the variety of the shapes, the structure of the land, the unexpected counterpoint or contrast: it was delightful. . . .

At this juncture a reminder may be useful that only the pure monotypes are reproduced here, not those that have been retouched in pastel, crayon or gouache; these fall outside the scope of the series of which this book forms a part, and the ambiguity that permits the pure monotypes to be classed as a form of print cannot really be stretched any further to take in the rest. In fact Degas originally regarded the monotype as no more than a basis for colour, and the dance scenes and *café-concerts* executed between 1874 and 1878 are almost always pastels *on* monotypes. Some are well-known: *The Star* and *Café on the Boulevard Montmartre* in the Caillebotte Bequest in the Louvre, *Le Pas battu* in the Bührle Collection, Zürich, or the *Café-concert* in the municipal museum at Lyons. With these pastels the monotype was used as a sort of pattern for the composition and the tonal values, replacing the preparatory drawing or wash. Then Degas became increasingly interested in the monotype in its own right, with its distinctive qualities of chiaroscuro, its beautiful inky blacks and the dazzling whites of its negative images, and the elements of surprise in the printing process, which could only partly be controlled. From this point on, the only monotypes he retouched in colour were normally second proofs, which were greyer, with the values and contrasts largely destroyed. Examples are *Woman in the Bath* (Lemoisne 730), on the second proof of our plate 155; *Women Getting out of the Bath*, in the Fila Collection, on the second proof of our plate 158; *La Toilette* (Lemoisne 1199), which is on a paler version of our plate 154; or the nude woman combing her hair (Lemoisne 799), on the second version of our plate 168; or again *The Rocky Slope*, a pastel on the second proof of a monotype in colour, today in the Belvedere Museum, Vienna. But the monotype series of the brothels and *The Cardinal Family* Degas left in their raw, natural state – reserving the virtuoso displays of pastels chiefly for the charms and illusions of the footlights. The pure monotype in black and white remained the vehicle for an objective and amused, but rarely very impressed, look at real life.

DISTINCTIVE FEATURES OF THE MONOTYPES

At first there was a contrast between Degas' more public paintings and pastels, and the monotypes which, like the drawings, were a private area for experiment and research in preparation for something more

finished. The monotype was in effect a preparatory sketch, concentrating not on the forms but on the relationships between the different elements and their arrangement on the page. In classical painting the artist would judge the balance of his composition by studying it in a mirror, so that, by no longer reading the picture from left to right like a book, he could correct his right-handed bias. Because the monotype inverts the drawing during printing, it is capable of playing the role traditionally assigned to the mirror. In practice, though, what attracted Degas to the technique was its speed and the element of surprise it contained – and also the possibility of controlling both speed and chance; in this respect he was much more like a photographer dealing with reality than a painter creating a reality of his own. But the unusual thing about these 'impressions' in black and white is that the 'life-drawing' is so clearly executed from memory – after all one can hardly imagine Degas setting out his materials and his press in the foyer of the Opéra or in the salon of a brothel.

The monotype is a reconstruction of an on-the-spot record; it is more than coincidental that the first monotypes made their appearance in the 1870s, the time when Degas was closest to the other Impressionists and was exhibiting with Manet, Monet, Renoir and the rest. Degas' pictorial style changed shortly after his first experiments with monotypes. Is this something more than chance? Obviously it is extremely difficult to know whether the monotypes and the paintings are different but contemporaneous manifestations of the same visual philosophy, or whether the monotype technique did indeed influence the painting. But certainly the rapidity of line, the bold, almost improvised quality of the silhouettes, the fluidity of the materials, in such paintings as *Woman ironing, against the light* (1874, in the Metropolitan Museum of Art, New York; Lemoisne 356) or *Viscount Lepic and his Daughters* (1876; Lemoisne 360), are entirely in the same spirit as the monotypes.

It was also at about this time (1877 or thereabouts) that the first 'snapshot' photographs appeared. The cross-influence between art and photography is a very strange business indeed. While Degas, like Delacroix and Courbet before him and Gauguin after him, frequently worked from posed photographs (particularly for portraits), the first snapshot photographs were of urban landscapes directly inspired by Impressionist paintings.

In terms of style, Degas' monotypes are more reminiscent of photographs than are his contemporary drawings or pastels. Partly this is because of the way black and white are organized, by tonal value rather than by line, but chiefly because of the way they apprehend reality. The monotype is a document about the world as it is, rather than a vision of the world which is dictated by some artistic principle – and Degas' observation is genuinely photographic, pinning down movement and disorder at a moment in time. This is what lies behind that impersonal detachment, that sense of distance that particularly appeals to the modern sensibility, but it is equally the reason for something furtive in the way it is perceived, a self-conscious observation; there's no feeling of a genre scene, but of something glimpsed through a keyhole. Perhaps it is not illogical that the technique closest to snapshot photography should have been the vehicle for the most personal area of Degas' vision, his voyeurism, if that is not too strong a word – the brothel scenes, the nudes and the pictures of women washing themselves.

Studying the monotypes puts one in a privileged position to understand Degas' work, giving access to his most personal and private concerns, his relations with women and with femininity. The very least that can be said is that a fascination with women, a mixture of love and disgust, is the obsessional theme

that runs right through his work. But why should the monotype be more indiscreet and more revealing than Degas' other forms of expression? Apparently it is a fact that Degas did confine his erotic portraiture to this branch of his art, and his prudish family destroyed the majority of the pieces that might be considered indecent at the time the inventories were drawn up after his death.

In its life and immediacy the process is closer to the lightning sketch than the print. Because it is printed on paper, and because an element of chance affects the values and contrasts, it is close to photography, where one is never quite sure how a shot will look until the second stage of the operation. The technique is in some way more devious, more voyeuristic, than when something is drawn directly from life, where the confrontation between the portrait (painting or pastel) and the model takes place at the same time as the picture is being created. Degas' recording mechanism was his eye; it was not until he was back in his studio that he called on his powers of memory or imagination and noted down in lithographic ink the scene he had observed and which he had, in a sense, stolen without the protagonists being in the least aware of it.

In a way the monotype is a print, a technique that doubly distances the scene represented because, between the act of the hand that draws and the finished product, there intervenes the printing process and the inversion of the image. Yet at the same time the monotype is, both in theory and by definition, a one-off impression, it is unique and it therefore retains the distinctive character of a drawing, something that is traditionally kept in a portfolio and enjoyed by one person at a time. One feels it can hardly be by chance that Degas reserved this naturally ambiguous technique (an original produced by a process of reproduction, in which chance counts for as much as skill) for the very element of his own personality that was also the most ambiguous, namely his relations with the world of femininity. Whether it is coincidental or not, the monotypes do provide an opportunity to get just a little closer to a particular aspect of Degas' vision of the world. While it may not add a great deal to what one can imagine for oneself about the private life of a middle-class misanthrope and hardened bachelor, as regards his sensibility in general it is extraordinarily revealing.

II A VISION OF A WORLD

WOMEN

We have an eyewitness report of Degas' behaviour with women from one of the most beautiful and gifted women of his circle, Berthe Morisot. The attractive dark-eyed model of Manet's *The Balcony* wrote to her sister Edma in 1871 (when Degas was thirty-seven): 'Judging by the many things he has said about you, I would say he is fairly observant. . . . He came and sat next to me as though planning to express heartfelt devotion, but I am afraid his devotion confined itself to a long commentary on Solomon's proverb: "Woman is the affliction of the just man." '

It appears that throughout his life Degas divided his feelings for women between, on the one hand, respectful and affectionate friendships and, on the other hand, the observation and enjoyment of female

animals. This painter of the female sex painted *ladies*, all eminently distinguished, some melancholy, others out of temper, women artists, women invalids, sisters in culture and in their awareness of the burden of life – these certainly are the images he leaves us of Berthe Morisot's sister, Edma Pontillon, or of Mesdames de Ruttis, Camus, Jeantaud, Henri Rouart, and indeed his own sister Marguerite. All their faces are evocative, assimilated and explained; but they surmount dresses not bodies. One has only to compare them with portraits of women by Ingres, Renoir or Manet.

But the nudes Degas reveals to us in his monotypes are the opposite, bodies without faces, to all appearances belonging to a different race of animals and a different social class from those other women. They are 'women one does not marry'. If Flaubert was the archetypal bourgeois among the writers of the time, Degas was certainly his counterpart among the painters.

There can be no doubt that the monotypes played as important a part as the studies of dancers in the development of Degas' concept of the nude. Within a single decade he moved from the academic Ingres-like nude of *The Plight of the City of Orleans* (1865) to the 'clothes-wearing' bodies of the monotypes of brothels or of women washing themselves – from the nude to the undressed body. It is a great mistake to see cruelty or disdain in Degas' way of looking at his models, and people who thought this at the time were quite wrong. His attitude is far more ambiguous than that of some censorious cynic. When you look through the amazing series of monotypes of free-moving bodies, you might well be reminded of something Degas said about a woman being discussed over dinner with his friends the Halévys (the remark was recorded by the son): 'She's of the people!' said Degas with enthusiasm. And added: 'It's in the ordinary people that grace resides.'

NUDES

The nudes in Degas' monotypes are of two sorts, which may be described as 'parodic' and 'evocative'. And curiously enough Degas employed a different technique for each type. The parodic or caricatural nude is most often drawn on the plate as a positive image with a witty and vivacious line that recalls the Japanese drawings of wrestlers or prostitutes in, for example, the *Mangwa*. We know that Degas, as well as his friends Bracquemond and Tissot, became interested in Japanese art as early as the 1860s, and that all his life he kept in his room, alongside his drawings of nudes by Ingres, the Kiyonaga diptych of women bathing. The parodic nudes are animal in nature, more comic than obscene, and deposited in a setting rather as though they were puppets: in some of the brothel scenes the canopies, mirrors, hangings and the plush create an ensemble in which the body is merely an additional prop (*pls. 85, 97, 111, 116, 119*). The other category of nudes includes some of the most mysterious and evocative Degas ever created; they are all produced by the negative image method and have that ghostly quality inherent in a technique that makes white seem to emerge from blackness, lighted areas from the dark, and flesh from shadows. These nudes are for the most part of women performing their toilet, standing in front of a window, or in the bath (*pls. 157–160*), combing their hair, in silhouette against the light (*pl. 168*), or illuminated by the firelight from the hearth (*pl. 167*) or by a lamp (*pl. 163*); they are conceived on a grander scale than the rest and have none of the improvised sketch-like character of the contemporary nudes in the prostitutes series.

82

Degas must have been particularly confident of their excellence, as this was the series that he chose to present to friends, mostly engravers themselves and certainly experts of one sort or another, rather than hiding them away in portfolios with the rest of the monotypes. The strangely primitive *Woman in the Bath* (*pl. 160*) bears a dedication to Rossana; *After the Bath* (*pl. 161*) to Michel Lévy; the superb *Woman on the Bed* (*pl. 163*) to the critic Philippe Burty; *Woman Reading* (*pl. 165*) to Ludovic Lepic. The remaining nudes, which fall into neither category, having neither the lively caricatural line of the one nor the tenebrist power of the other, are more *intimiste*, foreshadowing Bonnard. Examples are: *Girl putting on her Stockings* (*pl. 125*), *The Bath* (*pl. 132*) and *Nude Woman at the Door of her Room* (*pl. 128*). They employ both the techniques, that is, they are painted on the plate then worked over with a rag, brush or the fingertip.

In the same style is a series of *intimiste* portraits of women preparing for bed or getting up in the morning, from a bed with curtains, wearing only their little nightcaps; these seem to have come straight out of seventeenth-century Holland. One thinks of similar scenes by Brouwer and particularly such Rembrandt engravings as *Woman with the Arrow*. Degas seems to have amused himself by depicting a respectable middle-class bedtime scene in such a way that, if you look at the monotypes in order, they can be read off like a film sequence (*pls. 137–140*). It is not only the subject matter and composition but even the mood they evoke that is reminiscent of the golden age of Dutch painting. And it is interesting to note that Degas' allusions to the native art of Holland were instantly picked up by his contemporaries. After visiting the Salon of 1876, J.-K. Huysmans wrote of Degas: 'I had never been attracted to any pictures but those of the Dutch school, which satisfied my need for reality and for domestic life, so for me it was in truth like being possessed. The modern life that I searched for in vain in the exhibitions of the time . . . was revealed to me at a stroke, quite perfect.'

BROTHELS

Huysmans, Goncourt and the rest of the literary avant-garde of the 1870s and 1880s were, as it happened, peculiarly susceptible to Degas' brand of modern realism, and in this respect preferred him to the other painters of his generation. When Burty the critic wrote his review of the third Impressionist exhibition of 1877, at which a number of the retouched and the pure monotypes were on show, what he found striking about Degas was that 'he has chosen the more uncommon aspects of Parisian life . . . in his attitude to them he shows himself to be a man endowed with feeling, wit and a satirical eye, a speedy and most competent draughtsman. . . . The present-day Salons are too starchy to accept his delicate studies, whose literary equivalent is the pungent short story.'

Most of Degas' monotypes were executed between 1875 and 1885, which coincides with the period when the naturalist novel was at the height of its popularity. One of the 'more uncommon aspects' of Parisian life on which this branch of literature tended to concentrate was the theme of prostitution as a counterpoint to bourgeois life. Within a few years of each other, 1876–80, all the following were published: *Marthe, histoire d'une fille* by J.-K. Huysmans; *La Fille Élisa* by Edmond de Goncourt; *La Maison Tellier* by Maupassant; and, of course, *Nana* by Zola.

Degas certainly seems to have been the first painter to tackle this major theme of naturalist literature –

and, it must be said, in a more down-to-earth, less moralistic way than even Toulouse-Lautrec ten years after him. It is also the single theme that dominates the monotypes, accounting for about fifty in all.

The first thing that is so striking is the air of reality, of absolute immediacy, the feeling of a scene from life that has no idea it is being observed. Yet, by its very nature, the monotype has to be executed in a studio and therefore belongs to the worlds of memory and imagination. Possibly Degas jotted down a few quick sketches, but if so no trace of them has been found, or not to our knowledge. Perhaps they were destroyed at a later date, together with the monotypes that were considered to be obscene.

In practice this talk of realism is deceptive for it was certainly not standard practice for the girls to appear naked in the salon. Normally they would be partially clothed in shifts or corsets, as Degas sometimes represents them (*pls. 88–92*) and as they appear later in Toulouse-Lautrec's *La rue des Moulins*. Degas shows them not only waiting in the salon, but also in the rooms, 'before' and 'after', either on their own or with a companion. There is no moral condemnation, no feeling of pity at the sight of these sagging bodies on display, just a simple visual statement, totally depersonalized. Lautrec individualizes his brothel girls, gives them faces which are either stupid or bovine or, occasionally, kind. Later Rouault endowed them with the bodies of worn-out sluts and the bloated faces of nightmare. Not Degas. On the whole he enjoyed himself. *The Madame's Anniversary* (*pls. 99, 100*) in which the nude women in black stockings are presenting bouquets to a highly respectable matron, who looks a bit like an ageing priest, is of such humour and warmth that it could not possibly have been created by a bigot or a fanatic. Of the very few erotic scenes that exist – or, more accurately, that remain – the only one not treated in the comic vein of, for example, *The Customer, Supper Time* (*pl. 115*) is the Lesbian couple (*pl. 122*), which is imbued with a strong sense of poetry and a kind of grace. Its pronounced quality of relief is the result of a happy stroke of invention that made him use the same grey for the shadows that envelop the nude woman on her back as for the woman leaning over her, as though she, the 'aggressive' partner, were actually a part of the shadows, swooping out from them like a bird on to the female prey.

Customers are a rare sight in this world of waiting; a little man in a bowler hat appears on the sidelines in a few scenes, hesitant and far from being won over. In the two monotypes that show him alone in a room with a prostitute, he is dressed and gazing at the woman, while she is either in the bath (*pl. 129*) or combing her hair beside a basin (Ittleson Collection, New York). Because of the way he remains outside the scene, because of his voyeurism and his interest specifically in the sight of a woman engaged on her most intimate toilet, one cannot help but identify this little gentleman with the artist himself. It is after all a fact that with the exception of the naturalist scenes, which are more anecdotic and tend to represent naked women draped over Napoleon III couches, and of a few reclining bodies (*pls. 163, 165, 166*), Degas' portrayal of nude women reveals what amounts to an obsession with the theme of women performing their toilet.

NUDES: WOMEN PERFORMING THEIR TOILET

Just as the dancer was Degas' way of expressing movement, the woman at her toilet was a way of representing woman as she was. It is necessary to try and imagine what was meant in the 1870s by a 'nude' or

an 'academy'. Degas' women are not nudes, they are women without their clothes, and those contemporaries who thought them obscene were very well aware of that fact. These were the women they used to see in the streets, with whom they were intimate, and this certainly did not coincide with their mental image of the nude of antiquity; she, they had been taught, was made up of ideal elements encased in a silken skin. Because Degas showed women in what were considered to be animal attitudes, because he distorted the ideal academic proportions of the body by means of perspective, depicting what he saw and not what people ought to be shown, announcing like an innocent 'the Queen has no clothes', he seemed to them a voyeur on whom all sympathy was wasted.

'M. Degas, who in the past in his admirable paintings of dancers conveyed quite remorselessly the decline of the hired girl, coarsened by her mechanical skipping and monotonous jumping, furnishes us now in these nude studies with a lingering cruelty and a patient hatred. It seems as though he is tormented by the baseness of the society he keeps and has determined to retaliate and fling in the face of his century the worst insult he can devise, overturning that cherished idol, woman, degrading her by showing her actually in the bath in the humiliating postures of her intimate toilet.' This was the sort of interpretation put on Degas' vision – the speaker here being the author of naturalist novels, J.-K. Huysmans. But even the critics who weren't shocked by Degas' realism could not help being conscious of something faintly sordid, in a way it is difficult for us to imagine, looking at Degas' pastels and monotypes of women washing in the present day. The critic Félix Fénéon for example, although he practically discovered Seurat and Rimbaud and was actually an admirer of Degas, nevertheless described these women in a very ripe and decadent style; this was a few years later than Huysmans' comment, in 1886:

'Women crouched, like melons, swelling in the shells of their bath-tubs; one, chin against her breast, scrubs her neck, another's whole body is sharply contorted, her arm clutches her back and she addresses her coccygeal regions with a soapy sponge. A bony spine sticks out; upper arms shoot past juicy pear-shaped breasts and plunge straight down between the legs to wet a facecloth in the tub of water where the feet are soaking. There's a collapse of hair on shoulders, bosom on hips, stomach on thighs, limbs on their joints, and viewed from above as she lies on her bed, with her hands plastered against her buttocks, the slut looks like a series of bulging jointed cylinders. Seen from the front, kneeling, thighs apart, head drooping towards the flaccid torso, a girl is drying herself. And it is in obscure furnished hotel rooms, in the humblest circumstances, that these richly patinated bodies, bodies that bear the bruises of marriages, childbirth and illness, divest themselves and spread their limbs.'

Of course the nudes are by no means as ungainly or unwholesome as Degas' contemporaries liked to think. They were considered ugly simply because they were considered shocking. The women are no stouter and no more out of proportion than the fat and fleshy *baigneuses* of that erotic masterpiece of the *toilette*, *The Turkish Bath* by Ingres (a picture, incidentally, which fascinated Degas as a young man and which he continued to regard as one of the peaks of artistic achievement). Nor were the women any uglier than the contemporary nudes by Bouguereau and Regnault, which seem to us today far more hypocritically obscene. The point is that they are not 'situated' in the manner traditional for the nude in art, that is, either standing or reclining, with the gesture of modesty or special clothing that betokens that they know they are being observed. The great difference is that you are not conscious of the model adopting a pose. Which of course is precisely what Degas wanted. He liked to see woman as 'the human

animal taking care of herself, a cat licking herself. . . . The nude has always been portrayed in poses that presuppose an audience, but my women are simple, straightforward women, concerned with nothing beyond their physical existence. Just look at this one: she is washing her feet.' This was said to George Moore about one of his drawings that was exhibited in 1886. Degas concluded with this crucial sentence, also recorded by the English writer: 'It's as though one were peeping through the keyhole.'

Since Eve was first represented in pictures, through all those Susannas and Bathshebas of classical art, the theme of the woman washing herself has always served as a pretext for the portrayal of the nude. Degas transformed this traditional iconography by a sort of parody. As they take their baths in their rooms, his women have neither the rustic alibi nor the proletarian motivation of Millet's or Courbet's peasant women on the banks of a stream, nor have they the benefit of the oriental pretext provided by the Turkish baths of late Ingres. There is no doubt that he invests his images of women in their tubs or zinc baths with something of his own aggression against the modern world – which he was the first to paint but the last to defend. Ernest Rouart knew him well and relates that 'one of the bees in his bonnet was to campaign against the cleanliness that is rampant in our time'. Apparently he exclaimed about the century of Louis XIV: 'Perhaps they were dirty, those people, but at least they had some distinction! Then look at us, we're clean all right, but we're so ordinary.' He used the theme of the woman performing her toilet as a vehicle to express something about the aspect of a woman's body that interested him most, at least as much as movement had fascinated him in the past – and his historiographer Lemoisne believes it was the studies of ballet dancers that first led him to the nude; what preoccupied him was the one thing for which no one was prepared to forgive him: the animal nature of woman.

One cannot fail to notice the number of visual and sometimes verbal associations that existed for Degas between horses and women. He chose his models much like a horse-breeder, making the following entry in his notebook, for instance (*Carnets*, volume XX, p. 87): 'Éliza Richard. 66, fbg St-Honoré – blonde – well-built; Catherine Essler. Rue des Nonnains d'Hyères. 7 – brunette – elegant – white teeth.'

He noted down elsewhere the following reflection on his trip to Burgundy in 1890: 'for the traveller the horse's trot is kinder than a woman's step'. Or again, there is Daniel Halévy's respectful note of 1888 in his copybook: 'Today Monsieur Degas said: "There are women who exist not to be spoken to but to be caressed."' Degas sounds as though he is patting a horse's withers. The reverse holds true as well, for in a sonnet called 'Pur sang' he describes, with anthropomorphic sensuality, a horse that is 'nervous and naked in her silken robe'.

There were two parts of the female body in particular that obsessed Degas, and continued to do so throughout his life, in the monotypes as well as the pastels and the drawings; these are the head of hair and the slope of the buttocks, the portions of the 'human animal' that correspond to the mane and rump in the horse (*pls. 96, 97, 108, 129, 144*). And the dancers (few examples of which are reproduced here because the monotypes retouched in pastel, and that includes most of the ballet scenes, fall outside the scope of this book) are less the girl-flowers they at first appear to be and really more girl-horses, trained, just like horses, to project an image of grace, speed and ease that takes no account of a reality made up of sweat, muscle and effort; Degas himself wrote that the magic of performance was 'supplied by distance and greasepaint'.

A sonnet written by Degas, who used to show all his poems to Mallarmé, indicates that his attitude to

the less fortunate, indeed to the basic realities of life, was entirely unimpassioned; 'La petite danseuse' describes the slum child beneath the tulle dress.

> *Si Montmartre a donné l'esprit et les aïeux*
> *Roxelane le nez et la Chine les yeux,*
> *Attentif Ariel, donne à cette recrue*
> *Tes pas légers de jour, tes pas légers de nuit,*
> *Fais que pour mon plaisir elle sente le fruit,*
> *Et garde, au Palais d'or, la race de sa rue.*

(If Montmartre gave her her wit and her forefathers/ Roxelana her nose and China her eyes,/ Attentive Ariel, pray give to this novice/ Your light steps by day, your light steps by night,/ For my pleasure let her smell the fruit,/ And preserve the offspring of her street in the Golden Palace.)

This is the background of the girls in the *corps de ballet* at the Palais Garnier, the 'petits rats' whose story Degas tells in the monotypes of *The Cardinal Family*.

THE CARDINAL FAMILY

Degas more often chose to portray girls washing and getting ready than sitting in the salon dressed up like ladies; equally, as often as the horse race itself, he would portray those indecisive moments of waiting around 'before the off'. He must have been particularly amused and interested by all that went on before and after a performance at the Opéra, and it comes as no surprise that he wanted to illustrate a book on the subject written by another opera-lover, who was also one of his best friends, Ludovic Halévy. The artist was very much a part of the Halévy circle, which has been well described by Jacques-Émile Blanche. It was a cultivated and liberal-minded group, linked politically to Marcellin Berthelot and Prévost-Paradol, and to music and the opera through Georges Bizet, whom Degas had got to know when he was in Rome as a young man while the musician was at the Villa Medici. This circle of friends was the very image of the talented bourgeoisie, with all its virtues and its prejudices, very much like Degas himself. Degas was anti-Dreyfus, and when the case was at its height near the turn of the century he broke off relations with his dear friend Ludovic Halévy. Yet his reaction was nothing like this when Halévy failed to appreciate the monotype illustrations Degas produced for his book.

Ludovic Halévy, the librettist of *Carmen* and *La Belle Hélène*, had published a satire on events backstage at the Opéra, all about the 'petits rats' and their procuring mamas. In fact there were two books, not one, *Monsieur et Madame Cardinal*, published in 1872, and *Les Petites Cardinal*, published in 1880. The illustrations for the first book were vignettes by Edmond Morin, and those for the second were done by Henri Maigret; both sets were equally mediocre. According to Marcel Guérin, Degas himself suggested the idea of using monotypes to illustrate a one-volume edition of his friend's book; it is also possible he had some such project in mind even before it acquired the title *Les Petites Cardinal*, for there is a study for one of the monotypes (*pl. 80*) in a notebook dated 1877 by J. Boggs. The monotypes were to be reproduced by Dujardin, reduced in size and by a photogravure process. The project was well advanced, indeed there is in existence a trial block for one of the illustrations (in the Bibliothèque Nationale).

For whatever reasons, the monotype illustrations apparently did not please the author of the book.

They were returned to their portfolios in Degas' studio, and there they stayed. They are listed in the catalogue of the sale of Degas prints held shortly after his death in 1918, but they were not sold. The complete set was eventually bought at the public auction in March 1928 by a group of collectors and bibliophiles, among them the art historian Marcel Guérin, the publisher Auguste Blaizot and the collector David Weill. They divided the originals among themselves and granted reproduction rights to the Blaizot publishing company. And so it finally came about that Ludovic Halévy's book with illustrations by Degas actually saw the light of day in September 1938 – almost sixty years after the artist originally conceived the project; the thirty-three monotypes are carefully reproduced in facsimile etchings by Maurice Potin. The technique employed by Degas is extremely free and easy; although up till then he normally employed the negative image system (using a rag or brush to remove the black ink previously painted over the plate), for the illustrations of *La Famille Cardinal* he drew the design directly on to the bare plate with a brush, using black or brown lithographic ink. The second proofs, which are paler, are frequently retouched in pastel, but the almost Japanese quality of the first proofs is very striking indeed. Of all the monotypes these are perhaps the most deft, and best give the impression of movement or activity – for example the whirlwind of dancers tumbling down the stairs (*pls. 61, 62*) – or the contrast between the static figures of the mother or gentleman friend, waiting and watching, and the quivering young ladies in their tutus (*pls. 59, 69*), delightful studies, original in composition, and full of humorous touches of observation. Backstage at the Opéra held no secrets for such an inveterate music-lover as Degas, and his correspondence shows him to have been very much *au fait* with the internal gossip of this little world, intervening with the director to put the case for a particular dancer, and so on.

The illustrations for *La Famille Cardinal* are really the reverse side of the coin from the decors and sets of Degas the painter of ballet dancers, celebrated for his pastels; he has left the stage and the rehearsal room and gone backstage; admiration and wonder have given way to amusement at the absurdity and cruelty of a world such as this. The light-hearted study of the Parisian *vie galante* is not without reference to the portraits of captivating *lorettes* and *cocodettes* and the scenes of Bohemian life and carnival conjured up by Gavarni, whose lithographs Degas quite literally adored. He collected them all his life, and the sale of his portfolios of prints after his death revealed that he owned more than two thousand.

The *Cardinal Family* series is one of the rare attempts in Degas' work at a sort of morality piece, somewhere between a caricature and a genre scene, though split up into separate incidents that frequently follow on from each other. And indeed, while it is true that the monotypes in general tend to remind one of photography, the illustrations for Halévy's book are far more reminiscent of the cinema, and a number of them, viewed in the correct order (*pls. 56–59* or *pls. 60–62*), are really very like film sequences.

LANDSCAPES

Undoubtedly Degas was more at home backstage at the Opéra than in natural scenery. For entirely pertinent reasons – such as that his poor eyesight made it difficult for him to tolerate strong daylight – but also for psychological reasons, his relationship with nature was very strange, especially for a man so closely associated with the early Impressionist battles.

In the notebook he kept as a young man in Italy (*Carnets*, volume XIX), he describes at length and with some emotion a so-called 'marine', outside Naples, which is in fact a landscape – that most traditional

state of mind of Romanticism. But it was not long before he professed a disgust for nature that paralleled Baudelaire's. Like the poet he was fond of urban landscapes and preferred the gaslight of the *café-concert* to the light of day. George Moore relates that he heard Degas at the Cirque Fernando saying to one of their mutual friends, a landscape painter: 'What you need is the natural life, what I need is the life of artifice.' Certainly it was the height of artifice to paint, as he did at the Opéra about 1866–8, the landscape used as the set for *Mademoiselle Fiocre in the Ballet: La Source* (in the Brooklyn Museum); it consisted of an imitation silver pond with fake reflections and artificial greenery.

At the very period when Monet, Renoir and Manet were using landscape as the means of liberating modern painting, Degas' relationship with Impressionism was ambiguous in the extreme. He could not find words scathing enough to express his scorn for his companions' desire to paint in the open air. To soak up external reality and then reproduce it as exactly as possible seemed to him the height of folly. 'He compared this sort of sport to angling,' relates Ernest Rouart, indeed 'he greatly extolled the method taught by Lecoq de Boisbaudran who advised his pupils to work almost entirely from memory.' Many of Degas' best-known barbs were directed at Impressionism. To the painter Zuolaga: 'well, at least you don't put too much air into your canvases!' To Jeanniot: 'what you've tried to convey is the air outdoors, the air we breathe, the open air. Well! A painting is above all a product of the artist's imagination, it should never be a copy . . . the air you see in paintings by the Masters is not air you can breathe.' Or again: 'falsify and add just a hint of nature. Drawing isn't a matter of what you see, it's a question of what you can make other people see.'

About 1869–70 when he was staying in Boulogne, not far from Manet, or in Trouville, or when he was there again in 1875, he produced in his studio some very delicate pastels and oils of beaches, deserted shores, patches of sky, expanses of hillside and sea; they are very understated and simple. The landscape monotypes in colour which he did in the 1890s employ a quite different technique, one that accentuates the visionary and chance character of his creations, but they nevertheless proceed from the same urge to reduce and simplify. To Degas, nature seemed possessed of something elemental and indeterminate. He would juxtapose expanses, spaces, blurs and bursts of light; what he saw were oceans before there were boats, hills before there were peasants, roads for the most part deserted; even the trees had not yet grown up, for these are the landscapes of prehistory, marshes, lichens and smoking rocks – and the tonal harmonies and subtle use of materials do nothing to sweeten their somewhat disturbing appeal.

Degas' hatred of nature, his well-known aversion to flowers, rare for a painter, recall Baudelaire's detestation of what he called 'stupid plants'. Nature is bad, the agent of untold disasters; there is a curious letter written by Degas which shows he had a fertile imagination for all the possible sources of catastrophe that could be engineered by the earth (more usually seen as a symbol of richness and plenty): 'There are meadows which are like sponges to walk across. What's to prevent the animals who eat and grow to maturity in this wet grass catching rheumatism, and then passing it on to us when we eat them?' (*Lettres*, August 1884). And if it wasn't worry it was sarcasm, as for instance: 'I am being *natural* for about another week' (*ibid*). One could go on for ever quoting examples of his wary relationship with the natural world. The only moment of harmony, of real interest, emotion even, is when nature is in motion. It is a radically different vision from, say, Cézanne's view at the same period of nature as something solid and unchanging, or the dazzling and tranquil vision of Monet and Renoir. Degas touches on this aspect in his

letter to Henri Rouart of 1866 (*ibid.* p. 108): 'We must continue to observe everything, the large boats and the small, the movement of people over the water and over the land as well. It is the motion of things and of people that gives pleasure and even consolation – if one can be consoled when one is so unhappy. . . . If the leaves on the trees did not stir how sad the trees would be, and ourselves too! There is some sort of tree in the garden of the house next door that moves in the wind. Well. I may be in Paris, in my nearly empty studio, but at least I can tell myself that tree is a delight. . . .' This ability to be soothed by the sight of movement in nature is really a variant on a comment made by Seurat in a letter from Honfleur in that same summer of 1886: 'Let us once again get drunk on light, it is a consolation.' Each in his different way seeks consolation from the natural world, and also a way of expressing in his art his most intimate and personal reactions to it.

Certainly Degas' landscapes, some of the finest and most profoundly felt being these monotypes in colour, perhaps because of their strangeness and dreamlike quality, illustrate just how deep were Degas' links with the nature he enjoyed only when it was in motion or recreated in his imagination. It is interesting to picture him eating dinner at Bougival, exclaiming as he noticed a clump of trees in the shadows: 'How beautiful they would be if Corot had painted them.' It is of course ironical that this should occur at Bougival, the home of Impressionism which, of course, made such an absolute cult of nature. Yet the success of this astonishing series of colour monotypes of the mountains of L'Estérel and the hills of Burgundy derives from a blend of accurate observation and ability to recreate the original mystery, in which Degas' love of 'dabbling' in technical matters played a crucial part. It was the fact that he had a good eye that enabled Degas to give an impression of the scene 'more true than nature', much to the amazement of his travelling companion as he watched him at work on the monotypes: 'Bartholomé was staggered to see him drawing the landscapes as though they were still before his eyes: "You realize", he said, "he didn't once stop me to take a closer look!"' Probably this shouldn't be taken too literally, but it does illustrate the power of a successful piece of work, in which synthesizing vision and imagination are perfectly fused.

Possibly these landscapes offer one of the best examples of what Degas was trying quite consciously to create in his work. The colour monotypes, like those in black and white of dancers and nudes, represent the quintessence of all he was aiming for, and so often achieved, namely, a kind of basic fidelity to which the personality of the artist would give its own significance, a 'mirror held up to life', rendered magical by the creative artist's visual intelligence. Degas gave a marvellous definition of his ambitions in a letter to his friend the painter Valernes. He said he was looking forward to meeting him to talk about Delacroix 'and (this is the art it is our task to practise) about everything that can lend enchantment to truth.'

<div align="right">FRANÇOISE CACHIN</div>

I gratefully acknowledge the help of those friends who have referred me to previously unpublished monotypes or who have offered valuable suggestions: Étienne Baulieu, Pierre Georgel, Jean O'Meara, Myriam Worms and, in particular, Henri Zerner whose exceptional knowledge of prints has been of especial value to me.

<div align="right">F.C.</div>

THE PLATES

I

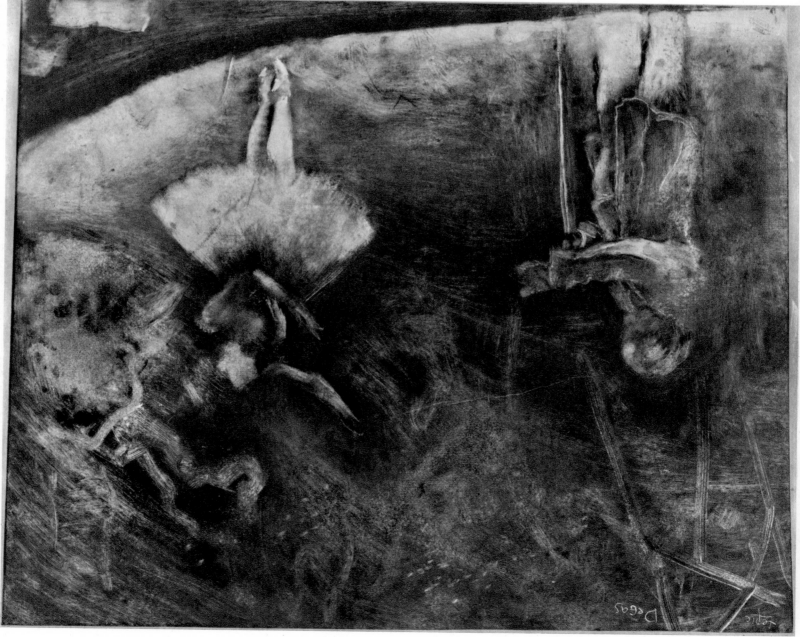

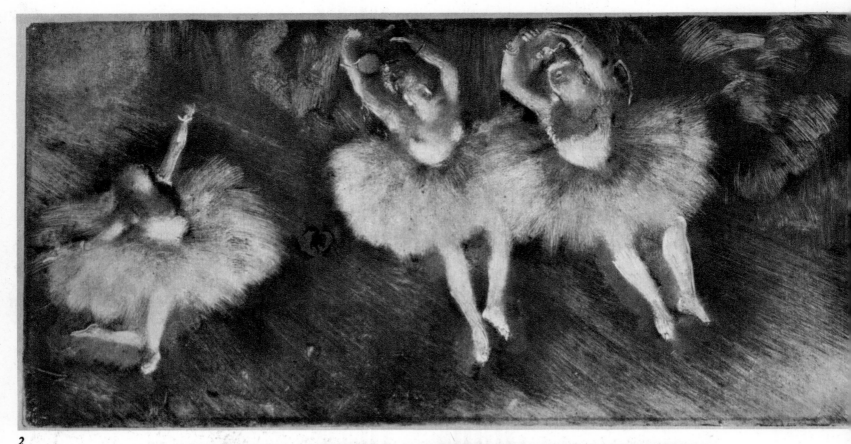

2

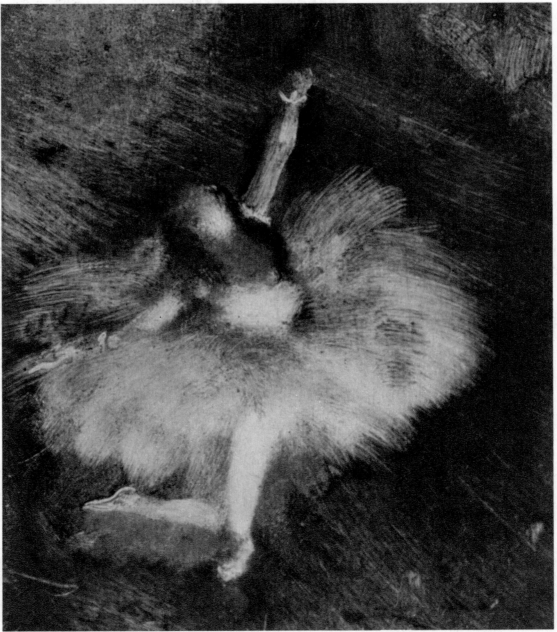

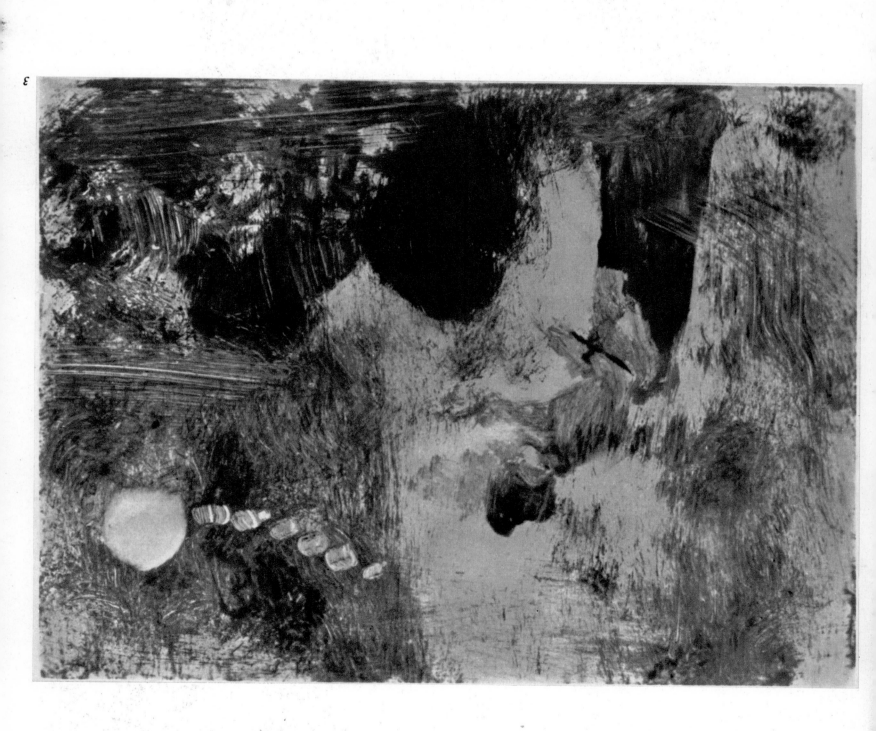

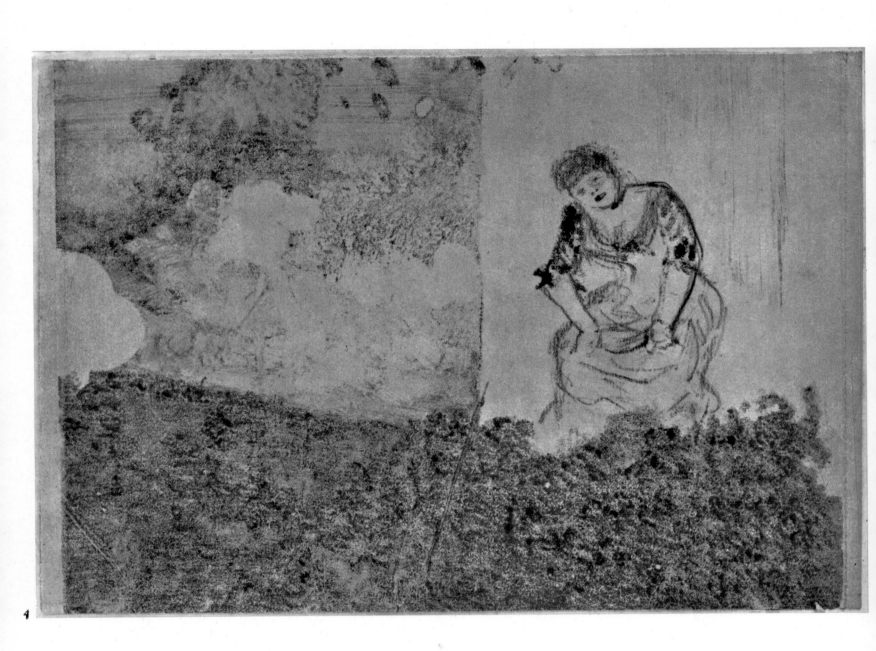

4

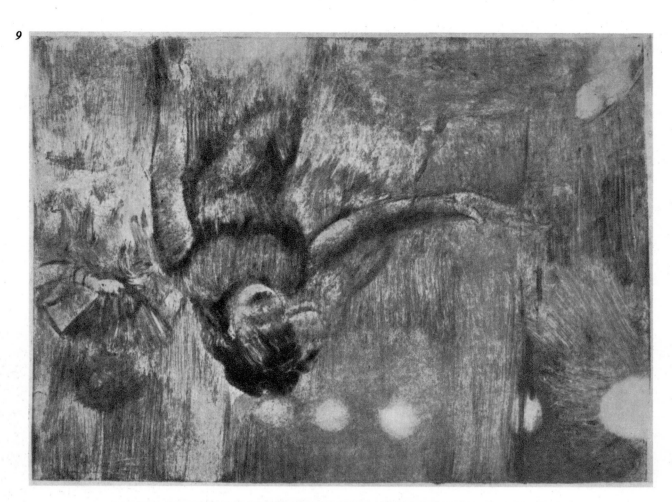

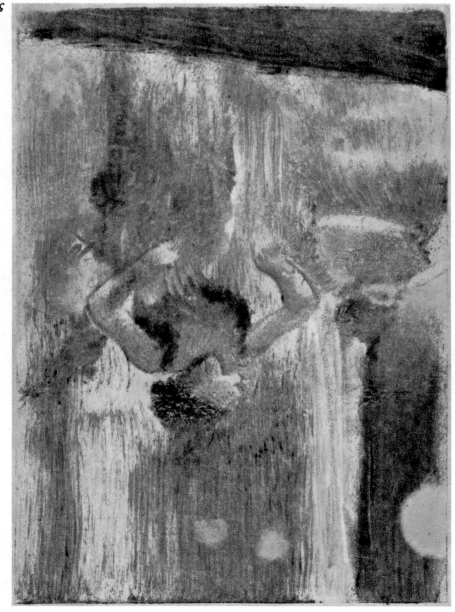

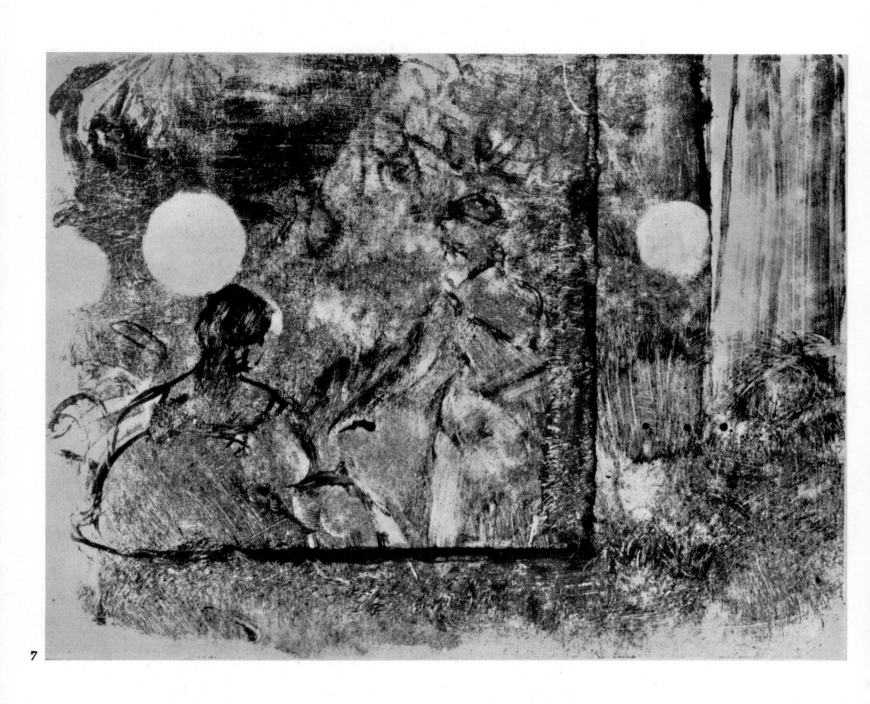

7

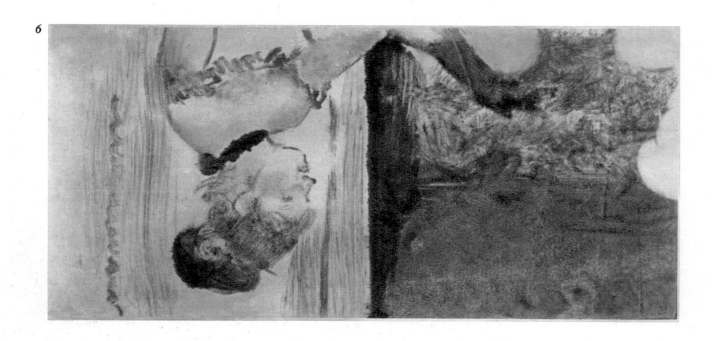

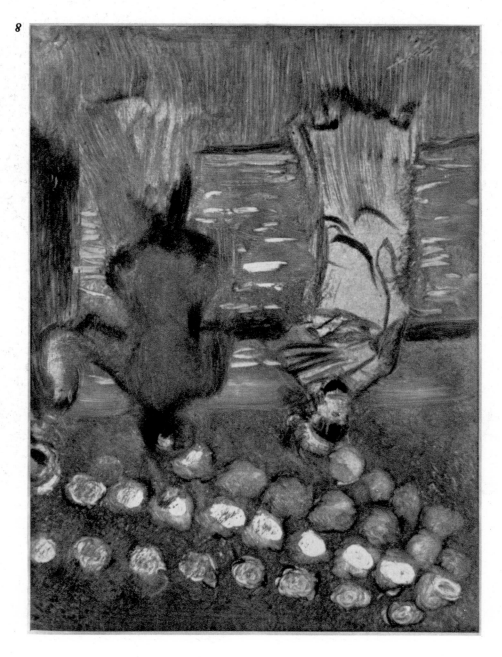

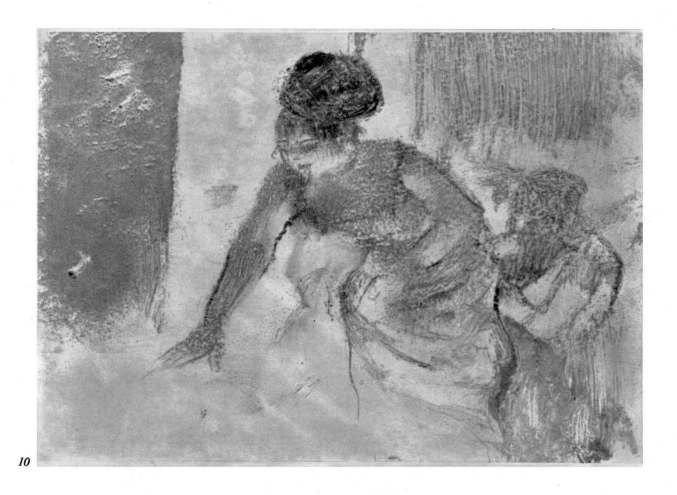

10

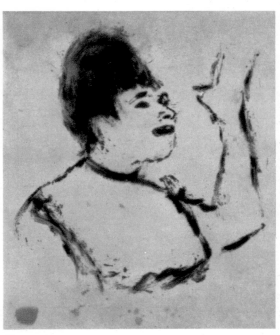

11

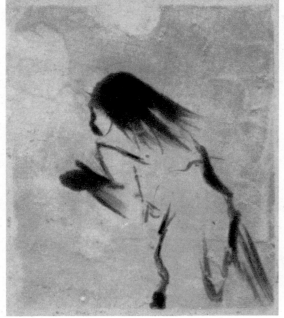

12

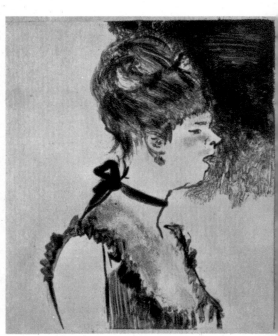

13

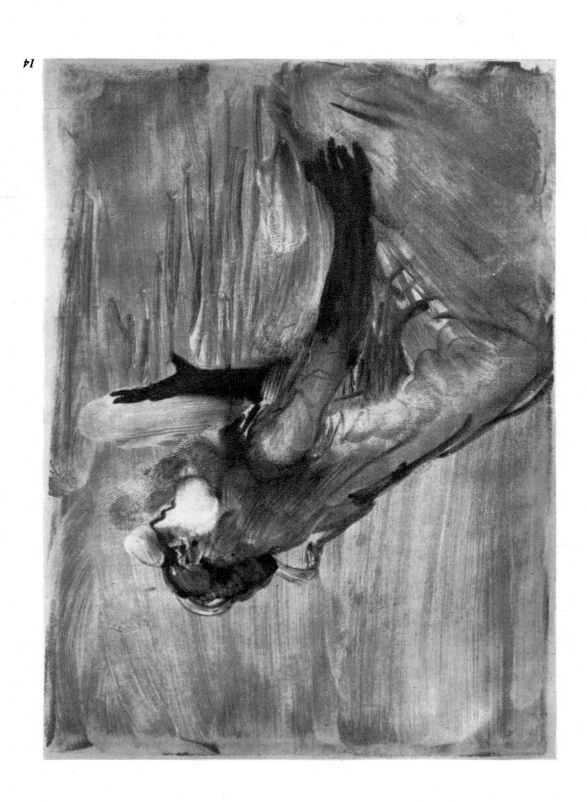

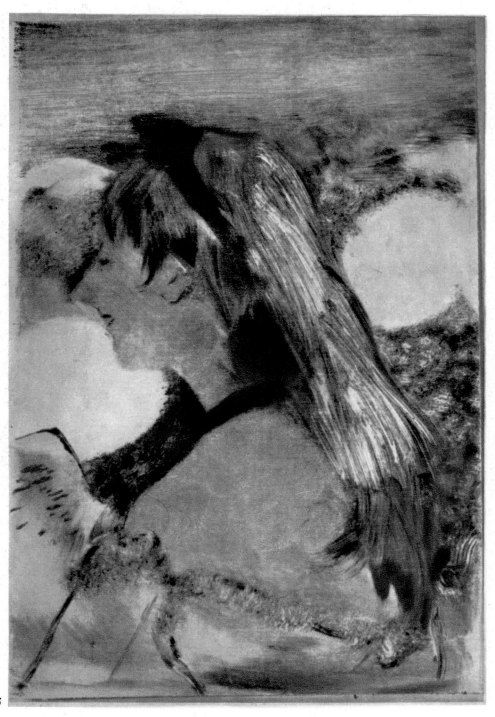

15

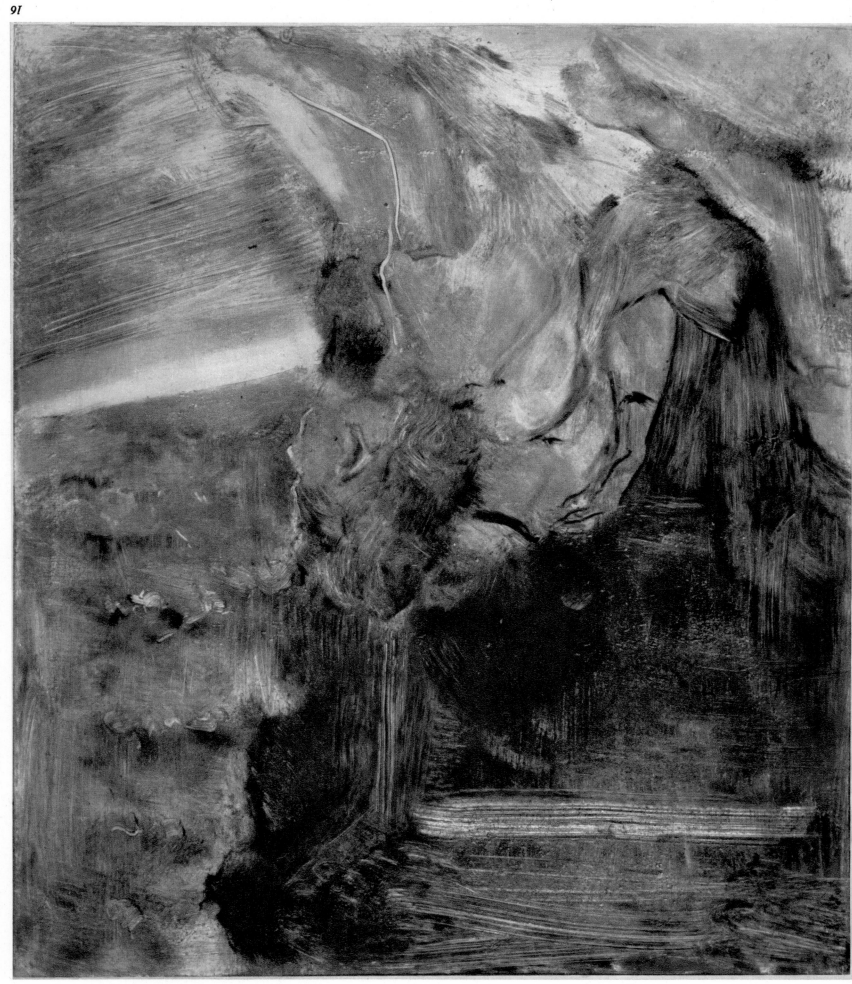

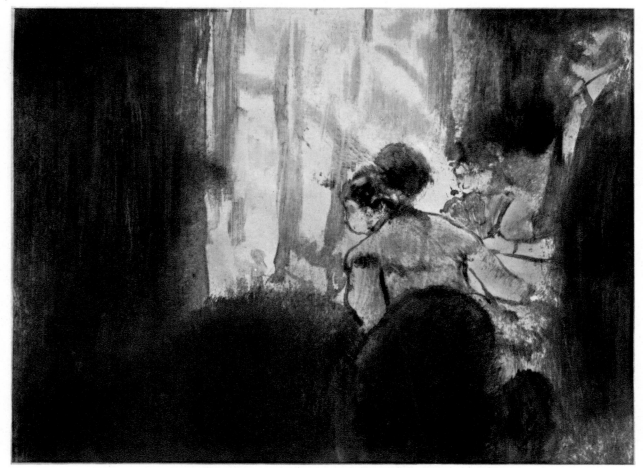

17

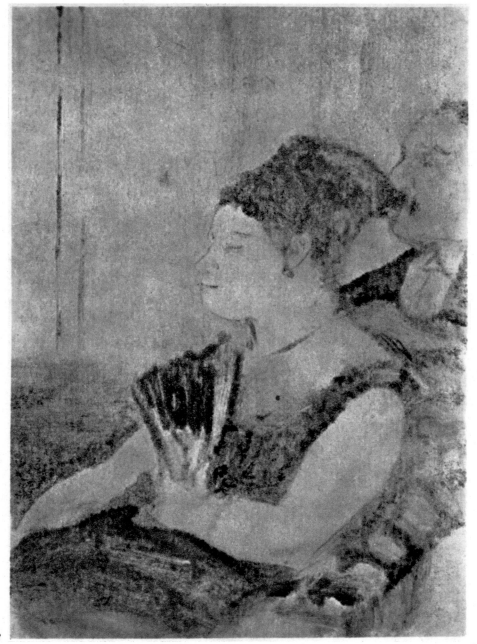

18

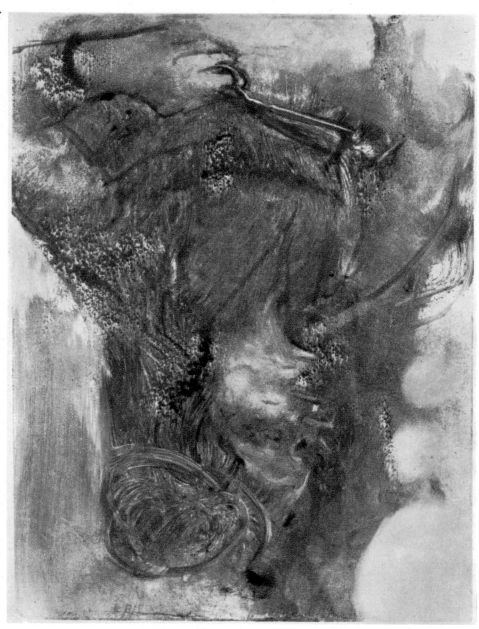

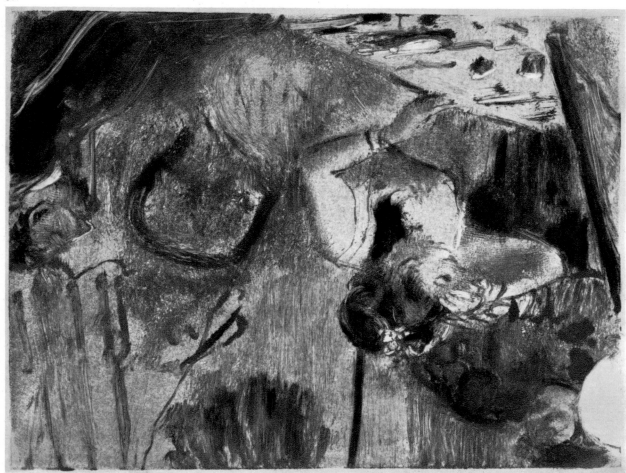

21

22

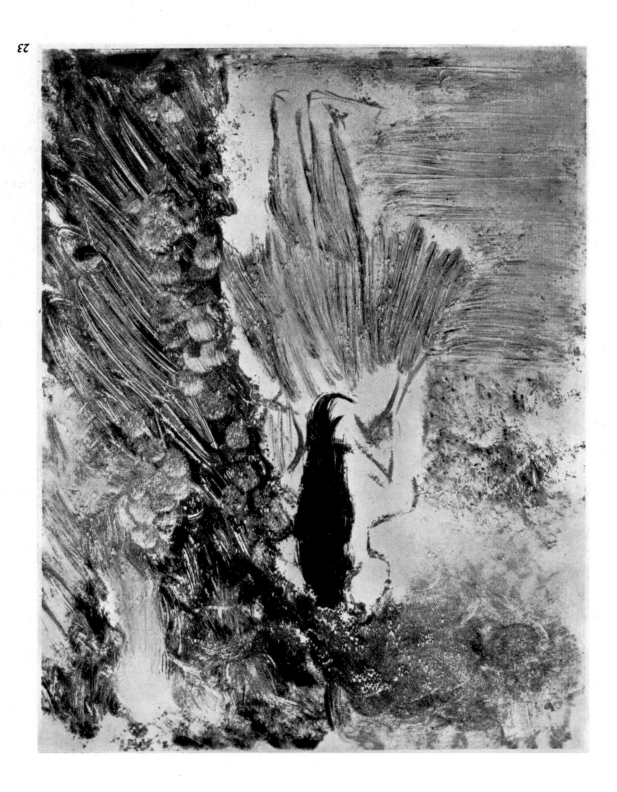

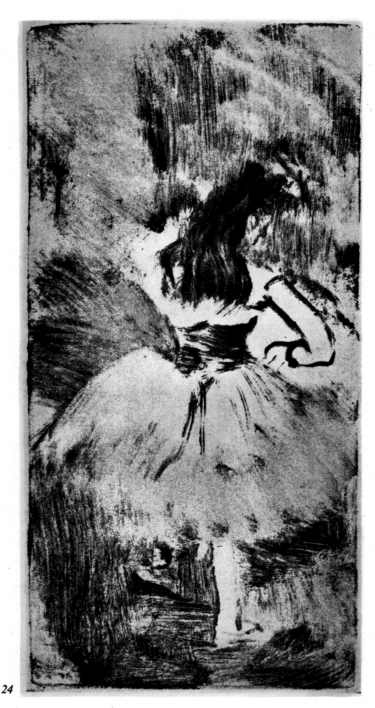

24

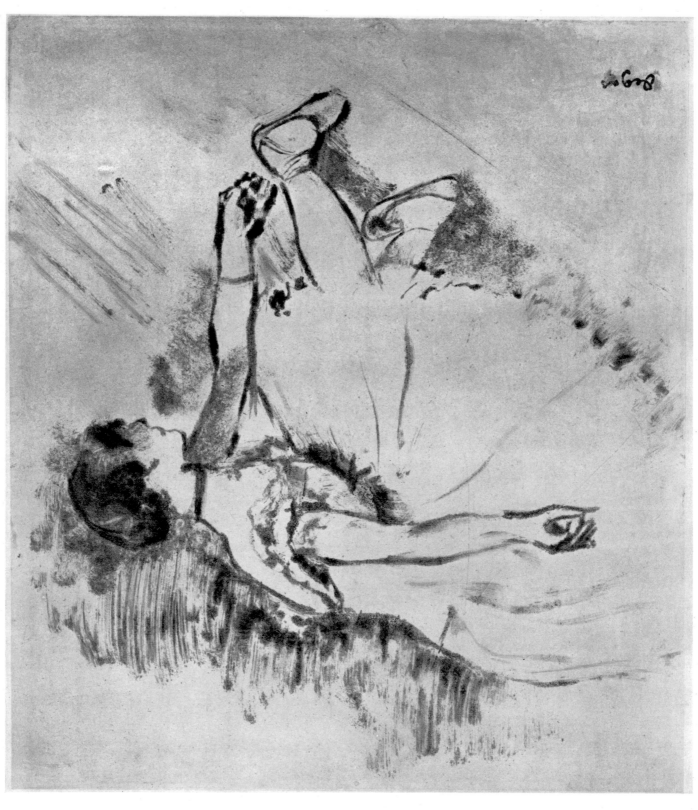

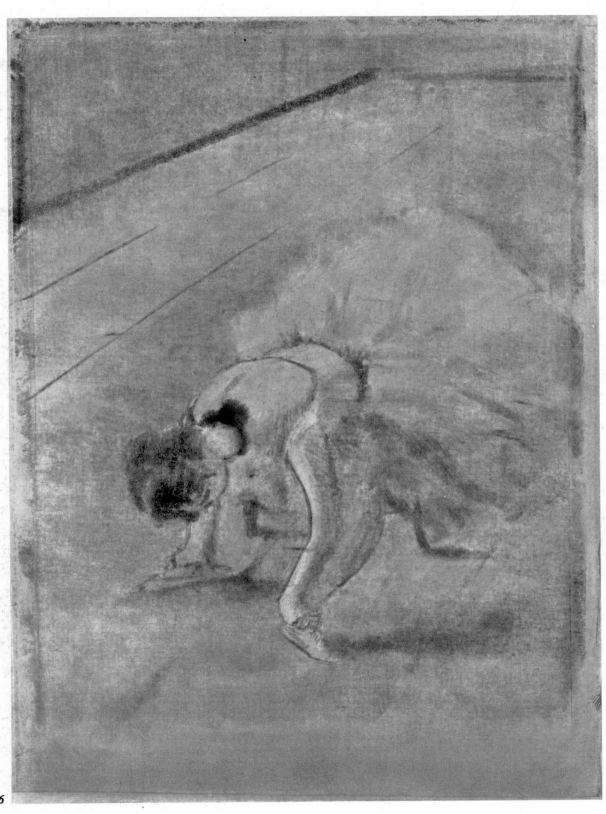

26

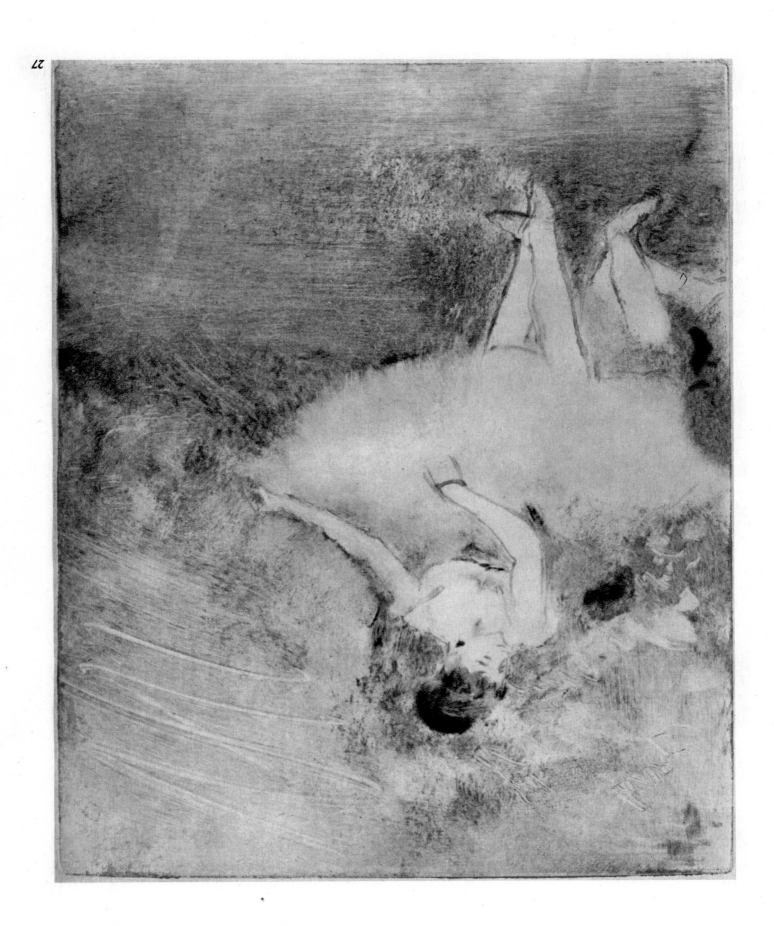

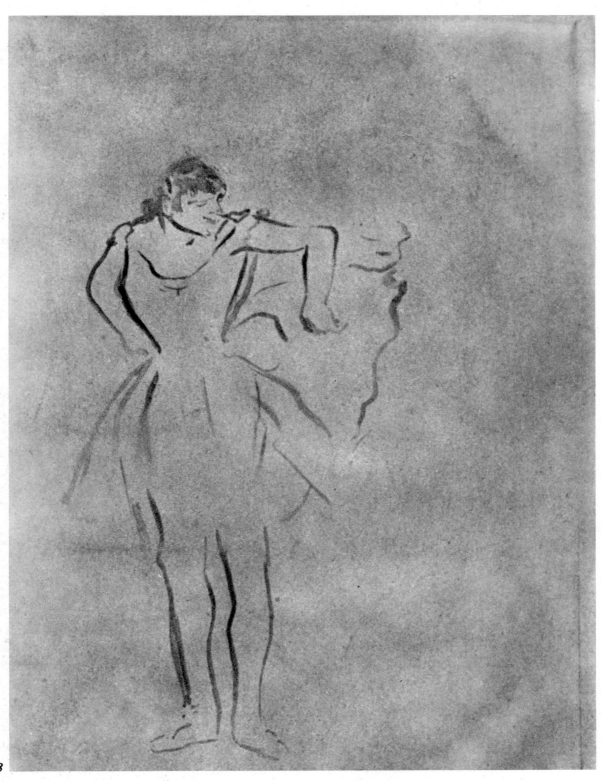

28

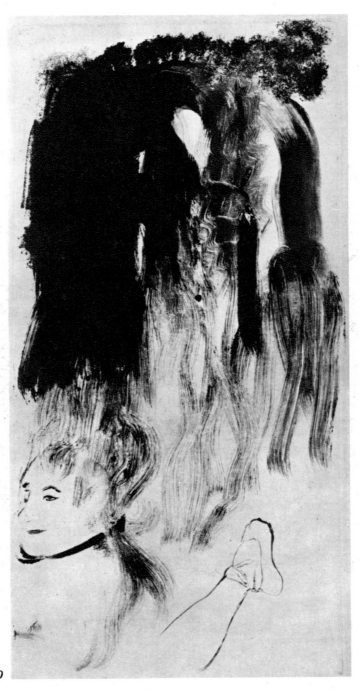

30

32

34

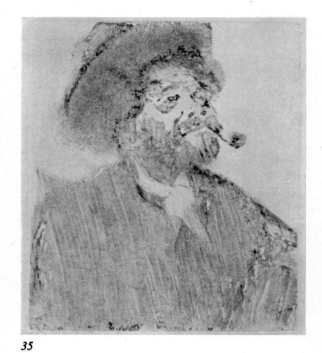

35

36

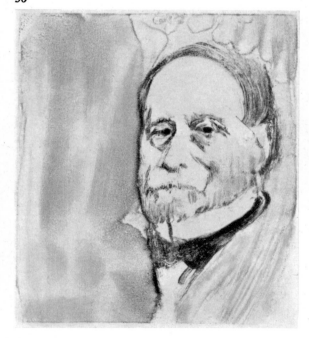

40

39

38

37

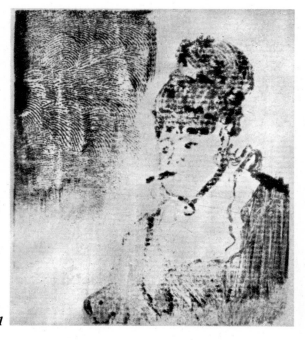

41

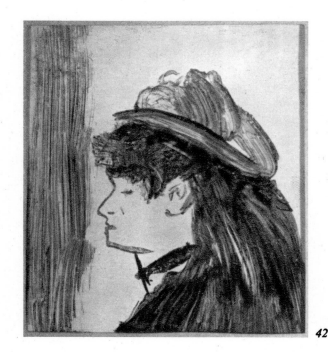

42

43

44

45

46

47

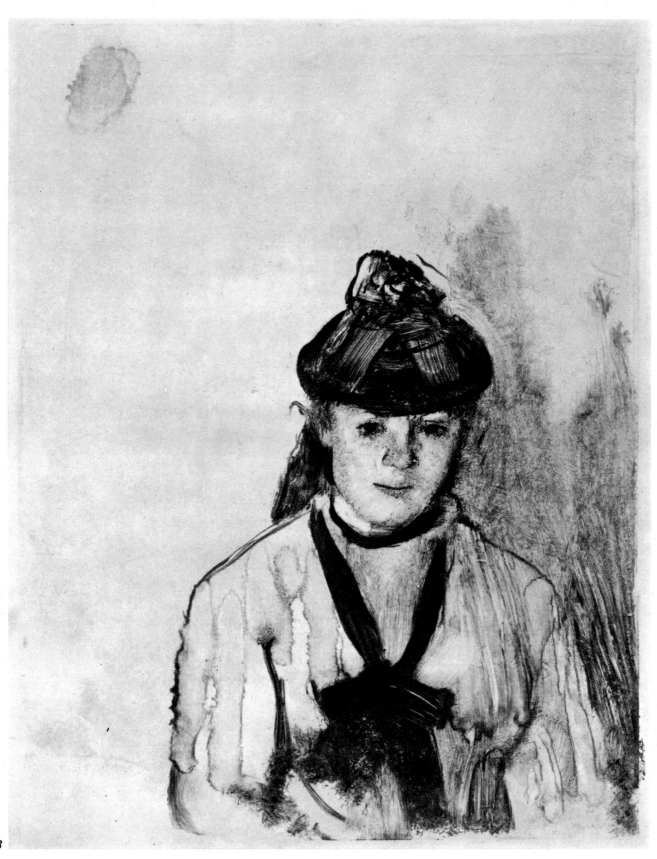

48

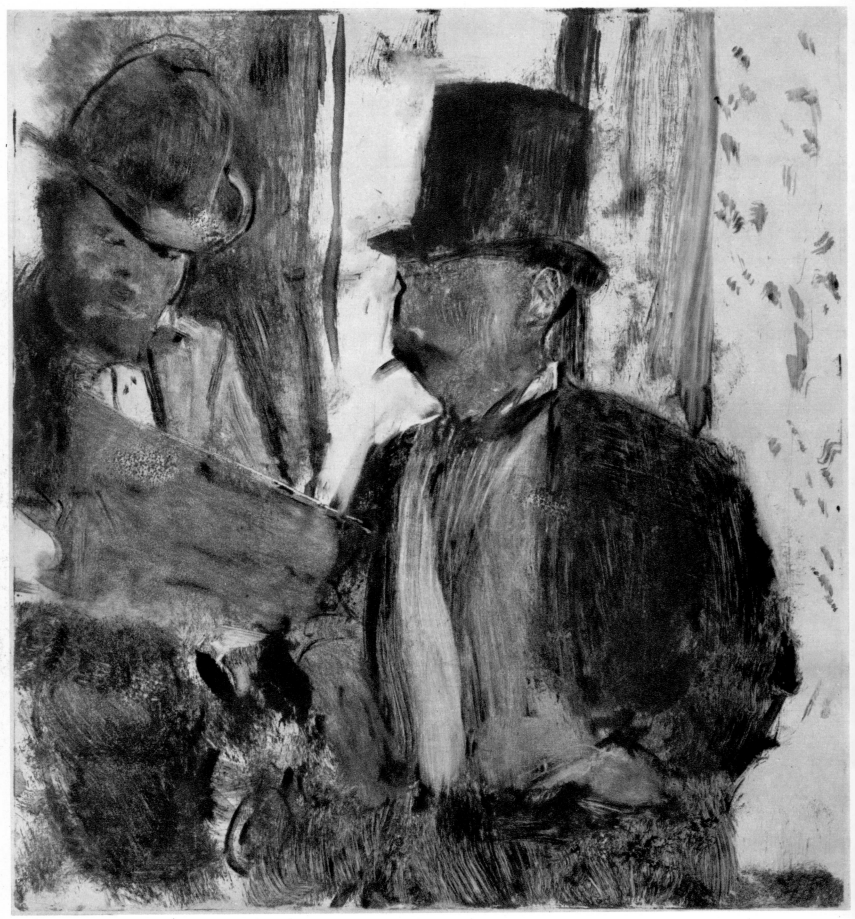

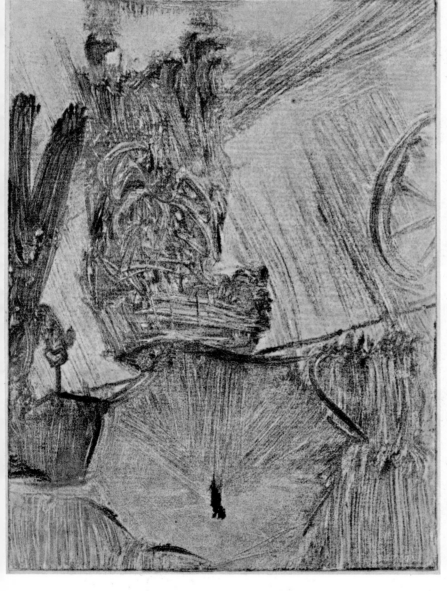

53

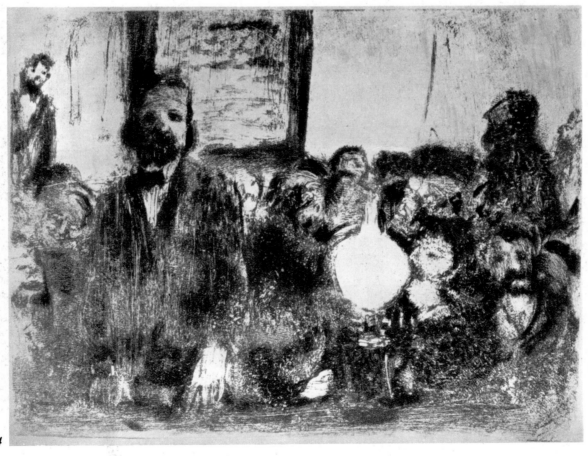

54

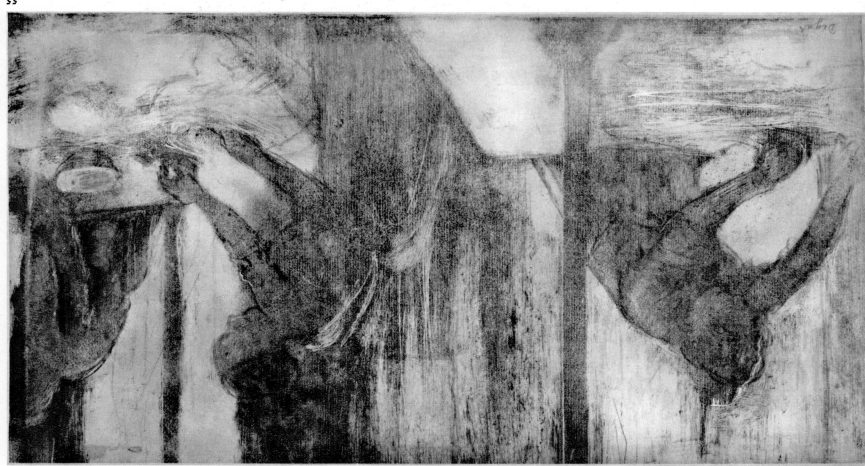

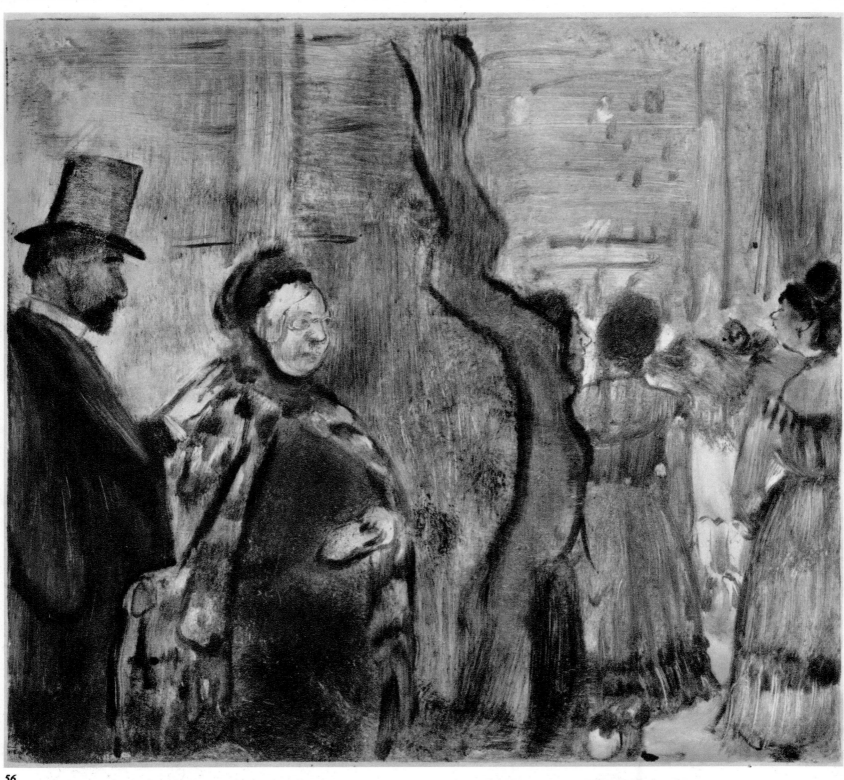

56

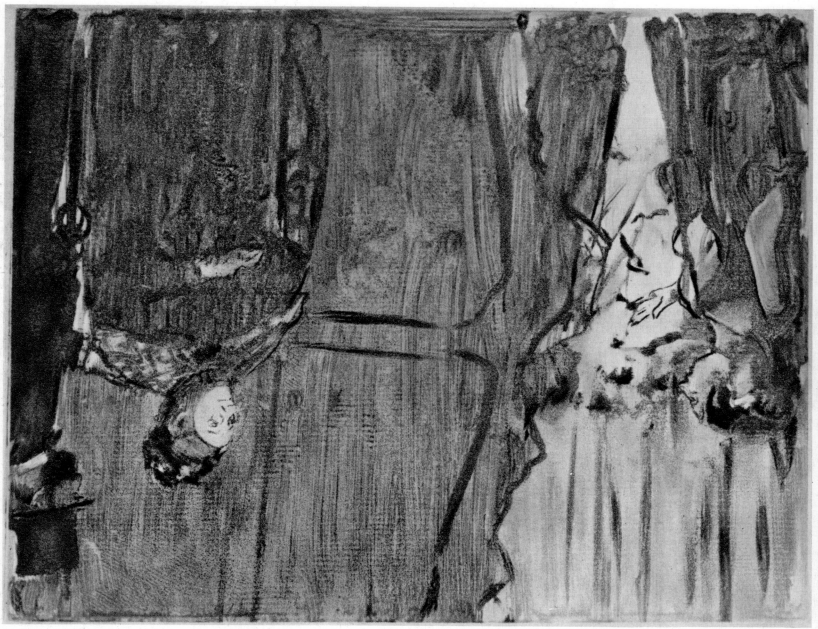

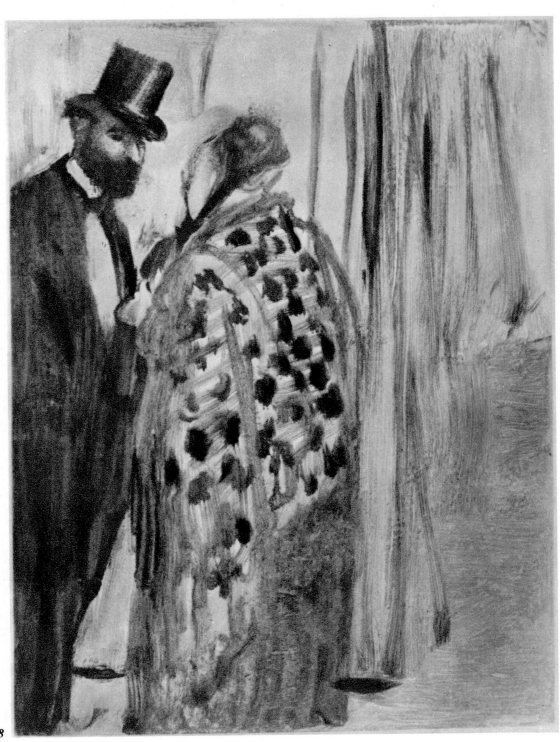

58

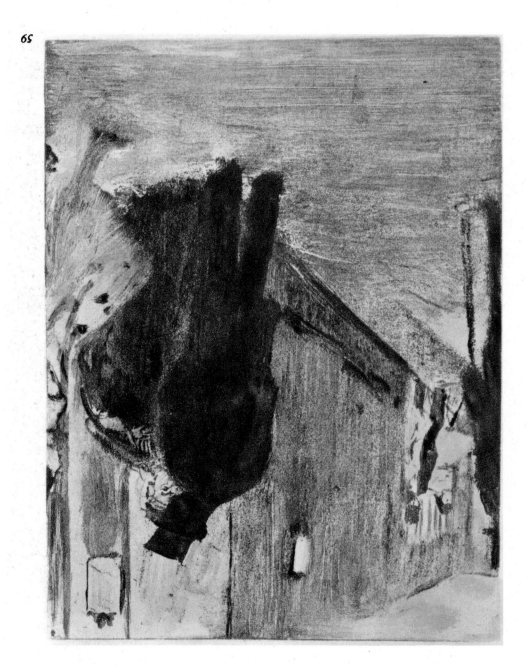

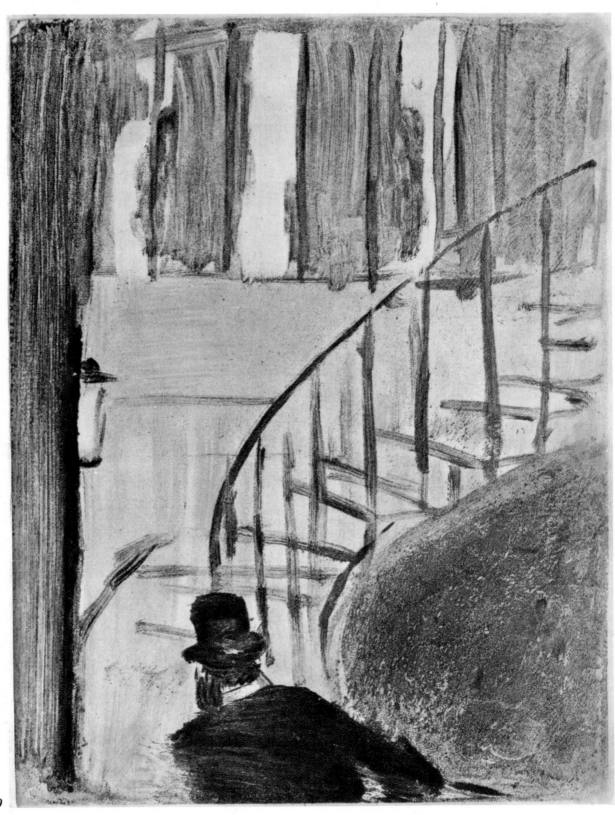

60

19

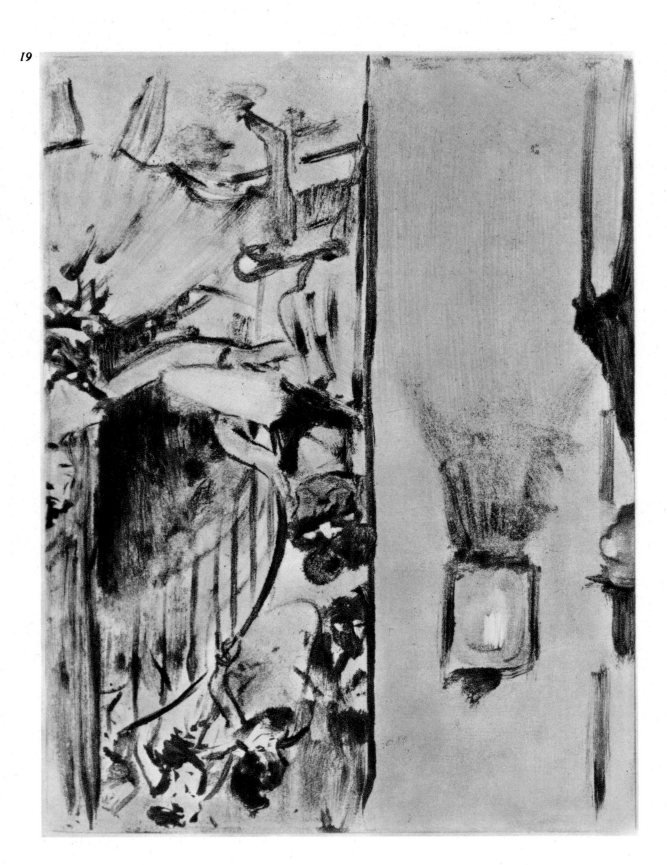

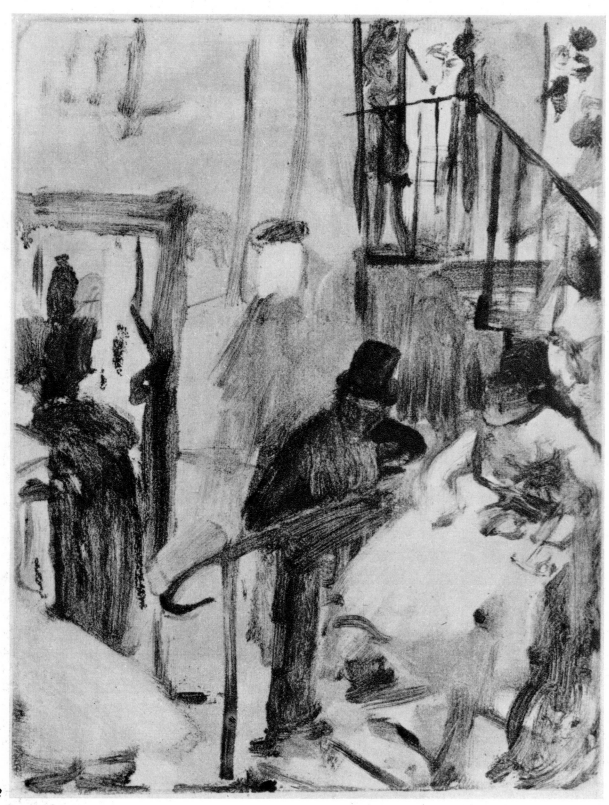

62

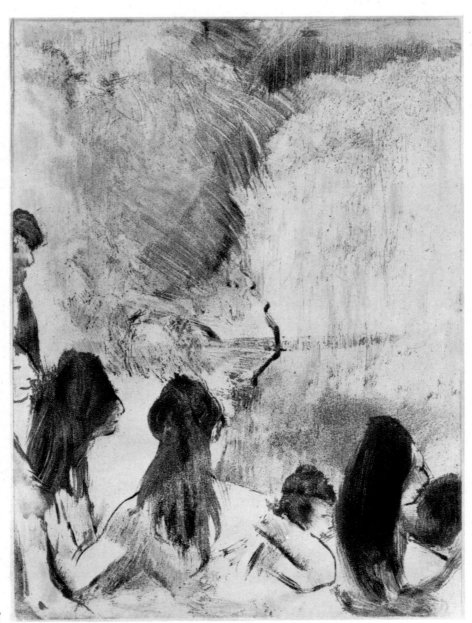

64

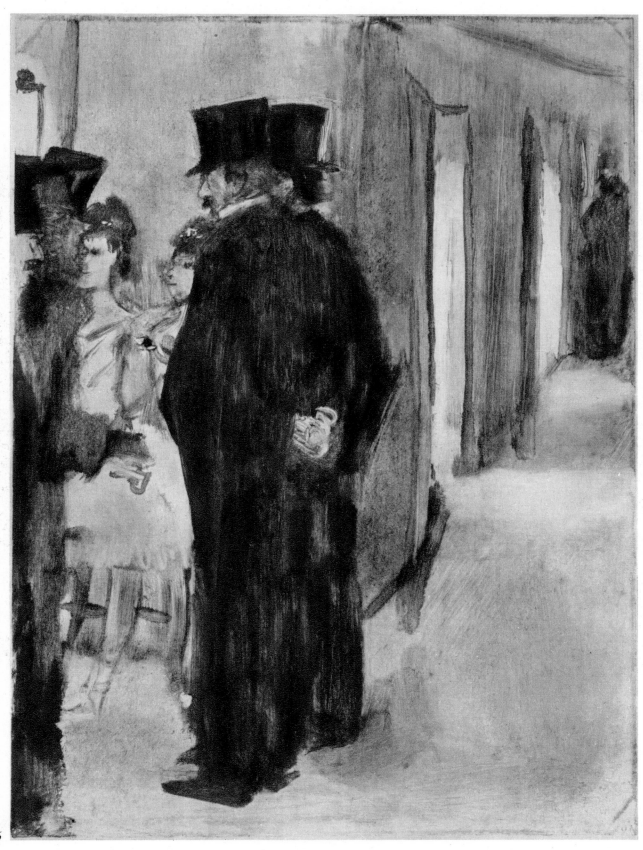

66

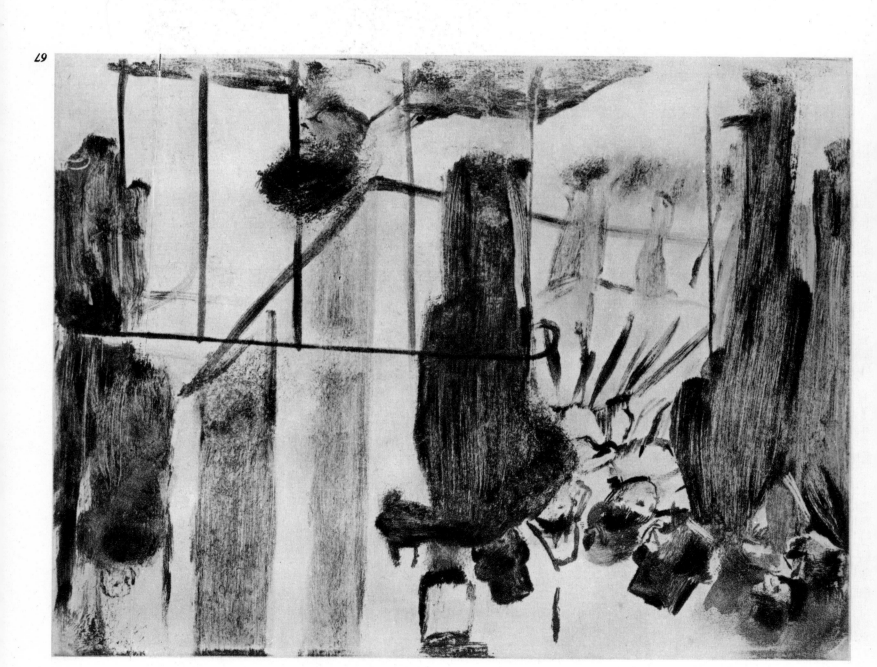

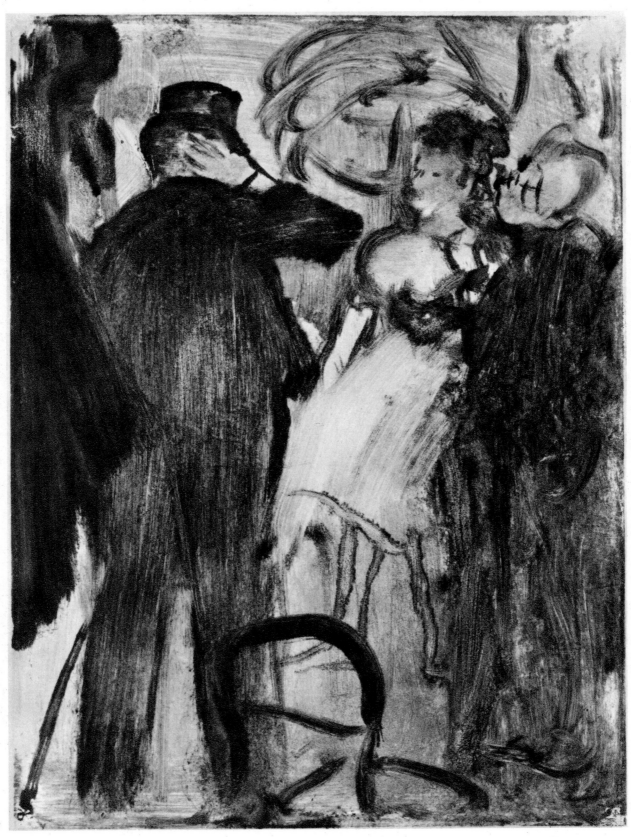

68

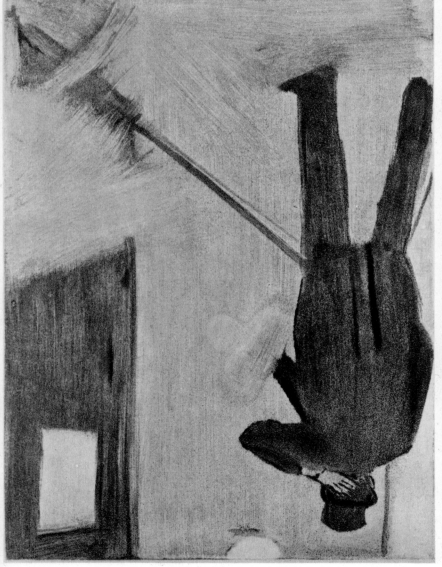

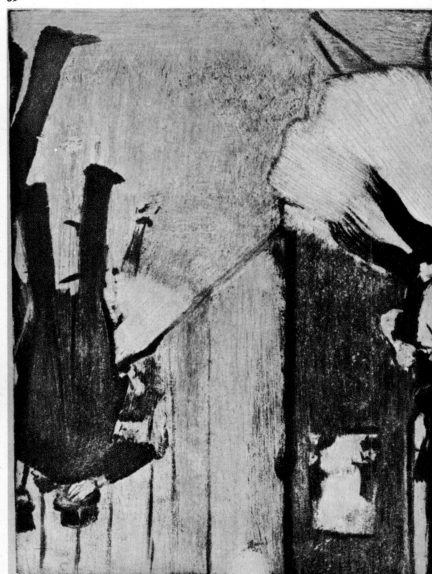

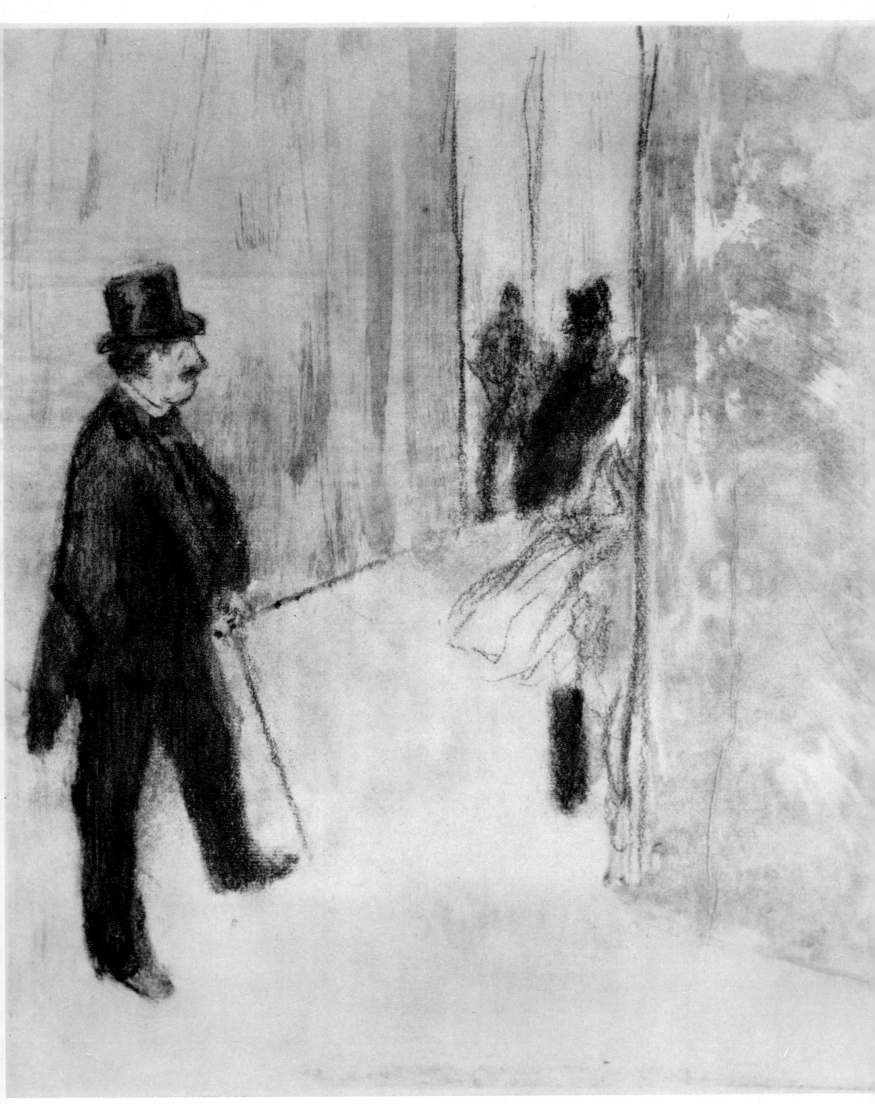

71

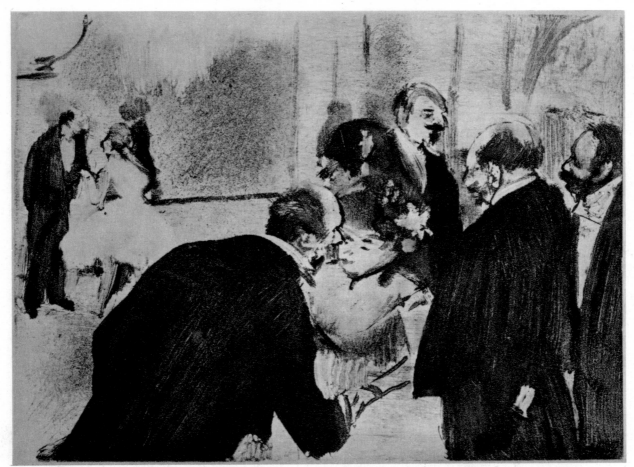

73

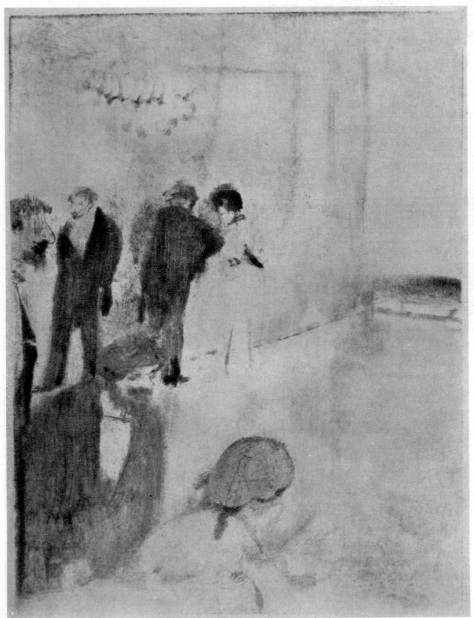

74

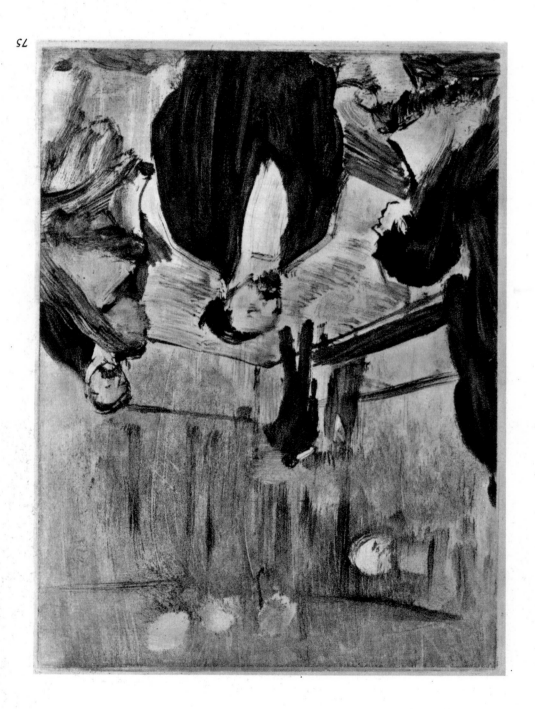

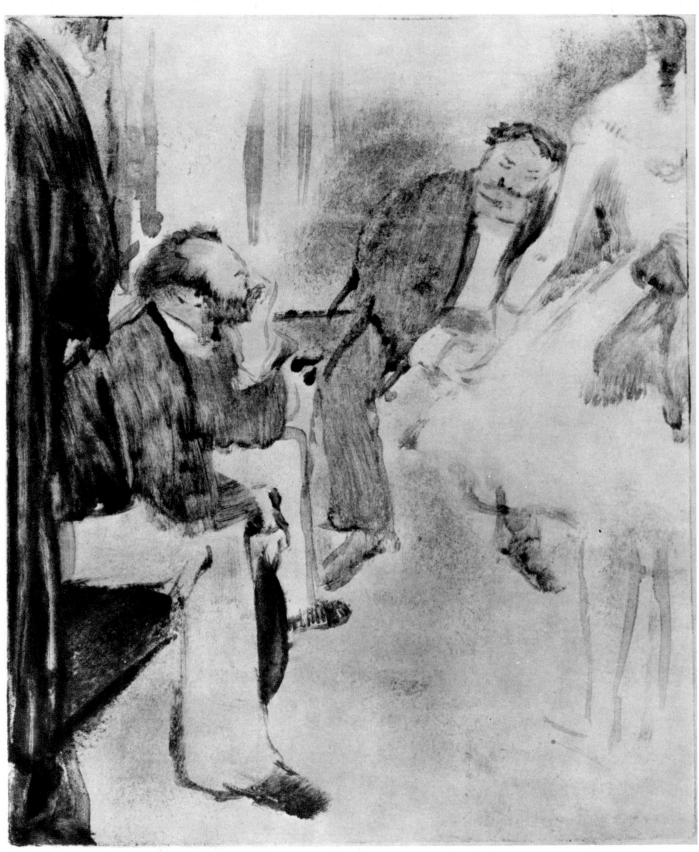

76

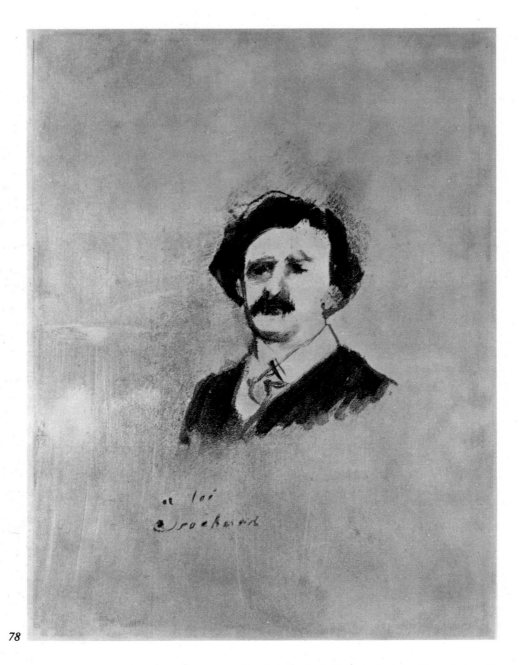

78

79

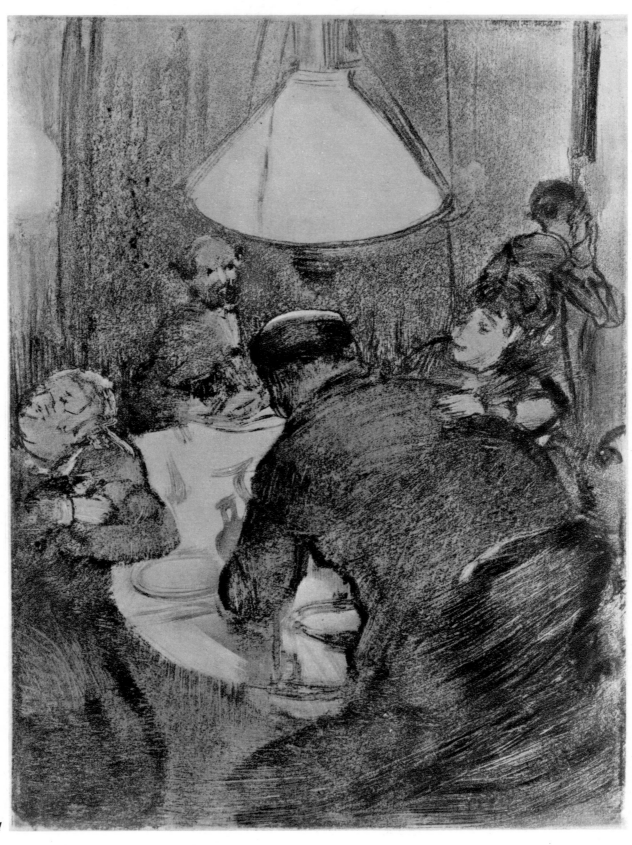

81

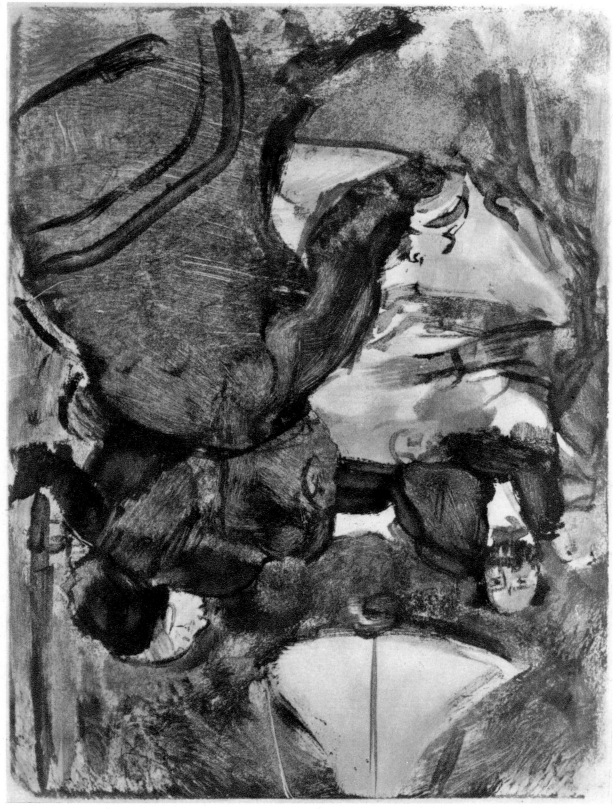

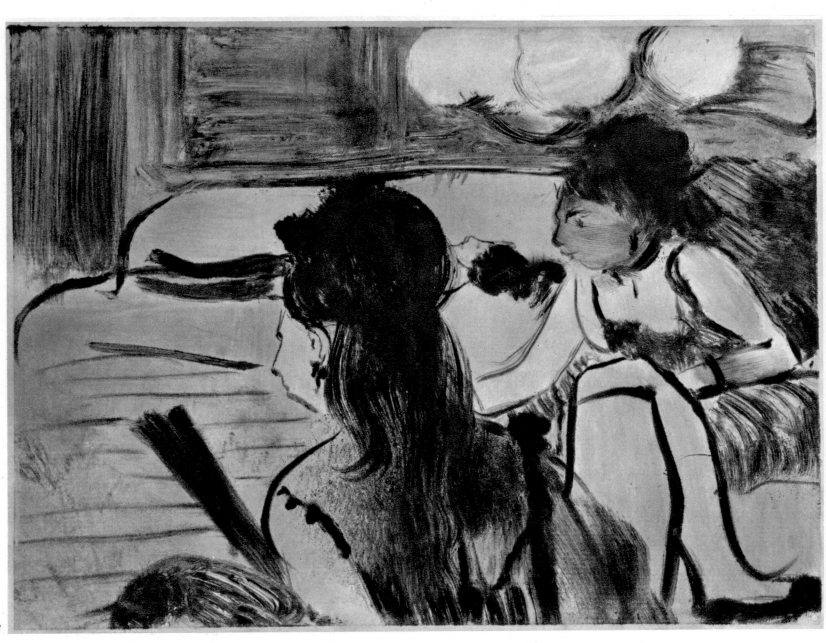

83

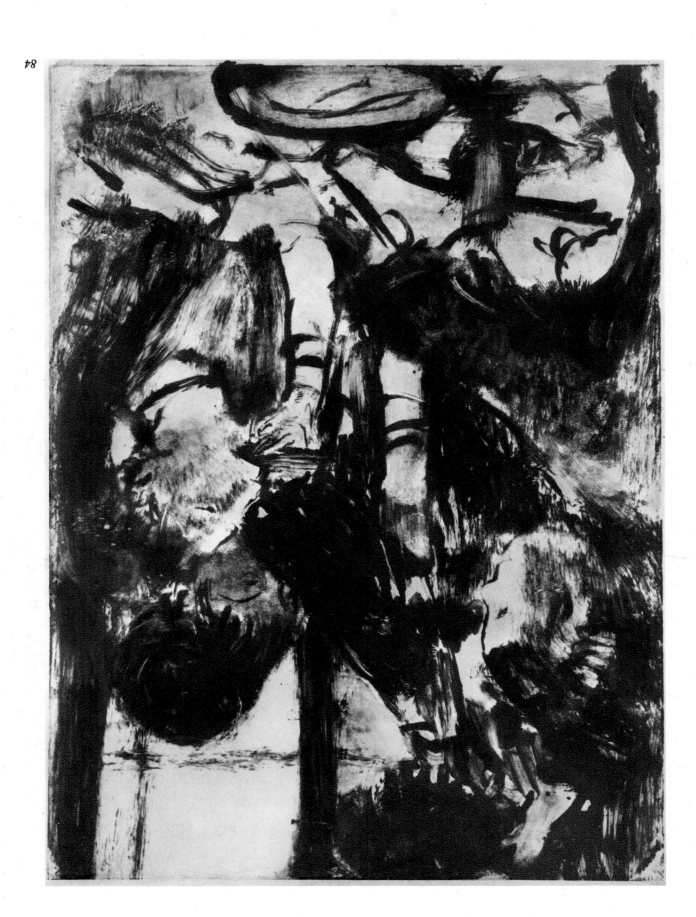

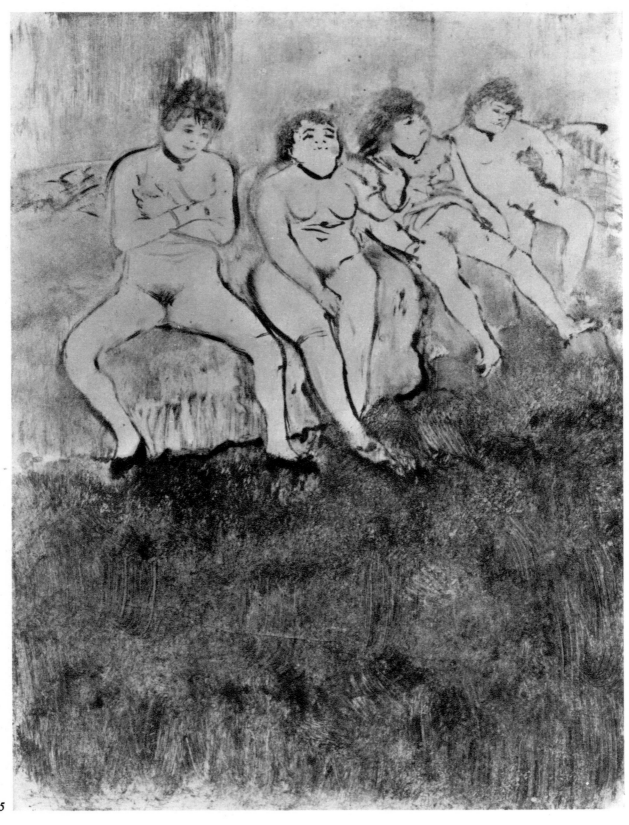

85

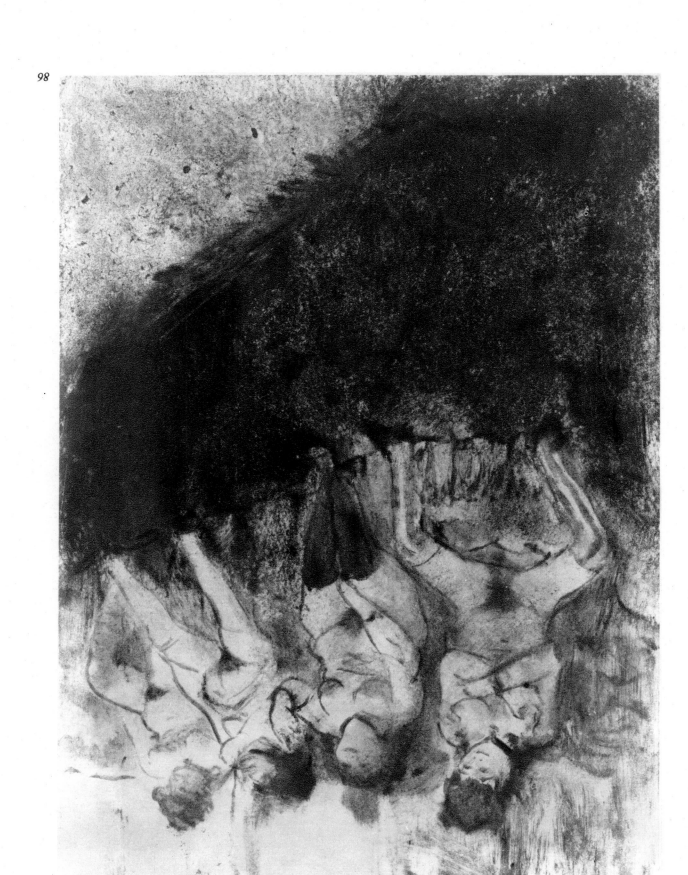

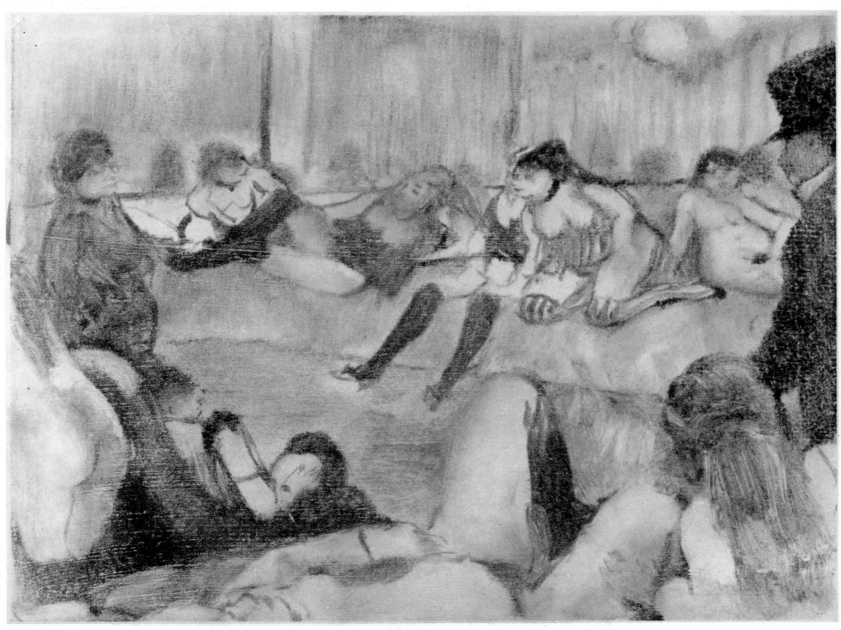

87

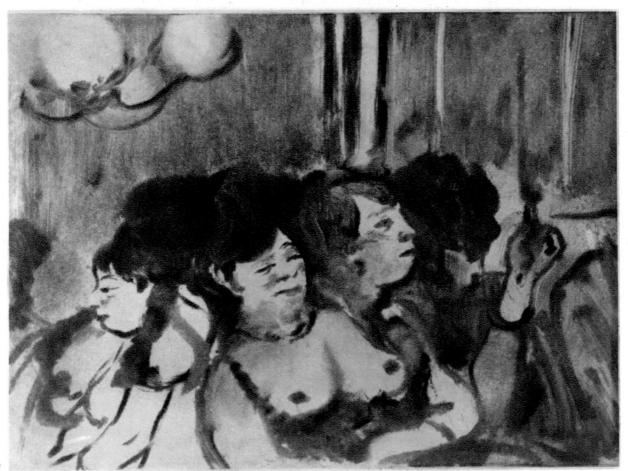

88

90

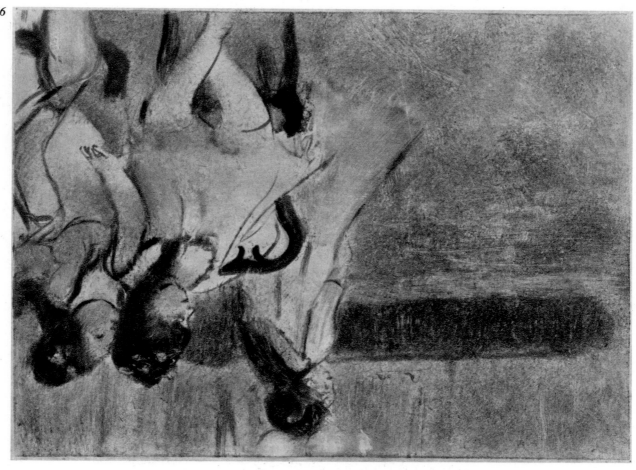

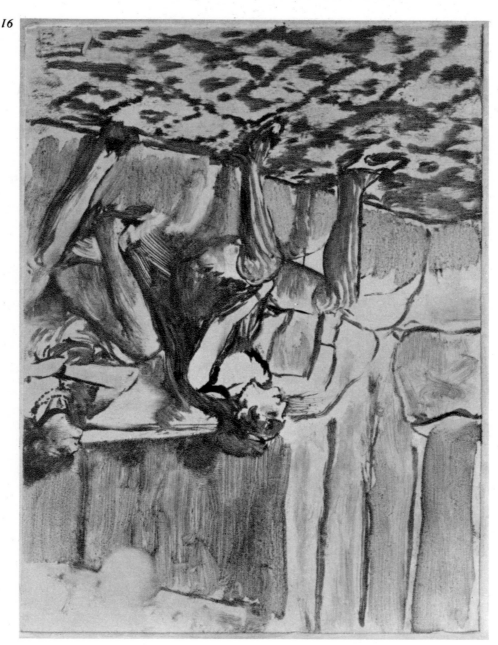

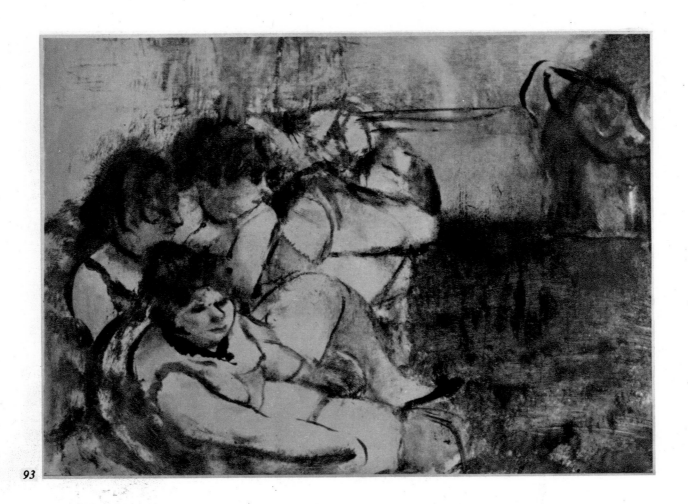

93

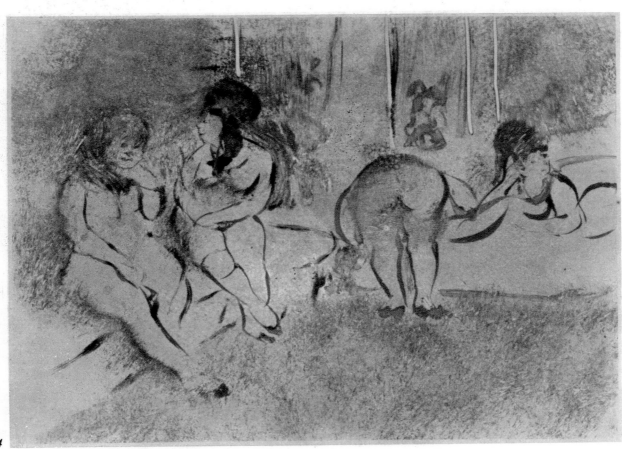

94

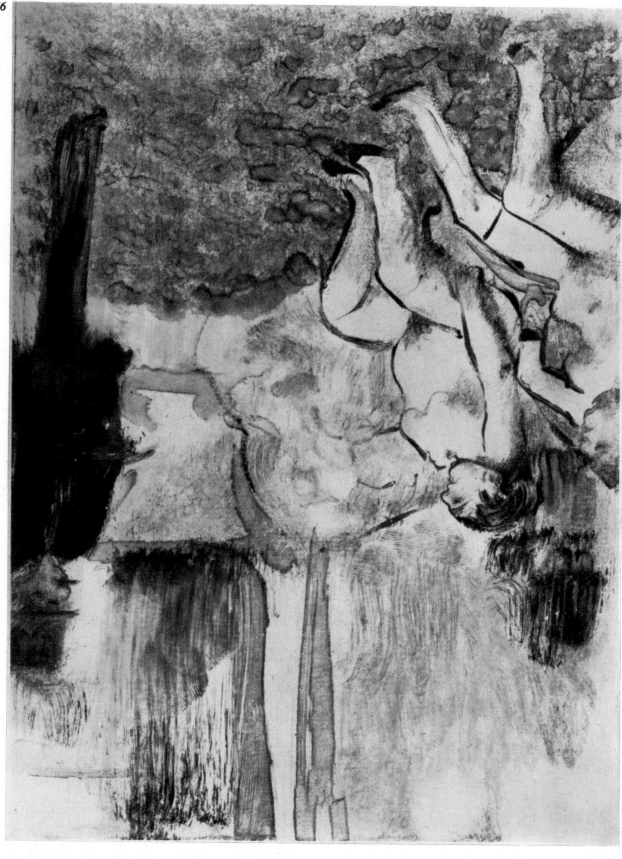

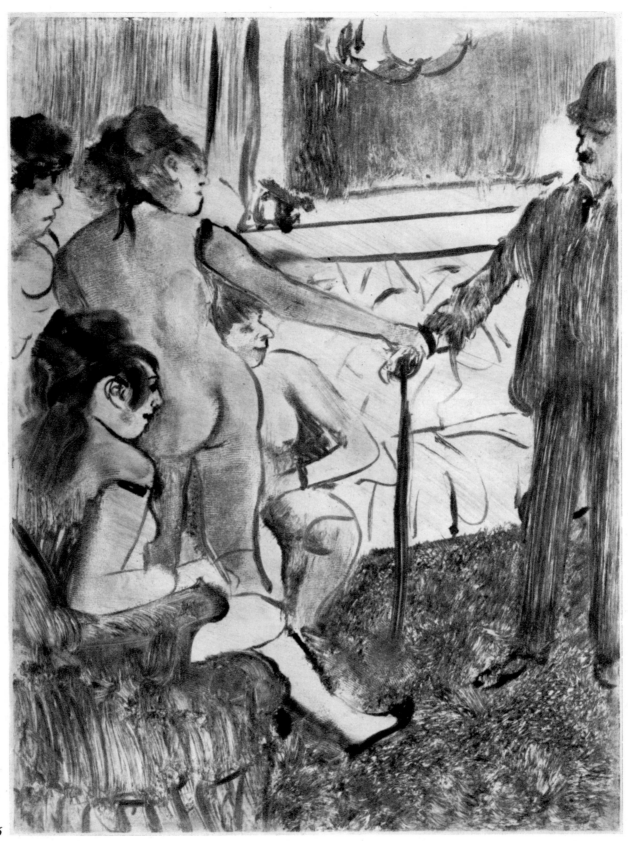

96

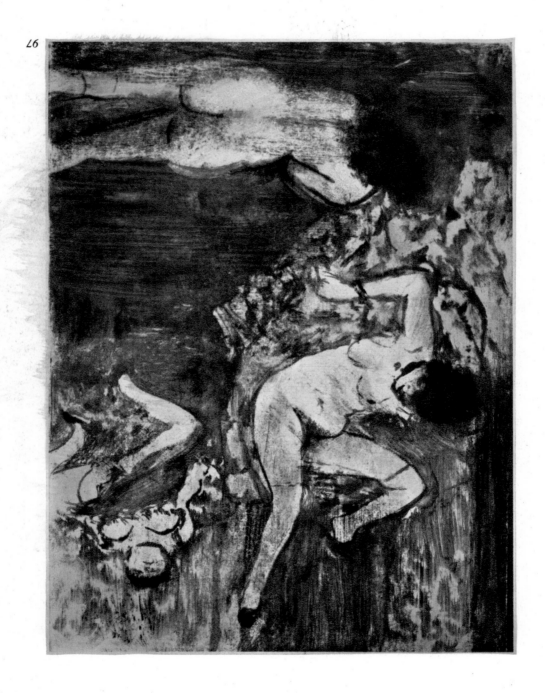

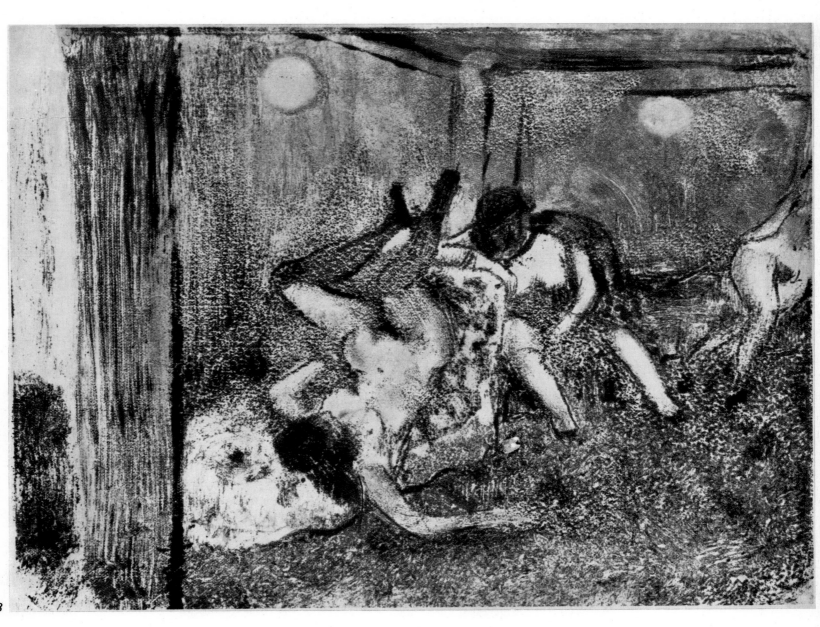

98

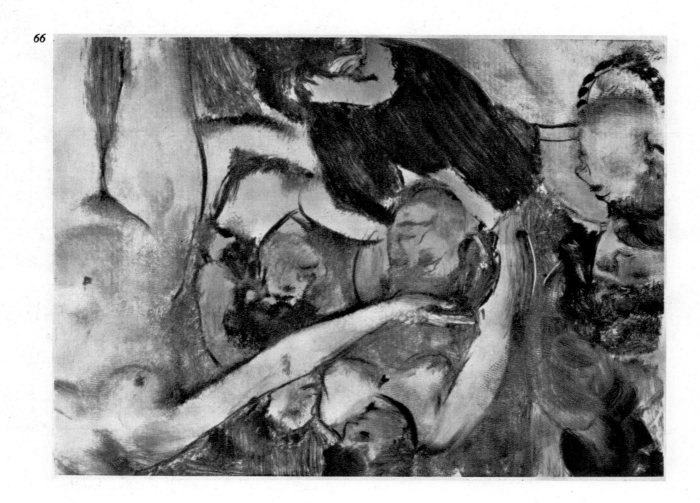

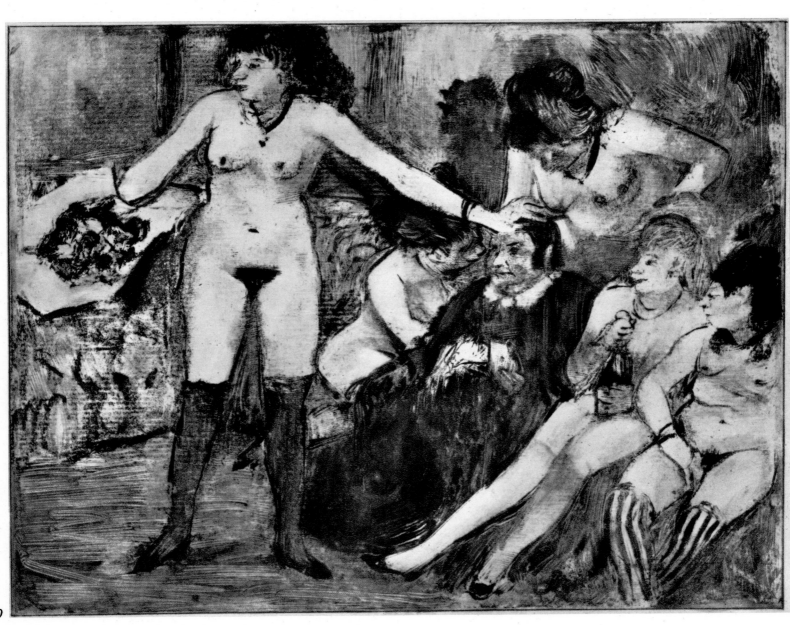

100

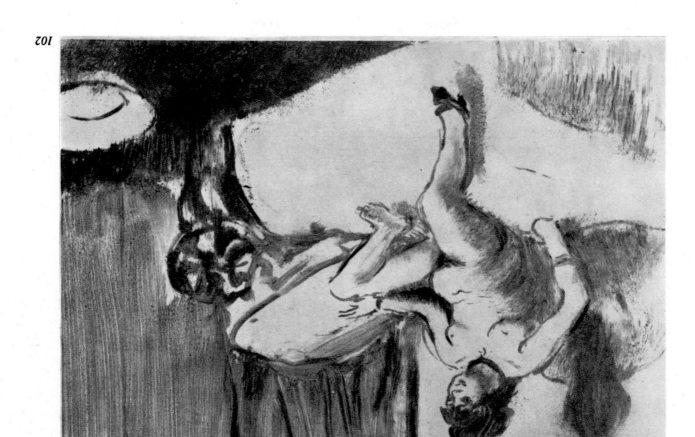

102

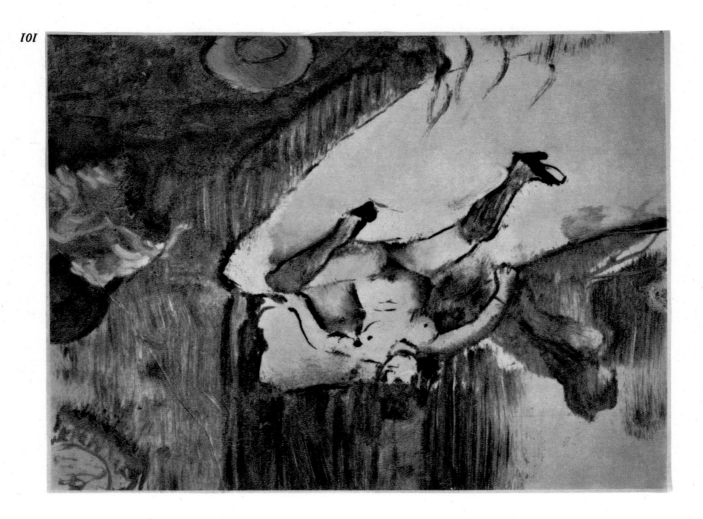

101

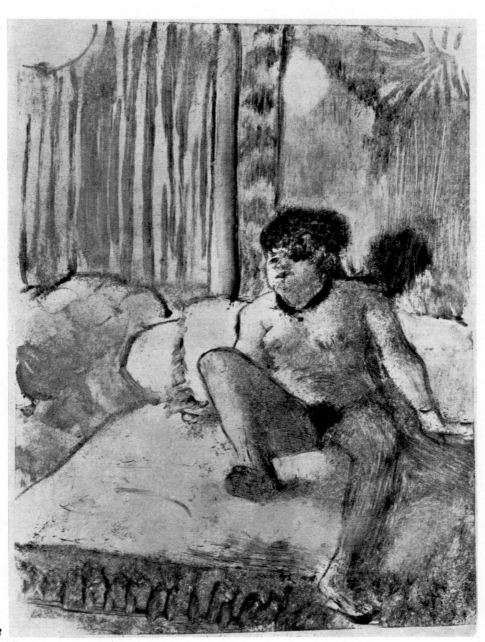

103

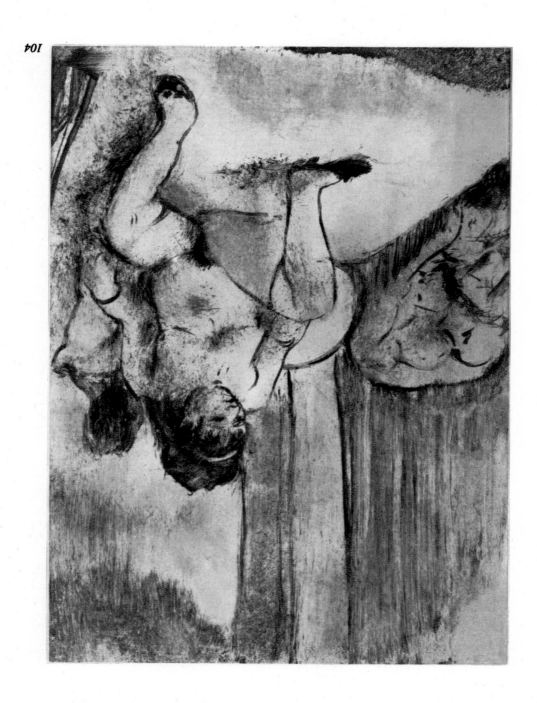

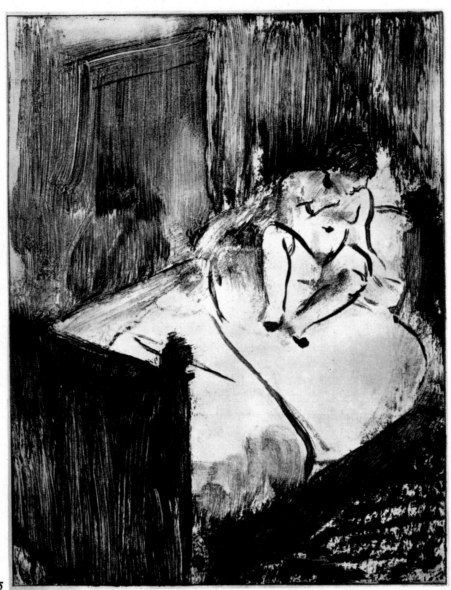

105

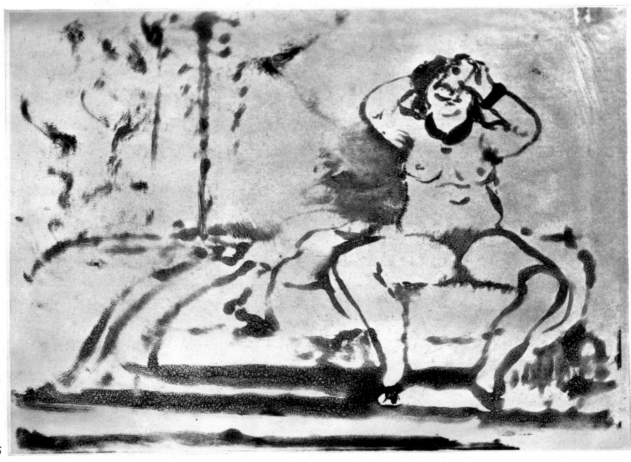

106

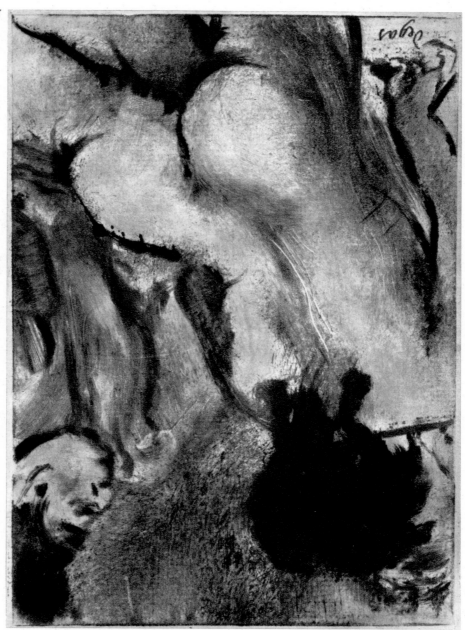

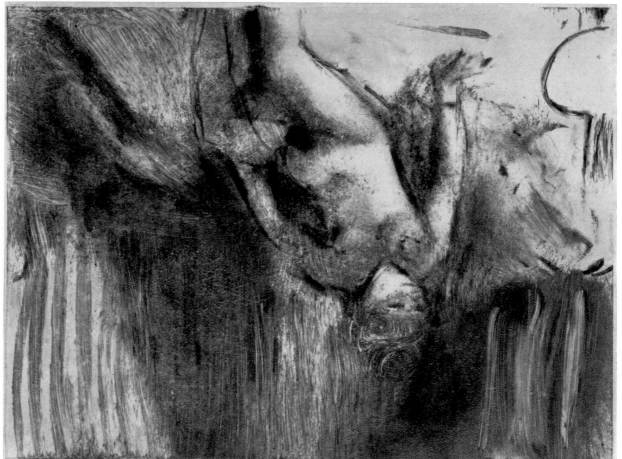

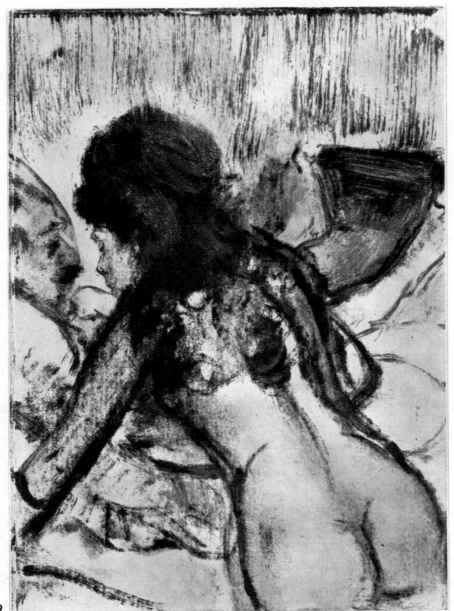

109

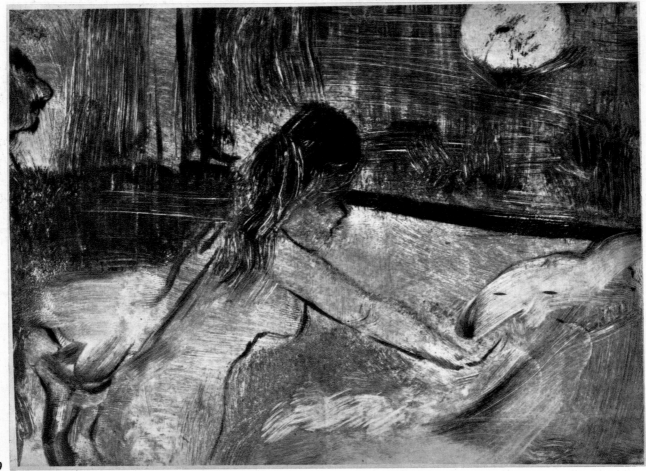

110

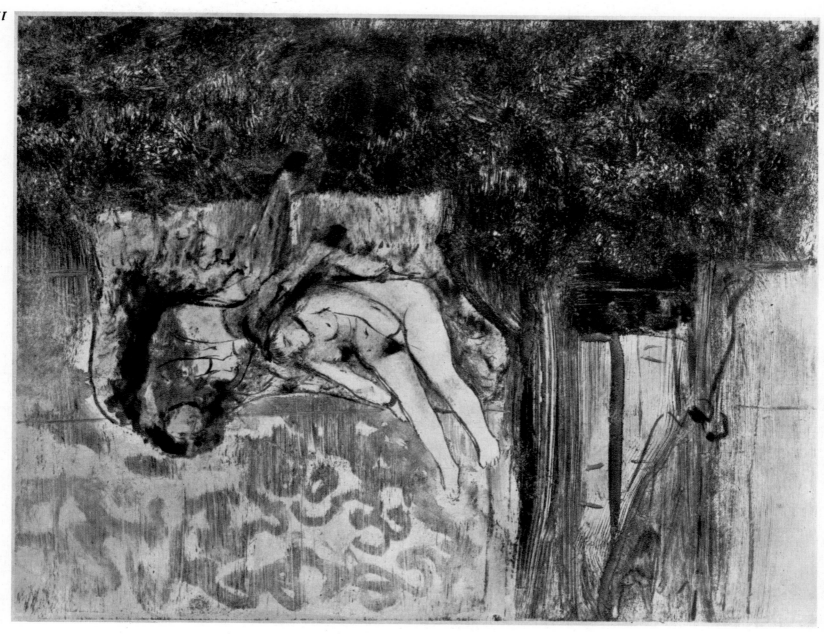

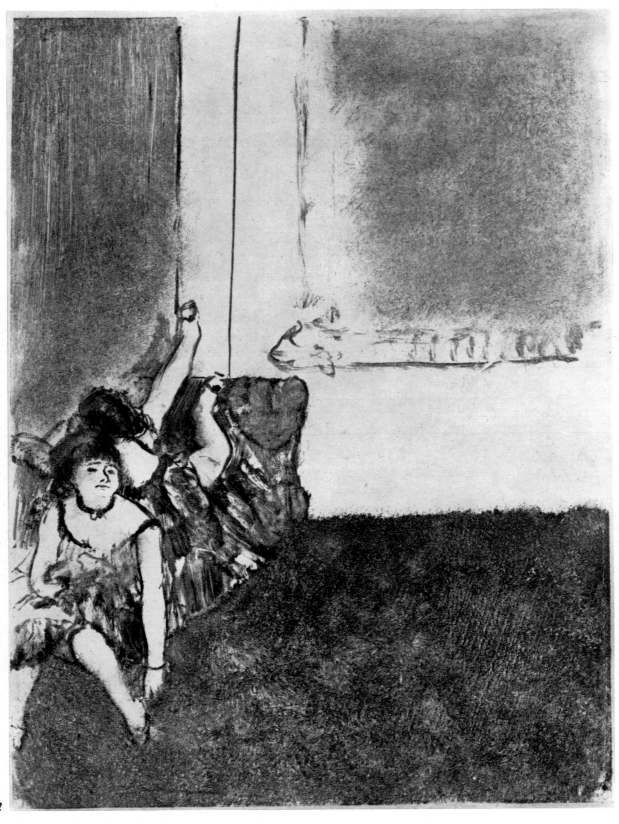

112

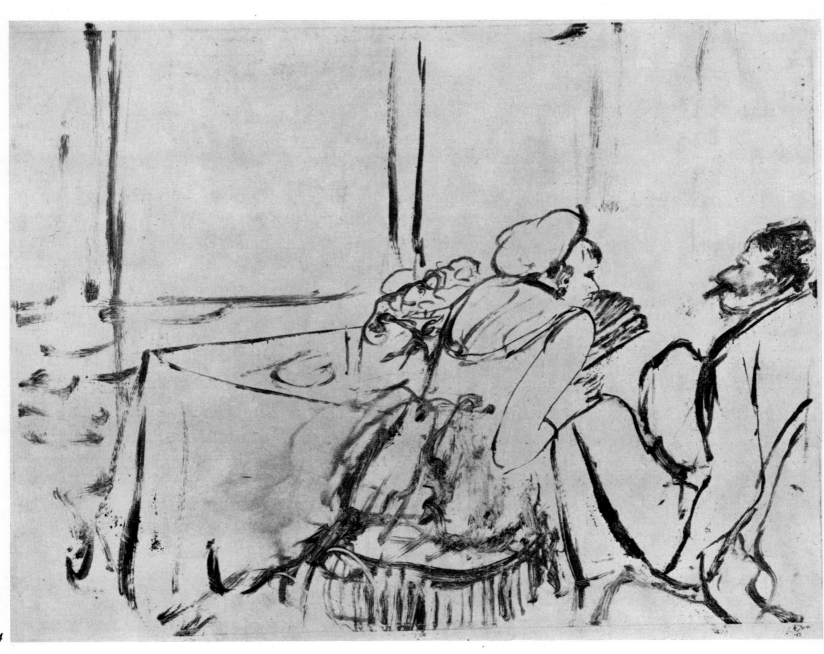

114

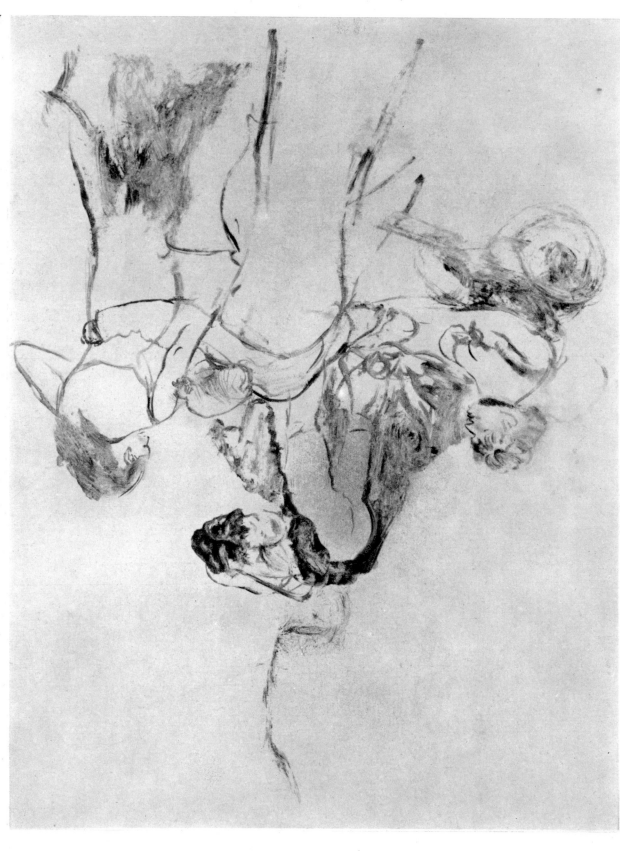

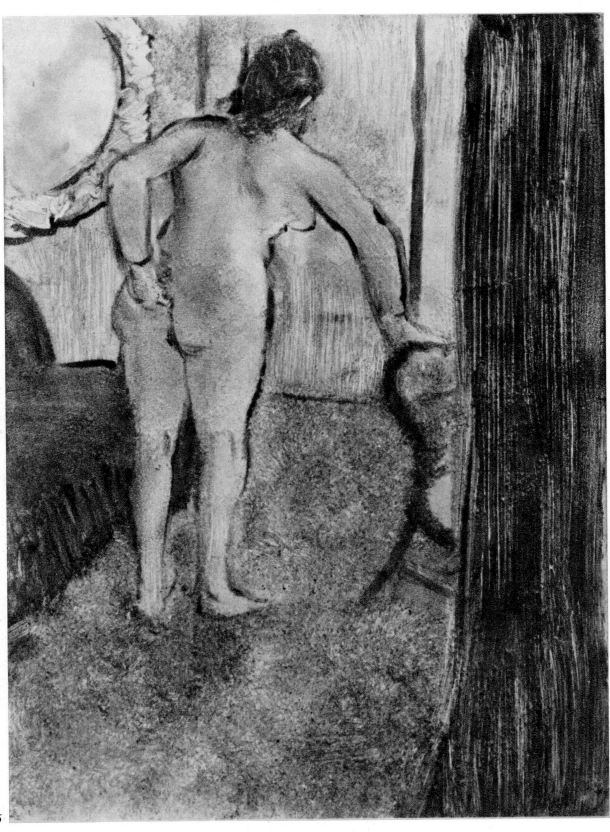

116

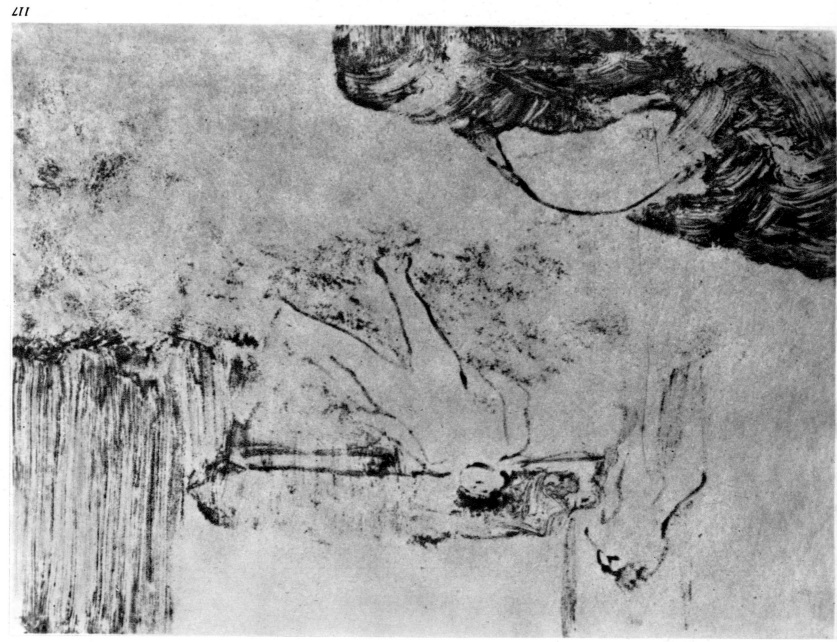

118

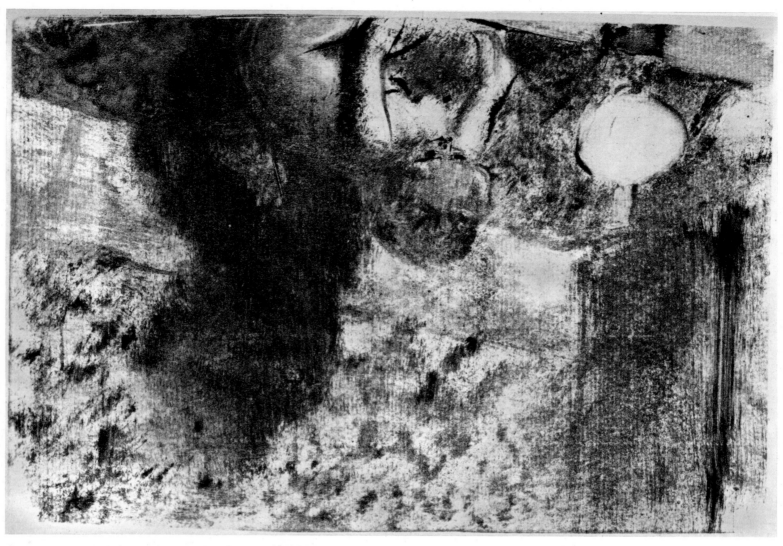

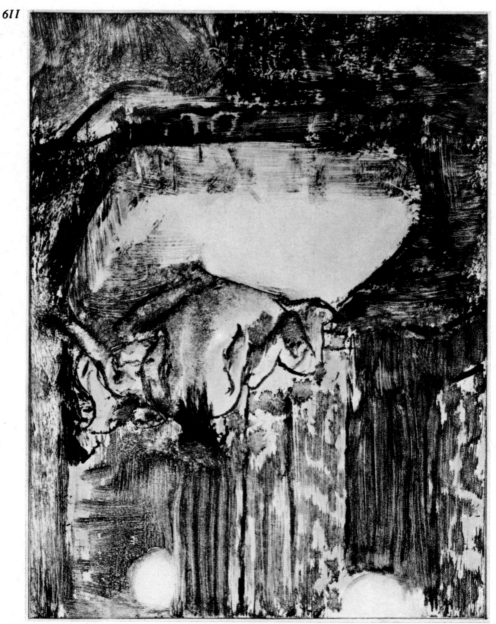

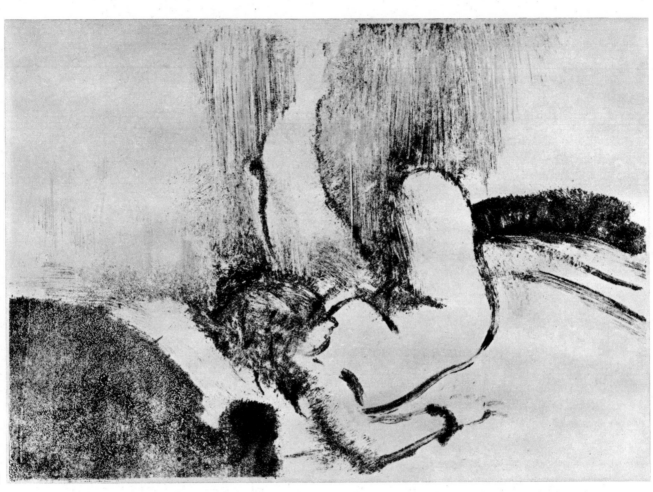

121

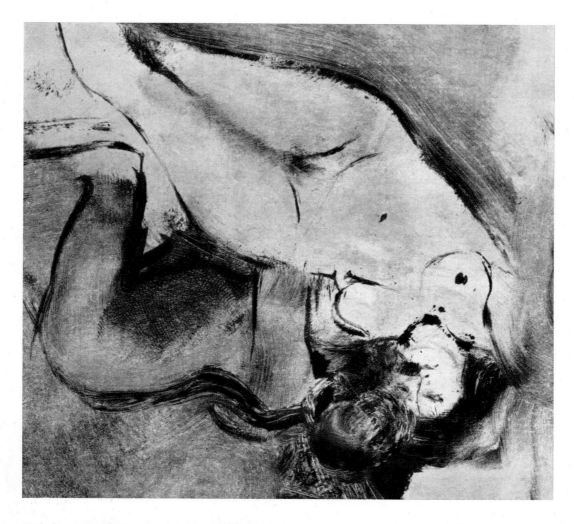

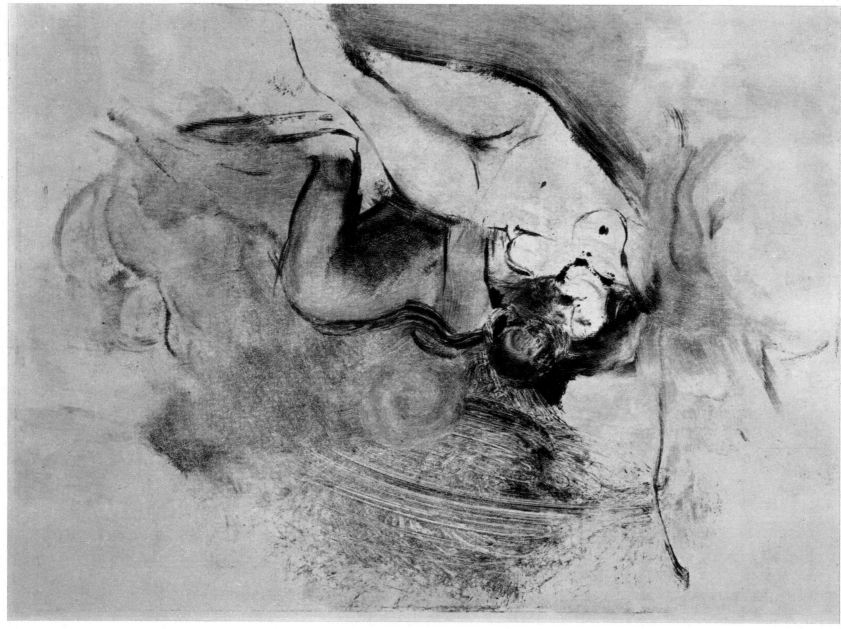

123

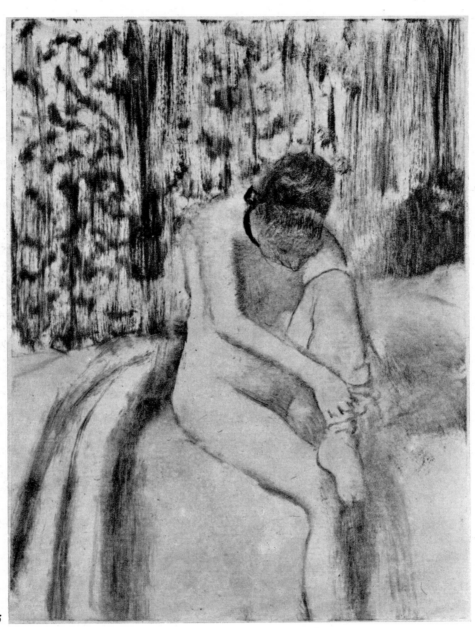

125

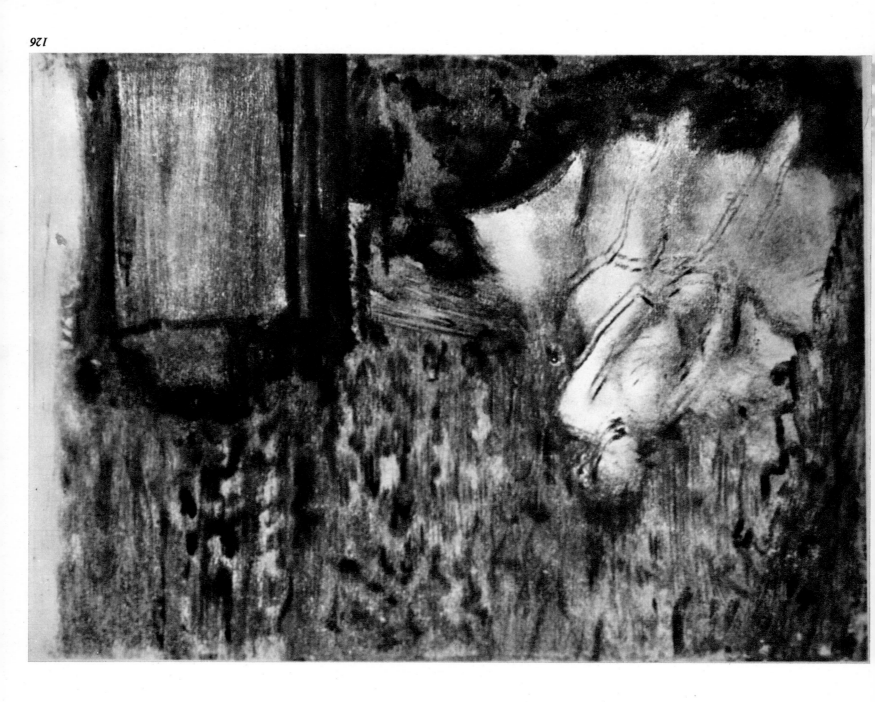

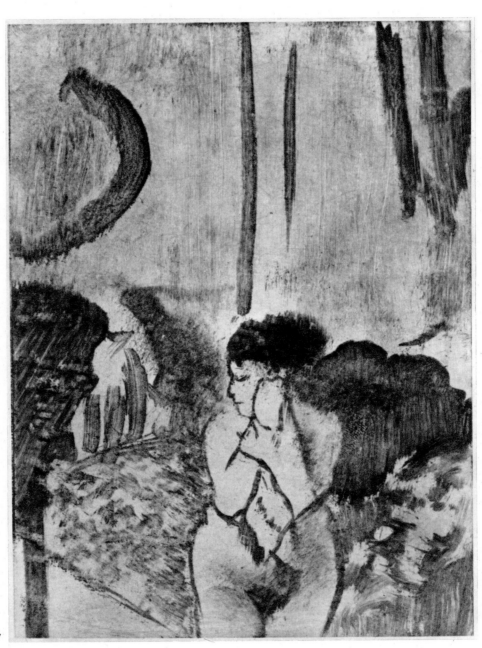

127

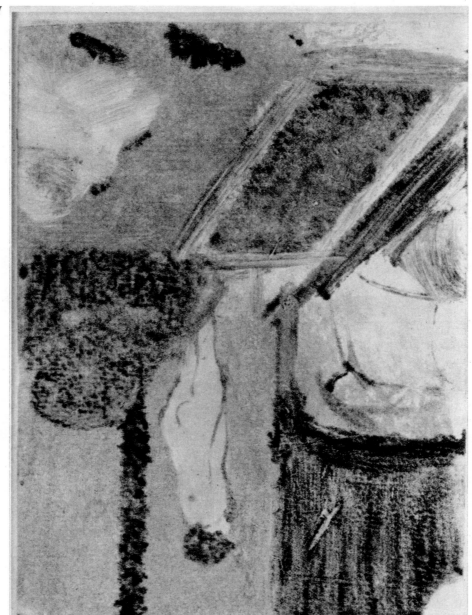

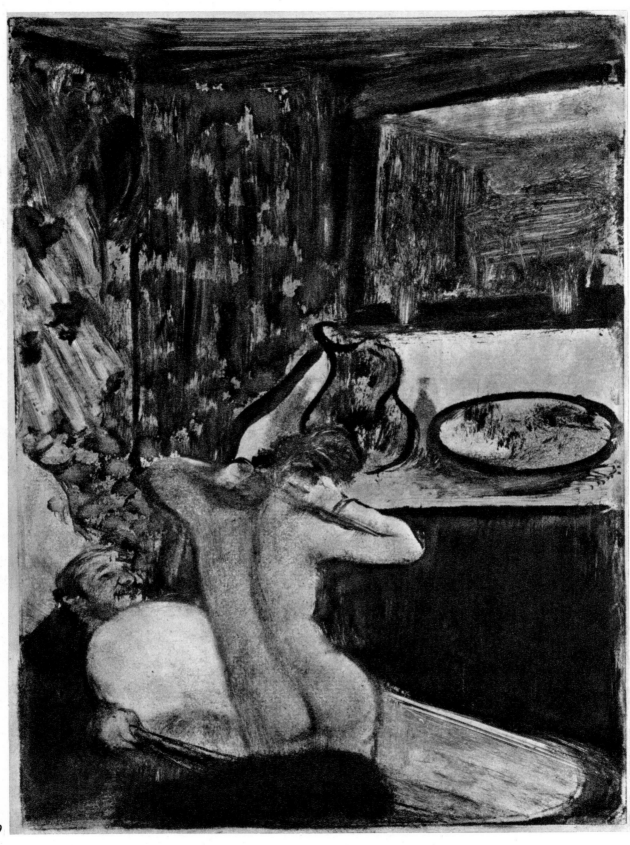

129

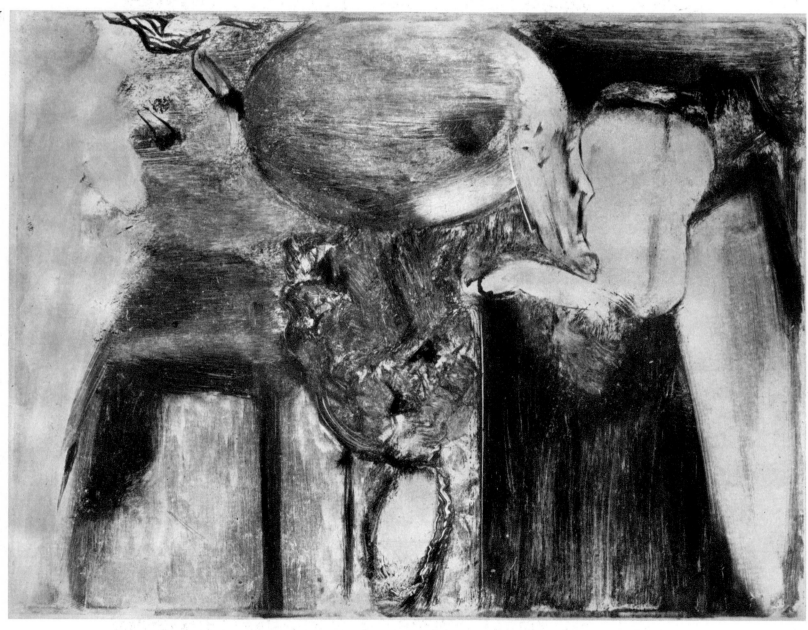

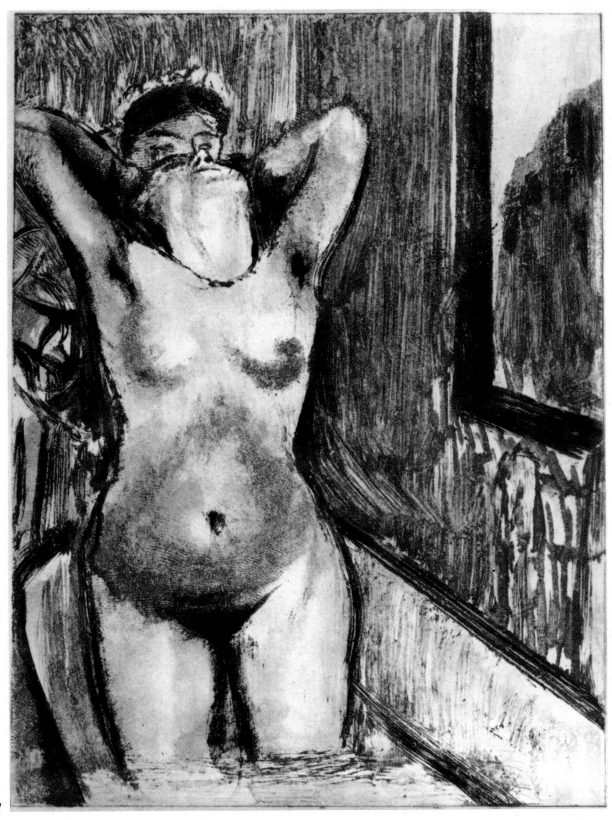

131

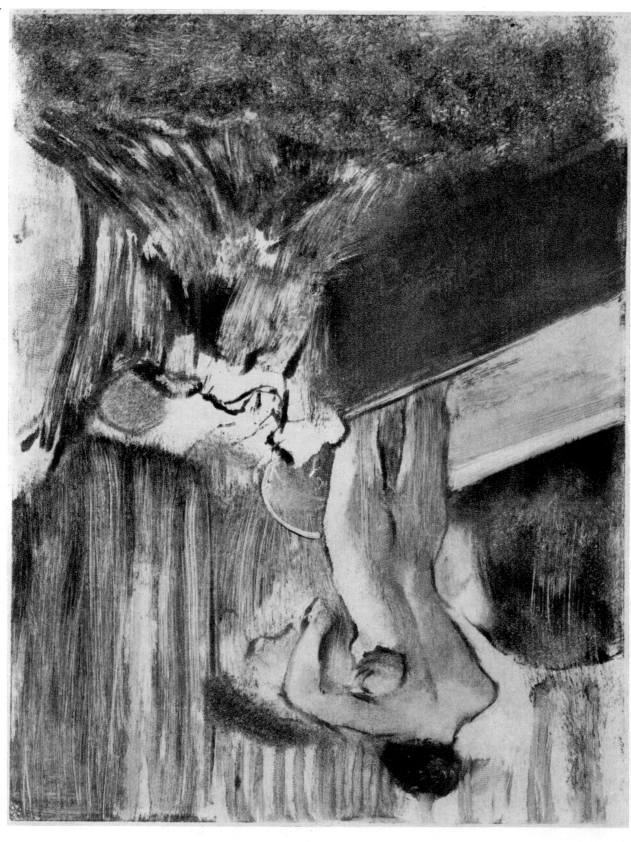

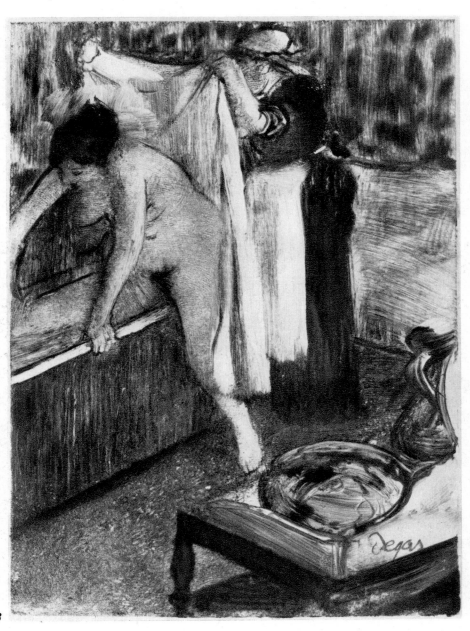

133

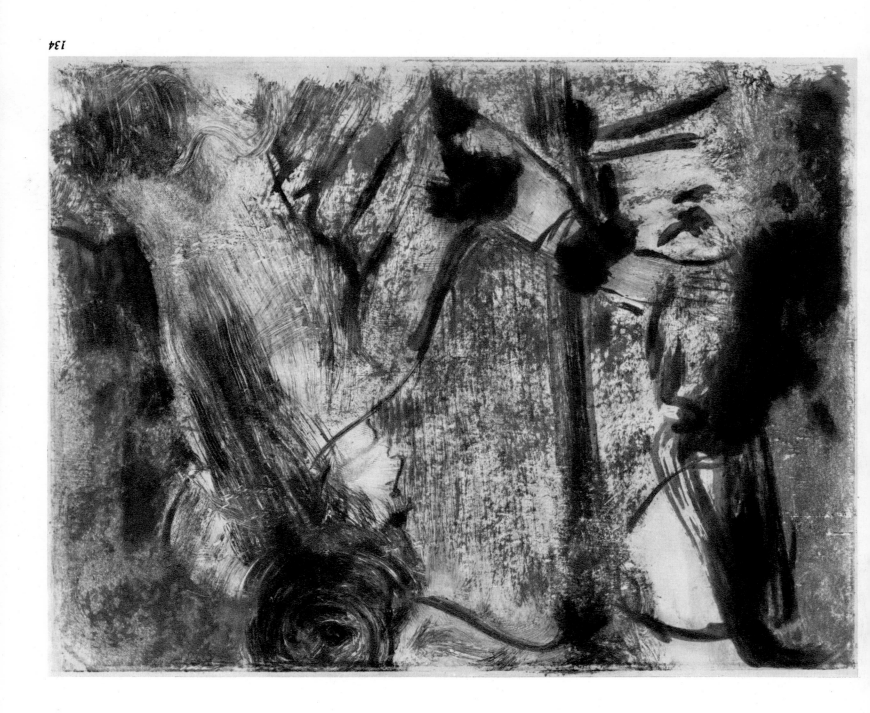

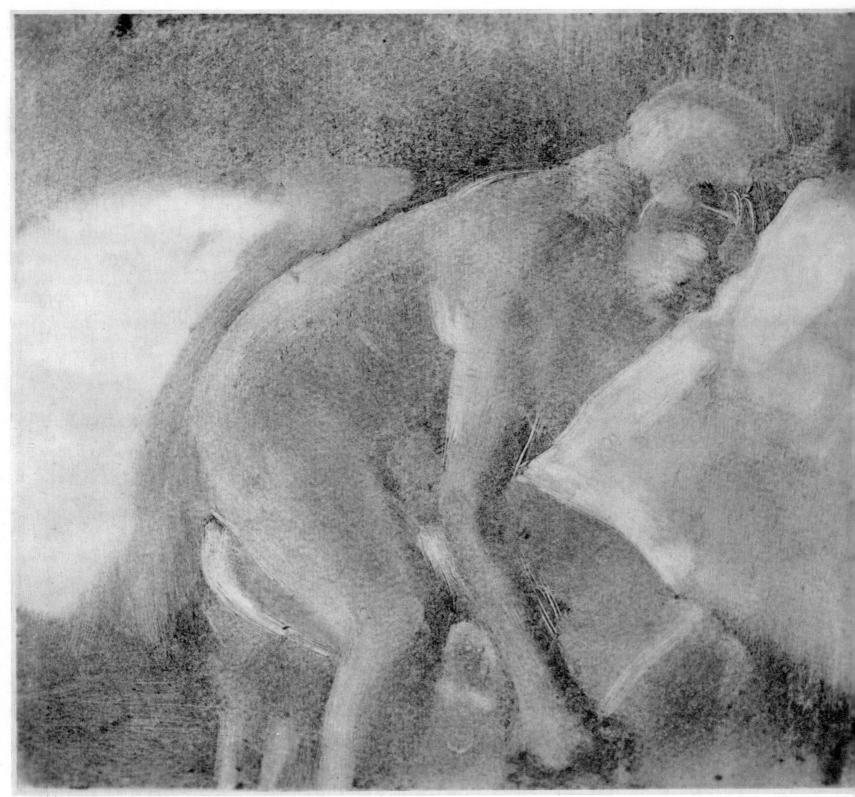

135

136

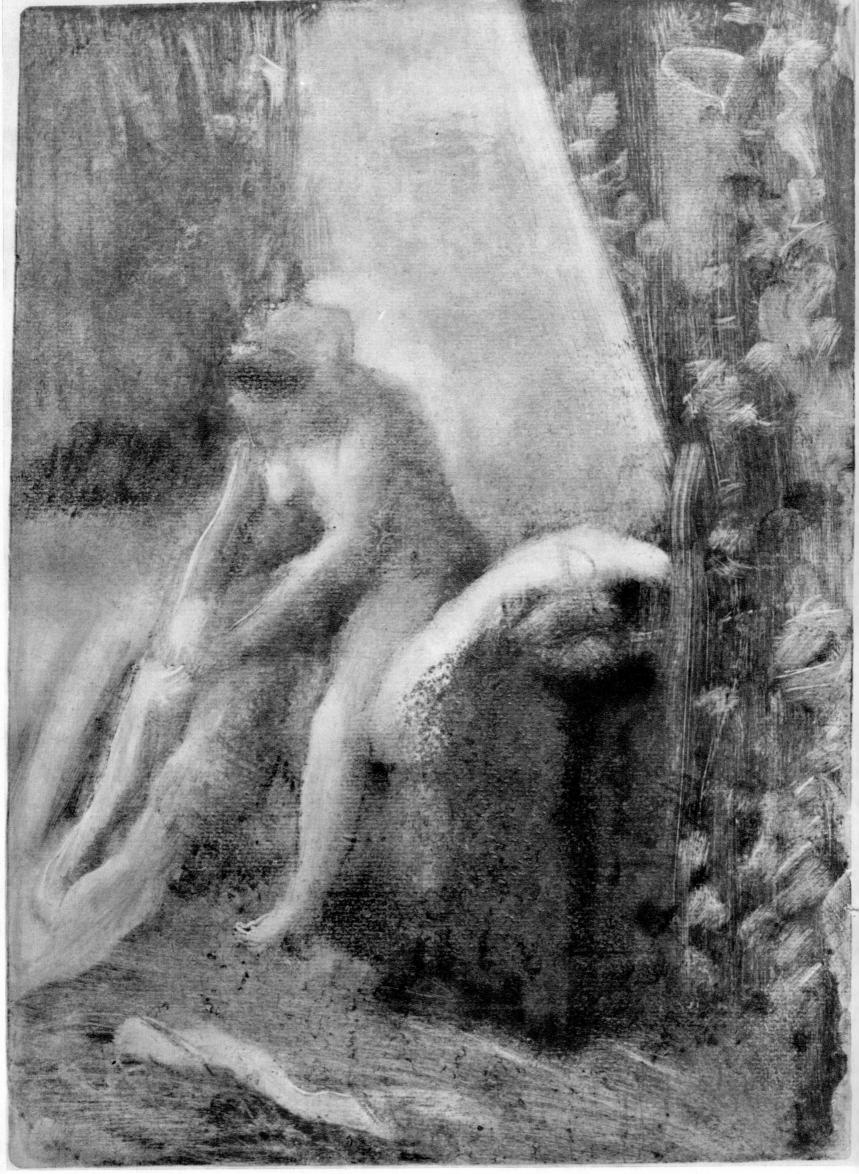

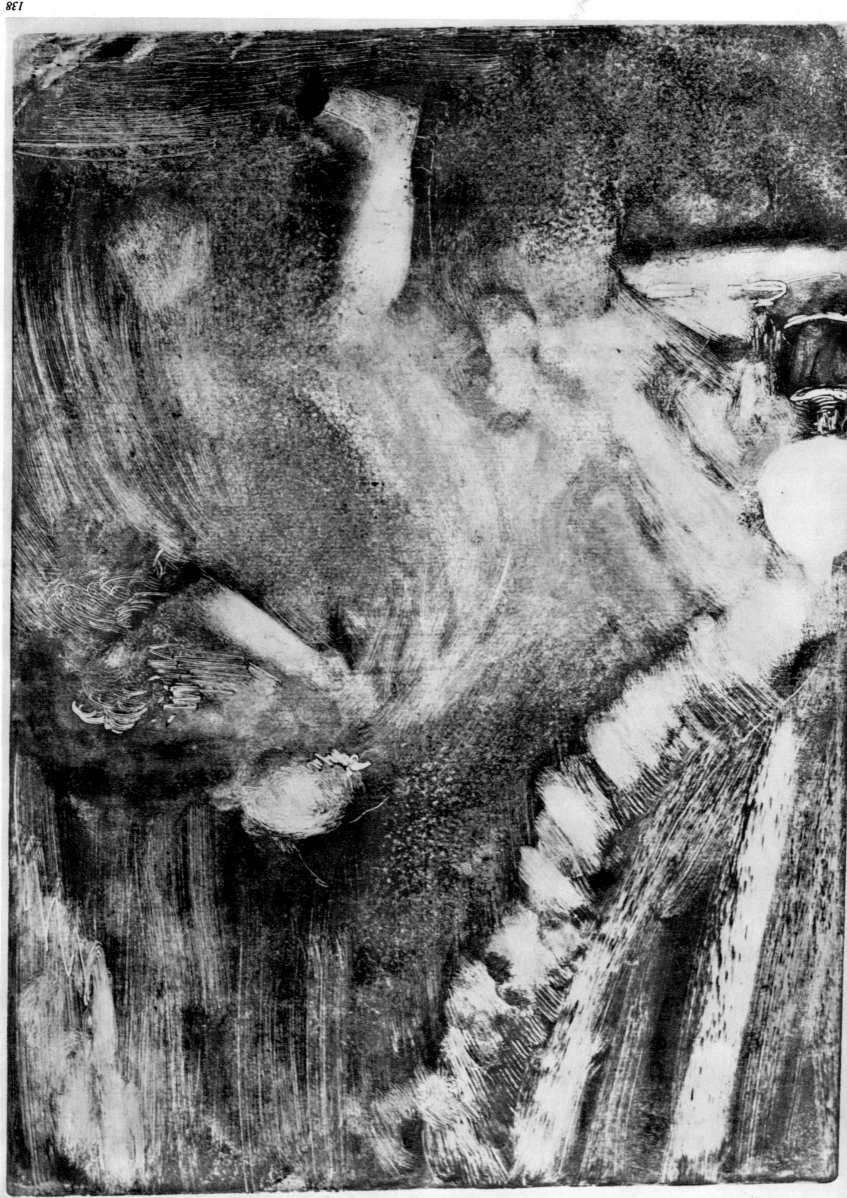

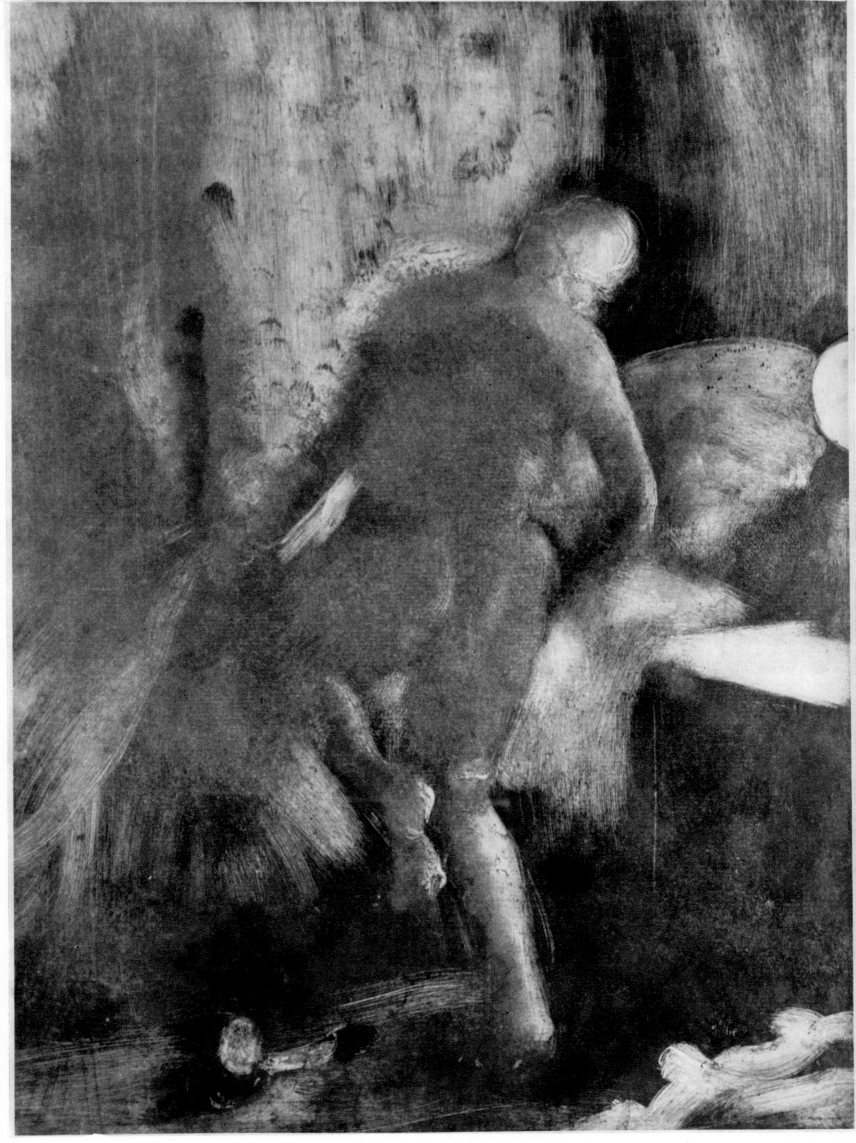

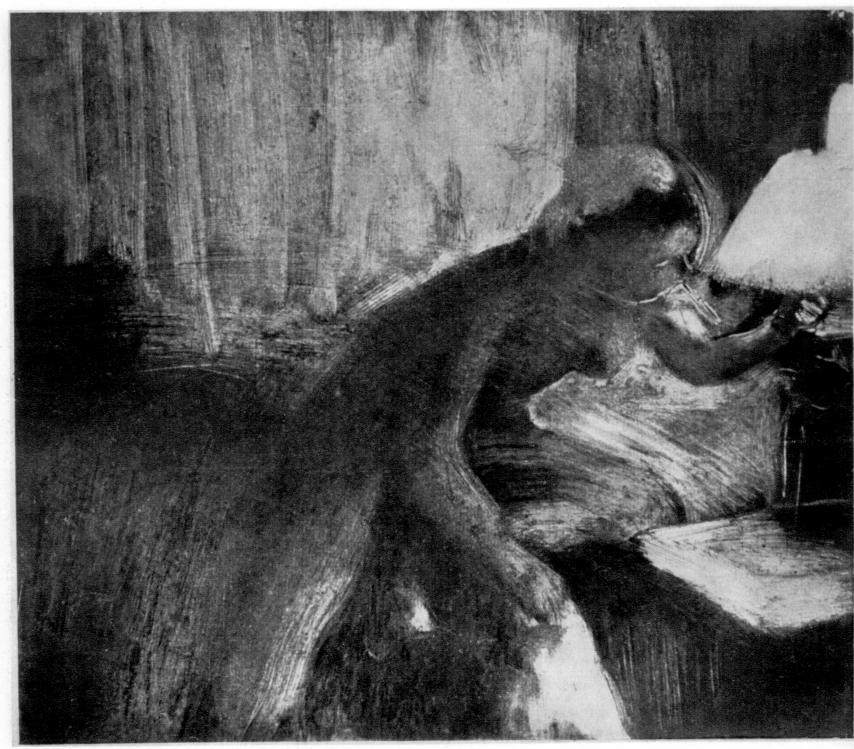

141

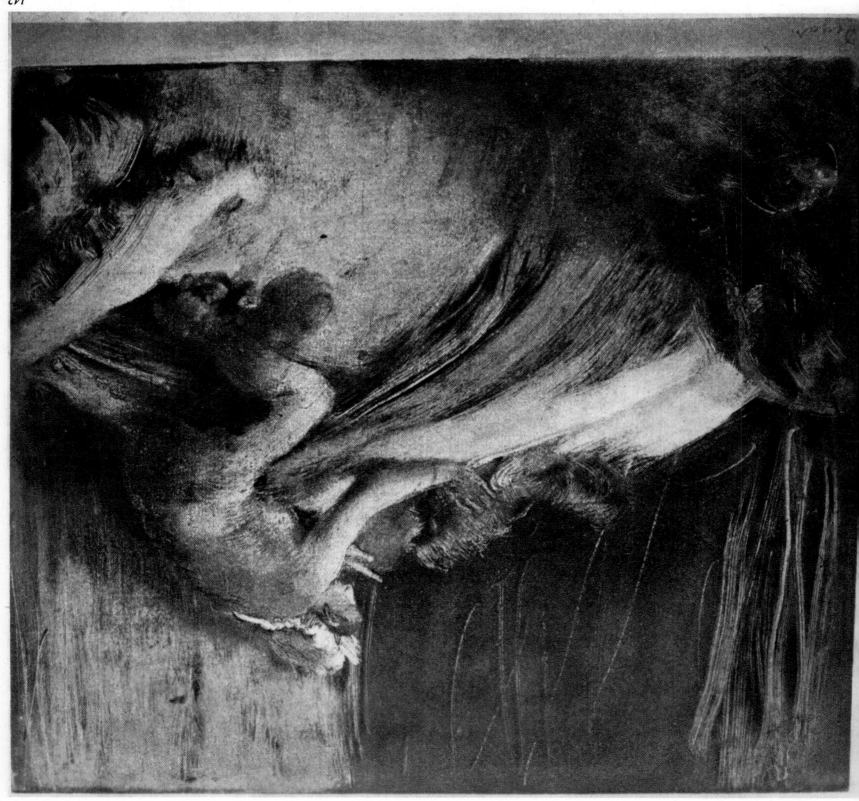

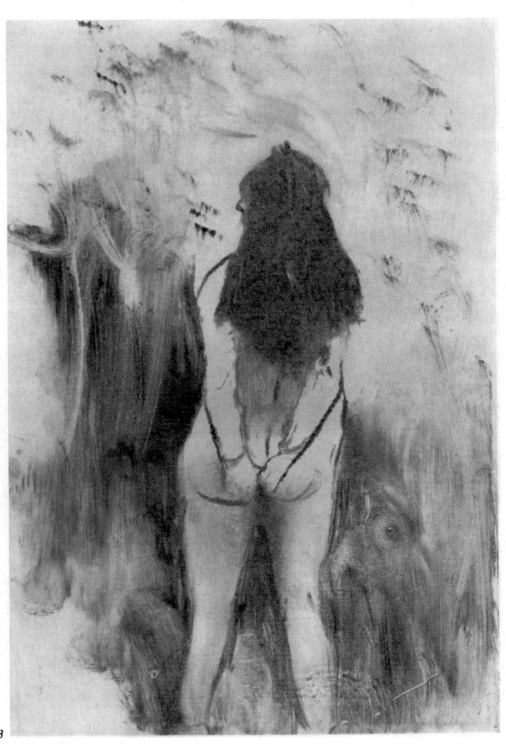

143

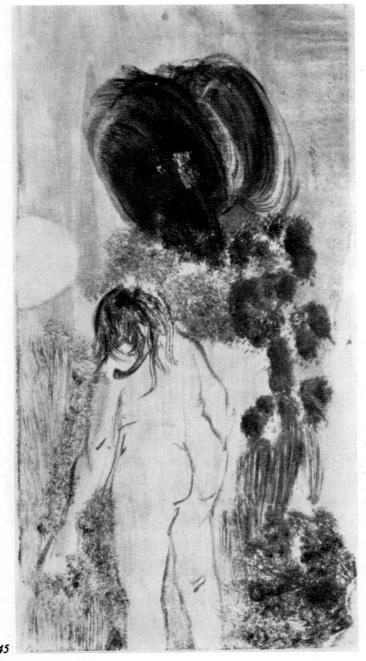

145

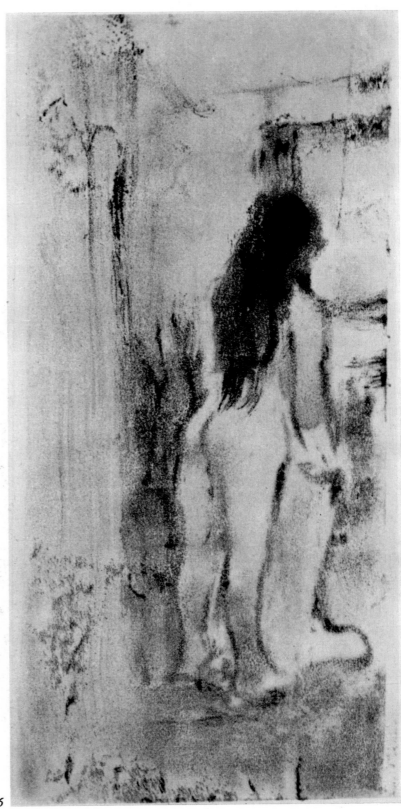

146

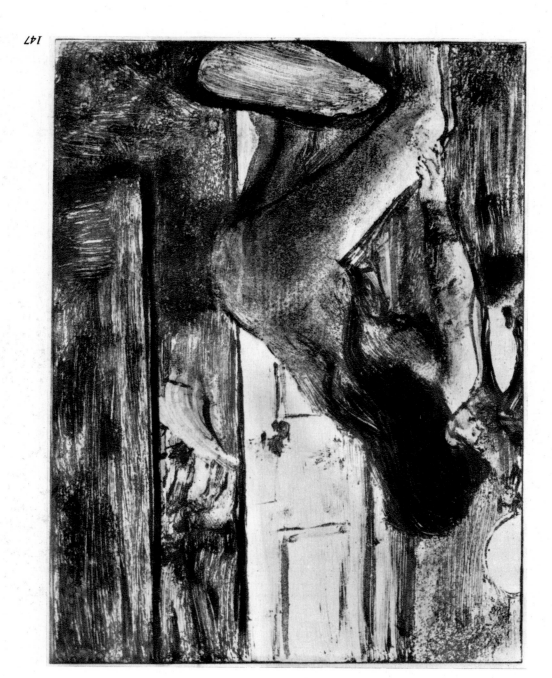

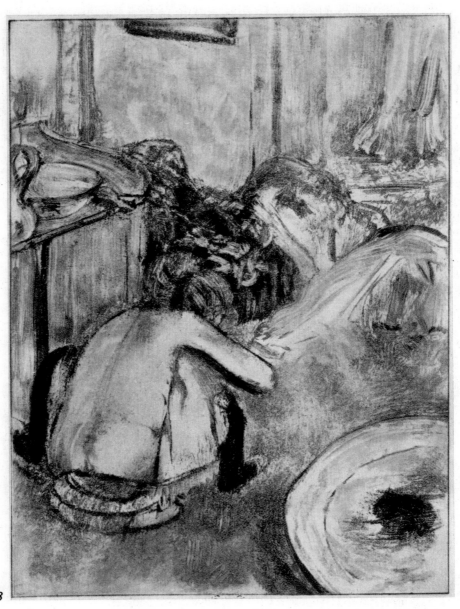

148

151

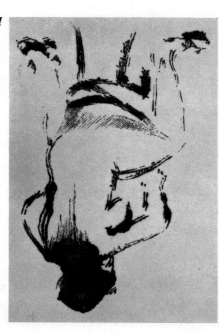

150

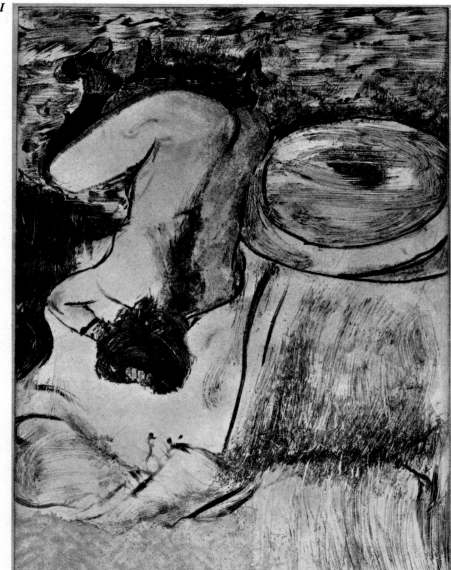

149

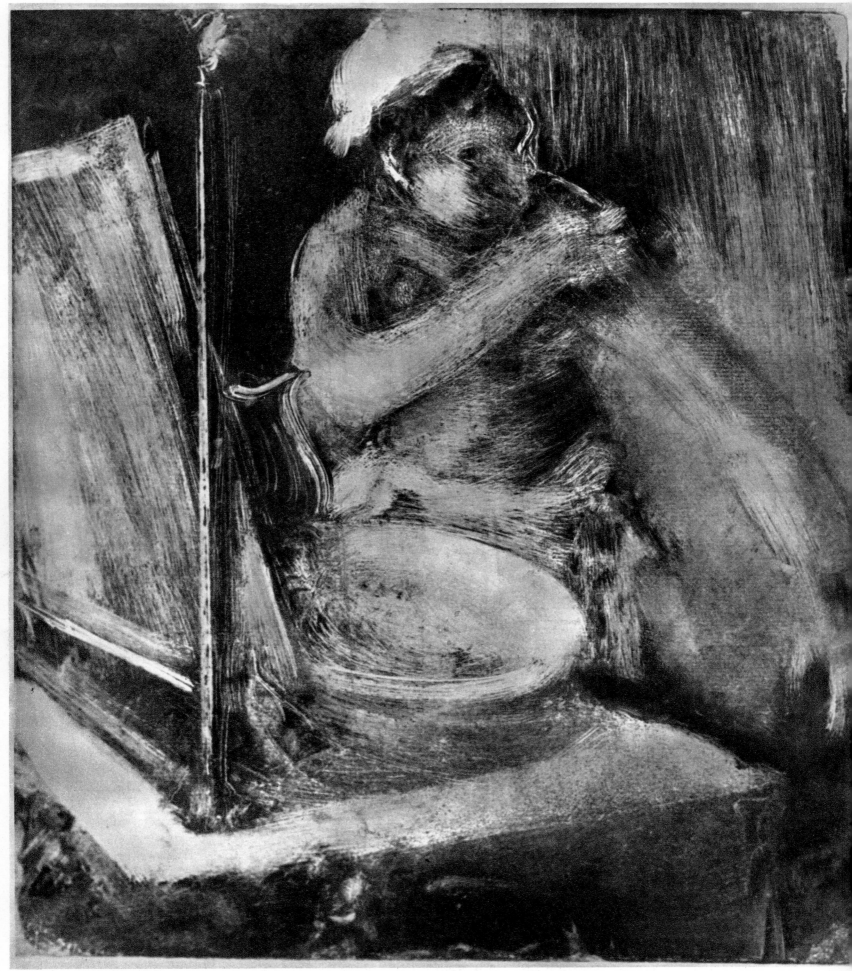

152

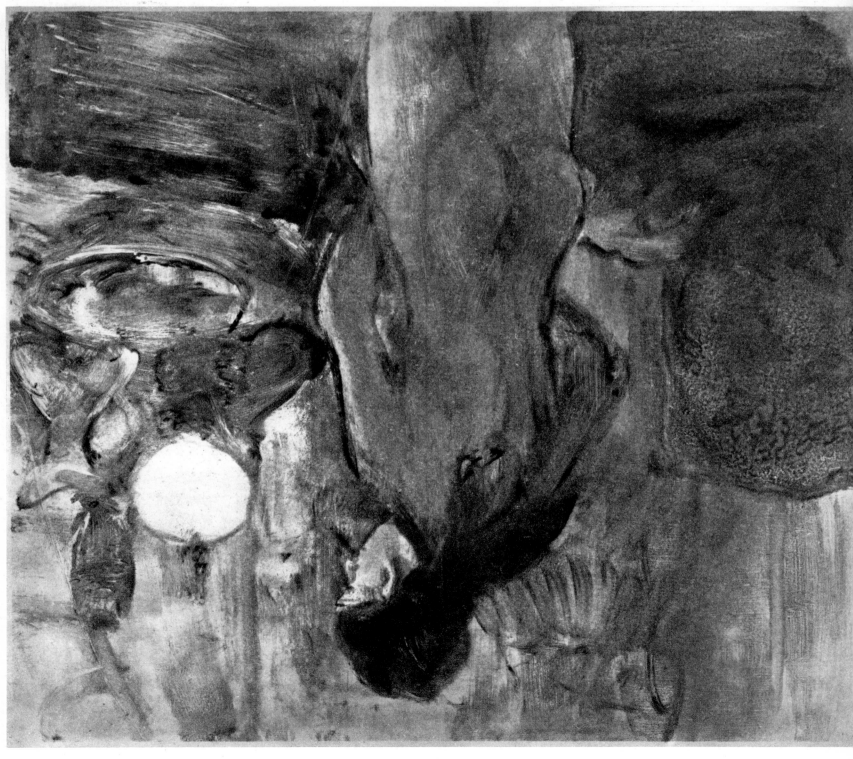

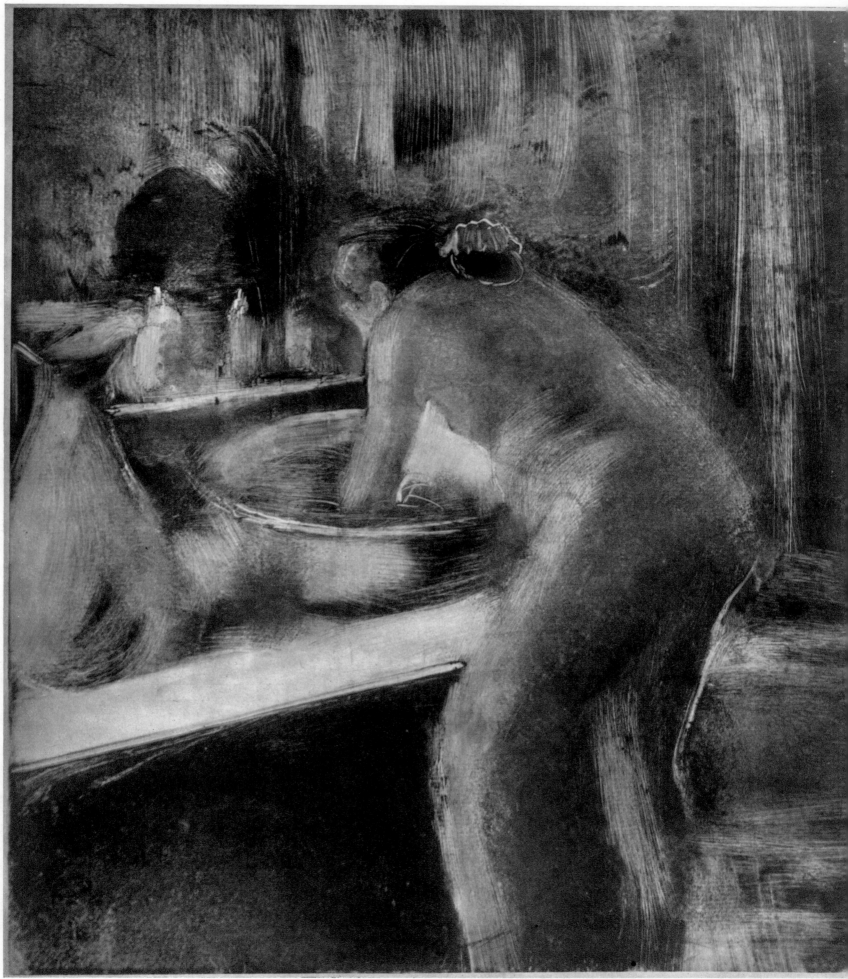

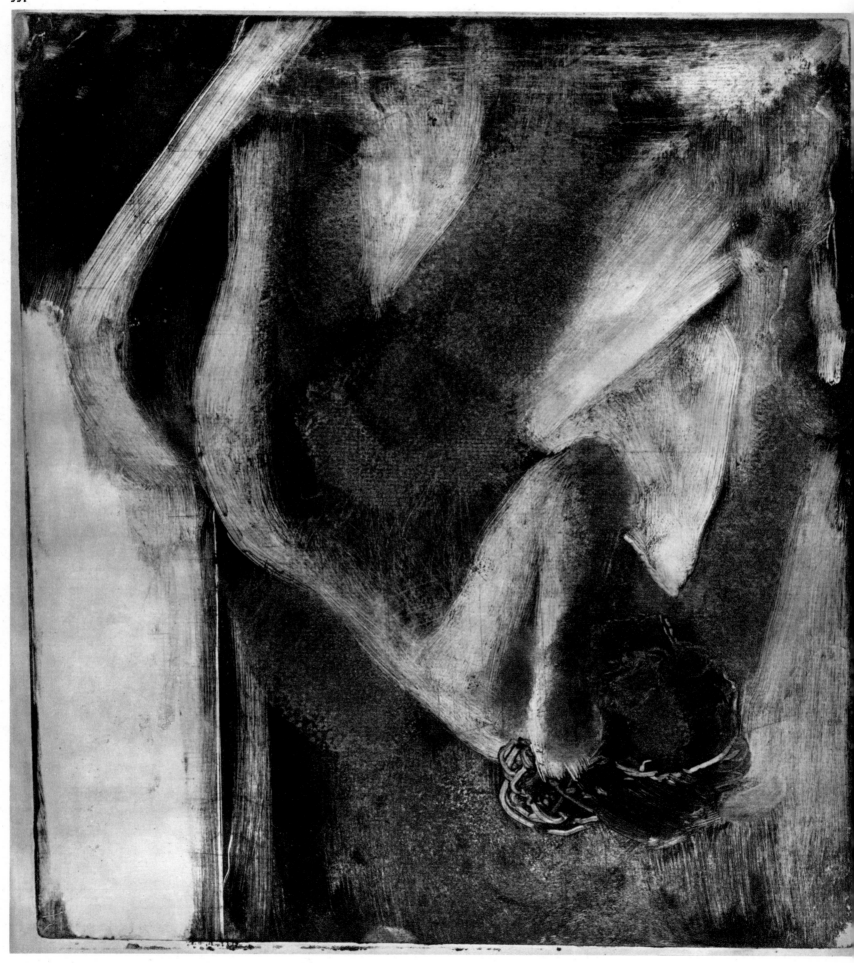

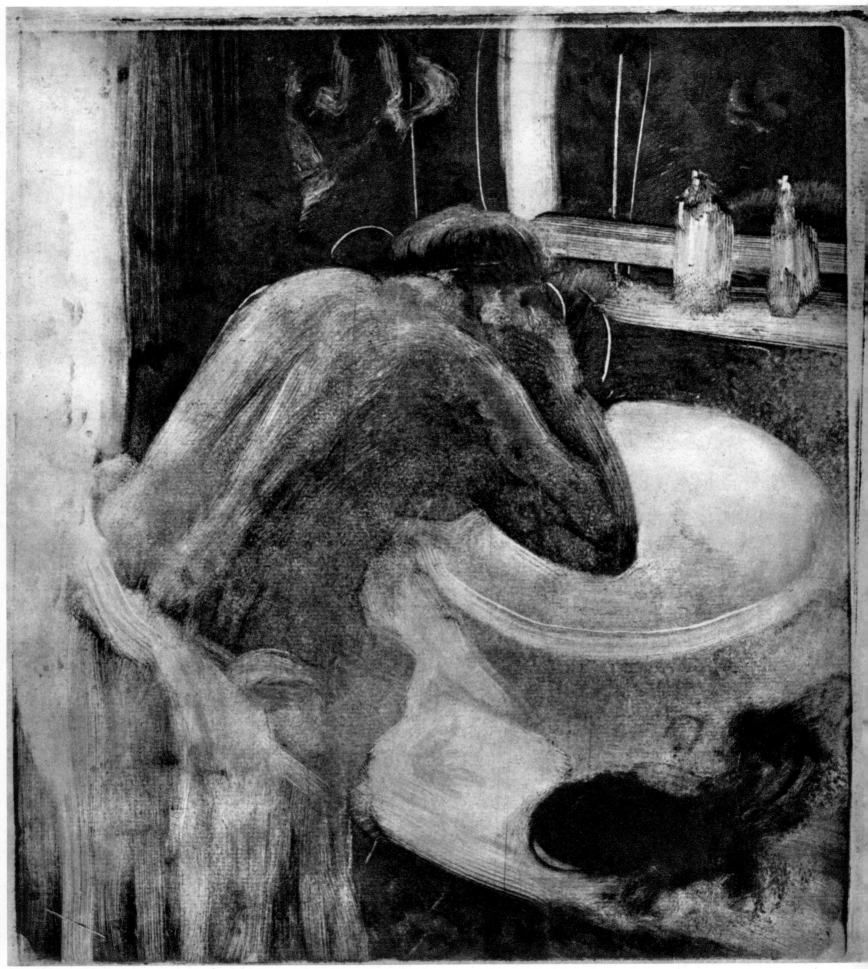

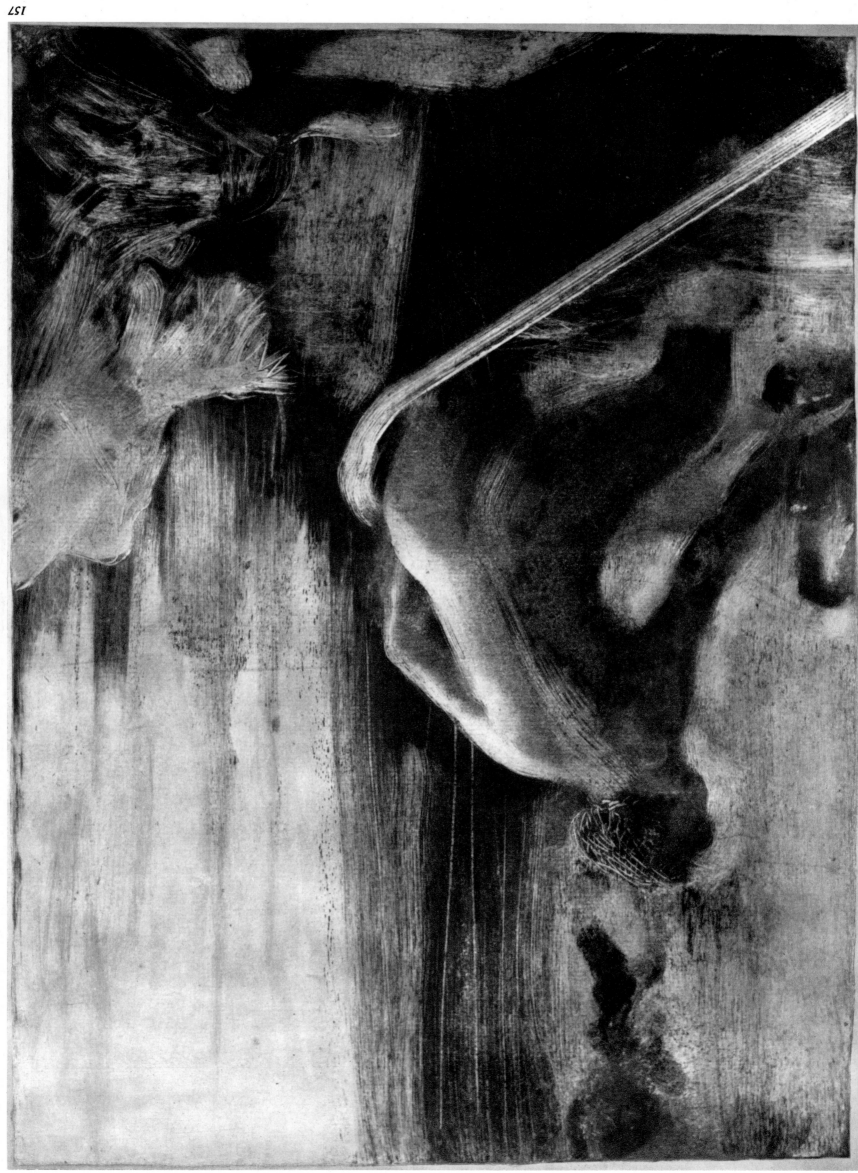

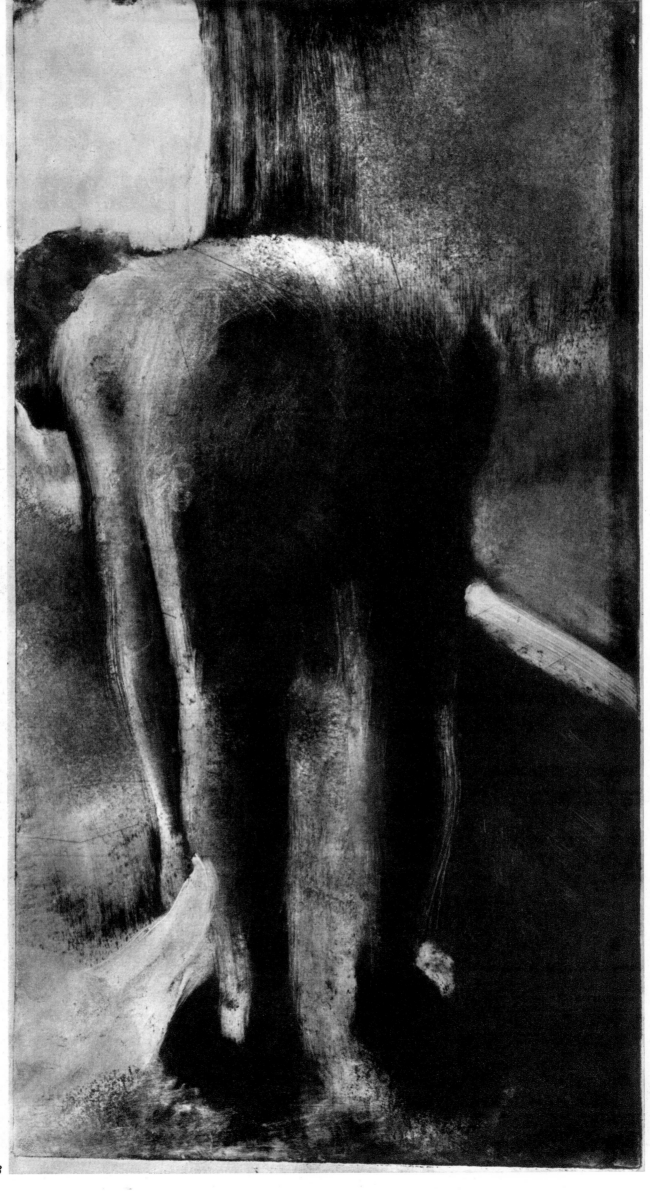

159

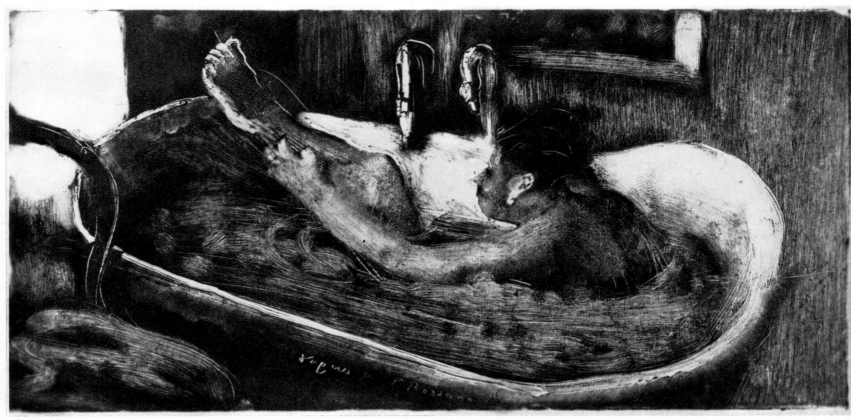

160

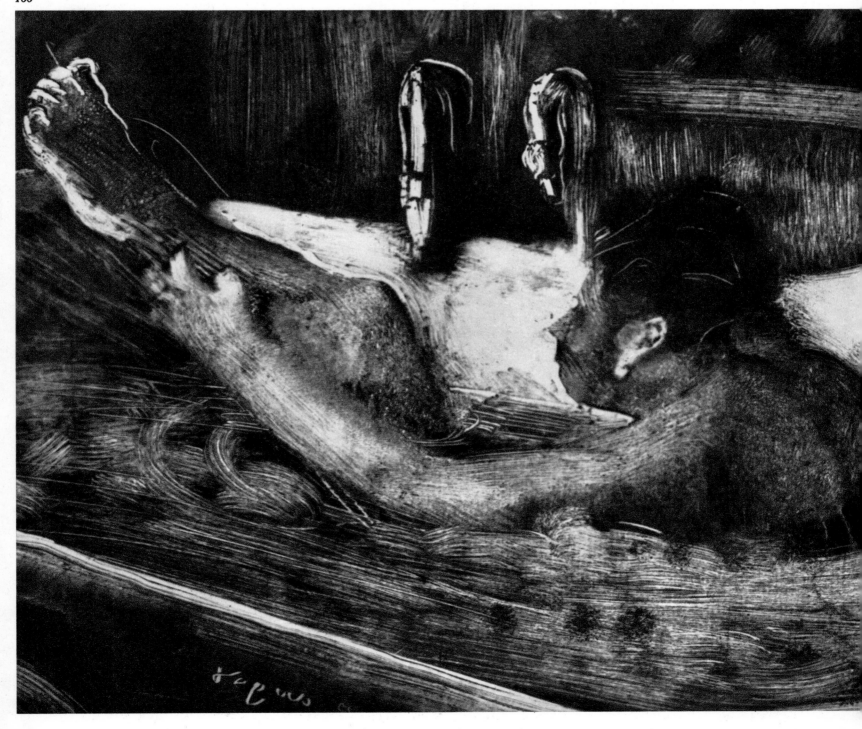

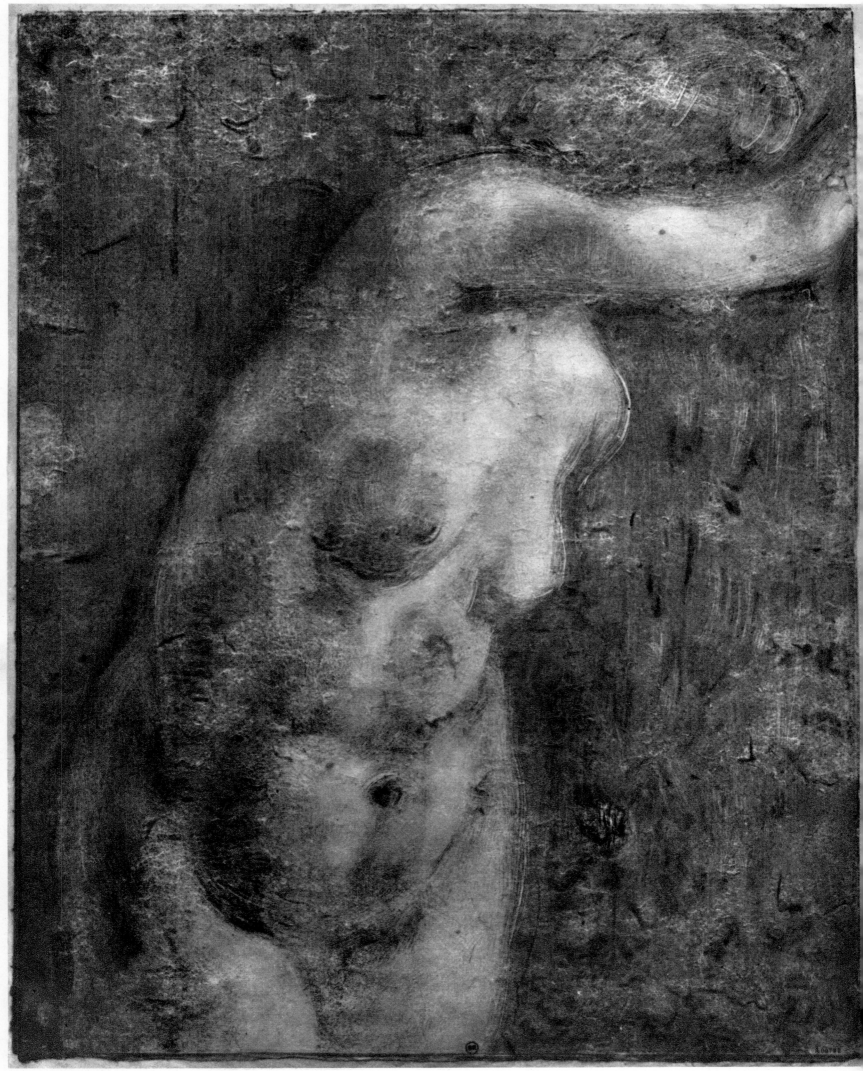

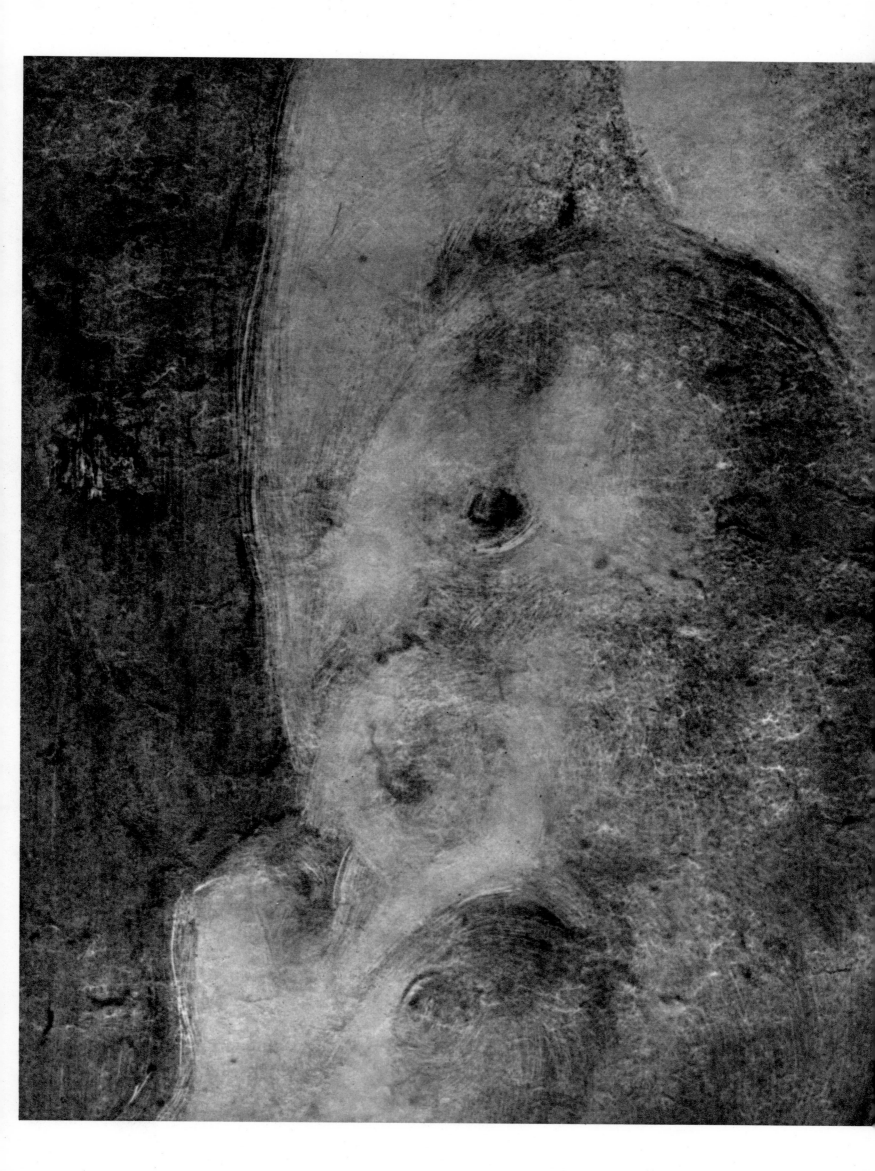

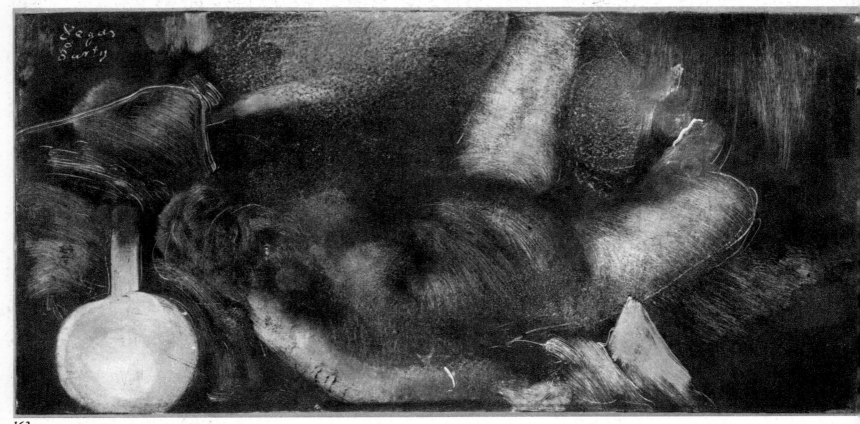

163

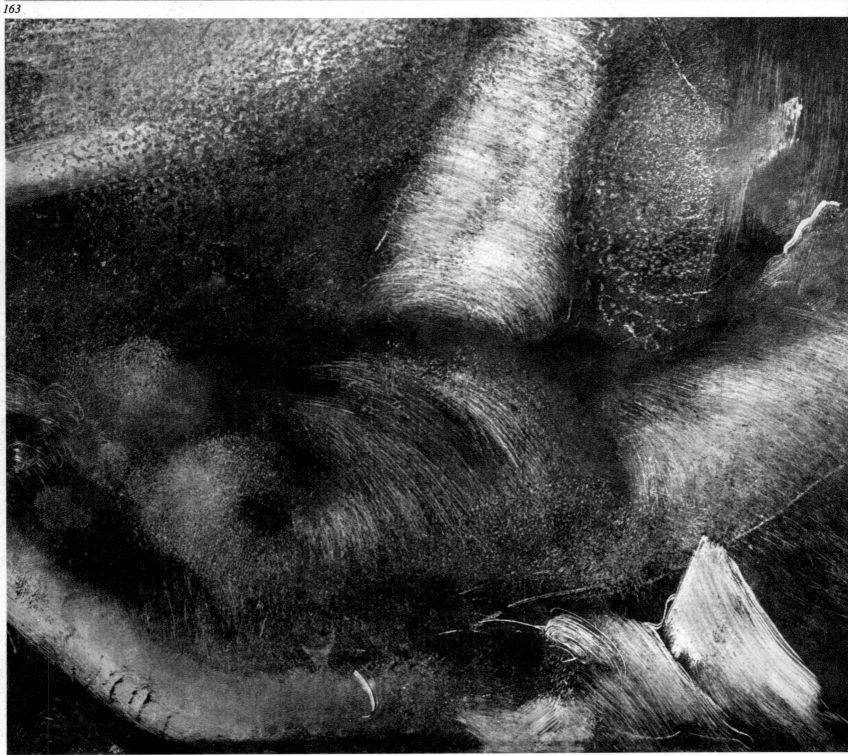

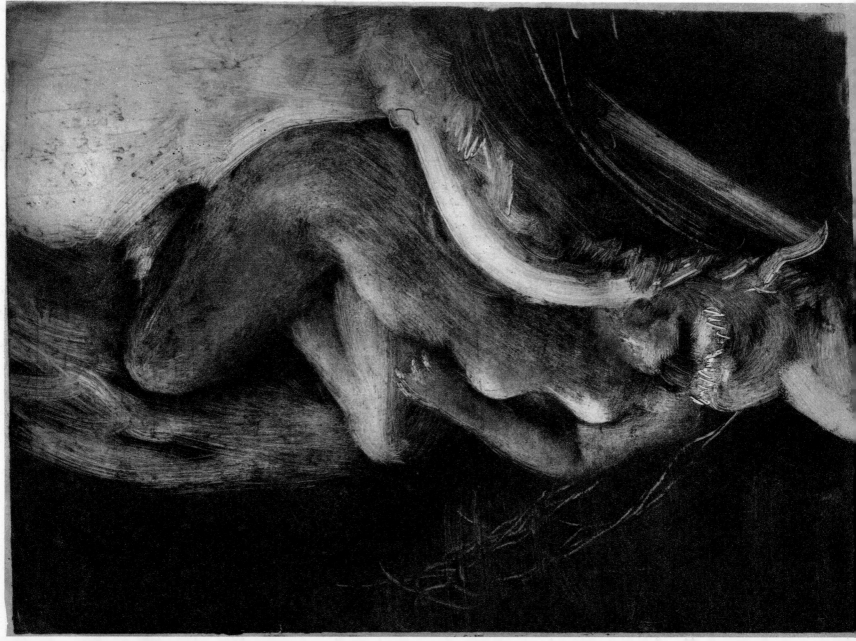

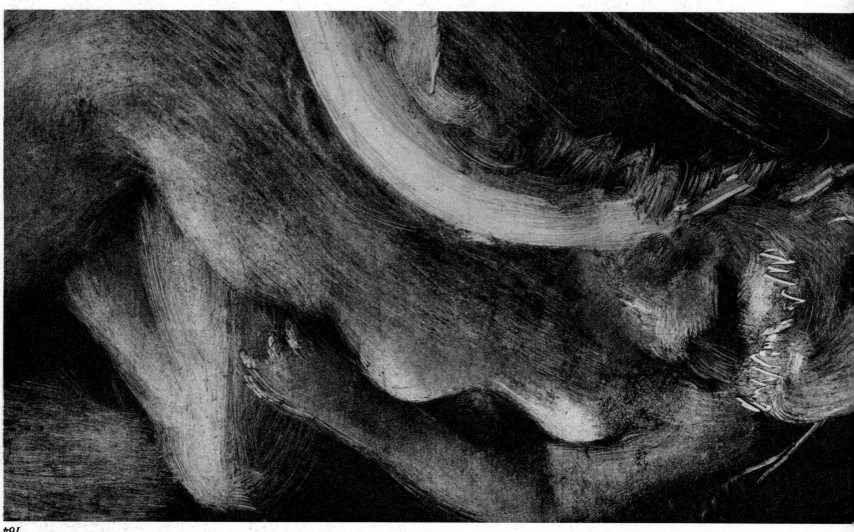

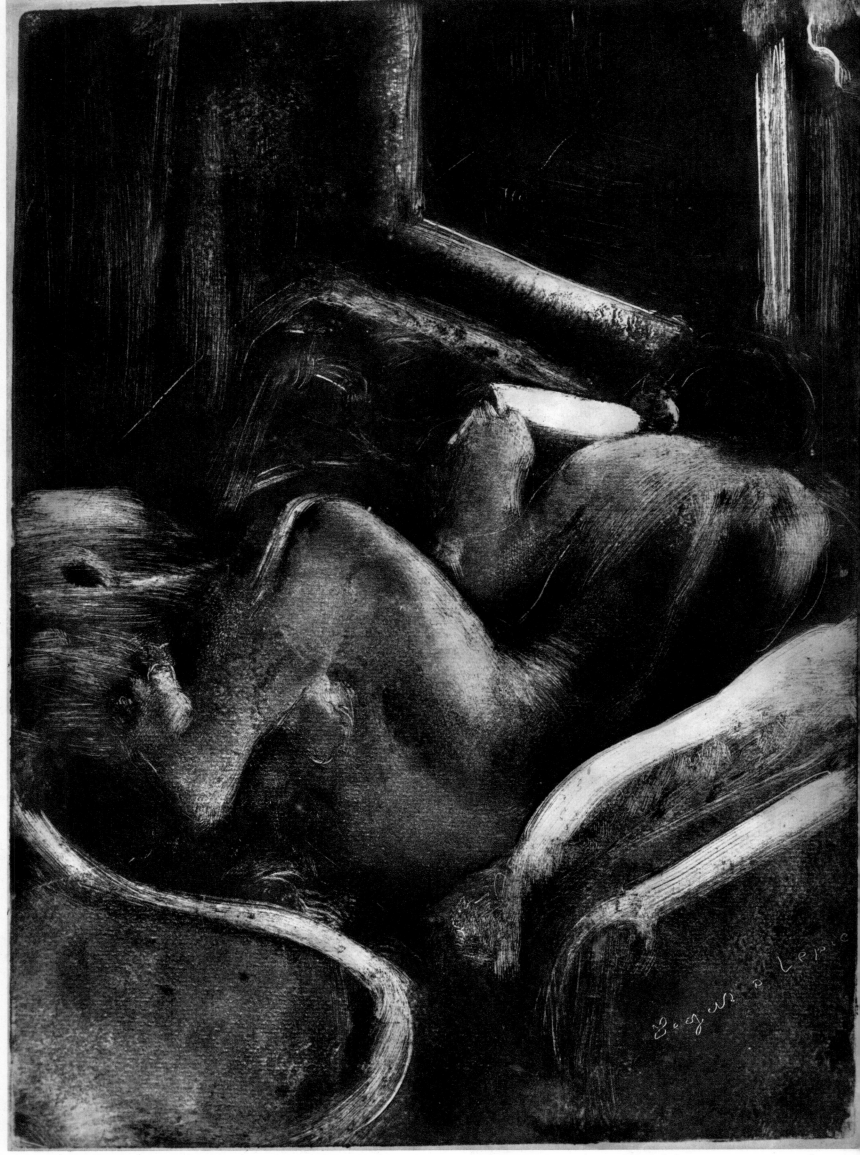

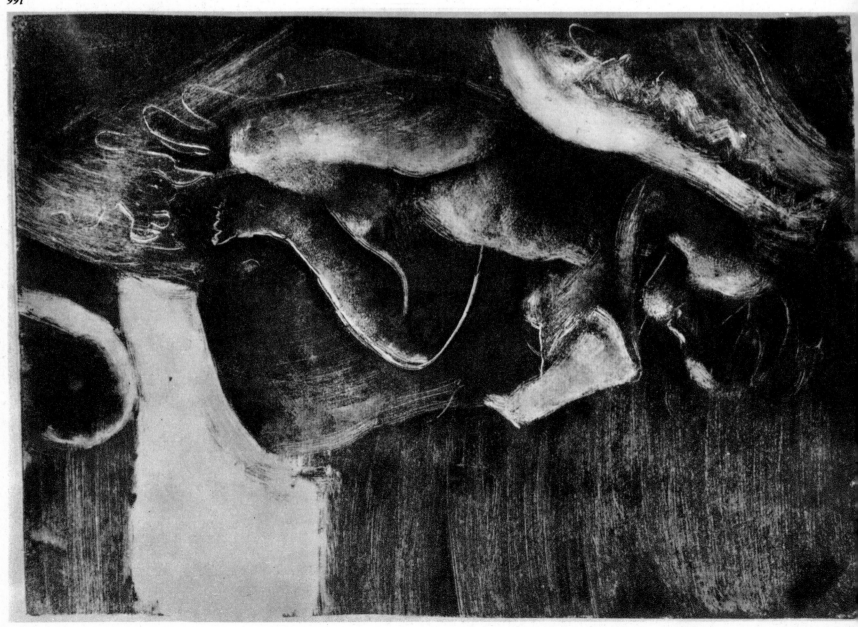

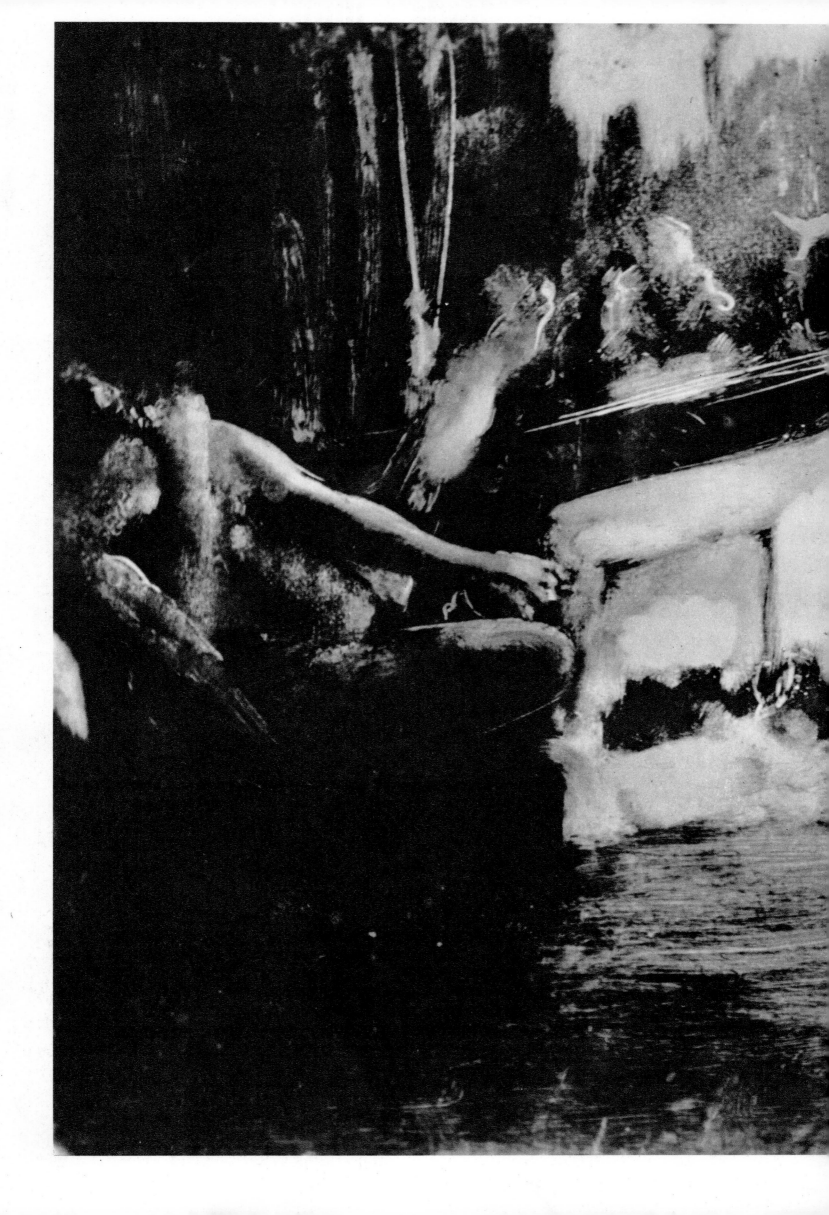

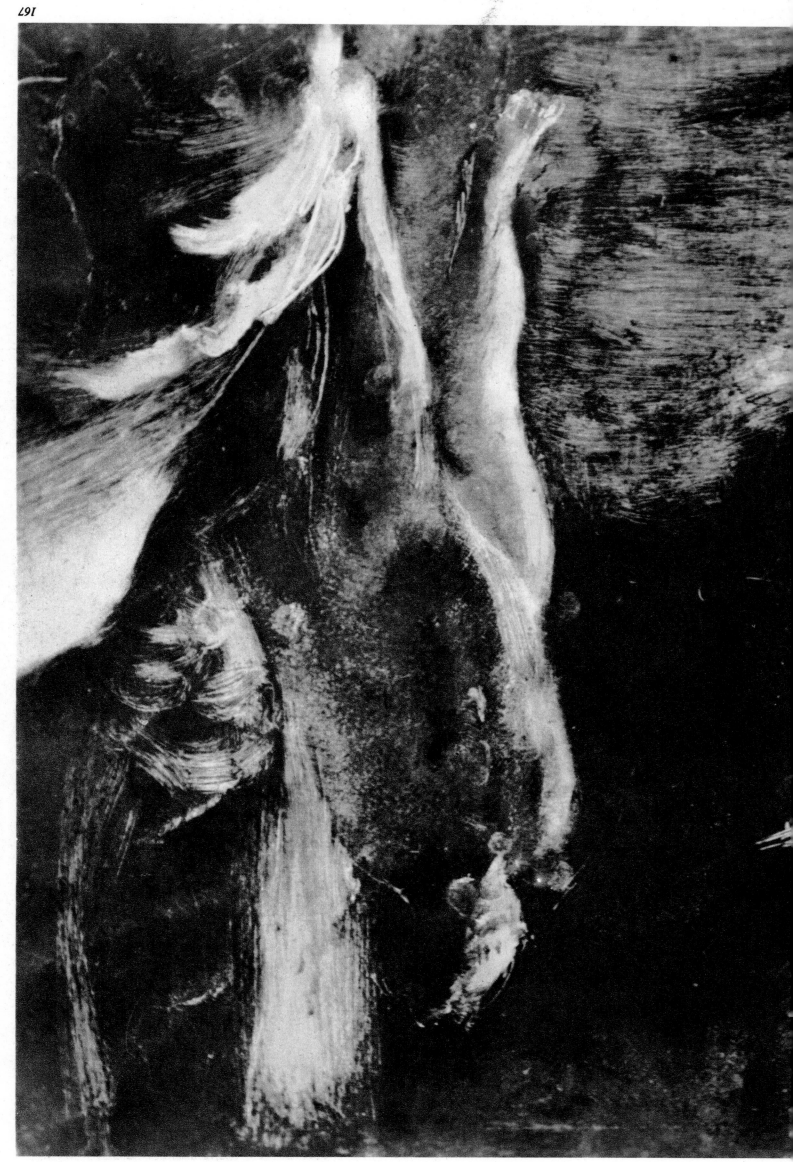

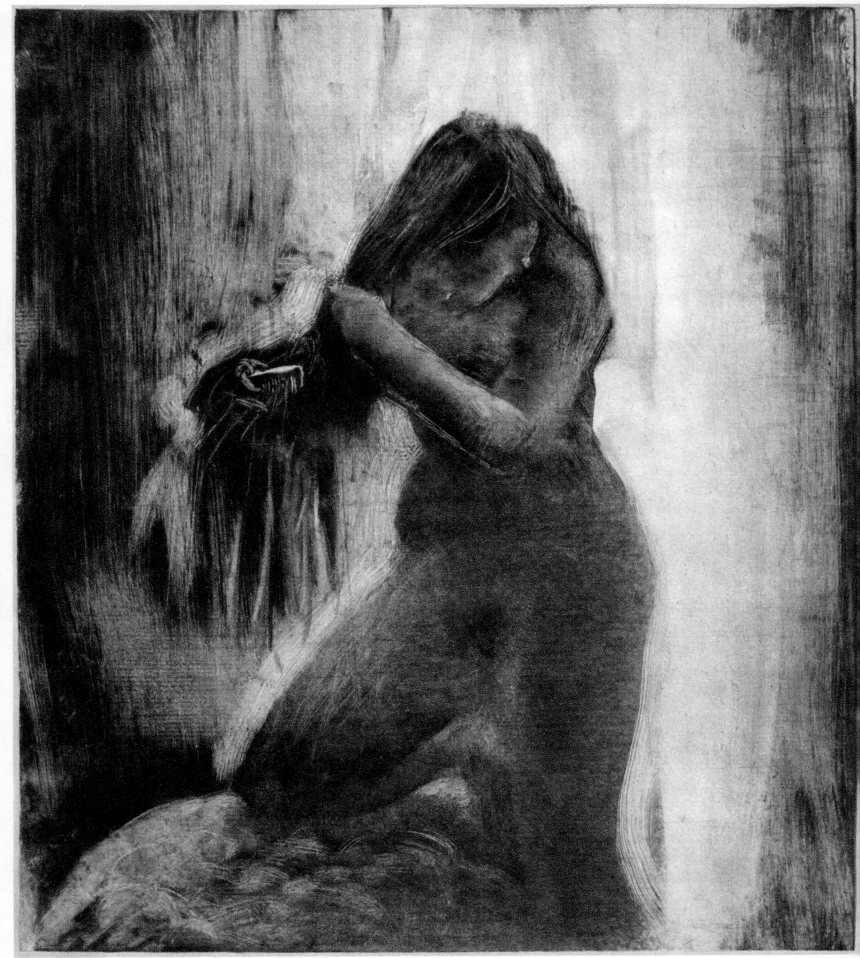

168

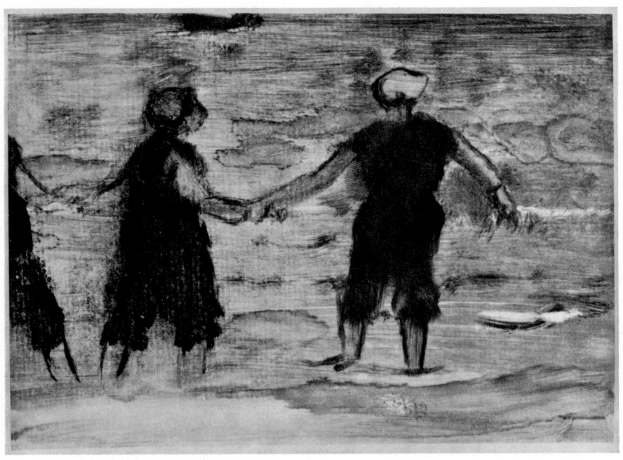

169

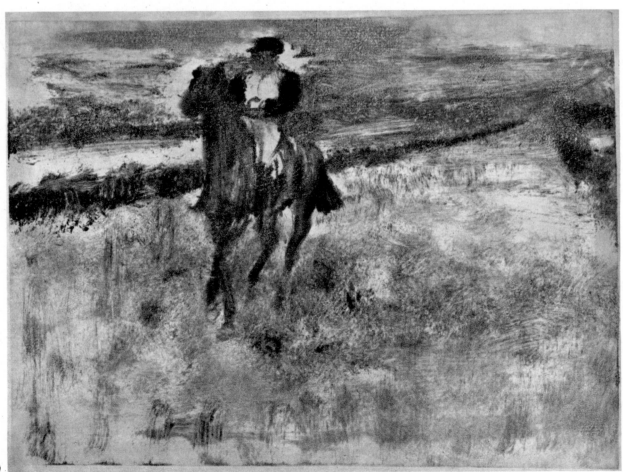

170

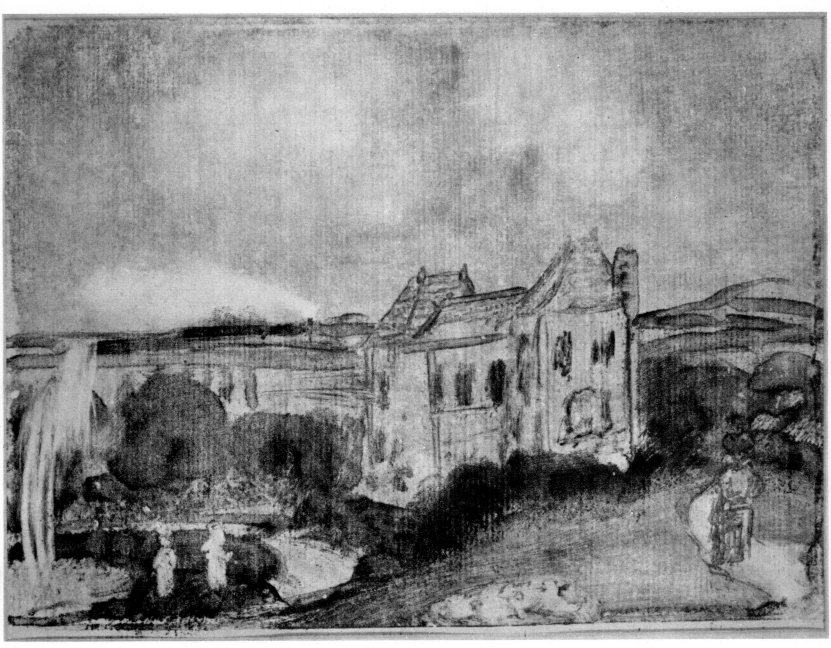

172

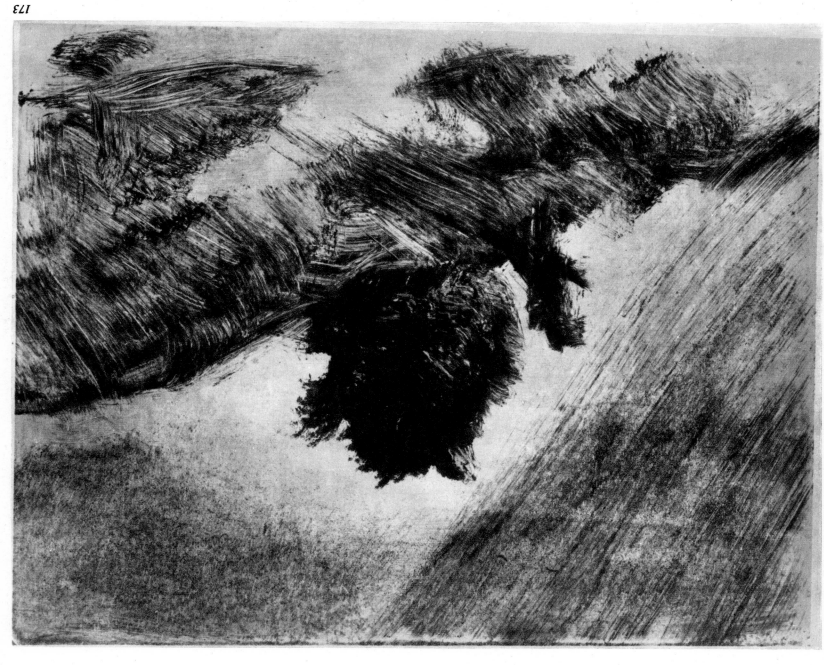

174

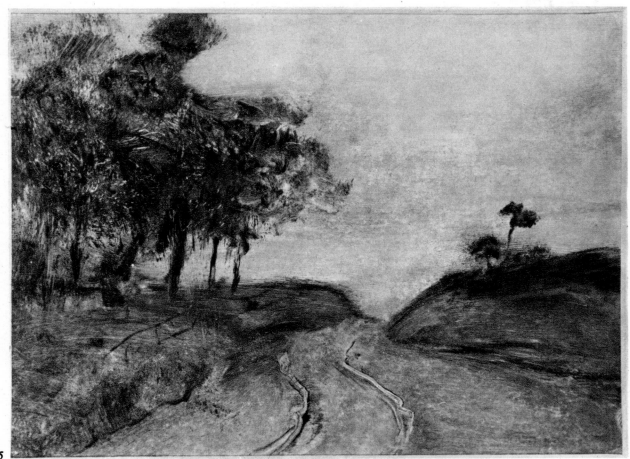

175

177

176

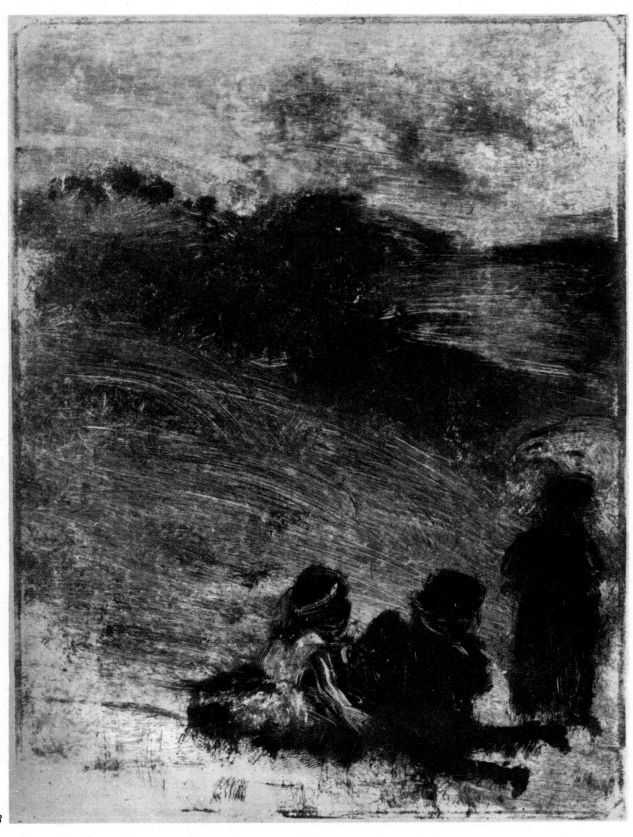

178

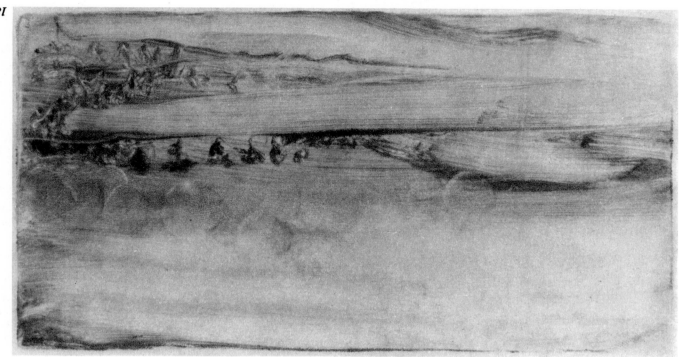

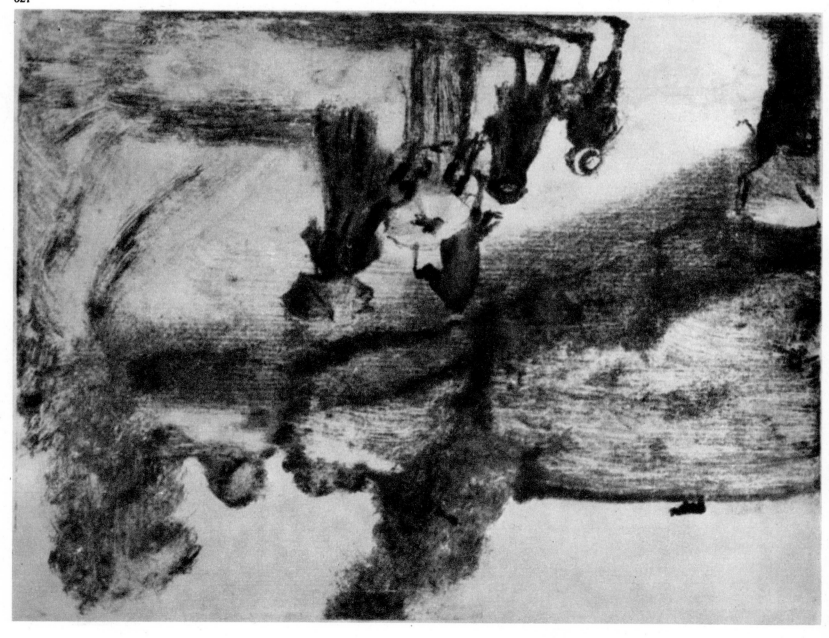

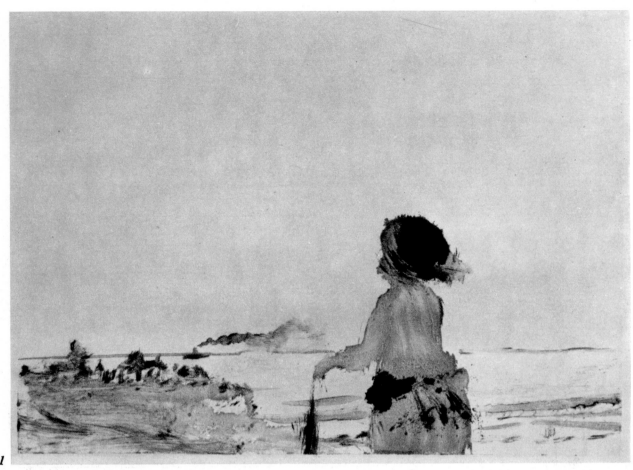

181

182

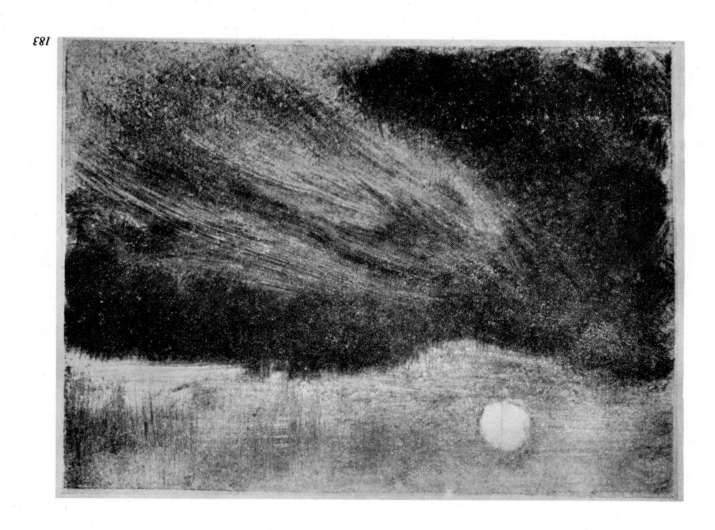

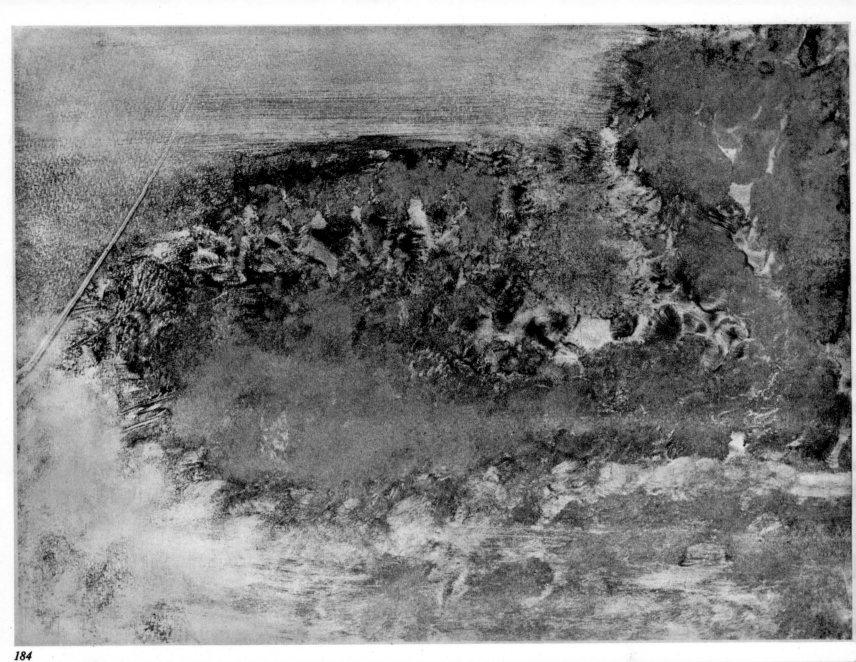

184

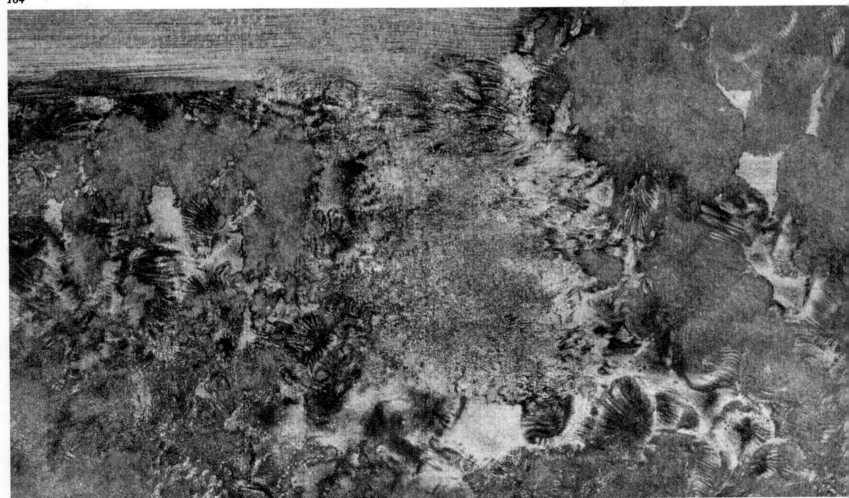

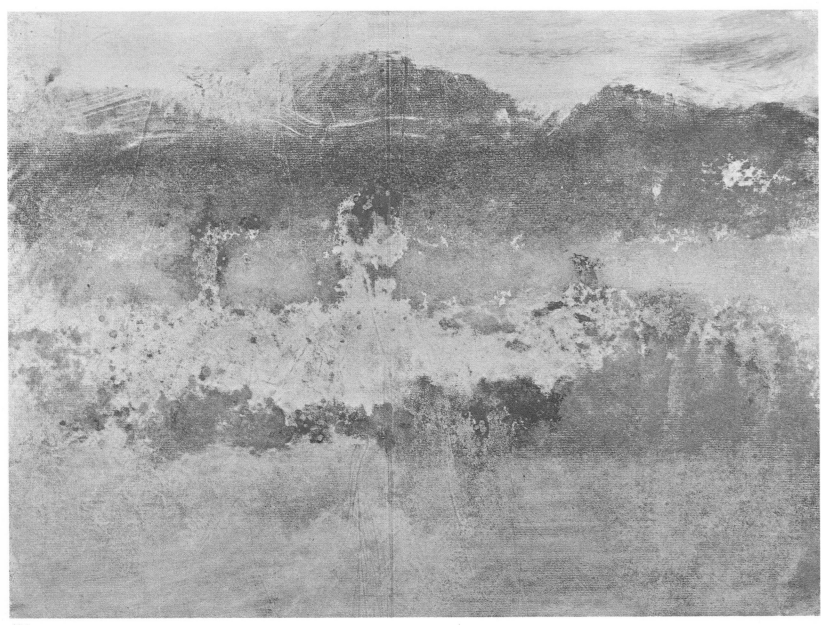

186

188

190

191 a

193

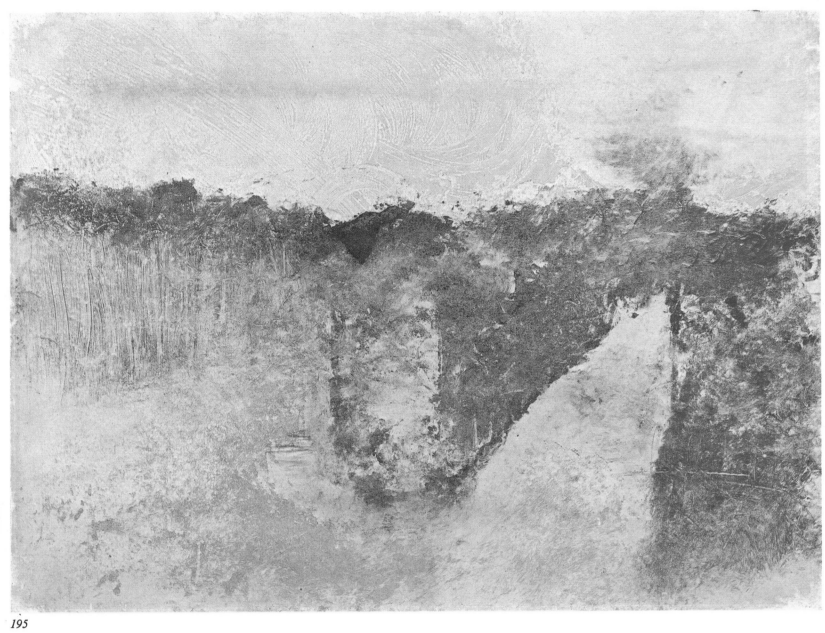

195

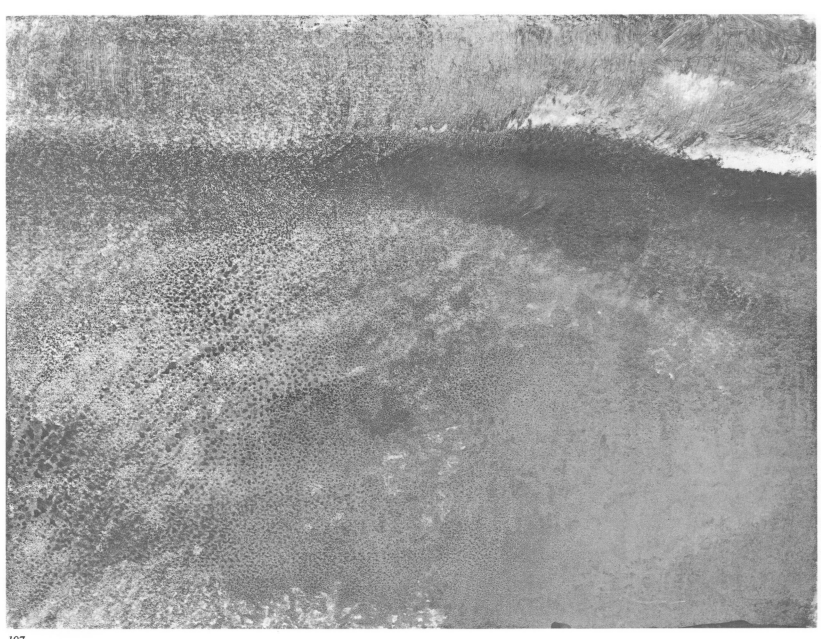

197

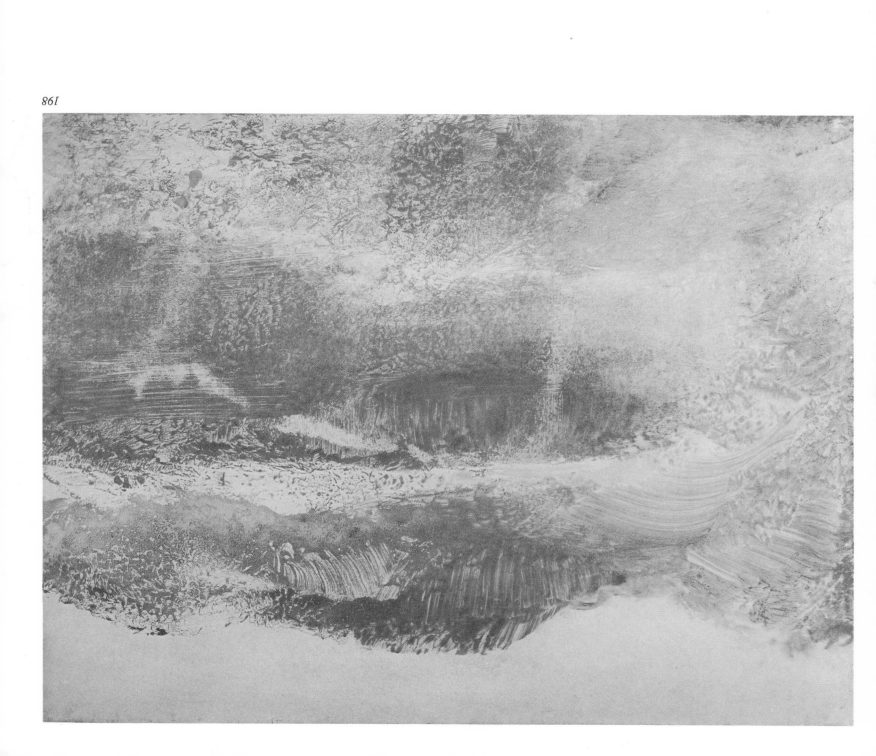

198

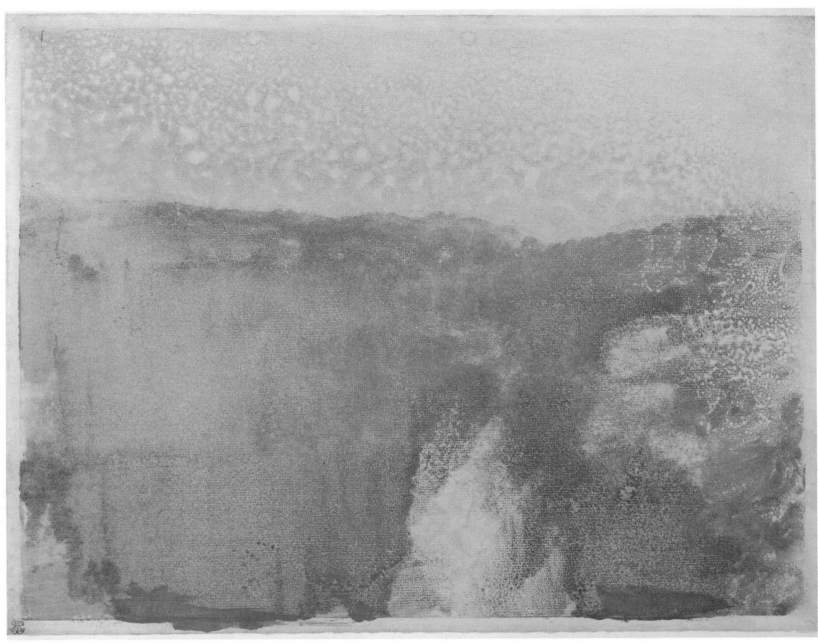

199

200

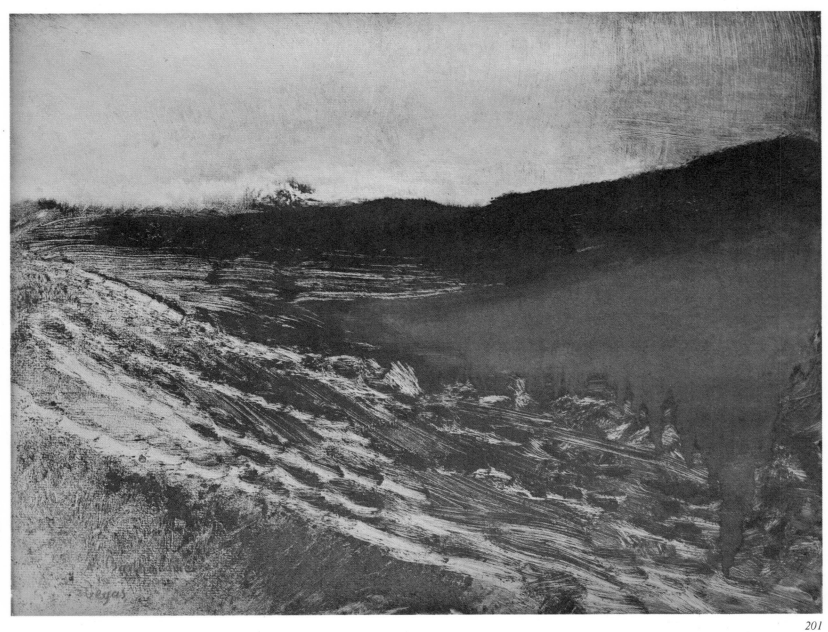

201

Catalogues

CATALOGUE OF THE ETCHINGS AND LITHOGRAPHS

In this catalogue compiled by JEAN ADHÉMAR the following abbreviations are used to refer to other catalogues and for internal cross references:

LD Delteil, L., *Edgar Degas. Le Peintre-Graveur illustré*, vol. IX, Paris 1919.
M Moses, P., 'Exhibition of Etchings by Degas', Foreword by John Rewald, Introduction and Notes by Paul Moses. The Renaissance Society at the University of Chicago, 1964.
L Lemoisne, P.-A., *Degas et son œuvre*. Paris 1946–9, 4 vols.
C Cachin, F., Catalogue of the Monotypes (this volume).
A Adhémar, J., Catalogue of the Etchings and Lithographs (this volume).

Dimensions are given in millimetres and inches, height preceding width.

1 GREEK LANDSCAPE, THE ANCHORAGE (PAYSAGE DE GRÈCE, LA RADE), early 1856. Etching, only state. 72×60 ($2\frac{7}{8} \times 2\frac{3}{8}$). LD 1, M 1. Cabinet des Estampes, Bibliothèque Nationale, Paris.
Delteil informs us that this landscape was executed at Degas' father's house and at the suggestion of Prince Soutzo, a friend of the family; as we also know that Degas was particularly close to the Prince in early 1856 (in that year he copied one of his landscapes), this seems the most likely date on historical grounds. Stylistically it makes more sense than *c.* 1860–6, which has also been suggested. The use of a line-etching technique shows the influence of Italian engravings on Degas at this time.
Prince Nicolas J. Soutzo, a Greek artist living in Paris and a great friend of Neuwerkerke, was a collector of landscapes; when his collection was sold (26 February 1876; see *Art*, IV, 241, 268) it included nothing by Degas but several Daumiers and the proof of a Claude landscape, formerly in the Esdaille, Lawrence and Gigoux Collections. In 1861 he had tried without success to exchange this landscape for a Van Ostade in the Cabinet des Estampes. His father, Gregorio Soutzo, was also a collector (date of sale of his collection: 17 March 1870).
In his notebooks in 1856 and 1859, Degas refers to Soutzo, recalling an 'extraordinary conversation' and expressing admiration for his 'courage in his studies' (the courage it took to embark on nature themes in large formats). This etching is not from nature as Degas had not visited Greece; Reff relates it to an illustration from an edition of *The Odyssey* published in London in 1854.
Two proofs were included in the Degas sale of 1919 (no. 111*b*.). There is one print stuck to a page of one of Degas' notebooks in the Cabinet des Estampes; Delteil refers to another in the A. Hébrard Collection. An impression from the cancelled plate is also in existence.

2 MOUNTAIN LANDSCAPE (PAYSAGE DE MONTAGNE, also called PAYSAGE ROCHEUX), 1856. Etching, only state. 110×100 ($4\frac{3}{8} \times 4$). Cabinet des Estampes, Bibliothèque Nationale, Paris.
After, or in collaboration with, Soutzo. Not listed by Delteil. One proof in the Cabinet des Estampes, and three in a notebook (*Carnets*, I, pp. 101, 102), one of which is a 1st state revised in preparation for a 2nd state.

3 SPORTING GENTLEMAN MOUNTING HIS HORSE (LE SPORTSMAN MONTANT SON CHEVAL), *c.* 1856. Etching, 2nd state of five. 84×74 ($3\frac{1}{4} \times 2\frac{7}{8}$). LD 9. Cabinet des Estampes, Bibliothèque Nationale, Paris.
Similar in style to the previous plate. Delteil does not suggest a date, but the engraving is contemporary with a charcoal sketch put up for sale on 7 June 1922.
1st state, pure etching. 2nd state (Cabinet des Estampes; proof formerly belonging to the Rouart Collection), main addition is cross-hatching on ground. 3rd state, with a few branches in the foreground on the right. 4th state, main addition is a tree on the right. 5th state, main addition is a second tree.
There were nine proofs included in the Degas sale of 1918, mostly trial proofs taken from the plate when the image was partially obliterated.

4 THE LOVERS (LES AMOUREUX), *c.* 1856. Etching, only state. 84×71 ($3\frac{1}{4} \times 2\frac{3}{4}$). LD 44. Kornfeld and Klipstein Collection, Bern.
A trial piece which is a first version of the following plate. Two proofs were included in the Degas sale of 1919 (no. 108).

5 HEAD OF YOUNG WOMAN seen in profile (TÊTE DE JEUNE FEMME, vue de profil; formerly called BUSTE DE FEMME), *c.* 1856. Etching, only state. 81×72 ($3\frac{3}{8} \times 2\frac{7}{8}$). LD 45. Kornfeld and Klipstein Collection, Bern.
Probably a reworking of the previous plate (LD 44). D. Rouart (see Bibliography) points out that this is an etching and not, as Delteil thought, done with the 'electric crayon'.
Included in the Degas sale of 1918, together with a proof of *The Lovers*. An impression from the cancelled plate is also in existence.

6 PORTRAIT OF AUGUSTE DE GAS, the artist's father, in fact of his grandfather RENÉ HILAIRE (PORTRAIT DIT D'AUGUSTE DE GAS), 1856. Etching and drypoint, only state. 130×107 ($5\frac{1}{8} \times 4\frac{1}{4}$). LD 2, M 4. The Art Institute of Chicago.
A drawing of this portrait can be seen in the background of the famous portrait of *The Belleli Family* in the Louvre (Jeu de Paume). As the family were in mourning for René Hilaire de Gas and his cousin Mme Belleli, the inclusion of the recently dead grandfather seems much more likely than a reference to someone still alive. This point has been made by Fries; see also the drawing in one of the notebooks in the Bibliothèque Nationale (*Carnets*, XV, p. 22). Degas had seen his grandfather in Naples in 1854, and this led Delteil to believe the etching was actually executed in Naples; in fact it appears to have been executed in Paris and to be based on a drawing. (The proof in the Fondation Doucet bears the inscription: 'Naples, 1857'.)
There are only five known proofs: (1) in the Cabinet des Estampes (formerly in the Rouart Collection); (2) in the Bibliothèque d'Art et d'Archéologie de l'Université de

Paris, Fondation Doucet (formerly in the Roger Marx Collection, no. 390 in the sale, bought for 600 francs); (3) formerly in the René de Gas and M. Guérin Collections; (4) in the Art Institute of Chicago, Sticknet Collection (1925, Guiot Collection); (5) National Gallery of Art, Washington, Rosenwald Collection (1925, Guiot Collection).

7 THE ENGRAVER JOSEPH TOURNY (LE GRAVEUR JOSEPH TOURNY), Rome, winter 1857 (not 1856 as Delteil suggests). Etching, only state. 228 × 143 (9 × 5⅝). LD 4, M 8. Staatliche Museen, Berlin.
Joseph Tourny (1817–80) was in Rome during the winter of 1857. He was a friend of Degas and certainly one of his instructors in etching, having himself won the Prix de Rome in that category in 1847. In 1857 he engraved a portrait of Baroche, President of the Council of State. It would appear that he afterwards gave up etching in order to devote himself to watercolour reproductions of 'famous pieces by the old masters' (Béraldi). Degas remained in touch with him until at least 1871.
This portrait is based on Rembrandt's *Self-portrait*, standing before an open window (Bartsch 22). Below the portrait itself are two marginal drawings.
A number of the proofs in existence are deliberately over-inked in such a way as to give a particular and distinct effect. Included in the Degas sale of 1918 were six proofs (some of which are the variants listed below under A 8.) and one 'part proof'. Proofs we know of are in: (1) the Museum of Fine Arts, Boston, bequeathed by Russell Allen in 1960 (probably the proof formerly in the Mlle Fèvre Collection); (2) the Cabinet des Estampes (formerly the Rouart Collection); (3) the Bibliothèque de l'Université de Paris, Fondation Doucet; (4) the Metropolitan Museum of Art, New York; (5) the Cincinnati Art Museum (exact duplicate of New York proof); (6) the Von Bode Museum, Kupferstichkabinett; (7) the Staatliche Museen zu Berlin, East Berlin.
In the Metropolitan Museum, New York, is an impression that apparently pre-dates the only known state. A later edition also exists, printed by Manzi on half-tone Japanese vellum (sepia and black).

8 Four variants of the PORTRAIT OF TOURNY (Quatre variantes du PORTRAIT DE TOURNY), 1857. The reason for the existence of these variants is not at all clear, unless they were experiments in printing technique – one is reminded of the 'mobile' etching advocated by Lepic.
Variant A: Here the portrait is more heavily inked and is cut off at waist-level. It was almost certainly one of the trial proofs included in the 1918 sale, probably the one described as a part proof. Has been regarded as a 1st state of A 7. Lessing Rosenwald Collection, Jenkintown, Pennsylvania. (Reproduced)
Variant B: Also printed to give an inky impression. Probably the proof reproduced on the catalogue cover for an anonymous sale at the Hôtel Drouot on 16 December 1908. Staatliche Kunsthalle, Karlsruhe. (Reproduced)
Variant C: A plate heavily inked and then wiped, in places, to give a particular blurred effect. A curtain has been added on the right-hand side. Metropolitan Museum of Art, New York.
Variant D: Reproduced by Peter Deitsch in Supplement B to the catalogue for his gallery in Paris, 1 June 1957.

9 DANTE AND VIRGIL, 'Per me si va nella citta dolente', Rome, winter 1857. Etching, 1st state (one before letters, the 2nd with letters). 116 × 86 (4⅝ × 3⅜). LD 11. Metropolitan Museum of Art, New York.
Wrongly called *Dante and Beatrice* until it was correctly identified by Marcel Guiot in 1933. Degas looked for subjects in *The Divine Comedy* (L 34). There are different treatments of this theme in drawings in one of the notebooks (*Carnets*, XXVIII, October 1856–July 1857, pp. 9, 10, 11, 17); also, in another of the notebooks, *Dante with Paolo and Francesca*.
1st state (Cabinet des Estampes, formerly in Rouart

Collection), the door and the cave are still light in colour.
2nd state (Metropolitan Museum of Art, New York; 1925, Fèvre Collection; included in Mlle Fèvre sale, 1934), the cave is black and there are two holes near the top.

10 PORTRAIT OF A YOUNG MAN, half-length; wrongly described as SELF-PORTRAIT OF DEGAS (BUSTE DE JEUNE HOMME, wrongly called DEGAS PAR LUI-MÊME), 8 November, 1857. Etching, only state, signed 'E. Degas f. 8 nov. 57'. Retouched proof. 115 × 92 (4½ × 3⅝). LD 5, M 6. Cabinet des Estampes, Bibliothèque Nationale, Paris.
This is a portrait of a friend from Rome, one of the Cal'darrosti group.
Included in the Degas sale of 1918 were two proofs (nos. 1 and 2); the first, which was described as a 2nd state proof, was (according to Delteil) a proof of the 1st state retouched with India ink – it was owned by René de Gas before passing to the Cabinet des Estampes; the second proof passed from the Fèvre Collection to the ownership of M. Guérin.

11 YOUNG MAN, SEATED, WITH VELVET BERET (JEUNE HOMME ASSIS AU BÉRET DE VELOURS), c. 1857. Etching, only state. 105 × 85 (4⅛ × 3⅜). LD 13. Kornfeld and Klipstein Collection, Bern.
Based on an etching by Rembrandt (Bartsch 268).
One proof was printed on the same sheet as A 22. Five trial proofs were included in the Degas sale of 1918 (no. 113). There is a proof in the Cabinet des Estampes, and one was auctioned at the Beurdeley sale.

12 WOMAN, wrongly described as OLD WOMAN (UNE DAME, wrongly called DAME AGÉE), c. 1857–60. Etching, 2nd and last state. 95 × 74 (3¾ × 2⅞). LD 6, M 10. Cabinet des Estampes, Bibliothèque Nationale, Paris.
Similar to portraits engraved at about this time by Bracquemond, e.g. the portrait of Meryon seated, also Whistler's portrait of Duret (1859), and several by Legros. Delteil says it resembles a drawing of a woman spinning, dated 16 August 1859.
1st state, before the background detail was added; one proof, in the Cabinet des Estampes, has been retouched by Degas and amended with a 3rd state in view; a second proof in the Rosenwald Collection, National Gallery of Art, Washington, may have been included in the Degas sale of 1919 (no. 6) together with two further proofs of this state.
2nd state, with the additional background detail, in the Cabinet des Estampes. It is possible that a 3rd state exists.

13 SELF-PORTRAIT (AUTOPORTRAIT), winter 1857 (not 1855). Etching, 1st state of five. 230 × 144 (9 × 5⅝). LD 10, M 9. Rosenwald Collection, Jenkintown, Pennsylvania.
Probably based on a drawing, in reverse, now in the Walter C. Baker Collection, New York.
1st state, an overall effect of lightness and delicacy, visually satisfying even though some lines of the face are faintly drawn; there are three proofs, one in the Cabinet des Estampes, a second in the Rosenwald Collection (Fèvre sale 1936, no. 6), and a third in the Metropolitan Museum, New York.
2nd state, deeper biting provides a greater contrast; proofs in the Cabinet des Estampes (donated by Atherton Curtis), and in the Metropolitan Museum, New York.
3rd state, a dramatic effect as the biting begins to obliterate the linear elements. Delteil read the date 1855, but it is clearly 1857. There were two proofs included in the Degas sale of 1919 (nos. 3 and 3b). One proof at the Art Institute of Chicago (anonymous sale of June 1952, 'chosen by Bracquemond'?); also Fondation Doucet, Univ. de Paris – proof formerly in the Roger Marx Collection, bought 1914 by Strölin for 2,500 francs, 'superb and very rare proof *of state*', with the background cleaned and various retouchings to the face.
4th state, the excess of black scraped away with a burnisher. One proof at the Fèvre sale, 1934 (no. 7); one proof at Art Institute of Chicago (formerly Rouart and M. Guiot

Collections), with pencil legend 'Degas by himself at 23, 1857'.

5th state, the eyes, nostrils and mouth emphasized, by Degas, who had retained the plate (by another hand according to Guérin). One proof in the Bibliothèque d'Art, Univ. de Paris, annotated: Florence, 1857, 3rd state. A further proof in the National Gallery, Washington (see above; wrongly described in Degas sale of 1919 (no. 3) as 3rd state).

The copperplate is in the Los Angeles County Museum, and there is also an impression taken from the cancelled plate in the Metropolitan Museum, New York.

14 MADEMOISELLE NATHALIE WOLKONSKA, *c.* 1867. Etching, only state. 103 × 75 (4 × 3). LD 7, M 11. Albertina, Vienna. According to Miss Boggs, this girl, who resembles Giovanna Belleli, was a relation. We also know that Degas' niece was the god-daughter of a Madame Wolkonska. The *Bottin* of 1860 tells us that a Wolkonska family lived in the rue Neuve des Mathurins – which would suggest that the portrait was not, as Miss Boggs suggested, executed in Florence.

Included in the Degas sale of 1918 (no. 24). In Marcel Guérin Collection. Impressions were also taken from the cancelled plate.

15 MADEMOISELLE WOLKONSKA, 2nd plate, *c.* 1861. Etching, 2nd and last state. 120 × 85 (4¾ × 3⅜). LD 8. The Art Institute of Chicago, the Joseph Brooks Fair Collection. This particular proof bears the stamp of Degas' studio and provenance; it was formerly in the Alfred Beurdeley and Moreau-Nélaton Collections.

1st state, without the profusion of flowers in the background; the figure less well defined; the model does not face out of the picture; the effect is that of a photograph of a first communion, indeed Guérin believes it was executed after a daguerreotype. Two proofs were included in the Degas sale of 1918 (nos. 25 and 26). Formerly in the Paul Petit, G. Viau and Alexis H. Rouart Collections.

2nd state, with the background details. See details above. Five proofs included in the Degas sale of 1918 (one bought by Mlle Fèvre). One proof in the Cabinet des Estampes (formerly in the Alexis H. Rouart Collection); another in the Fondation Doucet, Univ. de Paris.

16 THE INFANTA MARGARITA, after the Velazquez in the Louvre, *c.* 1861–2. Etching, 1st state of two. 132 × 108 (5¼ × 4¼). LD 12. Cabinet des Estampes, Bibliothèque Nationale, Paris.

There is a story that Degas was working directly on the copperplate in the Louvre when Manet came up and congratulated him; presumably, either before or after this, he must have produced an etching from a reproduction of the painting. It is difficult to be precise about the date of this piece; the meeting in the Louvre probably took place in late 1861 (according to Theodore Reff, Degas had permission to make copies in the Louvre in 1861 and 1862), yet this portrait has been thought to date from 1864–6. In one of the notebooks (dated 1859–60 by Reff) there is a partial copy in crayon which would have served for the etching. Degas betrays here the influence of the characteristic style of the Société des Aquafortistes, founded in 1862. The crude power of line recalls Manet; the more finished style of the head recalls Legros under the influence of Van Dyck; the leonine quality of the face is reminiscent of Whistler; and the way the aquatint is handled reminds one of Bracquemond's assistance with Manet's *Olympia*. Yet this is in no sense a pastiche, it has a delicacy and lightness of touch which belong entirely to Degas and is marked by his interest in human character.

1st state, Cabinet des Estampes (formerly in the Rouart Collection).

2nd state, with portions obliterated, changes to the window on the right. Included in Degas sale of 1918 (no. 112).

17 ÉDOUARD MANET, HALF-LENGTH PORTRAIT (ÉDOUARD MANET EN BUSTE), *c.* 1861. Etching and aquatint, last of four states. 130 × 106 (5⅛ × 4⅛). LD 14, M 13. Richard W. Dennison Collection, Boston, Mass. Delteil's 5th state is in fact a retouched proof of the 4th state.

1st state, pure etching. Fondation Doucet, Univ. de Paris; the Art Institute of Chicago (formerly Rouart, then Guiot Collection); one proof in the Degas sale of 1918 (no. 9) was formerly in the Roger Marx Collection, sold in 1914 for 510 francs (no. 393); one proof in Beurdeley sale, 1920.

2nd state, pure etching, with additional oblique lines at the top of the forehead, on the ear-lobe and at the point of the beard. Formerly in the Bracquemond Collection.

3rd state, jacket darkened with aquatint. Metropolitan Museum. Two proofs, wrongly described as proofs of the 2nd state, in the Degas sale of 1918, one *retroussé*, that is, produced by inking and wiping the plate during printing (nos. 10 and 11).

4th state, with additional aquatint. Three proofs, wrongly described as proofs of the 3rd state, in the Degas sale of 1918 (no. 12). Richard W. Dennison Collection, Boston; Cabinet des Estampes (formerly in Rouart Collection); Rosenwald Collection, National Gallery of Art, Washington; Cincinnati Art Museum (Degas Collection, Allyn C. Poole).

18 MANET SEATED, LEFT PROFILE (MANET ASSIS À GAUCHE), *c.* 1861. Etching, 2nd and last state. 171 × 120 (6¾ × 4¾). LD 15, M 14. Public Library, Boston, Mass.

1st state, the motif is complete. In Degas sale of 1918 (no. 13). Bibliothèque d'Art, Univ. de Paris; Formerly Bracquemond Collection.

2nd state, part of the motif is obliterated. Six proofs in Degas sale of 1918 (no. 14); one proof, in Degas sale 1919 (no. 248) has a small sketch of Manet in another pose (reproduced).

19 MANET SEATED, RIGHT PROFILE (MANET ASSIS TOURNÉ À DROITE), *c.* 1861. Etching, third state of four. 193 × 122 (7⅝ × 4¾). LD 16, M 15. The Art Institute of Chicago.

The style suggests that this is the latest of Degas' four portraits of Manet.

1st state, without the hat. Three proofs at Degas sale of 1918 (nos. 15–17), one a straight impression, two *retroussé* (inked and wiped for effect). Cabinet des Estampes (formerly Alexis H. Rouart Collection); Fondation Doucet, Univ. de Paris; Metropolitan Museum, New York; formerly Beurdeley, Bracquemond, Fenaille Collections; Museum of Fine Arts, Boston, Russell Allen Bequest, 1960.

2nd state, with the hat. Two proofs in Degas sale of 1918 (nos. 18 and 19). Fèvre sale, 1934 (no. 4). Detroit Institute of Art.

3rd state, the contours of the drawing are brought into sharper relief. In Degas sale of 1918 (no. 20). The Art Institute of Chicago (purchased from M. Lecomte).

4th state, face, hat and background scraped away with a burnisher. Five proofs at Degas sale of 1918 (no. 21).

20 MANET, *c.* 1861. Pen and lithographic ink. 250 × 400 (9⅞ × 15¾). Luigi Barbieri Collection, Italy.

Not listed by Delteil. Original drawing in pen and lithographic ink in the Fèvre Collection, with three transfer proofs. Included in sale of 29 May 1952.

21 RENÉ DE GAS, the artist's brother, *c.* 1861–2. Soft-ground etching, only state. 87 × 71 (3⅜ × 2¾). LD 3, M 5. Bibliothèque d'Art et d'Archéologie de l'Université de Paris, Fondation Jacques Doucet.

René de Gas was born in 1845 and became a journalist. According to Lemoisne, he still remembered in 1920 'the smell of acid in the flat where Degas was working in the kitchen, under Soutzo's direction'; this was in early 1857. It is possible therefore that the portrait dates from 1857 (when René was twelve) rather than from the period of experiment in 1862 (when René was seventeen).

Two proofs included in Degas sale of 1918 (nos. 22 and 23). Also one included in Manzi sale of 1919. One proof formerly in René de Gas Collection; three proofs formerly in the Mlle Fèvre Collection (at the sale of 1934, no. 2,

bought back by the family); the Art Institute of Chicago, donated in memory of Pauline K. Palmer (formerly Rouart Collection); Fondation Doucet, Univ. de Paris, probably the proof formerly in the Bracquemond Collection; Cabinet des Estampes.

22 LADY WEARING A BONNET (Mme Hertel?); (LA DAME AU BONNET), *c.* 1861–3. Etching, only state. 112 × 60 (4⅜ × 2⅜). Cabinet des Estampes, Bibliothèque Nationale, Paris.
Not listed by Delteil. An aid to dating is a fashion print, *Le Nouveau Foyer des Français. Mme de R. . . .*, executed in 1863. In 1875 the reverse side of the plate was used for the portrait of Hirsch. In his notebook (*Carnets*, XXII; 1868–73), Degas noted the following addresses: 'M. Hertel, 23, rue Germain-Pilon; Mme Hertel, chez la Comtesse H. Falsacappa, 26, via dell'Unita, Rome.' (Countess Felzacappa was the daughter of Madame Hertel; Degas drew a portrait of her in 1865.)
There is one proof printed on the same sheet as A 11. In all there are three known proofs, two in the Cabinet des Estampes (*Carnet*, I, p. 37), and the third in the Kornfeld and Klipstein Collection, Bern. *Bibliography*: P. Moses. 'Notes on an unpublished etching by Degas', *Gazette des Beaux-Arts*, October 1966.

23 MARGUERITE DE GAS, the artist's sister, *c.* 1862–5. Etching, 3rd state of four. 117 × 88 (4⅝ × 3½). LD 17, M 16. National Gallery of Art, Washington, DC.
M. Guérin says that there are five states but does not differentiate between the 4th and 5th.
This, Degas' most affectionate portrait, is of his sister, who in 1865 married M. Fèvre, an architect, and went away with him to Buenos Aires. In 1891, Degas said: 'My sister Marguerite is the only person who occasionally receives a letter from me'; and, on 4 November 1895: 'I am not exactly at my happiest, Marguerite is dead.' Pickvance believes the etching to date from *c.* 1859, yet the woman is wearing the same hat as one that appears in an engraving by Courboin dated 1865 (the hat-wearer is looking at the *Olympia*, in Octave Uzanne's *Monument esthémotique*).
1st state, on sheet of china paper; face and coat white, Degas studio; Mlle Fèvre and M. Guérin Collections, sold 29 May 1952.
2nd state, a great deal of added detail, background on left side still light in colour. M. Guérin Collection.
3rd state, with added detail, printed as an edition. Rosenwald Collection, National Gallery of Art, Washington, David Weill (sale of 1971); sold through Boerner, October 1971 (no. 4); Cabinet des Estampes (formerly Rouart Collection); formerly in Mlle Fèvre Collection.
4th state, the face is almost entirely obliterated, faint scoring over motif. Mlle Fèvre Collection, then Marcel Guérin.

24 ALPHONSE HIRSCH, 20 February 1875. Drypoint and aquatint, second and last state. 112 × 60 (4⅜ × 2⅜). LD 19, M 17. Museum of Fine Arts, Boston.
Hirsch (1843–84) was an etcher, represented in the Cabinet des Estampes by a single etching, after Goya (1868). His 'money-making sideline' was building up collections for businessmen, keeping 10 per cent commission for himself (Goncourt, *Journal*, 1877, p. 488).
It was in his garden that Manet painted *The Railway Station*. The tradition persists that on 20 February 1875 Degas, Hirsch, Marcellin Desboutin and Giuseppe de Nittis, all painter-engravers and etchers, met together to execute portraits of each other; this was presumably the idea of Desboutin, who had advocated drypoint since 1856, and of their friend Burty, another believer in the painter as etcher.
1st state, with annotation by Burty: 'the painter Alphonse Hirsch, Feb. 75 by de Gas', in Fondation Doucet, Univ. de Paris.
2nd state, with aquatint on the jacket and tie. Museum of Fine Arts, Boston, Frederick Brown Fund, 1956 (formerly Guérin Collection). A state described as 'very fine' was included in a sale of 21 June 1921. The copperplate is in the

Rosenwald Collection, National Gallery of Art, Washington.

25 ON STAGE, or PENUMBRA (SUR LA SCÈNE, or PÉNOMBRE), 1st plate, *c.* 1877. Aquatint. 70 × 104 (2¾ × 4⅛). LD 31. Kornfeld and Klipstein Collection, Bern.
One proof, *Pénombre*, in the Degas sale of 1918 (no. 110). Perhaps two proofs in the Roger Marx sale, 1914, (no. 399 or 400).

26 ON THE STAGE (SUR LA SCÈNE), 2nd plate, 1877. Softground etching, 5th state of five (or possibly six). 103 × 128 (4 × 5). LD 32, M 23. Achenbach Foundation, San Francisco.
Reproduced in the catalogue of the Degas sale of July 1919 is a so-called *dessin à l'essence* (drawing in ink thinned with turpentine?), no. 137b; this appears to be a state less finished than Delteil's 1st state and preceding it.
1st state, before most of the detail was added. Cabinet des Estampes (formerly Rouart Collection).
2nd state, additions include more tree-trunks and horizontal strokes; reproduced by Delteil. Included in Degas sale of 1918.
3rd state, the plate has been worked with a roulette, rather black effect overall. Cabinet des Estampes (formerly Rouart Collection); formerly in Bracquemond Collection; proof in Degas sale (?); Museum of Fine Arts, Boston (acquired 1963).
4th state, the edges of the plate are cleaned up and the corners squared off.
5th state, the plate is bevelled. This state was published in the guide to the Salon of 1877 of the Friends of the Arts in Pau. (The Salon opened on 8 January; in 1878 *The Cotton Merchants' Office* was bought by the Pau Museum.) Originally in Degas sale (?), a proof in bistre in the Philadelphia Museum, one in black ink in the Art Institute of Chicago, and one in the Achenbach Foundation, San Francisco (formerly C. J. F. J. Maasen Collection, acquired 1964).
Between 1911 and 1921 several proofs were sold without any indication of their state: sale of 21 February 1911; November 1911 (to Sagot); May 1913 (to Strölin); Roger Marx sale of 1914 (no. 396); 13 March 1917; 29 October 1918; and 13 March 1921.

27 ON STAGE (SUR LA SCÈNE), 3rd plate, 1877. Soft-ground etching, 4th and last state. 123 × 160 (4⅞ × 6⁵⁄₁₆). LD 33, M 24. Cabinet des Estampes, Bibliothèque Nationale, Paris. Probably a study for the version above, as sent to the Salon of 1877.
1st state, before the addition of the horizontal and sloping lines in the later states. Two proofs at the Degas sale of 1918.
2nd state, with sloping strokes across one leg of the dancer on the right. Degas sale (?).
3rd state, with horizontal strokes on the dancer's skirt. One proof (wrongly described as of 2nd state) in Degas sale of 1918.
4th state, most of the plate obliterated. Cabinet des Estampes; five proofs in the Degas sale of 1918.

28 DANCERS IN THE WINGS (DANSEUSES DANS LA COULISSE), *c.* 1877. Etching and aquatint, 5th state of nine. 140 × 103 (5½ × 4). LD 26, M 26. Bibliothèque d'Art et d'Archéologie de l'Université de Paris, Fondation Jacques Doucet.
Not 1875, as Delteil suggests, but related to the work of 1878–9.
1st state, with three dancers. In Degas sale of 1918 (no. 70).
2nd state, with aquatint used on the right to represent a stage flat. In Degas sale of 1918 (no. 71).
3rd state, with four dancers. In Degas sale of 1918 (no. 72).
4th state, with five dancers. Four proofs in Degas sale of 1918 (no. 73). Rosenwald Collection, National Gallery of Art, Washington.
5th state, the hair of three of the dancers heavily reworked, creating patches of black. Two proofs in the Degas sale of 1918 (no. 74). Fondation Doucet, Univ. de Paris.
6th state, the hair is now paler, and the face and head of the

dancer second from the front is sharply etched. In Degas sale of 1918 (no. 75).

7th state, the dancer with only her hair showing is replaced by one who towers above the others. In Degas sale of 1918 (no. 76). The Art Institute of Chicago, Joseph Brooks Collection (bought from G. Cramer).

8th state, the base of the flat on the left partially conceals the dancer second from the front. Eight proofs in the Degas sale of 1918 (nos. 77 and 80). Cabinet des Estampes; Achenbach Foundation, San Francisco; formerly Le Garrec Collection, 1937; formerly Alexis H. Rouart Collection.

Marcel Guérin inserted an additional state between the existing 3rd and 4th, in which the fourth dancer is complete but the fifth has not yet been added.

29 BEHIND THE SAFETY CURTAIN (DERRIÈRE LE RIDEAU DE FER), c. 1877-8. Trial piece, aquatint and drypoint, only state. 159×118 ($6\frac{1}{4} \times 4\frac{11}{16}$). LD 21, M 18. Cabinet des Estampes, Bibliothèque Nationale, Paris.

Plate etched in aquatint, with resin, white areas scraped with a burnisher. The figure is in drypoint, and scraped with a burnisher. The right hand appears to have been drawn in white, wiped off, then redrawn in drypoint and darkened.

One proof in the Degas sale of 1918 (no. 86). A good proof in the Fèvre sale of 22 October 1921, presumably the one acquired through C. G. Boerner for the Albertina, Vienna.

30 AUX AMBASSADEURS, c. 1877. Etching, aquatint and drypoint, 3rd and last state. 266×296 ($10\frac{1}{2} \times 11\frac{5}{8}$). LD 27, M 25. Rosenwald Collection, National Gallery of Art, Washington, DC.

Marcel Guérin suggests there may be five states but offers no proof of this. Possibly he is referring to the mention in the catalogue of the Degas sale of 1918 (nos. 68 and 69) of a half-obliterated plate and a spoilt sheet. Delteil suggested a date of 1875, which is certainly too early.

1st state, one figure only, before the background detail. One proof in the Degas sale of 1918 (no. 68); Albertina, Vienna (acquired through Gobin, together with the 3rd state in 1922).

2nd state, two figures, shadowy background, globes outlined. Cabinet des Estampes and Carnet VIII. One proof in Degas sale of 1918 (no. 69).

3rd state, piece of scenery enlarged, heavy inking for effect. Rosenwald Collection, National Gallery of Art, Washington; Fondation Doucet, Univ. de Paris.

There is one proof (3rd state?) heightened with pastel in the Louvre (Camondo Collection), dated 1885. An impression from the cancelled plate is in the Art Institute of Chicago, acquired through C. G. Boerner.

31 ACTRESSES IN THEIR DRESSING ROOMS (LOGES D'ACTRICES), c. 1879-80. Etching and aquatint, 3rd state of five. 160×212 ($6\frac{5}{16} \times 8\frac{3}{8}$). LD 28, M 32. Rosenwald Collection, National Gallery of Art, Washington, DC.

One of Degas' masterpieces. Delteil is wrong in suggesting 1875, Mary Cassatt's date is the correct one. The states as described by Delteil need revision too; his description of the 3rd state does not correspond to the illustration. We believe there are probably more than five states.

1st state (according to Delteil), the legs of the actress on the right have not yet been engraved. In the Degas sale of 1918 (no. 54).

2nd state, the legs are engraved, and the shadow of the chair is cast on the central partition. Cabinet des Estampes (formerly Rouart Collection); the Art Institute of Chicago; the Albert H. Wolf Memorial Collection (without the shadow of the chair, but in all other respects like 2nd state). In Degas sale of 1918 (no. 55).

3rd state, the shadow has disappeared and the panelling is not decorated. In Degas sale of 1918 (no. 56). Rosenwald Collection, National Gallery of Art, Washington. Part of the plate is pitted, where the varnish has eaten into the bite.

4th state, the panelling has a pattern. Four proofs in the Degas sale of 1918 (no. 57).

5th state, Stanford Art Museum; Albertina, Vienna (formerly in Sagot Collection); Fondation Doucet, Univ. de Paris (formerly in Bracquemond Collection).

32 WASHERWOMEN, also called WOMAN IRONING (LES BLANCHISSEUSES or LA REPASSEUSE), c. 1879. Etching and aquatint, 4th and last state. 118×160 ($4\frac{11}{16} \times 6\frac{5}{16}$). LD 37, M 33. Rosenwald Collection, National Gallery of Art, Washington, DC.

Note a reference in La Cigale, by Meilhac and Halévy, to an Impressionist painter getting ready to paint a washerwoman, setting up the washtub and clothes lines in his studio.

1st state, before the addition of vertical lines to the uprights and background, with a bowl on the table. Two proofs in Degas sale of 1918 (nos. 90 and 91), second proof retroussé (inked for effect). Exteens Collection, British Museum.

2nd state, with the addition of the vertical lines; the bowl is bigger and extends to the edge of the table; no aquatint. Proofs in the Degas sale of 1918 (nos. 92 and 92b). Bracquemond Collection.

3rd state, with the two patches of aquatint; the big bowl has disappeared. Proofs in the Degas sale of 1918 (nos. 93 and 94). Fondation Doucet, Univ. de Paris, proof sold at Roger Marx sale in 1914 (no. 395).

4th state, many individual elements have disappeared and there is an overall grey effect. Three proofs in the Degas sale of 1918 (no. 95). Rosenwald Collection, National Gallery of Art, Washington; Cabinet des Estampes (formerly Rouart Collection). M. Guérin says there is a proof of the 3rd or 4th state, signed, and heightened with pastel.

33 SINGER AT A CAFÉ CONCERT (CHANTEUSE DE CAFÉ CONCERT), c. 1878. Lithograph, 1st state of two. 252×192 ($9\frac{7}{8} \times 7\frac{1}{2}$). LD 53. The Art Institute of Chicago, Charles Derring Collection.

1st state, no detail in the foreground. Five proofs in the Degas sale of 1918 (nos. 132-6). Cabinet des Estampes (formerly Rouart Collection); Museum of Fine Arts, Boston (formerly Bracquemond, Delone, Barrion, Beurdeley and Russell Allen Collections); the Art Institute of Chicago (Derring Collection).

2nd state, foreground complete. One proof in the Degas sale of 1918 (no. 137). There is also a 'superb, very rare, proof', included in the sale of February 1914.

34 WOMAN WITH FAN or BOX NEAR THE STAGE (FEMME À L'ÉVENTAIL or LOGE D'AVANT-SCÈNE), c. 1878-79. Lithograph, only state. 231×206 ($9 \times 8\frac{1}{8}$). LD 56. Cabinet des Estampes, Bibliothèque Nationale, Paris.

Proof in Cabinet des Estampes (formerly Rouart Collection); Museum of Fine Arts, Boston (formerly Beurdeley, Bracquemond and Russell Allen Collections). One proof in the Degas sale of 1918 (no. 145). One proof in the Roger Marx sale of 1914 (no. 408), sold to Meder for 2,500 francs.

35 IN THE WINGS (DANS LA COULISSE), c. 1879-80. Lithograph, only state. 240×171 ($9\frac{1}{2} \times 6\frac{3}{4}$). LD 59. Den Kongelige Kobberstik Samling, Statens Museum for Kunst, Copenhagen.

The legend H. et Cie refers to Haviland, an industrialist and a famous collector, at whose house in Auteuil Degas worked on this lithograph. There were three proofs in the Degas sale of 1918, two on china paper and one heavily wiped proof (nos. 142 and 144); Beurdeley, Bracquemond, Fenaille and Viau Collections. One proof in the Cabinet des Estampes (formerly Rouart Collection); one in the Albertina, Vienna (on Japanese vellum, formerly in S. Meder Collection, 1923).

36 TWO DANCERS or IN THE WINGS (DEUX DANSEUSES or DANS LA COULISSE), 1878-9. Electric crayon (carbon pencil), two states. 112×102 ($4\frac{3}{8} \times 4$). LD 23, M 20.
a 1st state. Kornfeld and Klipstein Collection, Bern.
b 2nd and last state. Bibliothèque d'Art et d'Archéologie de l'Université de Paris, Fondation Jacques Doucet.
Mrs Browse realized the accepted date of 1875 was

probably wrong (this is the date given by Delteil, also Adhémar-Lethève), and suggested 1875–80. In our view this piece should be grouped with others executed with the electric crayon, probably in 1879–80; but it must be admitted that the decorative line-drawing here is in a rather different spirit.

1st state, one dancer only. Pellet Collection; Kornfeld and Klipstein Collection, Bern.

2nd state, greatly modified, with two dancers. City Art Museum, St Louis (stolen); Mr and Mrs Alexander J. Oppenheimer Collection, San Antonio, Texas (no doubt the above are the two proofs in the Degas sale of 1918); Fondation Doucet, Univ. de Paris, formerly in Roger Marx Collection; Cabinet des Estampes (formerly Rouart Collection and before that in Viau Collection); C. de C. sale, June 1919 (china paper); Albertina, Vienna (formerly Roger Marx Collection, 1914).

37 TWO DANCERS (DEUX DANSEUSES), c. 1876–7. Aquatint and drypoint, only state. 159 × 118 (6¼ × 4¹¹⁄₁₆). LD 22, M 18. Metropolitan Museum of Art, New York.
This and the preceding aquatints occupy a curious position in Degas' work. It is far from clear what technique precisely has been used. It would seem that the aquatint grain was applied thickly, the white strokes drawn with a burnisher and the black lines added by means of drypoint. The obvious amendments to the standing figure seem to indicate that Degas composed directly on to the plate. In the top right-hand corner, as in A 33, the word 'Berlin' is visible; this probably indicates the place of origin of the plate.
Six proofs in the Degas sale of 1918 (no. 84). Metropolitan Museum, New York (acquired 1925 through the Dick Fund); proof formerly in Bracquemond, Lerolle, Fenaille and David Weill Collections, sold through C. G. Boerner in October 1971 (no. 5).

38 DANCER WALTZING (DANSEUSE VALSANT), c. 1878. Drypoint. 99 × 138 (3⅞ × 5⅜). LD 18. Mn.d. Cabinet des Estampes, Bibliothèque Nationale, Paris. In Degas sale of 1918 (no. 87), Cabinet des Estampes.

39 SINGER (UNE CHANTEUSE), c. 1878. Aquatint and soft-ground etching, third and last state. 160 × 119 (6¹⁵⁄₁₆ × 4¹¹⁄₁₆). LD 25, M 22. City Art Museum, St Louis, Mo.
1st state, the arms and background have not yet been added. Two proofs at the Degas sale of 1918 (no. 51).
2nd state, the arms are added. Cabinet des Estampes (formerly Rouart Collection). One proof in the Degas sale of 1918 (no. 52).
3rd state, the singer's dress is extended to the foot of the plate, there are indications of a plant and a second figure. Two proofs in the Degas sale of 1918 (no. 53). City Art Museum, St Louis; Delteil mentions 'a variant in reverse' (a counterproof?) in the fourth Degas sale of July 1919 (no. 137c).

40 SINGER IN PROFILE (PROFIL DE CHANTEUSE), c. 1878. Etching and aquatint, 3rd and last state. 68 × 86 (2⅝ × 3⅜). LD 24, M 21. Pretenkabinet, Rijksmuseum, Amsterdam.
In style related to the engravings of 1877–8, rather than those of 1875 as Delteil suggested. Compare with Manet's Singer at a Café-concert (JW 332), which is dated 1879.
1st state, still in effect a line-etching, without the globes. In Degas sale of 1918 (no. 88).
2nd state, with globes added, but no aquatint. In Degas sale of 1918 (no. 88).
3rd state, aquatint added, very intense black. In Degas sale of 1918 (no. 88). Rijksmuseum, Amsterdam; Cabinet des Estampes.

41 THE DOG SONG (LA CHANSON DU CHIEN), c. 1877–8. Lithograph, only state. 352 × 231 (13⅞ × 9). LD 48. Cabinet des Estampes, Bibliothèque Nationale, Paris.
La Vie Parisienne (18 May 1878) quotes the following comment attributed to the singer Thérésa: 'All of Paris knows I've got a big mouth. And I intend to use it to sing

well.' Related to the painting (L 380) in the Havemeyer Collection, New York. A study for this motif (Charles Durand-Ruel Collection) was exhibited and also reproduced in the travelling exhibition organized by Miss Jean Boggs in 1967 (no. 81). Two proofs in Degas sale of 1918 (nos. 140 and 141). Delteil refers to two proofs, owned by Bracquemond and Rouart, the latter presumably being the print now in the Cabinet des Estampes. The Museum of Fine Art, Boston (Russell Allen Bequest) owns a proof with provenance listed as Roger Marx Collection; sale of 1914 (no. 403); Frapier; Guiot.

42 MADEMOISELLE BÉCAT AUX AMBASSADEURS, c. 1877. Lithograph, only state. 205 × 193 (8⅛ × 7⅝). LD 49. Library of Congress, Washington, DC.
La Vie Parisienne (11 January 1879) offered the following description of this type of singer: 'not much voice but . . . a real woman, underscoring the risqué lines with a gesture and a look, attractive motions with the arms, a peculiar way of standing, rather like a bird perching, leaning forward in an attitude of surrender.' Thanks to an article by Mlle Peyre (Gazette des Beaux-Arts, October 1967), the name of Mlle Bécat is quite a familiar one.
In his account of the fourth Impressionist exhibition (1879), Zola describes works by Degas: 'café-concerts of astounding life, the divas craning forward over the smoky lamps, lips apart.' The memory of these singers must have stayed with Degas for, in 1883 (Lettres de Degas recueillies par M. Guérin, p. 57), he recommended Lerolle to go and hear 'that admirable artist' Thérésa: 'She opens her large mouth and out comes the most vulgar and most moving voice you have ever heard.'
One proof in the Cabinet des Estampes (formerly in Rouart Collection); one proof in Fondation Doucet, Univ. de Paris (formerly Roger Marx Collection and sale in 1914, no. 4). Fourteen proofs included in the Degas sale of 1918 (nos. 118–29); of which one is in the Library of Congress, Washington (formerly Beurdeley?); another in the Museum of Fine Arts, Boston (Russell Allen Bequest, formerly Rouart Collection); and another in the Art Institute of Chicago (Degas' studio, then Guiot). See also the preparatory drawings in some of the notebooks.

43 MADEMOISELLE BÉCAT AUX AMBASSADEURS, plate with three motifs, c. 1877. Lithograph, only state. 291 × 243 (11½ × 9½). LD 50. The Art Institute of Chicago.
See also the monotype (C 4), a first attempt at this subject. Three proofs in the Degas sale of 1918 (nos. 129–31). Proofs now in the Art Institute of Chicago, Clarence Buckingham Collection (formerly C. Jacquin Collection); Cabinet des Estampes (formerly Rouart Collection); Fondation Doucet, Univ. de Paris (formerly Roger Marx Collection, sale, 1914, no. 404, sold for 4,600 francs); Museum of Fine Arts, Boston (gift of George Peabody Gardner, 1931). M. Guérin owned the top half of an impression, touched with pastel (formerly Zakarian Collection).

44 FOUR HEADS OF WOMEN (QUATRE TÊTES DE FEMMES), c. 1877–9. Lithograph, only state. 219 × 182 (8⅝ × 7¼). LD 54. The Art Institute of Chicago.
The woman wearing the hat is probably Ellen Andrée, the woman on the left most probably Thérésa. The portrait bottom right may be of Mme Faure, she of the 'stern profile, who sang The Fireman's Sister' (La Vie Parisienne, 19 July 1879). The basis of one of the portraits is the first proof of a monotype (C 38).
Two proofs in the Degas sale of 1918 (no. 177 on china paper, no. 178 on plain white). Proofs now in: the Art Institute of Chicago, Clarence Buckingham Collection (formerly Fenaille?); Fondation Doucet, Univ. de Paris (formerly Roger Marx Collection, sale 1914, no. 405, sold for 3,000 francs to Strölin); Cabinet des Estampes (formerly Alexis H. Rouart Collection).

45 AT THE CIRQUE MÉDRANO and NUDE WOMAN AT THE DOOR OF HER ROOM; (AU CIRQUE MÉDRANO; FEMME NUE

À LA PORTE DE SA CHAMBRE), plate with two motifs, 1876–9. Lithograph, only state. 162 × 252 (6⅜ × 9⅞). LD 46, 47. The Art Institute of Chicago.
According to Guérin these are monotypes transferred on to lithographic stone and reworked with litho pencil and scraper. Note the resemblance to the monotype C 128 (Janis 180).
Two proofs in Degas sale of 1918 (no. 146). Proofs now in the Art Institute of Chicago, Clarence Buckingham Collection (formerly Rouart Collection); Fondation Doucet, Univ. de Paris (Roger Marx Collection and sale 1914, no. 401); Cabinet des Estampes (formerly Rouart Collection).

46 LA TOILETTE; MARCELLIN DESBOUTIN; CAFÉ-CONCERT, plate with three motifs, c. 1876–8. Lithograph, 2nd and last state. 173 × 200 (6¾ × 7⅞). LD 55. Private collection.
The portrait of Desboutin is after a monotype of c. 1876.
1st state, in Degas sale of 1918 (no. 175); formerly Beurdeley Collection.
2nd state, overall effect is lighter – face, thighs of woman and apron – and hair reworked with scraper, no water in the bath. In Degas sale of 1918 (no. 176), reproduced Delteil. In private collection.
Degas pulled separate impressions of the Desboutin portrait, and of the left-hand motif (2nd state in Cabinet des Estampes, purchased from Rouart).

47 MAID COMBING HAIR (SUIVANTE DÉMÊLANT DES CHE-VEUX), c. 1876–9. Lithograph touched with ink, first state of two. 203 × 220 (8 × 8⅝). LD 62. Cabinet des Estampes, Bibliothèque Nationale, Paris.
Kornfeld suggests a date of c. 1890. Guérin believes it was drawn with printer's ink, probably on celluloid, then transferred on to lithographic stone.
1st state, before modification. In Degas sale of 1918 (no. 178b). Cabinet des Estampes ('no doubt the only proof' – Kornfeld, 1965).
2nd state, 'some areas removed with the scraper . . . and various modifications to the maid's hair and head.' One proof in the fourth Degas sale under the title *Impression* (no. 359).

48 SMALL BATHROOM (LE PETIT CABINET DE TOILETTE), c. 1879–80. Etching and electric crayon, 3rd state of four. 120 × 79 (4¾ × 3⅛). LD 34. The Art Institute of Chicago.
Note the similarities with later works of Bonnard and Vuillard.
1st state, before the addition of details, overall greyish effect. In Degas sale of 1918 (no. 100). Klipstein.
2nd state, with details added on day bed, sharper in general. Albertina, Vienna (acquired Sagot, 1923); Klipstein.
3rd state, aquatint bottom left-hand side. In Degas sale of 1918 (no. 101), wrongly described as proof of 2nd state. The Art Institute of Chicago, William McCallin McKee Memorial Collection.
4th state, further detail added, toilet articles more heavily outlined. In Degas sale of 1918 (no. 103). The Art Institute of Chicago (acquired through Cramer).

49 WOMAN GETTING OUT OF THE BATH (LA SORTIE DU BAIN), c. 1879–80. Electric crayon, etching, drypoint and aquatint. 127 × 127 (5 × 5). LD 39, M 35.
a 7th state of fifteen (Delteil). Museum of Fine Arts, Boston.
b 15th and last state (Delteil). Museum of Fine Arts, Boston.
There were fifteen states, according to Delteil; now it is thought there may have been as many as thirty-nine, plus ten intermediary states. Degas worked particularly hard at this plate, which he started one morning at Alexis Rouart's house after slippery ice had prevented him returning to his home. Rivière saw in it 'the spite of a disappointed bachelor'. Degas was conscious of this and said: 'Perhaps I have considered woman too much as an animal.' Previously he had said to Rouart, 'our friend Mme . . . must look like that when she gets out of her bath.' There is the

same fascination with ugliness and vulgarity in his reference to Mme Ganderax in 1891: 'She's ugly and ordinary enough for me to like her very well.'
Dates as late as c. 1882 have been suggested for this piece, but we believe that Degas was using the electric crayon for the first time. The fifteen states and forty-three proofs (according to Delteil) were represented at the Degas sale of 1918 (nos. 96–9). It is impossible to discuss each state in detail as not all have even been reproduced and are not therefore available for study. Degas drew partly on a monotype on this theme (C 133).
There are two proofs of the 1st state, in the Art Institute of Chicago (Degas sale of 1918, no. 96) and the Albertina, Vienna; one of the 2nd state in the Galerie Michel; proofs of the 4th state in the Art Institute of Chicago, the Library of Congress, Washington, and the Kupferstichkabinett, Berlin; proofs of the 8th and 9th state in the Metropolitan Museum, New York; and of the 7th and 15th in the Museum of Fine Arts, Boston.

50 HEAD AND SHOULDERS OF A WOMAN (BUSTE DE FEMME), c. 1878–9. Aquatint, only state. 110 × 110 (4⅜ × 4⅜). LD 42, M 29. The Metropolitan Museum of Art, New York.
The proof in the Metropolitan Museum is 'unique', according to Mary Cassatt who described it as an *essai à l'essence, grain liquide*. This would point to the use of ink thinned with turpentine and of a liquid ground, but the precise technique employed is obscure. This experimental piece dates from the period when Degas and Mary Cassatt worked together, exploring new processes. Mary Cassatt's *The Fan* and *The Loge* are contemporary with this plate.

51 WOMAN WEARING MANTILLA (FEMME À LA MANTILLE), c. 1879. Aquatint, only state. 160 × 118 (6⁵⁄₁₆ × 4¹¹⁄₁₆). LD 43. Private collection, Chicago. Like Delteil we know only of a small number of proofs taken from the unfinished plate after it was cancelled.

52 THE ACTRESS ELLEN ANDRÉE (L'ACTRICE ELLEN ANDRÉE; formerly called FEMME DEBOUT AU LIVRE), c. 1879. Electric crayon, 1st state of three. 114 × 79 (4½ × 3⅛). LD 20, M 28. Den Kongelige Kobberstik Samling, Statens Museum for Kunst, Copenhagen.
This 'exquisite flirt', to quote an interviewer of 1891, wears an almost identical costume in *Sketch of Portraits in a Frieze* (L 532), shown at the fourth Impressionist exhibition in 1879. The young actress is also seen with Desboutin in *The Absinthe Drinker* (c. 1876). Vollard tells us Degas thought her so talented that 'he would go down to the theatres on the boulevards just to see her act'. See also a drawing in the Boggs catalogue, p. 50.
1st state, not known by Delteil. Proof in Copenhagen (as above).
2nd state, no indication of ground. In Degas sale of 1918 (no. 104). Metropolitan Museum, New York.
3rd state, seven proofs in the Degas sale of 1918 (no. 105). Rosenwald Collection, National Gallery of Art, Washington.

53 MARY CASSATT IN THE LOUVRE, Museum of Antiquities (MARY CASSATT AU LOUVRE, Musée des Antiques), 1879–80. Etching, aquatint and electric crayon. 267 × 230 (10½ × 9). LD 30.
a 2nd state of six. The Art Institute of Chicago.
b 6th and last state. Kupferstichkabinett, Berlin.
We believe Degas took particular care over this piece as it was intended to advertise the journal *Le Jour et la Nuit* which Degas planned to edit in collaboration with friends; we also believe 1876, the date suggested by Delteil, to be too early (there are several reproductions of drawings in the fourth Degas sale, nos. 249, 250).
1st state, only the two figures, one in outline. Roger Marx sale, 1914, '1st state before the background'; Degas sale of 1918 (no. 48); David Weill sale, 1971.
2nd state, figures shaded, no background. In Degas sale of 1918 (no. 49). The Art Institute of Chicago (Rouart proof).
3rd state, background added but no diagonal lines on the

floor. Louvre, Paris; Metropolitan Museum, New York (Rogers Fund).

4th state, diagonal lines on floor added, no vertical lines on book. Cleveland Museum, Ohio (Charles W. Harkness Endowment Fund), acquired 1927 from Knoedler; Boymans van Beuningen Museum, Rotterdam.

5th state, with vertical lines on book. Alexis H. Rouart Collection; Brooklyn Museum; Albertina, Vienna (Sagot Collection).

6th state, with vertical lines over the diagonals already there. An edition of 100 printed on Japanese paper. Fourteen proofs on Japanese paper in Degas sale of 1918, plus a further six (no. 60). Included in sale of 31 March 1920. Cabinet des Estampes; the Art Institute of Chicago (formerly Albert Roullier Collection, retouched in red crayon on jacket); Achenbach Foundation, San Francisco (acquired through Colnaghi, 1970); Grunwald Graphic Art Foundation, University of California (gift of Mr and Mrs Grunwald, 1957). Kupferstichkabinett, Berlin.

54 MARY CASSATT in the Louvre, looking at paintings (Au Louvre, la peinture, MARY CASSATT), c. 1879–80. Etching, aquatint, drypoint and electric crayon. 301 × 125 (11⅞ × 5). LD 29, M 31.
 a 3rd state of twenty (?). The Art Institute of Chicago.
 b 12th state of twenty (?). The Art Institute of Chicago.
For the sale of the contents of Degas' studio, fifteen states were catalogued, but Delteil counted twenty. This is very much an open question as there are almost certainly more than twenty states, and the order suggested by Delteil is far from easy to follow.
1st state, almost a pure line-etching, with a light aquatint grain. Two proofs in Degas sale of 1918 (nos. 28 and 29). Cabinet des Estampes (formerly Rouart Collection).
2nd state, added detail but no background. Two proofs in Degas sale of 1918 (no. 30). Cabinet des Estampes (Rouart proof); the Art Institute of Chicago.
3rd state, part of edge of doorway, first details of floor. In Degas sale 1918 (no. 31). The Art Institute of Chicago (probably Rouart proof).
4th state, chief addition is second band of floor. In Degas sale of 1918 (no. 32).
5th state, with the skirting on the dado. Two proofs in Degas sale of 1918 (no. 38).
6th state, the second band of floor is accentuated and brought forward. Degas sale (nos. 41 and 47).
7th state, the edge of doorway encroaches on seated woman and the shape of Mlle Cassatt's hat is altered. Cleveland Museum, Ohio, gift of Leonard C. Hannager (included in Degas studio sale).
8th state, 'nine vertical strokes on the floor, above Miss Cassatt's hand.'
9th state, 'heavy almost horizontal strokes on the right side of the book.'
10th state, 'different decoration for edge of doorway. Aquatint grain on the features of the seated woman and on the book.' Cabinet des Estampes; formerly Rouart Collection.
11th state, 'erasures on the hair, clothes and paintings . . . a patch of aquatint on the skirting below the dado.'
12th state, retouching on the clothes and a grain of aquatint on the floor.
13th state, change in decoration on edge of doorway, third band of flooring. Cleveland Museum, Ohio (purchased from Knoedler, 1927).
14th state, only a trace remains of third band of flooring.
15th state, 'aquatint on floor erased between the door-edge and foot of seated woman; a trace of aquatint between the skirt and hand of the woman standing.' The Art Institute of Chicago, Walter S. Brewster Collection.
16th state, modification to edge of doorway (zigzag lines). Formerly H. Loys Deltail Collection.
17th state, grain of aquatint on the edge of door frame and the floor. (Reproduction touched with pastel in Art Institute of Chicago.)
18th state, grain of aquatint over almost whole of door frame and over floor. Formerly A. Martin Collection.

19th state, door frame simplified, and with a vertical groove run down the whole of its length. Formerly Viau Collection.
20th state, lines on the dado removed and replaced by aquatint. Black, rather heavy effect. Bibliothèque de l'Univ. de Paris; Carré Collection; J. Picot; A. Rouart.

55 SCHEME FOR A PROGRAMME (PROJET DE PROGRAMME), 1884. Soft-ground etching, 2nd state of four. 248 × 312 (9¾ × 12¼). LD 40, M 36. Cabinet des Estampes, Bibliothèque Nationale, Paris.
The final programme was executed as a lithograph (see entry below).
1st state, pure etching, without the signature on the sheet music. Formerly M. Guérin Collection.
2nd state, etching and aquatint. Cabinet des Estampes (formerly Rouart Collection).
3rd state, with further detail added and, bottom left, two lines to show white area. A proof of this etching in the Degas sale of 1918 (no. 114) gives no clue as to its state (Delteil believed 2nd and Guérin 3rd state).
Four different preparatory drawings were included in the fourth Degas sale, 1919 (nos. 257 and 258).

56 PROGRAMME for the reunion of former pupils of the Lycée de Nantes (PROGRAMME de la soirée des anciens élèves du Lycée de Nantes), 1884. Lithographic transfer of A 55 (above), only state. 270 × 380 (10⅝ × 14¹⁵⁄₁₆). LD 58. Cabinet des Estampes, Bibliothèque Nationale, Paris.
Among the artists who took part in this gala evening were Mlles Sabra, Mérante and Reichenberg, models or acquaintances of Degas, any one of whom could have asked him to design the programme. According to a letter written by Degas (Lettres, ed. M. Guérin, pp. 82–4), there was a second edition printed by Lemercier in 1895, consisting of twelve proofs.
Degas was very annoyed when Bouvenne exhibited the lithograph without asking his permission. 'I like to appear, at all occasions, in the costume and carrying the baggage of my own choosing. I cannot in the least congratulate you on this curious act of effrontery.'
Proofs in: Cabinet des Estampes (formerly Rouart Collection); Bibliothèque de l'Univ. de Paris (formerly Roger Marx Collection and sale, 1914, no. 409).

57 HORSES IN THE MEADOW (CHEVAUX DANS LA PRAIRIE), 1891–2. Soft-ground etching, 2nd state of three. 135 × 167 (5¼ × 6½). LD 66, M 39. Rosenwald Collection, National Gallery of Art, Washington, DC.
Marcel Guérin tells us that this engraving, like the following item, was intended as an illustration for a de luxe edition of the book by G. Lecomte (see below); it was, he says, based on a reverse image of a Degas painting dated 1871 (L 71; Theodore Reff refers to numerous studies in the notebooks of 1867–74); originally the task was entrusted to an engraver called Auguste Lauzet, who worked between 1865 and 1898, but Degas was unhappy with what he was doing and took it over. (Seen by Guérin in the de luxe edition of fifty of Lecomte's book.)
1st state, darker, otherwise close to following state. In sale of 1 December 1925 (Guérin Collection?).
2nd state, lighter in tone with additional etching. Rosenwald Collection, National Gallery of Art, Washington.
3rd state, Cabinet des Estampes.

58 DANCER ON STAGE, TAKING HER BOW (DANSEUSE SUR SCÈNE, SALUANT), 1891–2. Soft-ground etching and aquatint, 2nd state of two. 170 × 103 (6⅝ × 4). M 38. Durand-Ruel Collection, Paris.
Not known by Delteil. A note on the part of Mlle Paule Cailac, in the archives of J. Cailac, reveals that a proof of this engraving was discovered in the Durand-Ruel archives in 1925, together with a letter from Degas giving him the plate – which he had executed, like Les chevaux sortant du pré (A 57) as an illustration for G. Lecomte's L'Art Impressionniste (1892). The print is based on a Degas picture (L 490) then in the possession of Durand-Ruel.

1st state, no aquatint or black lines. In sale of 9 December 1925.
2nd state, with aquatint and heavy black lines. Durand-Ruel Collection.

59 TREES (LES ARBRES), *c.* 1892. Aquatint, 1st state of two. 386 × 401 (15¼ × 15¾). Cabinet des Estampes, Bibliothèque Nationale, Paris.
No reference to this etching by either Delteil or Moses.
1st state, 'etching done by Degas in my studio, Jeanniot'. Cabinet des Estampes.
2nd state, reworking of ground; 'done under his direction by me, Jeanniot'. Cabinet des Estampes. Edition of twenty-five (no. 18).

60 DANCER PUTTING ON HER SHOE (DANSEUSE METTANT SON CHAUSSON), *c.* 1892. Etching, only state. 179 × 117 (7 × 4⅝). LD 36, M 37. The Art Institute of Chicago.
Probably intended, like the preceding plates, as an illustration. Four proofs in the Degas sale of 1918. The Art Institute of Chicago (formerly Rouart, M. Guiot Collections); Fondation Doucet, Univ. de Paris.

61 THREE NUDE DANCERS PUTTING ON THEIR SHOES (LES TROIS DANSEUSES NUES METTANT LEURS CHAUSSONS), *c.* 1891–2. Soft-ground etching with pastel, only state. 195 × 268 (7⅝ × 10½). LD 41. Kornfeld and Klipstein Collection, Bern.
In a letter of 6 July 1891, Degas announced his intention of producing a series of lithographs of 'nudes of the dance'. In fact this is all he did although there are splendid drawings in much the same spirit (notably in the January 1966 exhibition at the Marlborough Gallery, London, provenance René de Gas, incorrectly dated 1900). The proof retouched by Degas and included in the Degas sale of 1918, no. 198 (described as a lithograph) passed to the Pellet, then the Guérin Collection, and is now owned by Kornfeld and Klipstein, Bern.

62 NUDE WOMAN AT HER TOILET, STANDING (FEMME NUE DEBOUT À SA TOILETTE), *c.* 1891. Lithograph, only state. 449 × 319 (17⅝ × 12½). LD 57. British Museum, London.
Transfer on stone of a wash drawing. The British Museum has a proof in bistre (Degas sale of 1918, no. 161; Bing Collection).

63 NUDE WOMAN AT HER TOILET, STANDING (FEMME NUE DEBOUT À SA TOILETTE), *c.* 1890. Lithograph, 3rd state of four. 333 × 245 (13⅛ × 9⅝). LD 65. Kupferstichkabinett, Berlin.
For comments on this and the preceding lithograph, see E. W. Kornfeld ('the 4th state according to Delteil is, in fact the 2nd').
1st state, hair not hanging loose. In Degas sale of 1918 (n. 162). Fondation Doucet, Univ. de Paris.
2nd state, more pronounced modelling of the woman's body. Four proofs known to Kornfeld: in former collections of M. Guérin (sale 9 December 1921); Beurdeley; Fenaille; A. H. Rouart.
3rd state, with loose hanging hair. About a dozen known proofs in: Degas sale of 1918 (no. 164); Kupferstichkabinett, Berlin; Dr and Mrs George Benston Collection, Chicago; Cabinet des Estampes; the Art Institute of Chicago (formerly Robert Light Collection, Boston) – proofs on wove and laid paper, mostly signed. Four proofs sold by Kornfeld and Klipstein, Bern.
4th state, reduced to dimensions of 358 × 240 (14⅛ × 9½), with additional detail; a section on the left has disappeared, other areas have been scraped away and are lighter in tone, e.g. the black patch on the chair. Ten or so proofs on yellowish wove paper, most of them signed in pencil in the bottom left-hand corner.

64 AFTER THE BATH (APRÈS LE BAIN), known as 1st plate, *c.* 1891. Lithograph, five states. 190 × 147 (7½ × 5¾). LD 60.
a 1st state. Bibliothèque d'Art et d'Archéologie de l'Université de Paris, Fondation Jacques Doucet.

b 4th state. The Art Institute of Chicago.
Guérin describes this as a drawing in greasy (lithographic) ink, probably on celluloid, and transferred on to the stone. In the Manzi sale of 1919, no. 128 was a 'drawing' in greasy ink on celluloid by Degas, which had been used as part of a heliographic process to transfer a counterproof on to damp paper through a press. We believe there are five, not six, states.
1st state, with flat tints. In Degas sale of 1918 (nos. 149–51). One proof has on it 'experiment done at Manzi's, Degas'.
2nd state, scraper used on the woman's buttock and leg. In Degas sale of 1918 (no. 152).
3rd state, additional detail, left arm now visible and contours altered. In Degas sale of 1918 (no. 153). Formerly Guérin Collection.
4th state, erasures, 'overexposed' effect. In Degas sale of 1918 (no. 154). Art Institute of Chicago, Bequest of Walter S. Brewster (formerly F. E. Bliss Collection).
5th state, numerous alterations, the figure is larger. In Degas sale of 1918 (no. 155).

65 AFTER THE BATH (APRÈS LE BAIN), known as 1st plate, *c.* 1891. Lithograph, only state. 205 × 147 (8⅛ × 5¾). LD 60 (6th state – see above). Cabinet des Estampes, Bibliothèque Nationale, Paris.
The length of the motif has been increased at the top, the figure is bigger. Miss Jean Boggs dates it as 1885–6, Mrs Janis as 1883. Degas used the 5th state of the previous lithograph (A 64) as a basis for a fresh lithographic stone. He left the new area at the top of the plate as in the 5th state, with a space above the woman's head. Then he shaded this in as far as the top of the head. He increased the size of the woman and reduced the size of the left-hand section (bed), using the scraper to conceal part of the left leg behind the towel. The hair is again as long as it was in the 1st state, longer than in the intermediary stages.
This one proof is the sole indication we have of the existence of the plate. It was in the Degas sale of 1918, no. 157, was acquired by Viau and, at the third sale of his collection in 1943, was purchased by the Cabinet des Estampes.

66 AFTER THE BATH or GETTING UP IN THE MORNING (APRÈS LE BAIN or LE LEVER), 2nd plate, *c.* 1891. Lithograph, 2nd state of two. 180 × 190 (7⅛ × 7½). LD 61. Bibliothèque d'Art et d'Archéologie de l'Université de Paris, Fondation Jacques Doucet.
M. Guérin tells us this is a transfer on to lithographic stone of a drawing in litho ink, probably on celluloid (drawing owned by M. Guérin, formerly in Manzi Collection).
1st state, before the hair and chair were fully drawn. Formerly M. Guérin Collection.
2nd state, with final touches to hair and chair. One proof on Japanese paper in Degas sale of 1918 (no. 60) plus further proofs (nos. 158 and 159). Proof in Cabinet des Estampes with the words, in Degas' writing, 'Experiment at Manzi's' (formerly Rouart Collection). Fondation Doucet, Univ. de Paris (Beurdeley sale of 1921, with: 'Experiment at Manzi's').

67 OUT OF THE BATH (LA SORTIE DU BAIN), small plate, *c.* 1891. Lithograph, first state of two. 312 × 262 (12¼ × 10⅜). LD 63. The Art Institute of Chicago.
1st state, with the woman on the right. A dozen proofs (on wove and on laid paper, most signed; six *via* Kornfeld and Klipstein); Bibliothèque de l'Université de Paris; Kupferstichkabinett, Berlin; Prentenkabinet, Rijksmuseum, Amsterdam; the Art Institute of Chicago (dep. Purchase Fund, bought from M. Guiot); Cabinet des Estampes; Curtis Collection; Albertina, Vienna (bought through Sagot). Four other proofs in private collections. An unidentified state that is probably the 1st in the Degas sale of 1918 (no. 166). Another that appears to be a 1st state in the Museum of Fine Arts, Boston (acquired *c.* 1958).
2nd state, dimensions reduced to 290 × 235 (11⅜ × 9¼). The maid and part of the background have disappeared. Two proofs sold by Kornfeld, a further two proofs known to

Kornfeld; one in the Museum of Modern Art, New York. Kornfeld's proofs came from the Exteens Collection; he in turn had them from his father-in-law Pellet, who had bought them from Degas.

68 OUT OF THE BATH (LA SORTIE DU BAIN), large plate, half-length, *c.* 1891. Lithograph, 1st state of five. Printed by Clot. 280×301 (11 1/16 × 11 7/8). LD 64. Kunsthalle, Hamburg. For details see Kornfeld (*Edgar Degas . . .*, Bern 1965). Guérin describes this as a drawing in greasy (lithographic) ink transferred on to stone, original drawing probably on celluloid.
1st state, line drawing. In Degas sale of 1918 (no. 167). Kunsthalle. Hamburg.
2nd state, modelling on the woman's body. One proof in Degas sale of 1918 (no. 168). Fondation Doucet, Univ. de Paris (former Roger Marx proof); proof in sale of 7 February 1923, now in Ulm Museum.
3rd state, woman's body strongly emphasized. In Degas sale of 1918 (no. 167); acquired Carré for the Art Institute of Chicago.
4th state, woman is bigger, changes in the maid's hand and head. Three proofs in Degas sale of 1918 (nos. 171–3).
5th state, some details have disappeared, scraper used, nude woman bigger still and right arm lower. In Degas sale of 1918 (no. 174). Three proofs sold by Kornfeld. The Art Institute of Chicago (formerly Keppel Collection). Two proofs in Cabinet des Estampes; one, originally owned by Curtis, bears the words 'pulled by me, A. Clot', which Curtis had asked him to write.

CATALOGUE OF THE MONOTYPES

This catalogue compiled by FRANÇOISE CACHIN is restricted to the pure, untouched monotypes, excluding all those heightened with watercolour, pastel, gouache or oil paint. Purely for reference purposes, a list has been included at the end of the catalogue of all works painted or drawn over monotypes.

Degas frequently pulled a number of proofs of the same monotype, each proof paler than the one before; we have thought it unnecessary to include reproductions of these second or third proofs but have supplied details, where available, at the foot of the entry for the original monotype. Where no first proof is obtainable, reproductions of the second or third proof have been used instead.

The French title quoted is normally the title by which that particular monotype has come to be known; in most cases it was supplied, not by the artist, but, in somewhat random fashion, by the organizer of an early sale or exhibition. The English titles are literal translations of the traditional French titles, except where an accepted English version already exists.

A number of abbreviations have been used for books, catalogues and exhibitions frequently referred to:

A Adhémar, J. Catalogue of Etchings and Lithographs (this volume).

C Cross-references within following Catalogue of Monotypes by Françoise Cachin.

BLAIZOT, L. H. *La Famille Cardinal*, illustrated with monotypes by Degas. Blaizot, Paris 1938.

DELTEIL *and* LD Loys Delteil, *Edgar Degas. Le Peintre-Graveur illustré*, vol IX. Paris 1919.

FOGG ART MUSEUM 1968 Exhibition of April–June 1968 at Fogg Art Museum, Harvard University. (See Janis, below.)

J Janis, E. P. 'Degas monotypes, essay, catalogue and checklist', a Fogg Art Museum publication relating to the above exhibition. The number (e.g. J1) refers to the order of the checklist, not to the exhibition catalogue.

LAFOND Lafond, P. A. *Degas*, 2 vols. Floury, Paris 1918–19.

LEFÈVRE GALLERY 'Degas Monotypes, Drawings, Pastels, Bronzes', exhibition held at the Lefèvre Gallery, London, April–May 1958; foreword by Douglas Cooper.

L Lemoisne, P.-A., *Degas et son œuvre*, 4 vols. Arts et Métiers Graphiques, Paris 1846–9.

ORANGERIE 1937 'Degas' exhibition; preface by P. Jamot, catalogue by J. Bouchot and Delaroche-Vernet, Paris, Musée de l'Orangerie 1937.

ORANGERIE 1969 'Degas, œuvres du musée du Louvre'; preface by H. Adhémar, catalogue by M. Beaulieu, M. Olivier and G. Monnier, Paris, Musée de l'Orangerie, June–September 1969.

DEGAS SALE 'Catalogue des tableaux, pastels et dessins par E. Degas et provenant de son atelier', Paris, Galerie Georges Petit, 4 vols. 1st sale: 6–8 May 1918; 2nd sale: 11–12 December 1918; 3rd sale: 7–9 April 1919; 4th sale: 2–4 July 1919. (Most of the monotypes were included in the 3rd sale.)

DEGAS SALE OF 1918 'Vente d'estampes, catalogue des eaux-fortes, vernis mous, aquatintes, lithographies et monotypes par E. Degas', Galeries Manzi-Joyant, Paris, 22 and 23 November 1918.

Dimensions are given in millimetres and inches, height preceding width.

THE BALLET AND THE CAFÉ-CONCERT

The monotypes of dancers, 1874–80, are the earliest of Degas' monotypes, roughly contemporary with the aquatints on the same theme (A 25, 26 etc.; LD 21 etc.).

It is possible to date the first of the monotypes, *The Ballet Master* (C 1), fairly accurately, something that is unfortunately not possible in most of the other cases. The second proof (touched with pastel), which is today in the Norton Simon Collection, was originally bought in 1875 by Mary Cassatt, acting on behalf of her friend the future Mrs Havemeyer. The Louvre picture of the same ballet master dates from 1874, which means one can confidently assume the monotype to date from the same year. Until about 1880, Degas used the monotype in parallel with all the other techniques, repeating a similar motif in oils, crayon, pastel, monotype, etc. All the scenes of ballet, theatre, *café-concert* and Parisian life were executed between 1877 and 1880.

It may seem strange that there are so few monotypes of dancers dating from the period 1875–9; in fact there are many of these, but they are not included in this catalogue because most of them were used as backgrounds for pastels. For the convenience of students of Degas we have included a list of these at the end of the catalogue. Some famous examples of pastels over monotypes are: *The Star* in the Jeu de Paume, Louvre, Paris, and *Two Dancers Entering the Stage* in the Fogg Art Museum, Harvard University.

It was during the winter of 1876–7 that Degas concentrated mostly on the theme of the *café-concert*, and especially the performances at the Théâtre des Ambassadeurs. The *Café-concert* in the Musée des Beaux-Arts, Lyons, a monotype touched with pastel, was shown at the third Impressionist exhibition in April 1877; the singer is Mlle Bécat who appears also in the monotypes C 4, 5. Even after 1877 Degas remained attached to the theme of the *café-concert*, and some of the monotypes is a slightly later style, such as for example C 13, may date from 1879–80.

1 THE BALLET MASTER (LE MAÎTRE DE BALLET), c. 1874. Black ink. 560 × 700 (22 × 27½). J 1. Rosenwald Collection, National Gallery of Art, Washington, DC.
Top left-hand corner, in reverse, inscription: Lepic-Degas.
Exhibition: Fogg Art Museum 1968, no. 1. *Bibliography:* Marcel Guérin, 'Notes sur les monotypes de Degas'. *L'Amour de l'Art*, vol. VI, 1924, pp. 75–80.
Apparently the first monotype executed by Degas. A 2nd proof, touched with pastel and gouache and with additional figures, is in the Norton Simon Collection, Fulleston, California (J 2).
The same ballet master appears in *The Ballet Class* (L 541) in the Louvre, painted in 1874; the teacher is probably the dancer Jules Perrot.

2 THREE DANCERS (TROIS DANSEUSES), c. 1878–80. Black ink on white paper. 200 × 417 (7⅞ × 16⅜). J9. The Sterling and Francine Clark Art Institute, Williamstown, Mass.
Inscription in the bottom right-hand margin: Degas to Cherfils.
Exhibition: Fogg Art Museum 1968, no. 4. *Bibliography:* Lafond, vol II, facing p. 24; Rouart, *Technique*, 1945, p. 57; Lilian Browse, *Degas Dancers*, 1947, no. 82a.
There is a 2nd proof touched with pastel in the Mrs Moorhead C. Kennedy Collection, New York (J 10).

3 CAFÉ-CONCERT (AU CAFÉ-CONCERT), *c.* 1876–77. Black ink on china paper. 159 × 216 (6¼ × 8½). J 24. Location unknown.
Exhibition: Los Angeles County Museum, 1958, no. 94.

4 MADEMOISELLE BÉCAT AUX AMBASSADEURS, *c.* 1877. Black ink on white paper, occasional heightening in pencil. 149 × 217 (5⅞ × 8⁹⁄₁₆). J 32. Den Kongelige Kobberstik Samling, Statens Museum for Kunst, Copenhagen.
Sale: Degas 1918, no. 184. *Bibliography:* Delteil no. 50.
This monotype was a trial piece for the lithograph of the same title (A 43).

5 MADEMOISELLE BÉCAT AUX AMBASSADEURS, *c.* 1877. Black ink on china paper. 160 × 115 (6⁵⁄₁₆ × 4½). J 33. Kornfeld and Klipstein Collection, Bern.
Bibliography: Delteil no. 51 (described as lithograph); Janis, 'The role of the monotype in the working method of Degas', *Burlington Magazine*, January and February 1967; p. 53 (January), p. 76 (February).
This monotype was printed on the same plate as *Morning Frolic* (C 121); see plate LD 51.
There is a 2nd impression of this monotype, touched with pastel, formerly in the César de Hauke Collection (J 34).

6 CAFÉ SINGER (CHANTEUSE DU CAFÉ-CONCERT), *c.* 1877. Black ink on white paper mounted on cardboard. 120 × 162 (4¾ × 6⅜). J 29. Kornfeld and Klipstein Collection, Bern.
Sale: Degas 1918, no. 197. *Exhibition:* Fogg Art Museum 1968, no. 8. *Bibliography:* Rouart, *Monotypes*, 1948, p. 8.
There is also a 2nd impression touched with pastel (L 455).

7 CAFÉ-CONCERT, MIRROR REFLECTION (SCÈNE DE CAFÉ-CONCERT, REFLET DANS UN MIROIR), *c.* 1877. Black ink on white paper. 160 × 210 (6⁵⁄₁₆ × 8¼). J 31. Location unknown.
Unsigned, atelier stamp verso.
Sale: Degas 1918, no. 198. *Exhibition:* Ny Carlsberg Glyptothek, 1948, no. 75. *Bibliography:* Rouart, *Monotypes*, 1948, pl. 15.
Probably a first attempt at the theme of *Aux Ambassadeurs* (A 30).

8 ILLUMINATIONS (ILLUMINATION), *c.* 1877. Black ink on white paper. 159 × 119 (6¼ × 4¹¹⁄₁₆). J 61. Lefèvre Gallery, London.
Atelier stamp verso.
Sale: Degas 1918, no. 304. *Exhibition:* Orangerie 1937, no. 204; Lefèvre Gallery, London, no. 2.

9 CAFÉ-CONCERT (AU CAFÉ-CONCERT), *c.* 1877. Black ink on china paper. 76 × 168 (3 × 6⅝). J 49. Lefèvre Gallery, London.
Bibliography: Lafond, vol. II.

10 CAFÉ SINGER (CHANTEUSE DU CAFÉ-CONCERT), *c.* 1877. Black ink on china paper. 113 × 159 (4½ × 6¼). J 48. Lefèvre Gallery, London.

11 BUST OF A SINGER WITH ARM RAISED (BUSTE DE CHANTEUSE AU BRAS LEVÉ), *c.* 1877. Black ink on white paper. 82 × 72 (3¼ × 2⅞). J 51. Mr and Mrs Hugo Perls Collection, New York.
In the same collection there is also a 2nd proof of this monotype (J 52).

12 CAFÉ SINGER SEEN FROM BEHIND (CHANTEUSE DE CAFÉ-CONCERT DE DOS), *c.* 1877. Black ink on white paper. 82 × 72 (3¼ × 2⅞). J 53. Mr and Mrs Hugo Perls Collection, New York.
Sale: Degas 1918, no. 276.

13 CAFÉ SINGER, RIGHT PROFILE (CHANTEUSE DE CAFÉ-CONCERT, PROFIL DROIT), *c.* 1878–80. Black ink on white paper. 80 × 72 (3⅛ × 2⅞). J 50. The Potter Palmer Collection, the Art Institute of Chicago.
Sale: Degas 1918, no. 273. *Exhibition:* Fogg Art Museum 1968, no. 13.

14 CAFÉ-CONCERT SINGER (CHANTEUSE DE CAFÉ-CONCERT), *c.* 1878. Black ink on white paper mounted on cardboard. 185 × 134 (7¼ × 5¼). J 47. Kornfeld and Klipstein Collection, Bern.
Sale: Degas 1918, no. 275. *Exhibition:* Kornfeld and Klipstein, 1964, no. 8; Fogg Art Museum 1968, no. 12.

15 CAFÉ-CONCERT SINGER (CHANTEUSE DE CAFÉ-CONCERT), *c.* 1878. Black ink on white paper. 182 × 123 (7⅛ × 4⅞). J 45. National Museum, Belgrade.
Bibliography: Rouart, *Les Degas et les Renoir inconnus du Musée de Belgrade*, 1966, no. 38.
This monotype was purchased by a Jugoslav collector from Ambroise Vollard, the publisher responsible for a series of Degas monotypes used as illustrations for *Mimes des courtisanes* by Pierre Louÿs (Vollard 1935).
There is also a 2nd impression of this monotype (Prouté Collection, Paris).

16 AT THE THEATRE (AU THÉÂTRE), *c.* 1878. Black ink on china paper. 309 × 275 (12⅛ × 10⅞). J 15. Bibliothèque d'Art et d'Archéologie de l'Université de Paris, Fondation Jacques Doucet.
Signed in the margin in the bottom left-hand corner; stamp of the collector Jacques Doucet at the bottom of the monotype, to the right of centre.
Exhibition: Galerie Georges Petit, 1924, no. 242.

17 THE LOGE (LA LOGE), *c.* 1878. Black ink on china paper. 120 × 164 (4¾ × 6⁷⁄₁₆). J 55. Private collection, London.
Atelier stamp verso, bottom left.
Exhibition: Orangerie 1937, no. 201; Ny Carlsberg Glyptothek 1948, no. 92; Lefèvre Gallery, London, 1958, no. 14.

18 THE LOGE (LA LOGE), *c.* 1878. Black ink on china paper. 167 × 120 (6½ × 4¾). J 56. Location unknown.
Sale: Degas 1918, no. 187.
A 2nd proof of this monotype, heightened in pastel, belongs to the Clark Collection of the Corcoran Gallery of Art, Washington (J 57).

19 AN INTIMATE MOMENT (L'INTIME), *c.* 1877–8. Black ink on white paper. 120 × 160 (4¾ × 6⁵⁄₁₆). J 186. Den Kongelige Kobberstik Samling, Statens Museum for Kunst, Copenhagen.
Sale: Degas 1918, no. 210. *Exhibition:* Fogg Art Museum 1968, no. 44.
The Copenhagen Museum also possesses a 2nd proof of this scene of an actress making up in her dressing room. (J 187).

20 WOMAN WITH SCISSORS or THE SONG OF THE SCISSORS (LA CHANSON DES CISEAUX (?)), *c.* 1877–8. Black ink on white paper, mounted. 160 × 120 (6⁵⁄₁₆ × 4¾). J 44. Charles Slatkin Collection, New York.
Atelier stamp on mount, verso.
Sale: Degas 1918, no. 264. *Exhibition:* Orangerie 1937, no. 189; Ny Carlsberg Glyptothek, 1948, no. 74; Fogg Art Museum 1968, no. 11.

21 CAFÉ-CONCERT SINGER (CHANTEUSE DE CAFÉ-CONCERT), *c.* 1877–8. Black ink on white paper. 160 × 121 (6⁵⁄₁₆ × 4¾). J 42. Robert A. Weiner Collection, New York.
Sale: Roger Marx, 1914, no. 392.
In all probability a 2nd proof. It was part of the collection of the turn-of-the-century art critic Roger Marx.

22 THE CLOWN (LE CLOWN), *c.* 1877–8. Black ink on white paper. 120 × 167 (4¾ × 6½). J 257. Known only from a photograph in the Witt Library, Courtauld Institute, London.

23 DANCER STANDING NEXT TO A STAGE-FLAT (DANSEUSE DEBOUT PRÈS D'UN DÉCOR), *c.* 1878–80. Black ink on white paper. J 16. Known only from a photograph in the Witt Library, Courtauld Institute, London. All other information about this monotype has disappeared.

24 DANCER SEEN FROM THE BACK (DANSEUSE VUE DE DOS), *c.* 1878–80. Black ink on white paper. J 17. Known only from a photograph in the Sterling and Francine Clark Art Institute, Williamstown, Mass.

25 DANCER IN FOURTH POSITION (DANSEUSE EN QUATRIÈME POSITION), *c.* 1878–80. Black ink on light grey paper. 205 × 179 (8⅛ × 7). J 19. The Helen and Alice Colburn Purchases Fund, Museum of Fine Arts, Boston.
Artist's stamp, bottom left-hand corner.
Sale: Degas 4th, of July 1919, no. 339. *Exhibition:* Fogg Art Museum 1968, no. 6.
A 2nd, heavily retouched impression of this monotype is in the Cabinet des Dessins, Louvre.

26 DANCER SEATED, MASSAGING HER ANKLES (DANSEUSE ASSISE SE TENANT LES CHEVILLES), *c.* 1878–80. Black ink on white paper. 200 × 150 (7⅞ × 6). J 20. Den Kongelige Kobberstik Samling, Statens Museum for Kunst, Copenhagen.
Atelier stamp verso.
Sale: Degas 1918, no. 109.

27 TWO DANCERS (DEUX DANSEUSES), *c.* 1878–80. Black ink on white paper. 217 × 177 (8 9/16 × 7). J 4. Den Kongelige Kobberstik Samling, Statens Museum for Kunst, Copenhagen.
Atelier stamp in the margin on the bottom right-hand corner.
Sale: Degas 1918, no. 192.

28 DANCER ARRANGING HER TUTU (DANSEUSE ARRANGEANT SON TUTU), *c.* 1878–80. Black ink on white paper. 200 × 155 (7⅞ × 6⅛). J 21. Known only from a photograph in the Witt Library, Courtauld Institute, London.

29 DANCER IN ARABESQUE (DANSEUSE EN ARABESQUE), *c.* 1878–80. Black ink on white paper. 290 × 260 (11⅜ × 10¼). J 22. D. Guérin Collection, Paris.
Atelier stamp in bottom left-hand corner.
Sale: Degas sale, no. 345.

30 FANTASY (FANTAISIE, danseuse), *c.* 1880. Black ink on white paper, pulled from a celluloid plate. 175 × 86 (6⅞ × 3⅜). J 246. Private collection, Great Britain.
Inscription: vignette no. 6 on celluloid.
Proof heightened with black ink after printing.

PORTRAITS AND SCENES OF PARISIAN LIFE

The earliest of the monotype portraits can be assigned the date of 1876 with reasonable certainty, thanks both to Degas' painting *The Absinthe Drinker*, in which the same model Marcellin Desboutin appears, and to a letter of that year written by Desboutin to de Nittis (see notes to C 35). With the remaining monotypes, there is little evidence, beyond that of style in general and the clothes worn by the models, to enable one to arrive at a more precise dating than approximately 1880. A number of the monotypes below were taken from the same plate, measuring 80 × 70 (3⅛ × 2¾) and were no doubt executed on the same occasion.

31 WOMEN IN A CAFÉ (FEMMES AU CAFÉ), *c.* 1876–7. Black ink. 112 × 161 (4⅜ × 6 15/16). J 60. Known only from a reproduction in *La Maison Tellier* (Vollard 1934, facing p. 24).
Related to the pastel over monotype *Women in Front of a Café, Evening*, in the Louvre, Caillebotte Bequest (J 58), and to *The Absinthe Drinker* of 1876 (Louvre, Camondo Bequest), depicting the café 'La Nouvelle Athènes', which is very similar in terms of composition.

32 A WALK IN THE PARK (PROMENADE DANS UN PARC), *c.* 1878. Black ink on china paper mounted on cardboard. 160 × 122 (6 5/16 × 4 13/16). J 237. Tex. de C. Van Kivell Collection, London. Atelier stamp on the mount, verso.
Sale: Degas 1918, no. 295.

Related to the sketch in oils of *c.* 1878 *At the Races* (L 495); note the similarities in each of the woman on the right, wearing a veil.

33 IN THE OMNIBUS (DANS L'OMNIBUS), *c.* 1878. Black ink on paper. 277 × 305 (10⅞ × 12). J 236. Pablo Picasso Collection.
Sale: Degas 1918, no. 202. *Bibliography:* Rouart, *Monotypes*, 1948, pl. 12.

34 THE DINNER (LE DÎNER), *c.* 1878. Black ink on china paper. 159 × 121 (6¼ × 4¾). J 255. Location unknown.
Atelier stamp verso.
Sale: Degas 1918, no. 208. *Exhibition:* Ny Carlsberg Glyptothek, 1948, no. 90; Lefèvre Gallery, 1958, no. 3.
Related to the two *Good Friday Dinner* illustrations in the *Cardinal Family* series (C 81, 82).

35 MAN SMOKING A PIPE (L'HOMME À LA PIPE), *c.* 1876. Black ink on grey-brown paper. 80 × 71 (3⅛ × 2¾). J 233. Madame le Garrec Collection, Paris.
Atelier stamp in the bottom margin on the right.
Sale: Degas 1918, no. 270. *Bibliography:* Delteil, no. 55. *Exhibition:* Fogg Art Museum 1968, no. 52.
The man is Marcellin Desboutin who appears in *The Absinthe Drinker* (Louvre) of 1876, smoking the same pipe and wearing the same hat. This monotype was used as the basis for a lithograph, part of a plate with three motifs (A 46; LD 55). A letter from Desboutin to de Nittis (published in M. Pittaluga, *De Nittis*, Milan 1963), quoted by Mrs Janis, relates that, in the summer of 1876, 'Degas is the only person I see every day, and yet he's no longer a friend, he's no longer a man, he's nothing but an artist! He's nothing but a plate of zinc or copper black with ink.'

36 MAN WITH BEARD (L'HOMME À LA BARBE), *c.* 1876–8. Black ink on china paper. 82 × 72 (3¼ × 2 13/16). J 232. W. E. Nickelson Fund, Museum of Fine Arts, Boston.
Atelier stamp in the bottom margin, to the right; below this, stamp of the Marcel Guérin Collection.
Sale: Degas 1918, no. 268. *Exhibition:* Fogg Art Museum 1968, no. 51.
Mrs Janis has suggested that this may be a portrait of a senator whom Degas could have seen in *l'Illustration*.

37 THE MAID (LA BONNE), *c.* 1880. Black ink on white paper. 82 × 72 (3¼ × 2 13/16). J 251. Mr and Mrs E. Powis Jones Collection, New York.
Sale: Degas 1918, no. 288. *Exhibition:* Fogg Art Museum 1968, no. 57.
There is another proof of this monotype (J 252; J. P. Richardson Collection, New York), in which the hair and black dress of the girl are much less pronounced, while the background is far more so. It is probably a 2nd proof.

38 BUST OF A WOMAN (BUSTE DE FEMME), *c.* 1880. Black ink on white paper. 82 × 70 (3¼ × 2¾). J 253. Mr and Mrs E. Powis Jones Collection, New York.
Exhibition: Fogg Art Museum 1968, no. 59.
Without doubt, a 2nd proof. This monotype was used as the basis for a lithograph, part of a plate containing four motifs (A 44; LD 54). The model seems to be the same as for the preceding monotype.

39 THE JET EARRING (PROFIL PERDU À LA BOUCLE D'OREILLE), *c.* 1880. Black ink on white paper. 82 × 73 (3¼ × 2⅞). J 243. Anonymous bequest, Metropolitan Museum of Art, New York.
Atelier stamp in bottom right-hand margin; next to this, stamp of the Marcel Guérin Collection.
Sale: Degas 1918, no. 181. *Exhibition:* Fogg Art Museum 1968, no. 56.

40 WOMAN SEEN IN PROFILE (FEMME DE PROFIL), *c.* 1880. Black ink on white paper. 83 × 72 (3¼ × 2 13/16). J 244. Location unknown.
Sale: Degas 1918, no. 280. *Exhibition:* Lefèvre Gallery 1968, no. 4.

41 WOMAN WITH A CIGARETTE (FEMME À LA CIGARETTE), *c.* 1880. Black ink on white paper. 82 × 92 (3¼ × 3⅝). J 249. Private collection, Paris.
Sale: Degas 1918, no. 287.
There is also a 2nd proof; exhibition at the Los Angeles County Museum, 1958, no. 92 (J 250).

42 WOMAN IN PROFILE (FEMME DE PROFIL), *c.* 1880. Black ink on china paper. J 245. Private collection, London.
Exhibition: Lefèvre Gallery, 1958, no. 9.

43 WOMAN IN PROFILE (FEMME DE PROFIL), *c.* 1880. Black ink on china paper. 80 × 70 (3⅛ × 2¾). J 247. Private collection, London.
Atelier stamp verso.
Exhibition: Lefèvre Gallery, 1958, no. 24.

44 WOMAN'S HEAD IN PROFILE (TÊTE DE PROFIL), *c.* 1880. Black ink on china paper. 70 × 80 (2¾ × 3⅛). J 248. Ferrers Gallery, London.
Exhibition: Lefèvre Gallery, 1958, no. 25.

45 PORTRAIT OF A WOMAN (PORTRAIT DE FEMME), *c.* 1880. Black ink on white paper. 81 × 71 (3⅛ × 2¾). J 239. E. V. Thaw Gallery Collection, New York.
Atelier stamp in bottom margin on the right.
Sale: Degas 1918, no. 291. *Exhibition:* Fogg Art Museum 1968, no. 55.

46 WOMAN IN PROFILE (FEMME DE PROFIL), *c.* 1880. Black ink on white paper, double impression, top to bottom. 89 × 150 (3½ × 6). J 241, 242. Location unknown.
Exhibition: Los Angeles County Museum, 1958, no. 93, formerly César de Hauke Collection.
The model is the same as for the preceding portrait.

47 MAN AND WOMAN, HEAD AND SHOULDERS PORTRAITS (HOMME ET FEMME, EN BUSTE), *c.* 1880. Black ink on china paper. 72 × 81 (2⅞ × 3⅛). Prouté Collection, Paris.
Atelier stamp in bottom right-hand corner. Not included in Janis checklist.
Sale: Degas 1918, no. 267; David Weill, 25–6 May 1871, no. 57.
There is a 2nd proof of this monotype in the British Museum (J 235).

48 PORTRAIT OF A WOMAN (PORTRAIT DE FEMME), *c.* 1880. Brown ink on china paper. 216 × 160 (8¼ × 6⁵⁄₁₆). J 238. The Art Institute of Chicago.
Stamp of the Marcel Guérin Collection in the bottom margin on the left.
Sale: Degas 1918, no. 280. *Exhibition:* Galerie Georges Petit, 1924, no. 136; Orangerie 1937, no. 173; Fogg Art Museum 1968, no. 54.
Degas must have retouched the very delicately modelled face after printing. There is a certain resemblance between this portrait and that of Ellen Andrée, the young actress who had posed with Desboutin for *The Absinthe Drinker.*

49 WOMAN IN A STRIPED BODICE (FEMME AU GILET RAYÉ), *c.* 1880. Black ink on white paper. 160 × 118 (6⁵⁄₁₆ × 4¹¹⁄₁₆). J 254. Albertina, Vienna.
Janis lists the location of this monotype as unknown.
Bibliography: Delteil, no 35, described as experimental aquatint done with a brush.

50 THE TWO EXPERTS (LES DEUX AMATEURS), *c.* 1880. Black ink on white paper mounted on cardboard. 299 × 270 (11¾ × 10⅝). J 234. The Clarence Buckingham Collection, the Art Institute of Chicago.
Atelier stamp on mount, verso.
Sale: Degas 1918, no. 189.
Mrs Janis has already pointed to the links between this monotype and *The Experts, Paul Lafond and Alphonse Cherfils Examining a Painting* (L 657) of 1881 or thereabouts, in the Marcel Guérin Collection. The figure on the left would be Paul Lafond, a friend of Degas and curator of the

museum at Pau, the first to own a Degas; the figure on the right, Degas' friend the collector Alphonse Cherfils.

51 WOMAN STANDING IN THE STREET, SEEN FROM BEHIND (FEMME DEBOUT DANS LA RUE, DE DOS), *c.* 1880. Black ink on white laid paper. 160 × 118 (6⁵⁄₁₆ × 4¹¹⁄₁₆). J 216. Carle Dreyfus Bequest, Cabinet des Dessins, Louvre, Paris.
Artist's signature stamp in bottom right-hand corner; atelier stamp on backing-sheet.
Janis lists the location of this monotype as unknown.
Exhibition: Orangerie 1969, no. 193. *Bibliography:* Rouart, *Monotypes,* p. 27.
This monotype was reproduced in the Blaizot edition of *La Famille Cardinal* (p. 108) but was probably not originally intended to form part of the series. For one thing, Degas always distinguished Mme Cardinal by the 'corkscrew curls' each side of her ears, and no such curls are shown here; for another thing, the theme of the picture does not correspond to any specific incident in Halévy's book.

52 IN THE RAIN (SOUS LA PLUIE), *c.* 1880. Black ink. J 217.
This monotype is known only from the reproduction in the Blaizot edition of *La Famille Cardinal,* p. 55 (although it in fact corresponds to no specific incident in the book).

53 AVENUE WITH TREES (L'AVENUE DU BOIS), *c.* 1880. Black ink on china paper. 111 × 159 (4⅜ × 6¼). J 260. Private collection, London.
Sale: Degas 1918, no. 297. *Exhibition:* Lefèvre Gallery, p. 958, no. 44. *Bibliography:* Rouart, *Monotypes,* p. 11.

54 THE PUBLIC MEETING (LA RÉUNION PUBLIQUE), *c.* 1880. Black ink on white paper. J 256. Known from the reproduction in Lafond, vol. II.
It is possible that this monotype was intended as part of the *Cardinal Family* series; there is a public meeting in *Monsieur Cardinal.* The Blaizot edition, however, does not use it.

55 WOMEN IRONING (LES REPASSEUSES), *c.* 1880. Black ink on paper. 226 × 428 (8⅞ × 16⅞). J 259. Bibliothèque d'Art et d'Archéologie de l'Université de Paris, Fondation Jacques Doucet.
Signed in the bottom left-hand corner, in pencil: Degas.
Degas most probably executed this monotype at the same time as the etching called *Woman Ironing* (A 32; LD 37). The central figure is the same in both compositions and was probably the model for a number of paintings, such as *Women Ironing, Seen Against the Light* (L 695) of 1882.

THE CARDINAL FAMILY, *c.* 1880

Ludovic Halévy published his *Monsieur et Madame Cardinal* in 1872, with illustrations by Edmond Morin, and *Les Petites Cardinal* in 1880, with illustrations by Henri Maigrot. According to Marcel Guérin it was Degas who had the idea of publishing a combined edition of his friend's book with his own monotypes as illustrations, reproduced by a photogravure process. If this is so, the date of execution is fixed at 1880, for we can for once be quite certain that the series was planned as a whole and executed from start to finish within a very brief period. It may have been a little before 1880 if Degas, being a close friend of Halévy, knew the books in their manuscript versions, or it may have been slightly later if the idea for the illustrations occurred to him only after the two editions were published.

56 LUDOVIC HALÉVY MEETING MADAME CARDINAL BACKSTAGE (RENCONTRE DE LUDOVIC HALÉVY ET DE MADAME CARDINAL DANS LES COULISSES). Black ink on white paper. 273 × 307 (10¾ × 12⅛). J 195. Huguette Berès Collection, Paris.
Sale: Degas 1918, no. 201; David Weill (Prints), 25 May 1971, no. 65. 'A fat lady, carelessly dressed, an old plaid over her shoulders and huge silver spectacles on her nose, stood perfectly still, leaning against a piece of scenery backstage at the Opéra; from this position, as though in ecstasy, she fixed her big staring eyes on the stage. . . . I went

up to the fat lady and tapping her on the shoulder said "bonjour" . . .' (L. Halévy, *Madame Cardinal*, pp. 17–18). There is also a 2nd proof of this monotype (J 196).

57 LUDOVIC HALÉVY MEETING MADAME CARDINAL BACK-STAGE (RENCONTRE DE LUDOVIC HALÉVY ET DE MADAME CARDINAL DANS LES COULISSES). Black ink on white paper. 159 × 210 (6$\frac{3}{16}$ × 8$\frac{1}{4}$). J 197. Known from the reproduction in the Blaizot edition of *La Famille Cardinal*, p. 33. *Sale:* Degas 1918, no. 201 (?).
A reverse image but otherwise very close to the preceding monotype.

58 CONVERSATION (Ludovic Halévy and Madame Cardinal). Black ink on white paper mounted on cardboard. 189 × 142 (7$\frac{3}{8}$ × 5$\frac{1}{2}$). J 198. Gift of the Print Club of Cleveland in honour of Henry S. Francis, Cleveland Museum of Art, Ohio.
Atelier stamp verso; The artist's signature stamp in the bottom margin on the right.
Sale: Degas 1918, no. 201. *Exhibition:* Fogg Art Museum 1968, no. 46. Reproduced in the Blaizot edition, facing p. 8. There is also a variant on this theme, a monotype heightened with pastel (J 199).

59 LUDOVIC HALÉVY TALKING TO MADAME CARDINAL (LUDOVIC HALÉVY PARLANT À MADAME CARDINAL). Black ink on white paper. 158 × 118 (6$\frac{1}{4}$ × 4$\frac{11}{16}$). J 200. Known from the reproduction in the Blaizot edition of *La Famille Cardinal*, p. 101. *Sale:* Degas 1918, no. 201.

60 LUDOVIC HALÉVY CLIMBING THE STAIRS (LUDOVIC HALÉVY MONTANT L'ESCALIER). Black ink on white paper. J 206. Known from the reproduction in the Blaizot edition, p. 91. *Sale:* Degas 1918, no. 201.

61 DANCERS COMING FROM THE DRESSING ROOMS (DANSEUSES SORTANT DES LOGES). Black ink on white paper. J. 207. Known from the reproduction in the Blaizot edition, p. 37. *Sale:* Degas 1918, no. 201.
'From the dancers' dressing room I saw fifteen or so young persons emerge, chattering, laughing, crying out, quarrelling or jostling, who launched themselves forward like an avalanche. . . . Respectfully I made way for this charming whirlwind and this whole constellation of dainty little *décolleté* creatures, dressed in silk and satin, clattered nimbly down the stairs.' L. Halévy, *Madame Cardinal*, p. 39–40.

62 DANCERS COMING DOWN FROM THE DRESSING ROOMS (DANSEUSES DESCENDANT DES LOGES). Black ink on white paper. J 208. Known from the reproduction in the Blaizot edition, p. 72. *Sale:* Degas 1918, no. 201.

63 AND THEN THE YOUNG LADIES FIDGETED DELIGHTFULLY IN FRONT OF THE MIRROR (ET CES DEMOISELLES FRÉTIL-LAIENT GENTIMENT DEVANT LA GLACE DU FOYER). Black ink on white paper, touched with spots of black pastel. 212 × 158 (8$\frac{3}{8}$ × 6$\frac{1}{4}$). J 209.
Artist's signature stamp and red atelier stamp both present.
Janis lists the location of this monotype as unknown. *Sale:* David Weill, 25–26 May 1971, no. 58.

64 FIVE DANCERS SEEN FROM BEHIND (CINQ DANSEUSES DE DOS). Black ink on white paper. 162 × 118 (6$\frac{3}{8}$ × 4$\frac{11}{16}$). J 210. Carle Dreyfus Bequest, Cabinet des Dessins, Louvre, Paris.
Signature stamp in bottom right-hand corner; atelier stamp on the backing-sheet.
Janis lists the location of this monotype as unknown. *Exhibition:* Orangerie 1969, no. 196. Reproduced in Blaizot, p. 119.

65 LUDOVIC HALÉVY FINDS MADAME CARDINAL IN THE DRESSING ROOM (LUDOVIC HALÉVY TROUVE MADAME CARDINAL DANS LES LOGES). Black ink on white paper. 210 × 160 (8$\frac{1}{4}$ × 6$\frac{5}{16}$). J 214. Miss Erwing Collection, Hartford, Connecticut.
Signed on the mount in the bottom right-hand corner.
'I caught sight of Mme Cardinal in a corner, her two big white corkscrew curls making a sort of formal hedge around the patriarchal face. Her snuff-box on her lap and the glasses on her nose, Mme Cardinal was reading the newspaper.' (*Madame Cardinal*, p. 40).
This is a 2nd proof; the 1st proof (location unknown; J 212) is touched with pastel, and is known from the reproduction in the Blaizot edition, p. 153. There is in addition a monotype that closely resembles this one, sold through Kornfeld and Klipstein in Bern (J 213); only by a few details is it clear that it is not in fact a 3rd proof of this monotype.
There is also, in the David Weill Collection, a variant on this composition, heightened with colour (J 215, described as location unknown).

66 PAULINE AND VIRGINIE CARDINAL CONVERSING WITH ADMIRERS (PAULINE ET VIRGINIE CARDINAL BAVARDANT AVEC DES ADMIRATEURS). Black ink on china paper, mounted. 215 × 165 (8$\frac{1}{2}$ × 6$\frac{1}{2}$). J 218. Bequest of Meta and Paul Sachs, Fogg Art Museum, Harvard University.
Unsigned; artist's signature stamp in the bottom right-hand corner; atelier stamp on the backing-sheet. Reproduced in Blaizot, p. 65.
'We were at the Opéra one evening, the run-down old Opéra in the rue Drouot. There were four of us . . . a Senator, a real Senator who sat in the Luxembourg wearing an embroidered robe, the First Secretary of a big foreign embassy, a painter, and myself, your humble servant. It all happened in a corridor. The old Opéra is full of delightful corridors with endless nooks and crannies dimly lit by smoky lamps. We caught the two little Cardinal girls in one of these corridors and asked them to do us the pleasure of dining with us at the *café anglais*. They were burning to come, those two little Cardinal girls: "but maman, maman will never agree, you don't know maman!" . . . and just at that moment, who should appear at the end of the corridor but that redoubtable mama in person' (*Les Petites Cardinal*, p. 64).
There is also a 2nd proof of this monotype, formerly in the H. Béraldi Collection (J 219).

67 PAULINE AND VIRGINIE IN CONVERSATION WITH ADMIRERS (PAULINE ET VIRGINIE EN CONVERSATION AVEC DES ADMIRATEURS). Black ink on paper, mounted. 160 × 210 (6$\frac{5}{16}$ × 8$\frac{1}{4}$). J 220. Mr and Mrs Clifford Michel Collection, New York.
Signature stamp in the bottom margin on the right; atelier stamp on the mount.
Sale: Degas 1918, no. 201. *Exhibition:* Fogg Art Museum 1968, no. 48. Reproduced in the Blaizot edition, p. 59.

68 THE MOST EMBARRASSED WAS THE MARQUIS CAVALCANTI (CELUI QUI TOURNAIT LE PLUS C'ÉTAIT LE MARQUIS CAVALCANTI). Black ink on white paper. 215 × 160 (8$\frac{1}{2}$ × 6$\frac{5}{16}$). J 222. Location unknown.
Proof bearing artist's signature stamp in the bottom right-hand corner and the red atelier stamp on the mount. Reproduced in the Blaizot edition, p. 143.
Sale: Degas 1918, no. 201; David Weill, 25–26 June 1971, no. 66.

69 IN THE CORRIDOR (DANS LE CORRIDOR). Black ink on light ochre laid paper. 160 × 119 (6$\frac{5}{16}$ × 4$\frac{11}{16}$). J 223. Carle Dreyfus Bequest, Cabinet des Dessins, Louvre, Paris.
Unsigned; signature stamp in bottom right-hand corner; atelier stamp on backing-sheet. Reproduced in Blaizot, p. 87.
Janis describes this monotype as location unknown.
Exhibition: Orangerie 1968, no. 194.
There are several photogravure fascimiles of this monotype, one in the Bibliothèque Doucet, another in the Le Garrec Collection.

70 LUDOVIC HALÉVY BACKSTAGE (LUDOVIC HALÉVY DANS LES COULISSES). Black ink on white paper, lightly retouched in pencil. 160×119 (6$\frac{5}{16}$×4$\frac{11}{16}$). Mme Huguette Berès Collection, Paris.
Formerly in the Marcel Guérin Collection. Janis makes no mention of this monotype.
There is also a second proof (cf. David Weill sale, 26 May 1971, no. 64).

71 AN ADMIRER IN THE CORRIDOR (UN ADMIRATEUR DANS LE CORRIDOR). Black ink on white paper. J 224. Known from the reproduction in the Blaizot edition, p. 81.

72 THE CARDINAL SISTERS TALKING TO ADMIRERS (LES PETITES CARDINAL PARLANT À LEURS ADMIRATEURS). Black ink on white laid paper. 261×218 (10$\frac{1}{4}$×8$\frac{1}{2}$). J 226. Carle Dreyfus Bequest, Cabinet des Dessins, Louvre, Paris.
Janis describes this monotype as location unknown.
Exhibition: Orangerie 1969, no. 195.

73 CONVERSATION IN THE GREEN ROOM (CONVERSATION AU FOYER). Black ink on white paper. J 227. Location unknown; monotype known by the reproduction in the Blaizot edition. p. 77.
This monotype was formerly in the Maurice Exteens Collection.

74 THE GREEN ROOM (LE FOYER). Black ink on white paper, mounted; 2nd proof. 160×118 (6$\frac{5}{16}$×4$\frac{11}{16}$). J 229. Rosenwald Collection, National Gallery of Art, Washington, D.C.
Artist's signature stamp on the bottom right-hand corner of the mount; also atelier stamp.
The 1st proof is reproduced in the Blaizot edition, p. 139 (J 228).

75 THE GREEN ROOM (LE FOYER). Black ink on white paper. J 230. Known from the reproduction in the Blaizot edition, p. 147.
Sale: Degas 1918, no. 201.

76 SEATED MAN AND DANCER (HOMME ASSIS ET DANSEUSE). Black ink on white paper, mounted; 2nd proof. 218×178 (8$\frac{1}{2}$×7). Location unknown.
No mention of this proof in Janis.
Artist's signature stamp in the bottom margin on the right; artist's stamp on the top left-hand corner of the mount.
Sale: David Weill, 26 May 1971, no. 63.
A 1st proof of this monotype is reproduced in the Blaizot edition. p. 111 (J 231).

77 TWO MEN AND TWO DANCERS (DEUX HOMMES ET DEUX DANSEUSES). Black ink on white paper; probably a 2nd proof. 310×273 (12$\frac{1}{4}$×10$\frac{3}{4}$). Carle Dreyfus Bequest, Cabinet des Dessins, Louvre, Paris.
No reference to this monotype in Janis.
Exhibition: Orangerie 1969, no. 197.

78 PORTRAIT OF VIRGINIE CARDINAL'S FAVOURITE, THE ACTOR CROCHARD (PORTRAIT DE L'ACTEUR CROCHARD, LE FAVORI DE VIRGINIE CARDINAL). Black ink on Dutch paper, mounted on heavy paper. 160×118 (6$\frac{5}{16}$×4$\frac{11}{16}$). J 201. Kornfeld and Klipstein Collection, Bern.
Unsigned; inscription 'to him [to you?] Crochard'; artist's signature stamp on the bottom right-hand corner of the mount. Reproduction in the Blaizot edition, p. 17.
Exhibition: Fogg Art Museum 1968, no. 47.

79 I DON'T UNDERSTAND, SAYS MONSIEUR CARDINAL (JE NE COMPRENDS PAS, DIT M. CARDINAL). Black ink on white paper; drawn with brush and wiping pad. 120×160 (4$\frac{3}{4}$×6$\frac{5}{16}$). J 202. Known by the reproduction in the Blaizot edition, p. 129.
Artist's signature stamp and red atelier stamp on the mount.
Sale: David Weill 25–26 June 1971, no. 67.

80 READING BY LAMPLIGHT (LA LECTURE SOUS LA LAMPE).

Black ink on paper. 215×160 (8$\frac{7}{16}$×6$\frac{5}{16}$). J 203. Known by the reproduction in the Blaizot edition, p. 105.
Sale: Degas 1918, no. 201; David Weill, 25 May 1971, no. 60.
There is also another proof of this monotype, location unknown.

81 THE FAMOUS GOOD FRIDAY DINNER (LE FAMEUX DÎNER DU VENDREDI). Black ink on china paper, mounted. 215×160 (8$\frac{7}{16}$×6$\frac{5}{16}$). J 204. Knoedler Gallery, New York.
Sale: Degas 1918, no. 201. Reproduced in the Blaizot edition, p. 29.
The scene of the quarrel between Virginie Cardinal's protector, the Marquis Cavalcanti, and M. Cardinal.

82 THE FAMOUS GOOD FRIDAY DINNER (LE FAMEUX DÎNER DU VENDREDI). Black ink on white paper. 215×160 (8$\frac{7}{16}$×6$\frac{5}{16}$). J 205. Known by the reproduction in the Blaizot edition, p. 69.
A more angry version of the previous scene.

BROTHEL SCENES, c. 1876–85

Since Lemoisne's catalogue it has been usual to assign a date of c. 1879 to the brothel scenes, although in fact there are few good reasons for picking on that particular year. A series of drawings of prostitutes in a sketchbook now in the Louvre dates from 1876–7, the two years that saw the publication in Paris of a number of naturalist novels on the theme of prostitutes and brothels: Marthe, histoire d'une fille by Huysmans, for example, and the highly successful La Fille Élisa by Edmond de Goncourt. But there is no attempt in these monotypes to individualize any of the prostitutes, and there are no grounds for believing they are intended as illustrations for one of these books. Nor is there anything to indicate that Degas executed all the monotypes in the course of the same year; in the end it is impossible to date them more precisely than between 1876 and 1885.

83 BROTHEL SCENE (SCÈNE DE MAISON CLOSE). Black ink on cream paper, heightened with pale ochre watercolour. 160×214 (6$\frac{5}{16}$×8$\frac{7}{16}$). J 68. Bibliothèque d'Art et d'Archéologie de l'Université de Paris, Fondation Jacques Doucet.
Signature in bottom right-hand corner: Degas. Stamp of the collector Jacques Doucet in bottom left-hand corner.
Reproduced in La Maison Tellier, Vollard 1934, facing p. 34.

84 IN THE SALON (AU SALON). Black ink on china paper. 214×160 (8$\frac{7}{16}$×6$\frac{5}{16}$). J 116. National Museum, Belgrade.
Formerly in Ambroise Vollard Collection. Bibliography: Rouart, Les Degas et les Renoirs inconnus du Musée de Belgrade, 1966.

85 WAITING I (L'ATTENTE). Black ink on china paper. 210×159 (8$\frac{1}{4}$×6$\frac{1}{4}$). J 64. Private collection, London.
Atelier stamp verso. Reproduced as an engraving (not a facsimile) in La Maison Tellier, Vollard 1934, p. 16.
Sale: Degas 1918, no. 221. Exhibition: Lefèvre Gallery, 1958, no. 7.

86 WAITING II (L'ATTENTE). Freshly inked variant on the preceding monotype. 216×159 (8$\frac{1}{2}$×6$\frac{1}{4}$). J 65. Pablo Picasso Collection.
Atelier stamp verso. Reproduced in Pierre Louÿs, Mimes des Courtisanes, Vollard 1935, facing p. 30.
Exhibition: Lefèvre Gallery 1958, no. 8. Bibliography: Rouart, Monotypes, 1948, pl. 40.

87 IN THE SALON (AU SALON). Black ink on white paper. 159×215 (6$\frac{1}{4}$×8$\frac{7}{16}$). J 82. Pablo Picasso Collection.
Atelier stamp verso. Formerly in Vollard Collection. Reproduced in La Maison Tellier, Vollard 1934, facing p. 32.
Sale: Degas 1918, no. 222. Exhibition: Orangerie 1937, no. 192; Lefèvre Gallery 1958, no. 11. Bibliography: Rouart, Monotypes, 1948, p. 34.

88 IN THE SALON (AU SALON). Black ink on white paper. 120 × 160 (4¾ × 6 5/16). J 79. Bibliothèque d'Art et d'Archéologie de l'Université de Paris, Fondation Jacques Doucet. Signed in the bottom margin on the left; stamp of the collector Jacques Doucet in the centre of the bottom margin. Reproduced in *La Maison Tellier*, Vollard 1934, facing p. 40. There is also a 2nd proof in existence (J 80).

89 PROSTITUTE SEATED IN AN ARMCHAIR (PENSIONNAIRE ASSISE DANS UN FAUTEUIL). Black ink on white paper. 158 × 114 (6¼ × 4½). J 78. Known from the reproduction in *La Maison Tellier*, Vollard 1934, facing p. 20.

90 BROTHEL SCENE, IN THE SALON (MAISON CLOSE, COIN DE SALON). Ink on china paper. 166 × 118 (6½ × 4 11/16). J 71. Private collection, New York. Traces of fingerprints top left and centre left. *Exhibition*: Fogg Art Museum, 1968, no. 17. *Bibliography*: Rouart, *Monotypes*, 1948, p. 29.

91 TWO GIRLS IN A BROTHEL (DEUX FILLES). Black ink on china paper, mounted. 160 × 121 (6 5/16 × 4¾). J 81. Kornfeld and Klipstein Collection, Bern. Reproduced in Pierre Louÿs, *Mimes des courtisanes*, Vollard 1935, facing p. 46. *Sale*: Degas 1918, no. 220. *Exhibition*: Fogg Art Museum 1968, no. 21. *Bibliography*; Rouart, *Monotypes*, 1948, pl. 35.

92 PROSTITUTES WEARING SHIFTS (PENSIONNAIRES EN CHEMISE). Black ink on china paper. 119 × 162 (4⅝ × 6⅜). J 69. Bibliothèque d'Art et d'Archéologie de Paris, Fondation Jacques Doucet. Signature in bottom left corner; stamp of the collector Jacques Doucet at the very edge of the impression, centre bottom. Reproduced in A. Vollard, *Souvenir d'un marchand de tableaux*, 1937, and in P. Louÿs, *Mimes des courtisanes*, Vollard 1935, facing p. 66. There is also a 2nd impression in existence (J 70).

93 IN THE SALON (AU SALON). Black ink on white paper. 111 × 159 (4⅜ × 6¼). J 66. Private collection, Great Britain. Atelier stamp verso. Reproduced in P. Louÿs, *Mimes des courtisanes*, Vollard 1935. *Sale*: Degas 1918, no. 221. *Exhibition*: Lefèvre Gallery 1958, no. 15; Ny Carlsberg Glyptothek 1948, no. 83.

94 WAITING TIME (ATTENTE). Black ink on china paper. 112 × 159 (4⅜ × 6¼). J 67. Pablo Picasso Collection. Publisher's stamp verso. Reproduced in P. Louÿs, *Mimes des courtisanes*, Vollard 1935. *Exhibition*: Orangerie 1937, no. 121; Lefèvre Gallery 1958, no. 28.

95 THE CUSTOMER (LE CLIENT). Black ink on white paper. 215 × 159 (8 7/16 × 6¼). J 85. Pablo Picasso Collection. Unsigned; atelier stamp verso. Reproduced in *La Maison Tellier*, Vollard 1934, facing p. 22; *Eros Magazine*, spring 1962, p. 66. *Sale*: Degas 1918, no. 221 (in a lot of 16). *Exhibition*: Lefèvre Gallery 1958, no. 6.

96 THE SERIOUS CUSTOMER (LE CLIENT SÉRIEUX). Black ink on china paper. 210 × 159 (8¼ × 6¼). J 86. Peploe Collection, London. Atelier stamp verso. Reproduced in *La Maison Tellier*, Vollard 1934, facing p. 18; *Eros Magazine*, spring 1962, p. 71. *Sale*: Degas 1918, no. 221 (in a lot of 16). *Exhibition*: Orangerie 1937, no. 198; Ny Carlsberg Glyptothek, 1948, no. 87; Lefèvre Gallery 1958, no. 30.

97 RELAXATION (REPOS). Black ink on china paper. 159 × 121 (6¼ × 4¾). J 73. Private collection. Atelier stamp verso. Reproduced in P. Louÿs, *Mimes des courtisanes*, Vollard 1935, facing p. 70. *Sale*: Degas 1918, no. 221. *Exhibition*: Orangerie 1937,

no. 194; Lefèvre Gallery 1958, no. 26; Fogg Art Museum 1968, no. 19 (loaned anonymously).

98 COURTESANS (COURTISANES). Black ink on paper. 156 × 212 (6⅛ × 8¼). J 74. National Museum, Belgrade. Formerly A. Vollard Collection. Reproduced in P. Louÿs, *Mimes des courtisanes*, Vollard 1935, facing p. 22.

99 THE MADAME'S ANNIVERSARY (LA FÊTE DE LA PATRONNE). Brown ink on white paper. 115 × 159 (4½ × 6¼). J 88. Location unknown. Formerly in the Vollard Collection. Reproduced in P. Louÿs, *Mimes des courtisanes*, Vollard 1935, facing p. 24. *Exhibition*: Lefèvre Gallery 1958, no. 19. *Bibliography*: Rouart, *Monotypes*, 1948, pl. 31. There is also a variant of this scene, of which this monotype would form the centre portion, in which the nudes on the left and the right are seen full-length. The proof is heightened with pastel (J 89).

100 THE MADAME'S ANNIVERSARY (LA FÊTE DE LA PATRONNE). Black ink on white paper. 155 × 202 (6⅛ × 7 15/16). J 90. Known from the reproduction in *La Maison Tellier*, Vollard 1934, facing p. 12.

101 RESTING ON THE BED (REPOS SUR LE LIT). Black ink on china paper. 120 × 160 (4¾ × 6 5/16). J 91. Pablo Picasso Collection. Atelier stamp verso. Reproduced in La *Maison Tellier*, Vollard 1934, facing p. 48. *Exhibition*: Orangerie 1937, no. 197; Lefèvre Gallery 1958, no. 16. *Bibliography*: Eros Magazine, spring, 1962, p. 60.

102 RESTING ON THE BED (REPOS SUR LE LIT). Black ink on china paper. 114 × 159 (4½ × 6¼). J 92. Mrs Gerald Corcoran Collection, London. Reproduced in *La Maison Tellier*, Vollard 1934, facing p. 6. *Exhibition*: Orangerie 1937, no. 193; Lefèvre Gallery, 1958, no. 12; Fogg Art Museum 1968, no. 23. *Bibliography*: Rouart, *Monotypes*, 1948, p. 37.

103 RESTING ON THE BED (REPOS SUR LE LIT). Black ink on china paper mounted on heavy paper. 160 × 120 (6 5/16 × 4¾). J 97 Madame Le Garrec Collection, Paris. Reproduced in *La Maison Tellier*, Vollard 1934, facing p. 38, and in P. Louÿs, *Mimes des courtisanes*, Vollard 1935, facing p. 38. *Exhibition*: Fogg Art Museum 1968, no. 24. There is also a paler counterproof, location unknown (J 98).

104 RESTING ON THE BED (REPOS SUR LE LIT). Black ink on china paper. 159 × 121 (6¼ × 4¾). J 95. Location unknown. Atelier stamp verso. *Sale*: Degas 1918, no. 229. *Exhibition*: Lefèvre Gallery, 1958, no. 17. There is also a counterproof of this monotype (J 96).

105 RESTING ON THE BED (REPOS SUR LE LIT). Black ink on white paper. J 93. Known by the reproduction in *La Maison Tellier*, Vollard 1934, facing p. 6, and in M. Dormoy, *Les Monotypes de Degas*, Paris 1936, no. 51.

106 INDISCRETION. Black ink on china paper. 118 × 160 (4 11/16 × 6 5/16). J 100. Known from a photograph in the Witt Library, Courtauld Institute, London. *Sale*: Degas 1918. There is also a counterproof of almost equal quality of impression, however this would appear to be the 1st proof because the line makes more sense with the image this way round. The woman appears to be examining the watermark on a banknote to assure herself that it is genuine.

107 WAITING TIME (ATTENTE). Black ink on china paper. 119 × 160 (4 11/16 × 6 5/16). J 103. Gift of Mrs Charles Glore. The Art Institute of Chicago. Reproduced in *La Maison Tellier*, Vollard 1934, p. 47. *Sale*: Degas 1918, no. 228. *Exhibition*: Orangerie 1937, no. 195; Fogg Art Museum 1968, no. 26.

108 THE BAWD (L'ENTREMETTEUSE). Black ink on paper. 160 × 118 (6$\frac{5}{16}$ × 4$\frac{11}{16}$). J 107. Bibliothèque d'Art et d'Archéologie de l'Université de Paris. Fondation Jacques Doucet. Signed bottom left-hand corner; stamp of the collector Jacques Doucet in the margin at the bottom. Reproduced in *La Maison Tellier*, Vollard 1934, and in P. Louÿs, *Mimes des courtisanes*, Vollard 1935, facing p. 74.

109 CONVERSATION. Black ink on white paper. 160 × 120 (6$\frac{5}{16}$ × 4$\frac{3}{4}$). J 106. Mrs Gerald Corcoran Collection, London. Atelier stamp verso. Reproduced in P. Louÿs, *Mimes des courtisanes*, Vollard 1935, facing p. 18.
Sale: Degas 1918, no. 221 (in a lot of 16). *Exhibition*: Lefèvre Gallery 1958, no. 5; Fogg Art Museum 1968, no. 27.
Bibliography: Rouart, *Monotypes*, 1948, pl. 36.

110 PREPARATIONS (PRÉPARATIFS). Black ink on china paper. 121 × 159 (4$\frac{3}{4}$ × 6$\frac{1}{4}$). J 105. Location unknown. Atelier stamp verso. Reproduced in *La Maison Tellier*, Vollard 1934, p. 63 (engraving).
Sale: Degas 1918, no. 221 (in a lot of 16). *Exhibition*: Lefèvre Gallery 1958, no. 18.

111 SIESTA IN THE SALON (SIESTE DU SALON). Black ink on china paper. 159 × 210 (6$\frac{1}{4}$ × 8$\frac{1}{4}$). J 72. Private collection. Atelier stamp verso. Reproduced in P. Louÿs, *Mimes des courtisanes*, Vollard 1935, facing p. 54.
Exhibition: Lefèvre Gallery 1958, no. 20; Fogg Art Museum 1968, no. 18 (loaned anonymously).

112 SIESTA, BROTHEL SCENE (LA SIESTE, SCÈNE DE MAISON CLOSE). Black ink on china paper mounted on heavy paper. 215 × 159 (8$\frac{7}{16}$ × 6$\frac{1}{4}$). J 75. Katherine Bullard Fund, Museum of Fine Arts, Boston.
Formerly in Marcel Guérin Collection.
Sale: Degas 1918, no. 225. *Exhibition*: Fogg Art Museum 1968, no. 20.

113 RELAXATION (REPOS). Black ink on china paper. 159 × 216 (6$\frac{1}{4}$ × 8$\frac{1}{2}$). J 83. Pablo Picasso Collection. Atelier stamp verso. Reproduced in *La Maison Tellier*, Vollard 1934, facing p. 58.
Sale: Degas 1918, no. 221 (in a lot of 16). *Exhibition*: Orangerie 1937, no. 196; Ny Carlsberg Glyptothek, 1948, no. 86; Lefèvre Gallery 1958, no. 23.

114 THE PRIVATE ROOM (LE CABINET PARTICULIER). Black ink on china paper mounted on heavy paper. 160 × 215 (6$\frac{5}{16}$ × 8$\frac{7}{16}$). J 114. Katherine Bullard Fund, Museum of Fine Arts, Boston.
Atelier stamp verso; monogram stamp of the collector Marcel Guérin in the bottom margin on the right.
Sale: Degas 1918, no. 206. *Exhibition*: Galerie Georges Petit, Paris, 1924, no. 234; Fogg Art Museum 1968, no. 28.

115 THE CUSTOMER, SUPPER TIME (L'AMATEUR, LE SOUPER). Black ink on china paper. 210 × 160 (8$\frac{1}{4}$ × 6$\frac{5}{16}$). J 115. Mrs Everett McNear Collection.
Atelier stamp verso.
Sale: Degas 1918, no. 221 (in a lot of 16). *Exhibition*: Ny Carlsberg Glyptothek 1948, no. 81; Lefèvre Gallery 1958, no. 22; Fogg Art Museum 1968, no. 29.

116 IN THE SALON OF A BROTHEL (DANS LE SALON D'UNE MAISON CLOSE). Black ink on china paper. 210 × 159 (8$\frac{1}{4}$ × 6$\frac{1}{4}$). J 87. Lefèvre Gallery, London.
Reproduced in *La Maison Tellier*, Vollard 1934, facing p. 4.
Sale: Degas 1918, no. 223. *Exhibition*: Lefèvre Gallery 1958; Fogg Art Museum 1968, no. 12. *Bibliography*: M. Dormoy, *Les Monotypes de Degas*, Arts et Métiers Graphiques, Paris 1936, no. 51; Rouart, *Monotypes*, 1948, pl. 21; *Eros Magazine*, spring 1962, p. 70.

117 FARNIENTE. Black ink on china paper. 160 × 217 (6$\frac{5}{16}$ × 8$\frac{9}{16}$). J 102. Known only from a photograph in the Witt Library, Courtauld Institute, London.
Sale: Degas 1918, no. 234.

118 WAITING FOR THE CUSTOMER (EN ATTENDANT LE CLIENT). Black ink. 150 × 210 (5$\frac{15}{16}$ × 8$\frac{1}{4}$). J 104. Maurice Guérin Collection, Paris.
Reproduced in P. Louÿs, *Mimes des courtisanes*, Vollard 1935, facing p. 14.
The shadowy figure approaching the bed, seen in the mirror, is presumably the customer.

119 ON THE BED (SUR LE LIT). Black ink on china paper. 210 × 159 (8$\frac{1}{4}$ × 6$\frac{1}{4}$) (?). J 109. Pablo Picasso Collection.
Reproduced in P. Louÿs, *Mimes des courtisanes*, Vollard 1935, facing p. 52.

120 IN FRONT OF THE LAMP (DEVANT LA LAMPE). Black ink on paper mounted on cardboard. 136 × 200 (5$\frac{3}{8}$ × 7$\frac{7}{8}$). J 112. R. G. Michel Collection, Paris.
Atelier stamp verso.
Sale: Degas 1918, probably no. 262.

121 MORNING FROLIC (ÉBAT MATINAL). Black ink on china paper. 119 × 162 (4$\frac{11}{16}$ × 6$\frac{3}{8}$). J 94. David Weill Collection.
Sale: Degas 1918, no. 138 or 139 (as lithograph). Reproduced in Delteil (no. 52) as a lithograph.
The rather pale grey inking of this monotype leads one to think it may be a counterproof.

122 TWO WOMEN (DEUX FEMMES). Black ink on light tan paper. 214 × 283 (8$\frac{7}{16}$ × 11$\frac{1}{8}$). J 117. Katherine Bullard Fund, Museum of Fine Arts, Boston.
Sale: Degas 1918, no. 221 (in a lot of 16). *Exhibition*: Fogg Art Museum 1968, no. 30.
Compare with another monotype, heightened with pastel, on a Lesbian theme (J 118).

123 UNTITLED ZINC PLATE, used to print a monotype that has since disappeared or been destroyed. 108 × 159 (4$\frac{1}{4}$ × 6$\frac{1}{4}$). J 108. Cabinet des Estampes, Bibliothèque Nationale, Paris. This plate, which has been broken in two, is a rare example of the brothel scenes we know existed and which the Degas family judged to be obscene and therefore, in all probability, destroyed.

NUDES, DOMESTIC SCENES AND WOMEN AT THEIR TOILET, c. 1878–90

With the exception of a few monotypes linked with the brothel scenes, the *Women at Their Toilet* are very close to the pastels and drawings on the same theme produced between approximately 1880 and 1890, including the famous series shown at the eighth and last Impressionist exhibition in 1886. To give a precise date to each monotype is almost impossible, except as a subjective judgment, however their style places them in all cases somewhere between 1878 and 1890.
In some instances it seems that the same plate has been used several times in succession.

124 NUDE WOMAN DRYING HER FACE (FEMME NUE S'ESSUYANT LA FIGURE), c. 1879. Black ink on white paper. 153 × 114 (6 × 4$\frac{1}{2}$). J 113. Known from the reproduction in *La Maison Tellier*, Vollard 1934, facing p. 44; later reproduced in *Eros Magazine*, spring 1962, p. 69.

125 GIRL PUTTING ON HER STOCKINGS (FEMME METTANT SES BAS), c. 1880. Black ink on china paper mounted on cardboard. 159 × 121 (6$\frac{1}{4}$ × 4$\frac{3}{4}$). J 169. Mrs H. O. Havemeyer Bequest, The Metropolitan Museum of Art, New York.
Exhibition: Fogg Art Museum 1968, no. 40.
This monotype was given by Degas to Mary Cassatt, who gave it to Mrs Havemeyer in 1889; there is a pencil note on the mount to this effect, in Mrs Havemeyer's handwriting.

126 GETTING DRESSED, PUTTING ON STOCKINGS (LE LEVER, LES BAS), c. 1880. Black ink on paper. 160 × 215 (6$\frac{5}{16}$ × 8$\frac{7}{16}$). J. 170. Location unknown.
Sale: Degas 1918, no. 214. *Exhibition*: Los Angeles County Museum, 1958, no. 95.

There is a 2nd impression of this monotype which has been cut across diagonally from the top left-hand corner (J 171).

127 THE EARRING (LA BOUCLE D'OREILLE), c. 1880. Black ink on china paper. 159 × 121 (6¼ × 4¾). J 99. Lefèvre Gallery, London.
Sale: Degas 1918, no. 214. *Exhibition:* Lefèvre Gallery 1958, no. 43; Fogg Art Museum 1968, no. 25.

128 NUDE WOMAN AT THE DOOR OF HER ROOM (FEMME NUE À LA PORTE DE SA CHAMBRE), c. 1880. Black ink. 161 × 118 (6 5/16 × 4 11/16). J 180. Katherine Bullard Fund, Museum of Fine Arts, Boston.
Stamp of the collector Marcel Guérin in the bottom margin on the left.
Sale: Degas 1918, no. 215. *Exhibition:* Galerie Georges Petit, Paris, 1924, no. 233; Fogg Art Museum 1968, no. 42.
This monotype is probably a first attempt at one of the motifs on the lithograph A 45.

129 ADMIRATION, c. 1880. Black ink on pale ochre paper, with two light touches of colour. 215 × 161 (8 7/16 × 6 5/16). J 184. Bibliothèque d'Art et d'Archéologie de l'Université de Paris, Fondation Jacques Doucet.
Signed in pencil in the bottom margin on the left; stamp of the collector Jacques Doucet in the bottom margin, right of centre. Reproduced in *La Maison Tellier*, Vollard 1934, facing p. 50.
Without doubt a brothel scene; compare with another monotype heightened with pastel (exhibited at the Fogg Art Museum in 1968, no. 43), in which a man is watching a nude woman combing her hair, next to a bathtub.

130 THE TUB (LE TUB), c. 1880. Brown ink on china paper. 160 × 211 (6 5/16 × 8 5/16). J 189. Location unknown.
Stamp of the collector Marcel Guérin in the bottom margin on the left.
Exhibition: Galerie Georges Petit, Paris, 1924, no. 232 (from the Guillaume Guérin Collection).

131 WOMAN STANDING IN THE BATH (FEMME DEBOUT DANS UNE BAIGNOIRE), c. 1880. Black ink on paper. J 173 Known only from the reproduction in P. Louÿs, *Mimes des courtisanes*, Vollard 1935, facing p. 62.
Bibliography: Rouart, *Monotypes*, 1948, pl 17.

132 THE BATH (LE BAIN), c. 1880. Black ink on white paper. 213 × 164 (8⅜ × 6 7/16). J 172. Den Kongelige Kobberstik Samling, Statens Museum for Kunst, Copenhagen.
Sale: Degas 1918, no. 217. *Exhibition:* Fogg Art Museum 1968, no. 41.

133 WOMAN GETTING OUT OF THE BATH (SORTIE DU BAIN), c. 1880. Black ink on white paper. 157 × 118 (6 3/16 × 4 11/16). J 176. Cabinet des Estampes, Bibliothèque Nationale, Paris.
Signed in pencil in the bottom right-hand corner: Degas. Formerly in the George Viau Collection.
Exhibition: Galerie Georges Petit, Paris, 1924, no. 235. *Bibliography:* Rouart, *Monotypes*, p. 24.
The same composition exists with the image reversed, heightened with pastel (Caillebotte Bequest, Cabinet des Dessins, Louvre; J 175). Degas also executed an engraving with the electric crayon (A 49; LD 39), the first state of which is somewhat similar to this monotype.
Traces of fingerprints are visible, used to model the contours of the woman's body.

134 THE FINAL TOUCHES (DERNIERS PRÉPARATIFS DE TOILETTE), c. 1880. Black ink on china paper. 160 × 215 (6 5/16 × 8 7/16). J 188. Achenbach Foundation, California Palace of the Legion of Honor, San Francisco.
Atelier stamp on the mount.
Sale: Degas 1918, no. 219. *Exhibition:* Fogg Art Museum 1968, no. 45.

135 THE BIDET (LE BIDET), c. 1880. Black ink on white paper. 275 × 295 (10⅞ × 11⅝). J 155. Private collection, Paris.

This is very probably a 2nd, even a 3rd proof. *Sale:* Degas 1918, no. 244.

136 GETTING DRESSED, SEATED WOMAN PUTTING ON HER STOCKINGS (LE LEVER, femme assise mettant ses bas), c. 1885. Black ink on white paper, very light touches of pastel on the hands and the torso, and white gouache on the white sheet on the right. 295 × 270 (11⅝ × 10⅝). J 168. Camondo Bequest, Cabinet des Dessins, Louvre, Paris.
Signed half-way down the picture on the left-hand side: Degas.
Exhibition: Galerie Georges Petit, Paris, 1924, no. 249; Orangerie 1937, no. 24, and 1969, no. 208.

137 GETTING UP – STOCKINGS (LE LEVER, les bas), c. 1880–5. Black ink on paper. 379 × 278 (14⅞ × 10 15/16). J 167. Print Room, Nasjonalgalleriet, Oslo.
Atelier stamp verso.
Sale: Degas 1918, no. 241. *Exhibition:* Fogg Art Museum 1968, no. 39.

138 GETTING INTO BED (LE COUCHER), c. 1880–5. Black ink on white paper. 378 × 277 (14⅞ × 10 15/16). J 166. Print Room, Nasjonalgalleriet, Oslo.
Atelier stamp verso.
Sale: Degas 1918, no. 254. *Exhibition:* Fogg Art Museum 1968, no. 38.

139 GETTING INTO BED (LE COUCHER), c. 1885. Black ink on white paper. 380 × 280 (14 15/16 × 11 1/16). J 129. Private collection, Great Britain.
Formerly in the Vollard Collection.
Sale: Degas 1918, no. 253. *Exhibition:* Ny Carlsberg Glyptothek, 1948, no. 79; Los Angeles County Museum, 1958, no. 98. *Bibliography:* Rouart, *Monotypes*, 1948, pl. 23; Janis, *Burlington Magazine*, February 1967, part II, pp. 79, 80.
There is also a 2nd impression of this monotype, touched with pastel; L 747 (as a pastel) and J 130.

140 GETTING INTO BED (LE COUCHER), c. 1885. Black ink on white paper. 227 × 440 (8⅞ × 17⅜). J 133. Known from the reproduction in the catalogue of the sale held at the Hôtel Drouot, 22 June 1925, no. 72.
Sale: Degas 1918, no. 252. *Bibliography:* Janis, *Burlington Magazine*, February 1967, part II, p. 79.
In the Tate Gallery, London (Frank Stoop Bequest) is a 2nd impression touched with pastel (J 134).

141 WOMAN PUTTING OUT HER BEDSIDE LAMP (FEMME ÉTEIGNANT SA LAMPE DE CHEVET), c. 1885. Black ink. 274 × 310 (10⅞ × 12⅛). J 131. Known from the reproduction in the catalogue of the sale held at the Hôtel Drouot, 22 June 1925, p. 29.
Sale: Degas 1918, no. 255.
There is a pastel over monotype of this same scene, which belongs to Mme Friedmann, Paris (J 132).

142 AWAKENING (LE REVEIL), c. 1885. Black ink on white paper, 260 × 300 (10¼ × 11⅞) (?). J 164. Known only from the reproduction in *L'album Degas*, Vollard 1914, pl. 6.
Signed in bottom margin to the left, and on the mount on the right-hand side.

143 NUDE WOMAN SEEN FROM BEHIND (FEMME NUE DE DOS), c. 1880. Black ink on china paper. 190 × 129 (7½ × 5 1/16) J 181. Location unknown.
Atelier stamp verso. Reproduced as an engraving (not facsimile) in *La Maison Tellier*, Vollard 1934, p. 39.
Sale: Degas 1918, no. 231. *Exhibition:* Lefèvre Gallery 1958, no. 29.

144 NUDE WOMAN IN HER ROOM, SEEN FROM BEHIND (FEMME NUE DE DOS DANS SA CHAMBRE), c. 1880. Black ink on china paper. 159 × 216 (6¼ × 8½). J 182. Lefèvre Gallery, London.
Atelier stamp verso. Reproduced in *La Maison Tellier*, Vollard, 1934, p. 27.

Sale: Degas 1918, no. 260. *Exhibition:* Lefèvre Gallery 1958, no. 21.

145 FANTASY, NUDE WOMAN (FANTAISIE, nu), *c.* 1880. Black ink on china paper. 172 × 90 (6¾ × 3½). J 183. Private collection, Paris.
Sale: Degas 1918, no. 315.

146 NUDE WOMAN SEEN FROM BEHIND, TOWEL IN HAND (FEMME NUE DE DOS, UNE SERVIETTE À LA MAIN), *c.* 1878. Black ink on china paper. 210 × 97 (8¼ × 3⅞). J 179. Location unknown. Known from a photograph in the Witt Library, Courtauld Institute, London.
Reproduced in Delteil, no. 55, this monotype is probably a first shot at the idea for the lithograph *La Toilette* (A 46 and LD 55).
Sale: Degas 1918, no. 232.

147 THE BIDET (LE BIDET), *c.* 1880. Black ink on china paper. 163 × 124 (6⅜ × 4⅞). J 110. Location unknown. Known from the reproduction in P. Louÿs, *Mimes des courtisanes*, Vollard 1935, facing p. 56.
There is another, paler, proof of this monotype in the John and Alice Rewald Collection, New York (J 111).

148 WOMAN ENGAGED ON HER INTIMATE TOILET (FEMME À SA TOILETTE INTIME), *c.* 1880. Black ink on white paper. 154 × 116 (6 × 4⅝). J 190. Location unknown. Known from the reproduction in *La Maison Tellier*, Vollard 1934, facing p. 36.
There is a 2nd proof touched with pastel in the Caillebotte Bequest, Cabinet des Dessins, Louvre (J 191).

149 NUDE WOMAN CROUCHING, SEEN FROM BEHIND (FEMME NUE ACCROUPIE DE DOS), *c.* 1880. J 192. Known only from the reproduction in P. Louÿs, *Mimes des courtisanes*, Vollard 1935, p. 48.
The dimensions are unknown, but the monotype was probably taken from the plate used for the preceding composition.

150 THE BIDET (LE BIDET), *c.* 1880. Black ink on china paper. 75 × 50 (3 × 2). J 193. Location unknown.
Reproduced as an engraved tail-piece in *La Maison Tellier*, Vollard 1934, foot of p. 35. Formerly in the collection of René de Gas.

151 WOMAN GETTING OUT OF THE BATH (FEMME SORTANT D'UNE BAIGNOIRE), *c.* 1883. Rough sketch, monotype in black ink on white paper. 126 × 128 (4¹⁵⁄₁₆ × 5). J 194. Location unknown.
The same composition is used, in reverse, for a pastel of 1883 (L 721).

152 LA TOILETTE, washing the arms, *c.* 1882. Black ink on white paper. 313 × 278 (12¼ × 10⅞). J 146. Grunwald Graphic Arts Foundation, University of California, Los Angeles. Unsigned; atelier stamp verso.
Sale: Degas 1918, no. 246. *Exhibition:* Ny Carlsberg Glyptothek, 1948, no. 88; Los Angeles County Museum, 1958, no. 97.

153 WOMAN AT HER TOILET, the washbasin (FEMME À SA TOILETTE, la cuvette), *c.* 1880–5. Black ink on china paper. 278 × 313 (10⅞ × 12¼). J 177. Private collection, London.
Exhibition: Lefèvre Gallery, 1958, no. 27. *Bibliography:* Rouart, *Monotypes*, 1948, pl. 18.

154 WOMAN WASHING (À SA TOILETTE), *c.* 1882–5. Black ink on white paper. 313 × 278 (12¼ × 10⅞). J 149. Bibliothèque d'Art et d'Archéologie de l'Université de Paris. Fondation Jacques Doucet.
Signed in the bottom margin on the left; stamp of collector Jacques Doucet in the bottom margin on the right.
Bibliography: Janis, *Burlington Magazine*, February 1967, part II, pp. 80, 81.
There is also a 2nd proof heightened with pastel (J 150).

155 LA TOILETTE – WOMAN IN THE BATH (LA TOILETTE – LE BAIN), *c.* 1882. Black ink on white paper, 313 × 278 (12¼ × 10⅞). J 123. Clarence Buckingham Collection, the Art Institute of Chicago.
Atelier stamp verso. Formerly in A. Vollard Collection.
Sale: Degas 1918, no. 243. *Exhibition:* Fogg Art Museum 1968, no. 33.

156 THE WASHBASIN (LA CUVETTE), *c.* 1882–5. Black ink on white paper. 311 × 273 (12¼ × 10¾). J 147. The Sterling and Francine Clark Institute, Williamstown, Mass.
Formerly in A. Vollard Collection.
Sale: Degas 1918, no. 245. *Exhibition:* Fogg Art Museum 1968, no. 36.
Compare with one of the best-known prints by Mary Cassatt, *La Toilette.*

157 WOMAN STANDING IN THE BATH (FEMME DEBOUT DANS UNE BAIGNOIRE), *c.* 1882–5. Black ink on pale ochre paper. 360 × 270 (14⅛ × 10⅝). J 125. Camondo Bequest, Cabinet des Dessins, Louvre, Paris.
Exhibition: Galerie Georges Petit, Paris, 1924, no. 248; Orangerie 1969, no. 207.

158 WOMAN DRYING HER FEET BY THE BATH (FEMME S'ESSUY-ANT LES PIEDS PRÈS D'UNE BAIGNOIRE), *c.* 1882–5. Black ink on a sheet of cream paper. 451 × 239 (17¾ × 9⅜). J 127. Camondo Bequest, Cabinet des Dessins, Louvre, Paris.
Exhibition: Grangerie 1969, no. 206. *Bibliography:* Janis, *Burlington Magazine*, February 1967, part II, p. 80.

159 THE TUB (LE TUB), *c.* 1882–5. Black ink on white paper. 420 × 541 (16½ × 21¼). J 151. Bibliothèque d'Art et d'Archéologie de l'Université de Paris, Fondation Jacques Doucet.
Signed bottom right in pencil.
Bibliography: Janis, *Burlington Magazine*, February 1967, part II, p. 80.
There is also a 2nd impression heightened with pastel (L 890).

160 WOMAN IN THE BATH (FEMME AU BAIN), *c.* 1882–5. Black ink on heavy paper. 200 × 429 (7⅞ × 16⅞). J 119. Private collection, Paris.
Signature and inscription written, in reverse, on the newly printed sheet: Degas to P. Rossana. Stamp of the collector A. Beurdeley in the bottom margin on the right.
Exhibition: Orangerie 1937, no. 209; Ny Carlsberg Glyptothek, 1948, no. 77; Fogg Art Museum 1968, no. 31.
In the Cabinet des Dessins in the Louvre is a monotype very similar to this one except that it is heightened with pastel; it is listed as a pastel in the Lemoisne catalogue. Rossana was a potter from Limoges whom Degas recommended to his friend Haviland in a letter of 1879–80.

161 AFTER THE BATH (APRÈS LE BAIN), *c.* 1882–5. Black ink on white paper. 280 × 375 (11¹⁄₁₆ × 14¾). J 121. Elsa Essberger Collection, Hamburg.
Signature and inscription written, in reverse, bottom right on the newly printed sheet: 'Degas to his friend: Michel Levy'.
Exhibition: Los Angeles County Museum 1968, no. 96; Fogg Art Museum 1968, no. 32.
Compare with the similar pastel over monotype in the Dunbar Sherwood Collection, New York (J 122).

162 FEMALE TORSO (TORSE DE FEMME), *c.* 1885. Brown ink on Japanese rice paper mounted on cardboard. 500 × 393 (19⅝ × 15½). J 158. Cabinet des Estampes, Bibliothèque Nationale, Paris.
Signed bottom right in pencil; Bibliothèque Nationale stamp centre bottom.

163 WOMAN ON THE BED (FEMME ÉTENDUE SUR UN LIT), *c.* 1885. Black ink. 200 × 417 (7⅞ × 16⅜). J 137. Kovler Gallery, Chicago.
Signature and inscription, in reverse, top left-hand side, written in the fresh ink: Degas to Burty.

Exhibition: Orangerie 1937, no. 208; Ny Carlsberg Glyptothek, 1948, no. 46. Bibliography: M. Guérin, 'Notes sur les monotypes de Degas', L'Amour de l'Art, 1914, pl. 19. Philippe Burty was an art critic, a friend of Degas and one of the first to lend support to the Impressionist group.

164 SLEEP (LE SOMMEIL), c. 1885. Black ink on cream-coloured vellum. 276 × 378 (10$\frac{7}{8}$ × 14$\frac{7}{8}$). J 135. Department of Prints and Drawings, British Museum, London.
Sale: Degas 1918, no. 239. Bibliography: M. Guérin, 'Notes sur les monotypes de Degas', L'Amour de l'Art, 1924.
There is also a 2nd impression, heightened with pastel, formerly in the Charles Vignier Collection (J 136).

165 WOMAN READING (LISEUSE), c. 1885. Black ink on white paper. 380 × 278 (14$\frac{15}{16}$ × 10$\frac{7}{8}$). J 141. Rosenwald Collection, National Gallery of Art, Washington, DC.
Signature and inscription, in reverse, bottom right, written in the freshly applied ink: Degas to Lepic.
Exhibition: Fogg Art Museum 1968, no. 34.
The Kunsthalle in Bremen has in its possession the inked glass slab from which the monotype was pulled (J 142).

166 READING AFTER A BATH (LA LECTURE APRÈS LE BAIN), c. 1885. Black ink on white paper. 277 × 386 (10$\frac{7}{8}$ × 15$\frac{1}{4}$). J 139. Private collection, USA.
Unsigned; atelier stamp verso.
Sale: Degas 1918, no. 249; Kornfeld, 1936, no. 23.
There is a 2nd proof owned by Garik Fine Arts, Arcola and Philadelphia (J 140).

167 THE FIRESIDE (LE FOYER, la cheminée), c. 1880. Black ink on white paper. 415 × 586 (16$\frac{3}{8}$ × 23$\frac{1}{8}$). J 159. Private collection, Paris.
Unsigned.
Exhibition: Galerie Georges Petit, Paris 1924, no. 150; Orangerie 1937, no. 207; Ny Carlsberg Glyptothek, 1948, no. 78; Fogg Art Museum 1968, no. 37. Bibliography: M. Guérin, 'Notes . . .', L'Amour de l'Art, 1914, p. 77; Rouart, Technique, 1945, pp. 56, 74, also Monotypes, 1948, pl. 20.

168 NUDE WOMAN COMBING HER HAIR (LA CHEVELURE), c. 1880–5. Black ink on sheet of cream paper. 313 × 279 (12$\frac{1}{4}$ × 11). J 156. Cabinet des Dessins, Louvre, Paris.
Sale: Degas 1918, no. 247. Exhibition: Orangerie 1937, no. 210, also 1969, no. 209.
There is also a 2nd impression heightened with pastel in the P. Schlumberger Collection, New York (J 157).

LANDSCAPES 1878–93

The monotypes of landscapes in black and white belong stylistically to the late 1870s, early 1880s. In certain cases it is possible to be more precise; for example, By the Sea (C 181) may date from the summer of 1882, following the visit to the Halévys at Étretat, or from 1884, after the visit to Dieppe.
There is considerably more certainty about the date of some of the monotypes in colour of remembered or imaginary landscapes. In the autumn of 1890 Degas and Bartholomé made a short trip to Burgundy, spending a few days in Diénay with their friends the Jeanniots. While they were there, Georges Jeanniot (see Bibliography) tells us, Degas executed his first monotypes in colour. He continued with the technique when back in Paris and, in the winter of 1892–3, exhibited at Durand-Ruel's gallery a series of monotypes of landscapes in colour; unfortunately no catalogue was made of them at the time.

169 WOMEN BATHING (LES BAIGNEUSES), c. 1876–80. Black ink on white paper. 114 × 159 (4$\frac{1}{2}$ × 6$\frac{1}{4}$). J 262. Location unknown.
Atelier stamp verso.
Sale: Degas 1918, no. 301. Exhibition: Lefèvre Gallery, 1958, no. 10.
Compare with a Degas painting of 1876, similar in composition except that the bathers are nude (L 377); note too the

resemblance of a picture by Gauguin, which is perhaps making a conscious reference to this monotype: Women Bathing at Dieppe, 1885 (National Museum of Western Art, Tokyo).

170 THE JOCKEY (LE JOCKEY), c. 1878–80. Black ink on china paper. 120 × 160 (4$\frac{3}{4}$ × 6$\frac{15}{16}$). J 261. Sterling and Francine Clark Art Institute, Williamstown, Mass.
Stamp of the collector Marcel Guérin in the bottom left corner of the margin.
Sale: Degas 1918, no. 302. Exhibition: Fogg Art Museum 1968, no. 60.

171 HORSE, SIDE-VIEW (CHEVAL DE PROFIL), c. 1878–80. Monotype lightly touched with charcoal. 300 × 408 (11$\frac{7}{8}$ × 16$\frac{1}{8}$). Gift of the Hon. Francis Biddle, The Corcoran Gallery of Art, Washington, DC.
Signature stamp in bottom left-hand corner. No entry in the Janis checklist.

172 CASTLE AND FOUNTAIN (CHÂTEAU ET JET D'EAU), c. 1878–80. Black ink on paper. 162 × 215 (6$\frac{3}{8}$ × 8$\frac{7}{16}$). J 271. Department of Prints and Drawings, British Museum, London.
Sale: Degas 1918, no. 312.

173 LANDSCAPE (PAYSAGE), c. 1878–80. Black ink on white paper. 160 × 210 (6$\frac{15}{16}$ × 8$\frac{1}{4}$). J 268. Albert Reese Collection, New York.
Mrs Janis has some doubts about the authenticity of this piece, comparing it with certain examples of this technique by Pissarro.

174 TWO TREES (DEUX ARBRES), c. 1878–80. Black ink on white paper. 83 × 70 (3$\frac{1}{4}$ × 2$\frac{3}{4}$). J 273. Mr and Mrs E. Powis Jones Collection, New York.
Sale: Degas 1918, no. 316. Exhibition: Fogg Art Museum 1968, no. 66.

175 THE ROAD (LA ROUTE), c. 1878–80. Black ink on china paper. 118 × 161 (4$\frac{5}{8}$ × 6$\frac{15}{16}$). J 266. Rosenwald Collection, National Gallery of Art, Washington, DC.
Sale: Degas 1918, no. 309. Exhibition: Galerie Georges Petit, Paris, 1924, no. 338; Fogg Art Museum 1968, no. 63.

176 WILLOW TREES (LES SAULES), c. 1880. Black ink on white paper. 118 × 163 (4$\frac{11}{16}$ × 6$\frac{3}{8}$). Private collection, Paris.
Not included in the Janis checklist of monotypes. Atelier stamp verso; stamp of the collector Marcel Guérin in the bottom margin on the left-hand side.
Sale: Degas 1918, no. 311; Hôtel Drouot sale, 9 October 1968.

177 PATH UP THE HILL (LE CHEMIN MONTANT), c. 1878–80. Black ink on paper, mounted. 117 × 160 (4$\frac{5}{8}$ × 6$\frac{15}{16}$). J 267. Horatio Greenough Curtiss Fund, Museum of Fine Arts, Boston.
Atelier stamp on the top right-hand corner of the mount.
Sale: Degas 1918, no. 308. Exhibition: Fogg Art Museum 1968, no. 64.

178 RESTING IN THE FIELDS (REPOS DANS LES CHAMPS), c. 1878–80. Black ink on paper. 212 × 160 (8$\frac{3}{8}$ × 6$\frac{15}{16}$). J 265. Sterling and Francine Clark Art Institute, Williamstown, Mass.
Atelier stamp verso.
Sale: Degas 1918, no. 229. Exhibition: Fogg Art Museum 1968, no. 62.

179 THE FAMILY WALK (LA FAMILLE EN PROMENADE), c. 1880. Brown ink on white paper. 158 × 213 (6$\frac{1}{4}$ × 8$\frac{3}{8}$). J 263. Known from the reproduction in the catalogue of the Degas 1918 sale of prints, no. 296. Present location unknown.

180 THE RIVER (LA RIVIÈRE), c. 1878–80. Brown ink on china paper. 89 × 173 (3$\frac{1}{2}$ × 6$\frac{3}{4}$). J 272. Katherine Bullard Fund, Museum of Fine Arts, Boston.
Atelier stamp in the bottom margin on the right; stamp of

the collector Marcel Guérin in the bottom right-hand corner.
Sale: Degas 1918, no. 307. *Exhibition:* Fogg Art Museum 1968, no. 65.

181 BY THE SEA (AU BORD DE LA MER), *c.* 1880. Black ink on white paper. 117 × 158 (4⅜ × 6¼). J 264. Mr and Mrs Peter A. Wick Collection, Boston, Mass.
Atelier stamp and stamp of the collector Marcel Guérin in the bottom margin on the left.
Sale: Degas 1918, no. 300. *Exhibition:* Fogg Art Museum 1968, no. 61.

182 SMOKE FROM THE FACTORY (FUMÉE D'USINE), *c.* 1880–4. Black ink on paper. 119 × 160 (4¹¹⁄₁₆ × 6¹⁵⁄₁₆). J 269. Private collection, London.
Sale: Degas 1918, no. 316.

183 MOONRISE (LEVER DE LUNE), *c.* 1880. Brown ink on white paper. 119 × 161 (4¹¹⁄₁₆ × 6¹⁵⁄₁₆). J 270. Known from the reproduction in Lafond, *Degas,* 1919. Present location unknown.

184 LE CAP FERRAT. Monotype in colour (reproduced here in black and white); unsigned. J 308. Present location unknown.

185 DUSK IN THE PYRENEES or SPRING TIDE (CRÉPUSCULE DANS LES PYRÉNÉES or LA GRANDE MARÉE), *c.* 1890–3. Monotype in colour on cream paper. 286 × 388 (11¼ × 15¼). J 307. Mrs Phyllis Lambert Collection, Chicago.
Exhibition: Fogg Art Museum 1968, no. 77.

186 L'ESTÉREL or AUTUMN LANDSCAPE (L'ESTÉREL or PAYSAGE D'AUTOMNE), *c.* 1890–3. Monotype in colour. 300 × 400 (11⅞ × 15¾). J 300. Mr Robert Rothschild Collection, New York.
Exhibition: Fogg Art Museum 1968, no. 76.
There is also a second impression owned by Paul Kantor, Beverly Hills (J 301).

187 FOREST IN THE MOUNTAINS (FORÊT DANS LA MONTAGNE), *c.* 1890–93. Monotype in colour. 299 × 403 (11⅞ × 15⅞). J 297. Mrs Bertram Smith Collection, New York.
Exhibition: Durand-Ruel, 1893; Galerie de l'Œil, 1964; Thaw Gallery, New York, 1964; Fogg Art Museum 1968, no. 73. *Bibliography:* Rouart, *L'Œil,* no. 117 (1964).

188 MOUNTAIN STUDY – THE RED HILL (EFFET DE MONTAGNE – LA COLLINE ROUGE), *c.* 1890–3. Monotype in colour on cream paper. 299 × 395 (11⅞ × 15½). J 298. Mrs Phyllis Lambert Collection, Chicago.
Exhibition: Fogg Art Museum 1968, no. 74.

189 STUDY OF AUTUMN IN THE MOUNTAINS (EFFET D'AUTOMNE DANS LA MONTAGNE), *c.* 1890–3. Monotype in colour. 300 × 400 (11⅞ × 15¾). J 299. R. M. Light & Co. Collection, Boston, Mass.
Exhibition: Durand-Ruel, 1893; Galerie de l'Œil, 1964; Gallery, New York, 1964; Fogg Art Museum 1968, no. 75.
Bibliography: Rouart, *L'Œil,* no. 117.

190 LANDSCAPE (PAYSAGE), *c.* 1890–3. Monotype in colour. 290 × 388 (11⅜ × 15¼). J 309. Mrs Phyllis Lambert Collection, Chicago.
Exhibition: Fogg Art Museum 1968, no. 78.

191 VILLAGE IN L'ESTÉREL (VILLAGE DANS L'ESTÉREL), *c.* 1890–3. Monotype in colour. 300 × 400 (11⅞ × 15¾). J 275. Cabinet des Estampes, Bibliothèque Nationale, Paris.
Exhibition: Galerie de l'Œil, 1964; Thaw Gallery, New York, 1964; Rijksmuseum, 1966, no. 173.
Bibliography: J. Adhémar, *Gazette des Beaux-Arts,* 1964, p. 372.
There is a 2nd proof of this monotype in the Cleveland Museum of Art (acquired 1966); it is reproduced here as no. 191a; J 276.

192 CAP HORNU, NEAR SAINT-VALÉRY-SUR-SOMME (LE CAP HORNU, PRÈS DE SAINT-VALÉRY-SUR-SOMME), *c.* 1890–3. Monotype in oils. 299 × 400 (11⅞ × 15¾). J 295. Campbell Dodgson Bequest, Department of Prints and Drawings, British Museum, London.

193 A LAKE IN THE PYRENEES (UN LAC DANS LES PYRENÉES), *c.* 1890–3. Monotype in oils. 298 × 396 (11¾ × 15⅝). J 302. Campbell Dodgson Bequest, Department of Prints and Drawings, British Museum, London.

194 MOUNTAIN LANDSCAPE (PAYSAGE DANS LA MONTAGNE), *c.* 1890–3. Monotype in colour. 304 × 400 (12 × 15¾). J 289. E. V. Thaw Collection, New York.
Exhibition: Durand-Ruel, 1893; Galerie de l'Œil, 1964; Thaw Gallery, New York, 1964; Fogg Art Museum 1968, no. 71.
Bibliography: Rouart, *L'Œil,* no. 117.

195 THE WAY THROUGH THE FOREST (LA ROUTE DANS LA FORÊT) *c.* 1890–3. Monotype in colour. 299 × 400 (11⅞ × 15¾). J 292. R. H. Light Collection, Boston, Mass.
Exhibition: Durand-Ruel, 1893; Galerie de l'Œil, 1964; Thaw Gallery, New York, 1964; Fogg Art Museum 1968, no. 72.
Bibliography: Rouart, *L'Œil,* no. 117.

196 LANDSCAPE (PAYSAGE), *c.* 1890–3. Monotype in oils. 297 × 396 (11⅝ × 15⅝). J 305. Mrs Elsa Sackler Collection, New York.
Exhibition: Galerie de l'Œil, Paris, 1964; Thaw Gallery, New York, 1964.

197 SQUALL IN THE MOUNTAINS (BOURRASQUE DANS LA MONTAGNE), *c.* 1890–3. Monotype in oils. 295 × 390 (11⅝ × 15⅜). J 306. Paul Kantor Collection, Beverly Hills.
Exhibition: Ny Carlsberg Glyptothek, 1948; Galerie de l'Œil, 1964; Thaw Gallery, New York, 1964.

198 RUSSET LANDSCAPE (PAYSAGE ROUX), *c.* 1890–3. Monotype in colour. 300 × 400 (11⅞ × 15¾). Robert M. Light Collection, Boston, Mass.
Formerly in Marcel Guérin Collection. Not included in the Janis checklist.

199 GREEN LANDSCAPE (PAYSAGE VERT), *c.* 1890–3. Monotype in colour. 300 × 400 (11⅞ × 15¾). Mrs L. Bertram Smith Collection, New York.
Formerly in the Marcel Guérin Collection (monogram of the Guérin Collection in the bottom left-hand corner). Not included in the Janis checklist.

200 LANDSCAPE WITH CLOUDLESS SKY (PAYSAGE AU CIEL CLAIR), *c.* 1890–2. Monotype in colour on cream paper. 300 × 400 (11⅞ × 15¾). J 313. Private collection, Paris.
Signed in pencil in the bottom left-hand corner. Listed by Lemoisne as a painting in oils thinned with turpentine (L 1063). Janis describes this monotype as location unknown. It was formerly in the Durand-Ruel Collection, and it is probable that it remained in the family after it was exhibited by the Durand-Ruel Gallery in the winter of 1892–3.

201 BURGUNDY LANDSCAPE (PAYSAGE DE BOURGOGNE), *c.* 1890–2. Monotype in colour on cream paper. 300 × 400 (11⅞ × 15¾). Cabinet des Dessins, Louvre, Paris.
Signed and dedicated in red crayon, in the bottom left-hand corner: to Bartholomé, Degas. Not included in the Janis checklist. This monotype was originally owned by Bartholomé, then formed part of the Le Masle Collection, and finally passed to the National Museums of France as part of the Le Masle Bequest.
We know that it was during the autumn of 1890 that Degas and the sculptor Bartholomé spent three weeks touring the Burgundy countryside in a gig. This monotype was a souvenir from Degas to his friend and it must have remained in his possession until he died in 1928.

LIST OF WORKS BASED ON MONOTYPES

Those monotypes which Degas painted or drew over in gouache or pastel we prefer to regard, not as monotypes, but as original works in their own right. Up to now they have often been classed simply as paintings or pastels but, for the purposes of information, we have included a list of all works based on monotypes. The list draws heavily on the work of Mrs E. P. Janis (op. cit.).

BALLET REHEARSAL (RÉPÉTITION DE BALLET), 1874–5. Pastel and gouache over monotype. 550 × 680 (21⅝ × 26¾). J 2. Formerly in Norton Simon Collection, Fullerton, California.

TWO DANCERS ENTERING THE STAGE (DEUX DANSEUSES ENTRANT EN SCÈNE), c. 1877–8. Pastel over monotype in black ink. 290 × 283 (11⅜ × 11⅛). J 3. Grenville L. Winthrop Bequest, Fogg Art Museum, Harvard University.

THE STAR (L'ÉTOILE), c. 1878. Pastel over monotype in black ink. 580 × 420 (22⅞ × 16½). J 5. Louvre, Paris.

DANCERS ON STAGE (DANSEUSES SUR SCÈNE), c. 1878. Pastel over monotype in black ink. 560 × 400 (22 × 15¾). J 6. Potter Palmer Collection, the Art Institute of Chicago.

THE STAR (L'ÉTOILE), c. 1876–8. Pastel over monotype in black ink. 370 × 270 (14⅝ × 10⅝). J 7. Mr and Mrs William Coxe Wright Collection, St David's, Pennsylvania.

THE STAR (L'ÉTOILE), c. 1878. Pastel over monotype in black ink. 380 × 280 (14¹⁵⁄₁₆ × 11¹⁄₁₆). J 7. Lutjens Collection.

THREE BALLET DANCERS (TROIS DANSEUSES DE BALLET), 1878–9. Pastel over monotype in black ink. 200 × 430 (7⅞ × 16⅞). J 10. Mrs Moorhead C. Kennedy Collection, New York.

PAS BATTU, c. 1879. Pastel over monotype in black ink. 270 × 295 (10⅝ × 11⅝). J 11. Emil Bührle Collection, Zürich.

DANCER ON STAGE WITH A BOUQUET (DANSEUSE SUR SCÈNE AVEC UN BOUQUET), c. 1878–80. Pastel over monotype in black ink. 270 × 380 (10⅞ × 14¹⁵⁄₁₆). J 12. Peter H. B. Frelinghuysen, M. C. Morristown, New Jersey.

TWO DANCERS ON STAGE (DEUX DANSEUSES SUR SCÈNE), c. 1878–80. Pastel over monotype in black ink. 380 × 270 (14¹⁵⁄₁₆ × 10⅝). J 13. Location unknown.

DANCERS IN YELLOW (DANSEUSES EN JAUNE), c. 1878–80. Pastel over monotype. 290 × 260 (11⅜ × 10¼). J 14. Location unknown.

THE CURTAIN (LE RIDEAU), c. 1881. Pastel over monotype. 273 × 324 (10¾ × 12¾). J 18. Paul Mellon Collection, Upperville, Virginia.

CAFÉ-CONCERT, c. 1877. Pastel over monotype in black ink. 370 × 270 (14⅝ × 10⅝). J 23. Musée des Beaux-Arts, Lyons.

CABARET (CAFÉ-CHANTANT), c. 1877. Pastel over monotype in black ink. 242 × 445 (9½ × 17½). J 26. W. A. Clark Collection, Corcoran Gallery of Art, Washington, DC.

THE DUET (LE DUO), c. 1877. Pastel over monotype in black ink. 118 × 159 (4¹¹⁄₁₆ × 6¼). J 27. Robert von Hirsch Collection, Basel.

CAFÉ-CONCERT (THE SPECTATORS), c. 1876–7. Pastel over monotype. 210 × 430 (8¼ × 16⅞). J 28. Location unknown.

CAFÉ-CONCERT, c. 1877–9. Pastel over monotype. 120 × 162. (4¾ × 6¼). J 30. Location unknown.

MADEMOISELLE BÉCAT AUX AMBASSADEURS, c. 1877–9. Pastel over monotype. 160 × 120 (6⁵⁄₁₆ × 4¾). J 34. Location unknown.

PIANIST AND SINGER (PIANISTE ET CHANTEUR), c. 1877. Monotype in black ink with touches of red watercolour. 160 × 120 (6⁵⁄₁₆ × 4¾). J 35. Location unknown.

CAFÉ-CONCERT SINGER or WOMAN IN A LOGE (CHANTEUSE DE CAFÉ-CONCERT or FEMME DANS UNE LOGE), c. 1877–8. Pastel and crayon over monotype in black ink. 141 × 186 (5½ × 7¼). J 36. Private collection, Paris.

CAFÉ-CONCERT SINGER (CHANTEUSE DE CAFÉ-CONCERT), c. 1877–9. Pastel over monotype. 160 × 150 (6⁵⁄₁₆ × 5⅞). J 37. Mr Stephen Caldwell Millet Jr. Collection, Washington, DC.

CAFÉ-CONCERT SINGER (CHANTEUSE DE CAFÉ-CONCERT), probably Mlle Dumay, c. 1877–9. Pastel over monotype. 150 × 120 (5⅞ × 4¾). J 38. Location unknown.

CAFÉ SINGER (CHANTEUSE DE CAFÉ), c. 1877–9. Gouache over monotype. 203 × 203 (8 × 8). J 39. Location unknown.

MADEMOISELLE DUMAY, SINGER, c. 1877–9. Pastel over monotype in black ink. 172 × 121 (6¾ × 4¾). J 40. John W. Warrington Collection, Cincinnati, Ohio.

CAFÉ-CONCERT SINGER (CHANTEUSE DE CAFÉ-CONCERT), c. 1877–9. Touches of red and white pastel over monotype in black ink. 160 × 120 (6⁵⁄₁₆ × 4¾). J 41. Location unknown.

CAFÉ-CONCERT (CHANTEUSE DE CAFÉ-CONCERT), c. 1877–8. Pastel over monotype. 160 × 110 (6⁵⁄₁₆ × 4⅜). J 43. Location unknown.

EXTRAS (LES SURNUMÉRAIRES), c. 1877. Pastel over monotype in black ink. 270 × 310 (10⅝ × 12¼). J 54. Cabinet des Dessins, Louvre, Paris.

AT THE THEATRE, SPECTATORS IN A LOGE (AU THÉATRE, SPECTATEURS DANS UNE LOGE), c. 1877. Pastel over monotype in black ink. 165 × 127 (6½ × 5). J 57. W. A. Clark Collection, Corcoran Gallery of Art, Washington, DC.

WOMEN IN FRONT OF A CAFÉ, EVENING (FEMMES DEVANT UN CAFÉ, LE SOIR; UN CAFÉ SUR LE BOULEVARD MONTMARTRE), c. 1877. Pastel over monotype in black ink. 410 × 600 (16⅛ × 23⅝). J 58. Louvre, Paris.

YOUNG WOMAN IN A CAFÉ (JEUNE FEMME À UN CAFÉ), c. 1877. Pastel over monotype in black ink. 131 × 172 (5⅛ × 6¾). J 59. Mr and Mrs Donald Stralem, New York.

THREE GIRLS IN A BROTHEL, SEEN FROM BEHIND (TROIS FILLES DE DOS), c. 1879. Pastel over monotype. 159 × 226 (6¼ × 8½). J63. Location unknown.

TWO WOMEN (DEUX FEMMES), c. 1878–9. Red, white and brown pastel over monotype in black ink. 163 × 119 (6⅜ × 4¹¹⁄₁₆). J 76. Bibliothèque d'Art et d'Archéologie de l'Université de Paris, Fondation Jacques Doucet.

TWO GIRLS IN A BROTHEL FACING EACH OTHER, SEATED (DEUX FILLES ASSISES DE FACE), c. 1878–9. Pastel over monotype. Dimensions unknown. J 77. Location unknown.

WAITING FOR A CUSTOMER (ATTENTE D'UN CLIENT), c. 1879. Monotype touched with colour. 121 × 161 (4¾ × 6¹⁵⁄₁₆). J 84. Location unknown.

THE MADAME'S BIRTHDAY (LA FÊTE DE LA PATRONNE), large plate, c. 1878–9. Pastel over monotype. 265 × 295 (10¾ × 11⅝). J 89. Location unknown.

NUDE WOMEN (FEMMES NUES), c. 1879. Pastel over monotype. 132 × 203 (5¼ × 8). J 118. Location unknown (formerly in the Lefèvre Collection, London).

WOMAN IN THE BATH SPONGING HER LEG (FEMME DANS SON BAIN S'ÉPONGEANT LA JAMBE), c. 1883. Pastel over monotype. 197 × 410 (7¾ × 16⅛). J 120. Louvre, Paris.

WOMAN LEAVING THE BATH (FEMME QUITTANT LE BAIN), 1886–90. 277 × 375 (10⅞ × 14¾). J 122. Mrs R. Dunbar Sherwood Collection, New York.

NUDE WOMAN IN THE BATH (FEMME NUE AU BAIN), c. 1883. Pastel over monotype. 310 × 280 (12¼ × 11 1/16). J 124. Location unknown.

THE BATH (LE BAIN), 1883. Pastel over monotype. 380 × 280 (14⅞ × 11). J 126. Location unknown.

WOMAN GETTING OUT OF THE BATH (LA SORTIE DU BAIN), c. 1880–5. Pastel over monotype. 450 × 240 (17¾ × 9½). J 128. Madame Gillou Collection, Paris.

GETTING INTO BED (LE COUCHER), c. 1883. Pastel over monotype. 380 × 280 (14 15/16 × 11 1/16). J 130. Location unknown.

WOMAN PUTTING OUT THE LAMP (FEMME ÉTEIGNANT SA LAMPE), c. 1883. Pastel over monotype. 330 × 380 (13 × 14 15/16). J 132. Madame Friedmann Collection, Paris.

GETTING INTO BED (LE COUCHER), 1880–5. Pastel over monotype in black ink. 240 × 450 (9½ × 17¾). J 134. C. Frank Stoop Bequest, Tate Gallery, London.

NUDE WOMAN LYING DOWN (FEMME NUE COUCHÉE), c. 1883–5. Pastel over monotype in black ink. 300 × 430 (11⅞ × 16⅞). J 136. Location unknown.

NUDE WOMAN LYING DOWN (FEMME NUE COUCHÉE), c. 1883–5. Pastel over monotype in black ink. 320 × 405 (12½ × 16). J 138. Location unknown.

WOMAN READING (FEMME LISANT), c. 1880–5. Pastel over monotype in black ink. 312 × 280 (12¼ × 11 1/16). J 143. Mrs Thibaut de Saint-Phalle Collection, New York.

THE CUP OF CHOCOLATE (LA TASSE DE CHOCOLAT), c. 1885. Pastel over monotype. 444 × 343 (17¼ × 13½). J 144. Private collection, South Africa.

BREAKFAST (LE PETIT DÉJEUNER), c. 1885. Pastel over monotype. 380 × 280 (14 15/16 × 11 1/16). J 145. Location unknown.

LA TOILETTE, c. 1885. Pastel over monotype. 310 × 270 (12¼ × 10⅝). J 148. Location unknown.

YOUNG GIRL AT HER TOILET (LA TOILETTE FILLETTE), c. 1885. Pastel over monotype. 310 × 270 (11⅞ × 10⅝). J 150. Location unknown.

WOMAN AT HER TOILET (FEMME À SA TOILETTE), c. 1885–90. Pastel over monotype. 430 × 580 (16⅞ × 22⅞). J 152. Location unknown.

WOMAN AT HER TOILET (FEMME À SA TOILETTE), c. 1880–5. Pastel over monotype. 280 × 380 (11 1/16 × 14 15/16). J 153. Paul Brame Collection, Paris.

WOMAN AT HER TOILET (FEMME À SA TOILETTE), c. 1880–5. Pastel over monotype. 310 × 400 (12¼ × 15¾). J 154. Location unknown.

NUDE WOMAN COMBING HER HAIR (FEMME NUE SE PEIGNANT),

c. 1884. Pastel over monotype in black ink. 300 × 270 (11⅞ × 10⅝). J 157. Pierre Schlumberger Collection, New York.

NUDE WOMAN WARMING HERSELF (FEMME NUE SE CHAUFFANT), c. 1880. Pastel over monotype. 450 × 270 (17¾ × 10⅝). J 160. Location unknown.

GETTING READY (SCÈNE DE TOILETTE), c. 1880. Pastel over monotype. 331 × 413 (13 × 16¼). J 161. Location unknown.

NUDE WOMAN LYING DOWN (FEMME NUE COUCHÉE), c. 1880–5. Pastel over monotype in black ink. 410 × 310 (16⅛ × 12¼). J 162. Location unknown.

NUDE WOMAN RECLINING ON A DIVAN (FEMME NUE ALLONGÉE SUR UN DIVAN), c. 1880–5. Pastel over monotype. 380 × 280 (14 15/16 × 11 1/16). J 163. Location unknown.

WOMAN WITH DOG, THE AWAKENING (FEMME AU CHIEN, LE REVEIL), c. 1880–5. Pastel over monotype in black ink. 260 × 310 10½ × 12¼). J 165. Location unknown.

WOMAN GETTING OUT OF THE BATH (FEMME SORTANT DU BAIN), c. 1877. Pastel over monotype. 170 × 280 (6¾ × 11 1/16). J 174. Location unknown.

WOMAN GETTING OUT OF THE BATH (FEMME SORTANT DU BAIN), c. 1877–9. Pastel over monotype in black ink. 160 × 215 (6 5/16 × 7 7/16). J 175. Caillebotte Bequest, Cabinet des Dessins, Louvre, Paris.

GETTING OUT OF THE BATH (LA SORTIE DU BAIN), c. 1879. Pastel over monotype. 210 × 159 (8¼ × 6¼). J 178. Private collection, Great Britain (formerly Vollard Collection).

ADMIRATION, c. 1877–80. Monotype in black ink with touches of dark red pastel below the nude and black pastel under the washstand. 316 × 227 (12¼ × 8⅞). J 184. Bibliothèque d'Art et d'Archéologie de l'Université de Paris, Fondation Jacques Doucet.

NUDE WOMAN DOING HER HAIR (FEMME NUE SE COIFFANT), c. 1877–9. Pastel over monotype in black ink. 215 × 161 (8 7/16 × 5 5/16). J 185. Ittleson Collection, New York.

LA TOILETTE, NUDE WOMAN CROUCHING SEEN FROM BEHIND (LA TOILETTE, FEMME NUE, ACCROUPIE DE DOS), c. 1881–5. Pastel over monotype in black ink. 160 × 120 (6 5/16 × 4¾). J 191. Caillebotte Bequest, Cabinet des Dessins, Paris.

LUDOVIC HALÉVY TALKING TO MADAME CARDINAL (LUDOVIC HALÉVY PARLANT À MADAME CARDINAL), c. 1880–3. Monotype in black ink with red and black pastel. 216 × 159 (8½ × 6¼). J 199. Location unknown.

LUDOVIC HALÉVY IN THE DRESSING ROOM (LUDOVIC HALÉVY DANS LE DRESSING ROOM), c. 1880–3. Monotype in black ink with pastel. Dimensions unknown. J 211. Location unknown (formerly in the David Weill Collection; sold 1971).

LUDOVIC HALÉVY TELLING MADAME CARDINAL A STORY IN THE DRESSING ROOM (LUDOVIC HALÉVY RACONTANT UNE HISTOIRE À MADAME CARDINAL DANS L'HABILLOIR), c. 1880–3. Monotype touched with colour (although Mrs Janis classifies it as black and white). Dimensions unknown. J 215. Location unknown.

DANCER AND AN ADMIRER (DANSEUR ET UN ADMIRATEUR), c. 1880–3. Monotype in black ink with touches of red and black pastel. Dimensions unknown. J 221. Location unknown.

VIRGINIE BEING ADMIRED WHILE THE MARQUIS CAVALCANTI LOOKS ON (VIRGINIE ÉTANT ADMIRÉE PENDANT QUE LE MARQUIS CAVALCANTI LA REGARDE), c. 1880–3. Monotype in black ink with touches of pastel. Dimensions unknown. J 225. Location unknown (formerly in David Weill Collection; sold 1971).

WOMAN IN HAT (FEMME AU CHAPEAU), *c.* 1877–80. Monotype touched with pastel. 85 × 70 (3⅜ × 2¾). J 240. Location unknown.

LANDSCAPE (PAYSAGE), *c.* 1890–3. Pastel over monotype in oils. 270 × 360 (10⅝ × 14⅛). J 274. Location unknown.

LANDSCAPE WITH SMOKESTACKS (PAYSAGE AVEC FUMÉE DE CHEMINÉES), *c.* 1890–3. Pastel over monotype in brown, green and purple oils. 280 × 400 (11 1/16 × 15¾). J 277. Private collection, New York.

LANDSCAPE (PAYSAGE), *c.* 1890–3. Pastel over monotype in oils. 244 × 286 (9⅝ × 11¼). J 278. Derek Hill Collection, Belfast.

AUTUMN LANDSCAPE (PAYSAGE D'AUTOMNE), *c.* 1890–3. Pastel over monotype in brown, purple and olive-green oils. 303 × 400 (12 × 15¾). J 279. Gift of Denman W. Ross, Museum of Fine Arts, Boston.

RIVER BANKS (BORDS DE RIVIÈRE), *c.* 1890–3. Pastel over monotype in oils. 300 × 400 (11⅞ × 15¾). J 280. Cottevieille Collection, Paris.

RIVER BANKS (BORDS DE RIVIÈRE), *c.* 1890–3. Pastel over monotype in oils. 300 × 400 (11⅞ × 15¾). J 282. Location unknown.

LANDSCAPE (PAYSAGE), *c.* 1890–3. Pastel over monotype in oils. 520 × 500 (20½ × 19⅝). J 282.

ROCKS ON A RIVER BANK (ROCHERS AU BORD D'UNE RIVIÈRE), *c.* 1890–3. Pastel over monotype in oils. 400 × 290 (15¾ × 11⅜). J 283. David Weill Collection, Paris.

LANDSCAPE (PAYSAGE), *c.* 1890–3. Pastel over monotype in moss-green, forest green, grey-blue and pale brick-red. 254 × 342 (10 × 13½). J 284. Gift of Denman W. Ross, Museum of Fine Arts, Boston.

LANDSCAPE (PAYSAGE), *c.* 1890–3. Monotype in oils touched pastel. 270 × 360 (10⅝ × 14⅛). J 285. Private collection, New York.

PATH IN THE FIELD (SENTIER DANS LA PRAIRIE), *c.* 1890–3. Pastel over monotype in oils. 300 × 395 (11⅞ × 15½). J 286. Location unknown.

RIVER (UNE RIVIÈRE), *c.* 1890–3. Pastel over monotype in oils. 300 × 400 (11⅞ × 15¾). J 287. Cottevieille Collection, Paris.

LANDSCAPE (PAYSAGE), *c.* 1890–3. Pastel over monotype in oils. 270 × 360 (10⅝ × 14⅛). J 288. Location unknown.

LANDSCAPE WITH WATER (PAYSAGE AVEC EAU), *c.* 1890–3. Monotype in oils touched with pastel. 300 × 390 (11⅞ × 15⅜). J 290. Location unknown.

CORNFIELD AND ROW OF TREES (CHAMP DE BLÉ ET LIGNE D'ARBRES), *c.* 1890–3. Pastel over monotype in oils. 250 × 340 (9⅞ × 13⅜). J 291. Horace Havemeyer Collection, New York.

ROCKY SLOPE (CÔTE ROCHEUSE), *c.* 1890–3. Pastel over mono-type in oils. 330 × 410 (13 × 16⅛). J 293. Private collection, Switzerland.

ROCKY SLOPE (CÔTE ROCHEUSE), *c.* 1890–3. Pastel over mono-type in oils. 320 × 390 (12⅝ × 15⅜). J 294. Belvedere Museum, Vienna.

MOUNTAINS AND VALLEY (MONTAGNES ET VALLON), *c.* 1890–3. Pastel over monotype in oils. 300 × 400 (11⅞ × 15¾). J 296. Location unknown.

LANDSCAPE or HILLS (PAYSAGE or LES COLLINES), *c.* 1890–3. Monotype in oils touched with pastel. 270 × 360 (10⅝ × 14⅛). J 303. Location unknown.

LAKE AND MOUNTAINS (LAC ET MONTAGNES), *c.* 1890–3. Pastel over monotype in oils. 250 × 340 (9⅞ × 13⅜). J 304. Horace Havemeyer Collection, New York.

VESUVIUS (LE VÉSUVE), *c.* 1890–3. Pastel over monotype. 250 × 300 (9⅞ × 11⅞). J 310. Private collection, Paris.

ISLAND AT HIGH TIDE (UN ÎLOT EN PLEINE MER), *c.* 1890–3. Pastel over monotype. 300 × 400 (11⅞ × 15¾). J 311. Bemberg Collection, Paris.

LANDSCAPE WITH ROCKS or LANDSCAPE WITH CLIFFS BY THE BEACH (PAYSAGE AVEC ROCHERS or PAYSAGE AVEC FALAISES PRÈS DE LA PLAGE), *c.* 1890–3. Pastel over monotype in oils. 257 × 345 (10⅛ × 13⅝). J 312. William H. Schab Collection, New York.

LANDSCAPE (PAYSAGE), *c.* 1890–3. Pastel over monotype. 270 × 320 (10⅝ × 12⅝). J 314. Location unknown.

UNDULATING LAND (TERRAINS VALLONNÉS), *c.* 1890–3. Pastel over monotype. 300 × 400 (11⅞ × 15¾). J 315. Location unknown.

LANDSCAPE (PAYSAGE), *c.* 1890–3. Pastel over monotype. 270 × 360 (10⅝ × 14⅛). J 316. Location unknown.

MOUNTAIN SITE (SITE MONTAGNEUX), *c.* 1890–3. Pastel over monotype. 300 × 400 (11⅞ × 15¾). J 317. Bemberg Collection, Paris.

FIELD BY A RIVER (PRAIRIE BORDANT UNE RIVIÈRE), *c.* 1890–3. Pastel over monotype. 250 × 390 (9⅞ × 15⅜). J 318. Location unknown.

OLIVE TREES AGAINST A MOUNTAIN LANDSCAPE (OLIVIERS SUR UN FOND MONTAGNEUX), *c.* 1890–3. Pastel over monotype. 250 × 340 (9⅞ × 13⅜). J 319. Horace Havemeyer Collection, New York.

CORNFIELD AND GREEN HILL (CHAMP DE BLÉ ET COLLINE VERTE), *c.* 1890–3. Pastel over monotype in oils. 260 × 340 (10¼ × 13⅜). J 320. Horace Havemeyer Collection, New York.

FIELD OF FLAX (LE CHAMP DE LIN), *c.* 1890–3. Pastel over mono-type in oils. 250 × 340 (9⅞ × 13⅜). J 321. Location unknown.

CATALOGUE CONCORDANCES

THE ETCHINGS AND LITHOGRAPHS: CONCORDANCE OF CATALOGUE NUMBERS

Delteil	Adhémar	Delteil	Adhémar	Delteil	Adhémar
1	1	23	36	45	5
2	6	24	40	46 and 47	45
3	21	25	39	48	41
4	7	26	28	49	42
5	10	27	30	50	43
6	12	28	31	51★	
7	14	29	54	52★	
8	15	30	53	53	33
9	3	31	25	54	—
10	13	32	26	55	46
11	9	33	27	56	34
12	16	34	48	57	62
13	11	35★		58	56
14	17	36	60	59	35
15	18	37	32	60	64
16	19	38	—	61	65
17	23	39	49	62	47
18	38	40	55	63	67
19	24	41	61	64	68
20	52	42	50	65	63
21	29	43	51	66	57
22	37	44	4		

Works included in the Adhémar catalogue but not listed by Delteil: 2, 8, 20, 22, 58, 59, 65

★Delteil nos. 35, 51 and 52 are monotypes. No. 35 corresponds to Cachin catalogue 49, and no. 51 to Cachin 5.

THE MONOTYPES: CONCORDANCE OF CATALOGUE NUMBERS

Cachin	Janis	Cachin	Janis	Cachin	Janis	Cachin	Janis
1	1	51	216	102	92	153	177
2	9	52	217	103	97	154	149
3	24	53	260	104	95	155	123
4	32	54	256	105	93	156	147
5	33	55	259	106	100	157	125
6	29	56	195	107	103	158	127
7	31	57	197	108	107	159	151
8	61	58	198	109	106	160	119
9	49	59	200	110	105	161	121
10	48	60	206	111	72	162	158
11	51	61	207	112	75	163	137
12	53	62	208	113	83	164	135
13	50	63	209	114	114	165	141
14	47	64	210	115	115	166	139
15	45	65	214	116	87	167	159
16	15	66	218	117	102	168	156
17	55	67	220	118	104	169	262
18	56	68	222	119	109	170	261
19	186	69	223	120	112	171	—
20	44	70	—	121	94	172	271
21	42	71	224	122	117	173	268
22	257	72	226	123	108	174	273
23	16	73	227	124	113	175	266
24	17	74	229	125	169	176	—
25	19	75	230	126	170	177	267
26	20	76	—	127	99	178	265
27	4	77	—	128	180	179	263
28	21	78	201	129	184	180	272
29	22	79	202	130	189	181	264
30	246	80	203	131	173	182	269
31	60	81	204	132	172	183	270
32	237	82	205	133	176	184	308
33	236	83	68	134	188	185	307
34	255	84	116	135	155	186	300
35	233	85	64	136	168	187	297
36	232	86	65	137	167	188	298
37	251	87	82	138	166	189	299
38	253	88	79	139	129	190	309
39	243	89	78	140	133	191	275
40	244	90	71	141	131	192	295
41	249	91	81	142	164	193	302
42	245	92	69	143	181	194	289
43	247	93	66	144	182	195	292
44	248	94	67	145	183	196	305
45	239	95	85	146	179	197	306
46	241	96	86	147	110	198	—
	242	97	73	148	190	199	—
47	—	98	74	149	192	200	313
48	238	99	88	150	193	201	—
49	254	100	90	151	194		
50	234	101	91	152	146		

SELECT BIBLIOGRAPHIES

I THE ETCHINGS AND LITHOGRAPHS

MAJOR EXHIBITIONS THAT INCLUDED ETCHINGS BY DEGAS

Third Impressionist exhibition, Paris, 1877 (nos. 58–60, 'drawings printed in greasy ink').

Fourth Impressionist exhibition, Paris, 1879 (no. 84).

Fifth Impressionist exhibition, Paris, 1880 (no. 44, 'etchings, trial pieces and states of plates').

'Paysages de Degas', Paris, Galerie Durand-Ruel, 1893.

'Degas. Prints, Drawings and Bronzes', New York, Grolier Club, 1922.

'Twenty-six Original Copperplates Engraved by Degas', Frank Perls Gallery, Beverly Hills, California, 1959, with texts by John Rewald and Jean S. Boggs.

'Exhibition of Etchings by Degas', Foreword by John Rewald, Introduction and Notes by Paul Moses, The Renaissance Society at the University of Chicago, 1964.

SALES HELD BEFORE AND SHORTLY AFTER DEGAS' DEATH

Anonymous sale, Paris, 21 February 1911 (no. 26).

Roger Marx sale, Paris, 26 April–2 May 1914 (fine collection of Degas etchings; expert Loys Delteil).

Degas sale, Paris, 6–7 November 1918 (no. 33, his print collection).

Sale of the contents of Degas' studio, Paris, Galeries Manzi-Joyant, 22–23 November 1918 (etchings, lithographs and monotypes, the most comprehensive collection; expert Loys Delteil).

Degas sale, Paris, 11–12 December 1918· (paintings, drawings, retouched prints; experts: Bernheim *jeune*, Durand-Ruel, Vollard).

Third sale of the contents of Degas' studio, Galerie Georges Petit, 7–9 April 1919.

Fourth sale of the contents of Degas' studio, 2–4 July 1919 (including retouched prints and 'impressions en noir').

Tenth sale of the contents of Degas' studio, 12 June 1934.

Mlle Fèvre sale, 1936.

PUBLICATIONS

Alexandre, Arsène, 'Degas graveur et lithographe'. *Les Arts*, no. 171, 1918.

Delteil, Loys, *Edgar Degas. Le Peintre-Graveur illustré*, vol. IX, 1919.

Kornfeld, E. W., *Edgar Degas, Beilage zum Verzeichnis des Graphischen Werkes von Lois Delteil*, for Richard H. Zinser in honour of his eightieth birthday. Bern 1965. 10 pages (a revised account of the states of LD 62, 63, 64, 65).

Lemoisne, Paul-André, *Degas et son œuvre*. Arts et Métiers Graphiques, Paris 1946–9, 4 vols.

Moses, Paul, 'Notes on an unpublished etching by Degas'. *Gazette des Beaux-Arts*, October 1966.

II THE MONOTYPES

All quotations and references in the body of the text have been taken from the following publications:

Blanche, Jacques-Émile, *La pêche aux souvenirs*. Flammarion, Paris 1949.

Degas, Edgar, *Lettres*. Grasset, Paris 1931.

Fénéon, Félix, *Les impressionnistes en 1866* (republished in *Au-delà de l'impressionnisme*). Hermann, Paris 1966.

Fèvre, J. *Mon oncle Degas*. Borel, Geneva 1949.

Halévy, Daniel, *Degas parle*. La Palatine, Paris 1960.

Huysmans, J.-K., *L'Art moderne*. Paris 1883.

Janis, Eugenia Parry, 'The role of the monotype in the working method of Degas', *Burlington Magazine*, January and February 1967.

Jeanniot, Georges, Articles in *La revue universelle*, 15 October, 1 November 1933.

Moore, George, *Impressions and Opinions*. New York 1891.

Rouart, Denis, *Degas à la recherche de sa technique*. Floury, Paris 1945.

Rouart, Denis, *Correspondance de Berthe Morisot*. Paris 1950.

Rouart, Ernest, Article in *Le Point*, February 1937 (issue devoted to Degas).

PHOTOGRAPHIC SOURCES

ETCHINGS AND LITHOGRAPHS

Achenbach Foundation for Graphic Arts, San Francisco 26
Albertina, Vienna 14
Art Institute of Chicago 6, 15, 19, 33, 43, 44, 45, 48, 49b, 53a, 60, 64b, 67
Bibliothèque Nationale, Cabinet des Estampes, Paris 1, 2, 3, 10, 12, 16, 22, 27, 29, 34, 38, 41, 46, 47, 55, 56, 59, 65
Bibliothèque de l'Université de Paris, Fondation Jacques Doucet, Paris 21, 28, 36b, 54b, 64a, 66
British Museum, London 62
Durand-Ruel, Paris 58
Kleinhempel, Hamburg 68

Library of Congress, Washington DC 42
Litym Museum, St Louis, Mo. 39
The Metropolitan Museum, New York 9, 37, 50
Museum of Fine Arts, Boston, Mass. 24, 49a
National Gallery of Art, Washington, DC 7a, 13, 23, 31, 32, 57
Public Library, Boston, Mass. 18
Rijksmuseum, Amsterdam 40
Staatliche Kunsthalle, Karlsruhe 8
Staatliche Museen, Berlin 7, 53b, 63
Statens Museum for Kunst, Copenhagen 35, 52
Albert Winkler, Bern 4, 5, 11, 25, 36a, 61

MONOTYPES

Achenbach Foundation for Graphic Arts, San Francisco 134
Ader et Picard, Paris 176
Albertina, Vienna 49
Art Institute of Chicago 13, 48, 50, 107, 155
Bibliothèque d'Art et d'Archéologie, Paris 83, 88, 92, 108
Bibliothèque Nationale, Paris 31, 37, 54, 89, 100, 105, 119, 123, 131, 133, 142, 147, 148, 149, 150, 162
Brame, Paris 135, 160, 167, 182
Brenwasser, New York 20
British Museum, London 164, 172
Bulloz, Paris 16, 55, 154, 159
A. C. Cooper, London 5, 9, 10, 53, 86, 87, 94, 95, 96, 99, 102, 109, 113, 153
Corcoran Gallery of Art, Washington, DC 171
Witt Library, Courtauld Institute of Art, London 3, 18, 22, 23, 28, 33, 41, 46, 106, 117, 126, 140, 141, 145, 146, 151, 166
Flammarion, Paris 29, 35, 37, 69, 70, 103, 118, 120, 124, 130, 157, 158, 168, 179
R. B. Fleming, London 8, 17, 93, 139
Fogg Art Museum, Harvard University, Cambridge, Mass. 66, 181
Grunwald Graphic Art Foundation, Los Angeles, 152
Peter C. Jones, New York 38, 174

Kleinhempel, Hamburg 161
Kovler Gallery, Chicago 163
La Niepce, Paris 56, 63, 68
Lefèvre Gallery, London 34, 40, 42, 43, 44, 85, 97, 101, 104, 110, 111, 115, 116, 127, 143, 144, 169
Louvre, Paris 136
Metropolitan Museum of Art, New York 39, 125
Musées Nationaux, Paris 77
Museum of Fine Arts, Boston, Mass. 25, 36, 51, 52, 57, 58, 59, 60, 61, 62, 64, 67, 71, 72, 73, 75, 79, 80, 81, 82, 112, 114, 122, 128, 177, 180
National Gallery of Art, Washington DC 1, 74, 165, 175
National Museum, Belgrade 15, 84, 98
Ny Carlsberg Glyptothek, Copenhagen 7
Eric Pollitzer, New York 11, 12
Walter Rosenblum, New York 21, 90
Statens Museum for Kunst, Copenhagen 4, 19, 26, 27, 132
Sterling and Francine Clark Art Institute, Williamstown, Mass. 2, 24, 156, 170, 178
E. V. Thaw Gallery, New York 45
O. Waering, Oslo 137, 138
Etienne Bertrand Weill, Courbevoie 47, 76, 121
Albert Winkler, Bern 6, 14, 30, 78, 91